ARCHITECTURE AND CUBISM

EDITED AND WITH AN INTRODUCTION BY

EVE BLAU AND NANCY J. TROY

ESSAYS BY

DAVID
COTTINGTON

ROBERT L.
HERBERT

DOROTHÉE
IMBERT

IRENA
ŽANTOVSKÁ
MURRAY

JAY BOCHNER

YVE-ALAIN BOIS

PAUL OVERY

BRUNO REICHLIN

KEVIN D.
MURPHY

BEATRIZ
COLOMINA

DETLEF MERTINS

Centre Canadien d'Architecture/Canadian Centre for Architecture, Montréal
The MIT Press, Cambridge, Massachusetts, and London, England

First MIT Press paperback edition, 2002

Printed and bound in the United States of America.

Library of Congress Cataloging-in-Publication Data

Architecture and cubism / edited and with an introduction by
 Eve Blau and Nancy J. Troy; essays by David Cottington ...
 [et al.].
 p. cm.
 "Many of the essays in this book were originally presented at a
colloquium ortanized by the Canadian Centre for Architecture" —
Pref.
 Includes index.
 ISBN 0-262-02422-5 (hc : alk. paper), 0-262-52328-0 (pb)
 1. Cubism (Architecture) — Europe. 2. Cubism — Europe —
Influence. I. Blau, Eve. II. Troy, Nancy J. III. Cottington, David.
IV. Centre canadien d'architecture.
NA958.5.C83A73 1997
720'.94'09041 — dc21 96-49785
 CIP

Design and composition by 10 9 8 7 6 5 4 3 2 1
Danielseed Design, SC, JR

MIT Press
Five Cambridge Center
Cambridge, MA 02142

CCA
Centre Canadien d'Architecture/Canadian Centre for Architecture
1920 rue Baile
Montréal, Québec
CANADA H3H 2S6

THIS BOOK

IS DEDICATED TO THE MEMORY OF

DANIEL ROBBINS

CONTENTS

FOREWORD

Daniel Robbins was a close friend and respected
colleague for many years. We first started working
together in 1970 as members of the committee to visit
the Fogg Art Museum and the Fine Arts Department at
Harvard University. The next year, on his appointment
as director of the Fogg, Danny invited me to study with
him ways of expanding the museum, revitalizing its
galleries and working spaces. This was my initiation
into the world of museums. How wonderfully well we
worked together, he as museologist, I as architect! In
the years that followed, our conversations continued
around the need to make architecture a public concern
through scholarship and presentation to the public.
Danny was a constant mentor and advisor in the
creation and development of the Canadian Centre for
Architecture (CCA). He prepared two key documents:
"On Founding an Architectural Museum," 1979, the
study that established the terms of reference for incor-
porating the CCA, and "A Study Center for the Canadian
Centre for Architecture," 1986, both of which he wrote
with his wife Eugenia Robbins. As a member first of the
Advisory Committee of the CCA (1977–1988) and

subsequently the Board of Trustees, from 1989 until his untimely death in January 1995, he contributed immeasurably to the deliberations that shaped the institution itself. Danny's enthusiasm for our work was boundless.

Always until the end a teacher, always joyous, Danny was a very rare person, taking the greatest pleasure in ideas, which he constantly pursued. He was always positive, seeing the best in the work and proposals of those he respected and of his students. He was sustained, and sustained others, through his encyclopedic knowledge and wide reading in philosophy, art, and science, his broad look beyond the boundaries of disciplines, his courage to go against the stream of received opinion and accepted historiography to open new discussions on twentieth-century art. In the last five years of a heroic struggle against debilitation and pain, he published one article each year.

To honour Daniel Robbins's unique relationship to the CCA as well as his achievements as a scholar, teacher, and museologist, the Canadian Centre for Architecture marked his very substantial contribution to scholarship of early twentieth-century art by organizing the colloquium "Architecture and Cubism" in 1993. That colloquium, which happily he was able to attend, and which included scholars of art history and architecture as well as landscape and literature, became the core of the present volume.

I am pleased to thank Nancy J. Troy, professor of art history at the University of Southern California, and Eve Blau, architectural historian, adjunct curator at the CCA, and editor of the *Journal of the Society of Architectural Historians,* for their careful and skillful work in editing this volume.

Phyllis Lambert
Director, Canadian Centre for Architecture
Montréal, August 1996

PREFACE

Many of the essays in this book were originally presented at a colloquium organized by the Canadian Centre for Architecture to celebrate the contributions that Daniel Robbins made to the fields of art and architectural history through his scholarship, teaching, and work as a museum curator and director.

Robbins entered the field of art history in the late 1950s when he began research for his dissertation, a study of the work of the French cubist painter Albert Gleizes. In 1961, he was appointed assistant curator at the Solomon R. Guggenheim Museum; from 1965 to 1971, he was director of the Museum of Art at the Rhode Island School of Design; thereafter, until 1974, he directed the Fogg Art Museum at Harvard University. In subsequent years he taught at a diverse range of colleges and universities, including Dartmouth, Williams, and Yale. In 1980, he was appointed May I. C. Baker Professor of the Arts at Union College, a position he held until his death in 1995.

Like many of the exhibitions he organized, Robbins's teaching and scholarship focused on French cubism, a movement that he regarded as much broader and in

some ways more complex than conventional histories have typically allowed. In numerous articles and exhibition catalogues, Robbins analyzed the ideologically charged construction of cubism extending back to the 1920s in order to reveal the limitations of a history of cubism defined in terms of Picasso and Braque, and to establish a framework for a more inclusive view in which the socially engaged dimensions of the movement could begin to be described and discussed. Robbins consistently worked to illuminate the historical circumstances in which cubism emerged in pre–World War I France, and he provided a historiographical account of the movement that goes far toward explaining the structure of current debates about cubist art, including those that have shaped the essays in this volume.

The possibility that Robbins seems to have envisioned, of finding a means to reconcile the formal and social-contextual emphases underlying cubist scholarship, is a challenge to which this book on architecture and cubism responds. For the essays brought together here represent the work of a disparate group of scholars, some of whose understanding of cubist painting has been indebted to Robbins's research or influenced by his ideas; others, particularly those who focus primarily on architecture, bring a significantly different set of theoretical and practical concerns to the understanding of cubism. The book therefore functions as an opportunity to deconstruct the conceptual limits within which cubist scholarship has most often operated. It offers multiple perspectives on the relationship between architecture and cubism not only by identifying and exploring particular instances of their intersection, but at the same time by articulating, or at least suggesting, a framework that enables us to recognize the validity and interdependence of theoretical, formal, historical, and contemporary concerns.

Eve Blau
Nancy J. Troy

EVE BLAU
NANCY J. TROY

INTRODUCTION

It is one of the central, if largely untheorized, tenets of the history of modern architecture that cubism forged a vital link between avant-garde practices in early twentieth-century painting and architecture. This notion, which circulated widely among artists, architects, and critics in Europe beginning in the 1920s, was first posited in historical terms by Sigfried Giedion in his influential book of 1941, *Space, Time and Architecture,* by means of a now famous pair of juxtaposed images: Pablo Picasso's *L'Arlésienne* of 1912, and Walter Gropius's workshop wing of the Bauhaus at Dessau of 1925–1926 (see fig. 7.2).[1] Not only did building and painting share in the *Zeitgeist,* Giedion suggested, embodying in their nonperspectival spatial compositions a new perception of space in terms of time, or "space-time," marked by planarity, transparency, and multiple viewpoints, but the paired images also proposed a genealogy. The technical and spatial innovations in the Bauhaus building—the "hovering, vertical grouping of planes" and "extensive transparency that permits interior and exterior to be seen simultaneously"—Giedion argued were not "the unconscious outgrowths of advances in engineering," but part of a conscious effort on the part of Gropius to give architectural form to "cubist" space.[2] Moreover, Giedion suggested, Gropius was not alone among architects in looking to cubist painting to find a model for spatial experience

that would be appropriate to modern architecture. In fact, he argued, the purist art of Le Corbusier, "coming out of French soil, was the closest of all to the aim of cubism and, at the same time, to architecture."[3] For Giedion, the translation into architecture of a new perception of space extrapolated from the cubist painters' "device of simultaneity" and "transparency of overlapping planes" was central to the architectural project of the modern movement in Europe in the 1920s.[4]

After World War II, Giedion's theme was taken up by Henry-Russell Hitchcock in *Painting toward Architecture* of 1948, the catalogue of an exhibition at the Museum of Modern Art with the explicitly programmatic purpose of illustrating "abstract painting of the 20th century which has influenced the development of modern architecture."[5] In his introductory essay, Hitchcock suggested that the fractured, carved-out spaces of early, analytical cubism had less to offer architects than later synthetic cubist paintings, which were concerned with spatial relations of far more subtle complexity and were therefore both "architectonic" and "abstract." Although "it was obvious that abstract painting, already so architectonic, could likewise provide a basis for large-scale architectural composition," the significant points of intersection between painting and architecture actually came after cubism, indeed, in its wake, Hitchcock maintained. "The most striking examples of the direct impingement of the ideals of abstract art on architecture in various European countries belong to the mid-'20s."[6] According to Hitchcock, the "new architecture," informed by these ideals, first took shape in France, Holland, and Germany, particularly in the work of Le Corbusier, J. J. P. Oud, Walter Gropius, and Ludwig Mies van der Rohe.[7] The most important links were not to cubist painting in the teens but to postcubism in France, the Dutch De Stijl movement, and the painters gathered at the Bauhaus in Germany. For Hitchcock, therefore, the historical connection between cubism and modern

architecture of the 1920s was less direct than Giedion had proposed, mediated through the postcubist painting and sculpture of the intervening years.

Faced with the crisis of modern architecture in the postwar consumerist environment of the 1950s, the concern of a new generation in American schools of architecture was not so much with the historical influence of cubist and postcubist painting on architecture, as it was to discover a more complex and compelling relationship between cubism and architecture than Giedion's paradigm seemed to allow. That is, the issue was no longer one of tracing historical influences but rather of focusing on the complexity of cubist space itself as a means of avoiding the cul-de-sac of functionalism as corporate style. In this context, the work of Gropius, for whom there was, according to Joan Ockman, "ostensibly little disjunction in adapting the program of the Bauhaus ... to American managerial democracy,"[8] could no longer represent the relationship between architecture and cubism, as it had done for Giedion.

At the University of Texas, Austin, in 1955–1956, architectural historian Colin Rowe and Robert Slutzky, who had studied painting with Josef Albers at Yale, returned to Giedion's original propositions and the argument of his juxtaposed images in *Space, Time and Architecture*, in an essay, "Transparency: Literal and Phenomenal" (not published until 1963), that is still widely regarded as the most compelling treatment of the relationship between architecture and cubism.[9] Although they endorsed Giedion's assertion that the translation into architecture of a new perception of space extrapolated from prewar cubist painting was central to modern architectural practice in the 1920s, Rowe and Slutzky claimed that the terms used (by Giedion and others) to describe the new spatial order of cubist painting, "simultaneity" and especially "transparency," were too imprecise to be useful concepts for a critical analysis of modern architecture.

To clarify the issue, Rowe and Slutzky borrowed from György Kepes and László Moholy-Nagy a concept of transparency that implies not merely "an optical characteristic" but a broad "spatial order," which they described as the "simultaneous perception of different spatial locations."[10] On the basis of this definition, Rowe and Slutzky distinguished between what they called *literal* transparency, "an inherent quality of substance—as in wire mesh or glass curtain wall," and *phenomenal* or seeming transparency, "an inherent quality of organization."[11] While the feeling for the former derived from two sources—the machine aesthetic and cubist painting—the feeling for phenomenal transparency, they claimed, derived from cubist painting alone, and particularly the analytical cubist compositions of 1911–1912 by Picasso, Braque, and Gris. The formal qualities of these paintings (identified as "frontality, suppression of depth, contracting of space, definition of light sources, tipping forward of objects, restricted palette, oblique and rectilinear grids, propensities toward peripheric development") had for Rowe and Slutzky far less to do with the straightforward, literal transparency of the Bauhaus building's glass walls than with the complex spatial layering, deliberately ambiguous interrelation of parts, and multiple signification of Le Corbusier's Villa Stein–de Monzie of 1926–1927 at Garches and his League of Nations project of the latter year.[12] For architects in the 1920s, and particularly for Le Corbusier, Rowe and Slutzky concluded, the translation into three dimensions of "cubist" space was not only optical but phenomenological; it involved a new spatial order, not just the proliferation of glazed wall surfaces in modern buildings of the period.

Rowe and Slutzky continued their examination of the formal properties of modern architecture in "Transparency: Literal and Phenomenal . . . Part II" (published in 1971 though written at the same time as Part I, in 1955–1956).[13] Having determined that some

of their suppositions in the first article were "tendentious" and "arguable" (in particular the implication that one of the causes or by-products of phenomenal transparency was a "preference for shallow space, or where such space was not possible, for stratification of deep space, so that the phenomenal as opposed to the real space could be experienced as shallow"), in the second installment they concentrated on the two-dimensional manifestation of phenomenal transparency as surface pattern, rather than its three-dimensional, spatial manifestation.[14] In this, the multiple readings afforded by superimposed grids on the surfaces of modern buildings, such as Le Corbusier's Algiers skyscraper project of 1933, are found to correspond to the layered surface patterns of Venetian Gothic and mannerist building facades. In its two-dimensional manifestation, therefore, phenomenal transparency would seem to have nothing at all to do with cubism. Instead, in Part II of their essay, Rowe and Slutzky chose to ground phenomenal transparency, now understood to be "the method of raising fluctuating figures into ambiguous prominence," in Gestalt psychology.[15] Yet, as Rosemarie Haag Bletter pointed out in her critique of the two articles, this operation involved a misunderstanding of Gestalt psychology, which is not about ambiguous, multiple readings but rather about the ordering principle of mind that resists such multiplicity and comprehends ambiguous figures in either one way or another, but not both simultaneously.[16]

But more significant in the context of the present volume is the critical repositioning of the concept of phenomenal transparency in the second installment of the essay. Posited in Part I as a perceptual link between cubist painting and modern architecture, in Part II phenomenal transparency is disengaged from both cubism and purism and relocated in an ahistorical, formalist discourse regarding fluctuating figures of architectural signification that might be described as foreshadowing postmodern concerns of the 1970s

and 1980s. The second installment of "Transparency" thus acknowledges the limitations of Rowe and Slutzky's original concept as historically linked to the cubist heritage, and redefines phenomenal transparency as a formal strategy that transcends historical periodization. Part II, as Bletter points out, therefore reveals the problems involved in approaching the relationship between architecture and cubism as a phenomenological aspect of perception.[17]

Yet the concept of phenomenal transparency, which helped to reveal to a new generation of architects the formal richness, complexity, and sophistication of Le Corbusier's architecture, proved to be remarkably productive. The impact of Rowe and Slutzky's articles on architectural practice in the 1970s (particularly the engagement of the New York Five with Le Corbusier's painting and architecture of the 1920s and 1930s)[18] has yet to be thoroughly examined, but the concept of phenomenal transparency itself was rapidly assimilated into architectural education. Largely disengaged from the historical question of the relationship between cubist painting and modern architecture, phenomenal transparency was reconstituted in the design curricula of a number of American schools of architecture (Cornell, Cooper Union, and Princeton, in particular) as well as the Eidgenössische Technische Hochschule in Zurich, as both an analytical tool and an "operative concept" by which the "organization of form could be conceptualized and realized in drawing."[19] Such exercises took the form of analytical drawings in which the spatial relationships between objects in cubist and purist paintings were meticulously plotted and diagrammed, as well as design problems where the formal properties associated with phenomenal transparency (visual ambiguity, stratified space, overlapping and interpenetrating figures, contradictory spatial dimensions, etc.) were conceived as configurational principles and applied to the solution of architectural problems.[20] Individually Rowe and Slutzky in

the 1970s and early 1980s also continued to explore the significance of cubist and postcubist art for architecture at both building and city scale; Rowe (with Fred Koetter), in *Collage City*, finding corresponding formal strategies in Braque and Picasso's synthetic cubist collages and the urban assemblage of architectural fragments, and Slutzky in the exploration of metaphor and collage in Le Corbusier's urban projects and buildings of the late twenties and after.[21]

▪ ▪ ▪

While cubism has been a central and continuous concern for modern architects as well as for theorists, critics, and historians of their work, the thematics of architecture have not assumed a comparably focal role in the historical or critical analysis of cubist painting. To be sure, architecture has been recognized as a very widespread and important trope in postcubist painting of the late teens and twenties (purism and constructivism, for example), but as a motif it rarely appeared in the work of Picasso, Braque, or Gris. When architecture is found to play a prominent role in cubism, the work in question invariably turns out not to have been done by any of these three canonical leaders of the movement. From an art historical perspective, therefore, any analysis of the relationship between architecture and cubism ultimately depends upon the contested definition of cubism itself. Quite apart from the question of whether there was such a thing as cubist architecture, today there is no consensus about the very meaning of cubism, as a style or as a historical phenomenon. Indeed, historians of cubism do not necessarily agree on who exactly was a cubist painter, or to whose work the written statements of the period apply.

Ever since 1920, when the dealer Daniel-Henry Kahnweiler first published *Der Weg zum Kubismus* (later translated as *The Rise of Cubism*), standard treatments of cubism have invariably defined it in

terms of Picasso, Braque, Gris, and Léger, all artists whose work Kahnweiler had handled before World War I.[22] Even in John Golding's still definitive study of the origins and early years of the cubist movement, *Cubism: A History and an Analysis 1907–1914* (written as a doctoral thesis at about the same time as Rowe and Slutzky's essays on "transparency," the book was originally published in 1959 and most recently revised in 1988), more than half of the text is devoted to the work of Picasso, Braque, and Gris. Not only does Golding use these painters' development as an organizing principle for his book, but he also accepts, with certain provisos, the distinction initially suggested by Kahnweiler between analytical and synthetic phases of cubism, separated by the invention of collage in 1912. Although Golding insists upon the realist aims of cubism, he does so in emphatically formalist terms and even invokes an architectural metaphor to characterize the 1911–1912 work of Picasso and Braque, which for Rowe and Slutzky exemplified phenomenal transparency. According to Golding:

> The method of composition used by the painters brought with it a new element of ease and fluidity. Most important, since form was now largely suggested rather than clearly defined, and since a strong linear quality was retained in the finished painting, it became much easier to combine the various views of an object or to synthesize in its depiction a greater amount of information. For example (although the painters never worked in such an obvious and theoretical way), plan, section and elevation of an object could be laid or drawn over each other, and then adjusted and fused to form a single, legible and highly informative image. Secondly, it was now obviously much easier to fuse figure and surroundings, thus emphasizing the "materiality" of

space and also ensuring the unity of the picture surface.[23]

Golding's description evokes Rowe and Slutzky's characterization of phenomenal transparency, which has structured the discussion of cubism and architecture in terms that only Le Corbusier's architecture seems to satisfy, just as Golding's construction of the history of cubism is germane to the work of Braque, Picasso, and Gris but to no other cubist painters. Thus, virtually every other practitioner of cubism (the exception is Fernand Léger) has, by definition, been able to play only a minor role in the history of the movement; in like manner, the work of Gropius, which exemplifies the category of literal transparency in Rowe and Slutzky's account, is relegated to inferior status in the history of modern architecture.

The dominant, formalist view of cubist painting began to be challenged in the 1960s, when Daniel Robbins published the first of several articles and exhibition catalogues focusing on the work of Albert Gleizes, Jean Metzinger, Robert Delaunay, Jacques Villon, and Raymond Duchamp-Villon, among others.[24] None of these artists experimented with collage, nor can the linked terms "analytical" and "synthetic" be used effectively to describe the evolution of their work. Unlike Picasso, Braque, and Gris, none of them signed exclusive contracts with Kahnweiler; instead, they exhibited their work in public venues in Paris and wrote books, essays, and statements in order to explain that work to a broad public. Moreover, these artists, unlike Picasso et al., were at least acquainted with architects (notably with Le Corbusier's mentor, Auguste Perret) and showed a lively interest in architecture and interior design, as demonstrated either by the subject matter of their paintings (in the case of Delaunay) or by their participation in the display of the Maison Cubiste at the Salon d'Automne of 1912 (where works by Gleizes, Metzinger, Villon, and Duchamp-Villon, among others,

were exhibited). Because of their engagements in the public arena, these artists were identified with cubism in press reviews and art publications of the period. From this, one might argue not only that these could be considered the "true" cubists—the ones whose work was widely available in Paris and who therefore were arguably even more closely associated with cubism by contemporary French audiences than Picasso, Braque, and Gris—but also that they approached the relationship between architecture and cubism in ways that are significant, no matter how different from the relationship that has been posited with the work of the canonical cubists. Nevertheless, for the architects who engaged cubism in their work, for Le Corbusier in particular, Gleizes, Metzinger, et al. were of little or no interest; the painters whose work was important to them were Picasso, Braque, Gris, and Léger.

Yet art and architectural discourses have generally not been sensitive to such nuances. Cubism has been treated as a monolith, and the paintings of one group of artists are often conflated with the writings of another. As a result, disparate and even antithetical theories and practices have been collapsed into an undifferentiated and therefore critically imprecise approach to the problem. As Yve-Alain Bois forcefully argues in this volume, it is impossible to explain Picasso's paintings by reference to the theoretical statements of Metzinger and Gleizes. Yet such explanations form the subtext of most art historians' accounts of the relationship between cubism and architecture; at the same time, architectural historians tend to see cubism not so much as it appeared to contemporary audiences but instead through the polemically charged lens of Le Corbusier's architecture, paintings, and theoretical work of the late teens and twenties, which identified cubism exclusively with the work of Picasso, Braque, Léger, and Gris, rather than that of Delaunay, Gleizes, or Metzinger, for example.[25]

Although Robbins did not directly engage the rela-

tionship between cubism and architecture, his practice of what has come to be known as the social history of art encouraged the recovery of a historical dimension of cubism that had been largely ignored in the formalist interpretive paradigm that has animated the interest of architects ever since Le Corbusier. Initially articulated by Kahnweiler and further developed by Alfred Barr, Jr., in the 1930s, this paradigm was ultimately instated by Clement Greenberg as a cornerstone of his model of modernism, which dominated art criticism in the United States throughout the 1940s and 1950s.[26] But an emphasis on social and political history was only one of several methodological possibilities that began to emerge in the 1960s in reaction to the dominance of Greenbergian formalism. By the late 1970s, Rosalind Krauss and Yve-Alain Bois had developed another, theoretically sophisticated alternative by turning to structural linguistics as a model for understanding the generation of meaning in works of art as a function of representational codes and conventions. Offering Ferdinand de Saussure's differential system of language as a paradigm for the operations of signification in cubist *papiers collés* in particular, Krauss and Bois were concerned to demonstrate that art, like language, resists fixed meanings; instead, meanings are generated within a system of relationships determined by shifting discursive functions. Thus for Krauss, Bois, and others who have embraced structuralist and poststructuralist theories of representation, the individual elements of a cubist *papier collé* can never be assigned a fixed or absolute meaning: "meaning is always mediated by the system; it is inevitably, irremediably, irrevocably, processed by the system's own structural relations and conventions."[27] From this perspective, it is impossible to read either the forms of a *papier collé* still life as signifying the presence of objects in nature, or the contents of *papier collé* newsprint as direct references to political, social, or historical events.[28] Rejecting the proposition that formal and political interpretations

should be given equal consideration, Krauss has stated, "I think one needs a model for how politics enters the work. . . . We need a model for how it gets instituted within the aesthetic structure. . . . It would be very easy to say, 'Yes, let's have many levels of meaning.' That would be friendly and nice, and we would all go home and feel good, but I'm resisting it because there is a difference between a reflectionist and a constructive view of art. . . . Any text, any utterance is constructed, because it's already in the mediated form of language. And a work of art is already in a mediated state; it's already in a frame and at a mediated level of signs— it's not in the world anymore."[29] The problem with this position, according to social historians of art, is not simply the premium it places on formal articulation as the key to the significance of cubism as a representational system, but also its refusal to admit the validity of a contextualist position that argues for a more direct relationship between art and social history.

According to this necessarily schematic historiography of cubism, the field appears to have been polarized around radically different conceptions of how works of art engage history and construct meaning. In practical terms the result has been an inability to integrate the historically important but architecturally insignificant Maison Cubiste, for example, with a theoretically informed and formally sophisticated approach to the relationship between cubism and architecture. In the past ten years, however, there have been several attempts to qualify and integrate these opposed positions. For example, David Cottington has examined the twin poles of Picasso's formal production and its relationship to social and intellectual issues, through an exploration of the previously overlooked "middle terms in the equations drawn between aspects of Cubism and the leading intellectual currents of the time: those material factors of discourse, ideology, relations of production within and through which, in the historical conjuncture of the prewar decade, Cubism

was constituted."[30] Instead of positing that social issues were germane to cubism simply because direct references were made to them in the newspaper fragments Picasso used to construct his *papiers collés,* Cottington shows how the complex forms of Picasso's art indirectly responded to a variety of interrelated intellectual, economic, and political pressures, including new types of patronage, the changing structure of the art market, and the formation of an avant-garde subculture, as well as political developments in prewar France. In the process, he argues that any interpretation of the *papiers collés'* engagement with political and other current issues has to contend with the ways in which the properties of the medium, and Picasso's specific manipulations of it, effectively preclude direct access to the ostensible subject matter of his work. In other words, Cottington shows, one cannot treat the formal structure as if it were literally transparent, as if it played no role in shaping the meaning of the work of art.

From a completely different perspective, Robin Evans makes a related and equally important point. Within the context of a monumental study of geometry and architecture, *The Projective Cast: Architecture and Its Three Geometries* (more or less complete at the time of his death in February 1993, but not published until 1995), Evans points to a connection between architecture and cubism, implicit though largely unexplored, in the juxtaposed images upon which Giedion founded his original argument in *Space, Time and Architecture.* The common ground between cubism and architecture, Evans suggests, was not a new conception of space, nor the perception of objects in space, nor even the relation between object and spatial matrix, but picture-making itself: "The cubists focused on representation, giving us pictures of pictures rather than pictures of things."[31] In the cubists' assault on single-point or traditional perspective systems, Evans argues, orthographic projection, as an abstract but

analytically powerful method of representing complex three-dimensional objects in two dimensions (the method by which the standard set of building plans, elevations, and sections is produced), provided an analogy—though not an explanation—for cubist pictorial composition. "It helped reassert the importance of the object within a practice that was on the verge of annihilating it; it provided a precedent showing that overlaid multiplicity adds up to a unified picture, a precedent also for the collapse of pictorial depth into a shallow stratum; and, in its more complex demonstrations, it rendered objects transparent and gave suggestive instances of rotation and discontinuity."[32] Giedion, Evans seems to suggest, may have recognized the essentially two-dimensional significance of "cubist" space—as a way of representing rather than imagining buildings—when, toward the end of *Space, Time and Architecture*, he used a photographic collage of eleven fragmentary images of Rockefeller Center in New York to illustrate a conception of space-time "analogous to what has been achieved in modern scientific research as well as in modern painting."[33] In this instance, it is not the material qualities of the building that Giedion relates to cubism, but its pictorial representation. According to Evans, cubism also made its way back into architecture by pictorial means— through the purist painting of Jeanneret into the architecture of Le Corbusier.

Evans's primary concern is with fragmentation and the "transactions" between architecture and geometry, not with the manifold complexities of the historical relationship between architecture and cubism. Yet within the context of his examination of fragmentation in twentieth-century architecture from the Maison Cubiste (1912) to deconstructivism in the 1980s and 1990s, he offers important insights into the relationship between cubism and modern architecture at the end of the twentieth century.[34] While noting that deconstructivist architects like Coop Himmelblau

have "found ways to project the chaotic dislocations from the virtual space of cubist painting back out into real space," Evans suggests that fracturing and fragmentation in deconstructivist architecture have less to do with the legacy of cubism than with postmodern discourses, initially formulated by Roland Barthes, Michel Foucault, and Jacques Derrida, that explore the destabilization of fixed meanings and the failure of the rationalist Enlightenment project.[35]

Though the open and seemingly fractured forms of deconstructivist architecture, as well as the rotated grids and "eroded" masses of the New York Five, can undoubtedly be understood in relation to cubism conceived as a problem of visual representation, they owe as much (if not more) to post–World War II developments in painting and sculpture, to the systematic investigation of the possibilities of the grid by such artists as Agnes Martin and Sol LeWitt for example, or the postminimalist, often site-specific works of Richard Serra and Gordon Matta-Clark.

In this volume we have therefore chosen to address the question of the relationship between architecture and cubism in historical terms, by returning to the original site of cubist art in pre–World War I Europe and then proceeding to examine a wide range of relationships between avant-garde practices in painting and architecture, as well as other forms of cultural production—including poetry, landscape, and the decorative arts—in France, Germany, the Netherlands, and the new Czechoslovak Republic during the early decades of the twentieth century. We have situated our examination within a narrow time frame in order to encompass a broad field of interdisciplinary inquiry. At the same time we have attempted to frame this discourse in terms consonant with the subject itself, as an open question—the responses to which are themselves multiple and open to question. Each essay therefore

takes as its central theme the problem posed by the volume itself, so that points of intersection—formal, theoretical, representational, historical, sociopolitical—are plotted across a broad field of inquiry, mapping coordinates that open up and expand (rather than bring to closure) the original parameters of the debate. Indeed, the topic mandates no single, absolute, or obvious intersection of artistic fields but instead suggests a whole range of relationships: architecture in cubism; cubism in architecture; architecture and cubism in literature, landscape, cinema, the metropolis, typography, etc. It is therefore especially well suited to the anthology format of this volume, in which the disparate backgrounds, interests, and theoretical commitments of the authors are necessarily foregrounded.

In his contribution to this volume, David Cottington turns from Picasso's *papiers collés* to focus on the Maison Cubiste, the only French work of the pre–World War I period that forged a material connection between cubism and the three-dimensional space of architecture. Paradoxically, Cottington notes, the architectural aspects of the Maison Cubiste were largely ignored by those who saw the project at the Salon d'Automne in 1912; instead, it was the interiors and the decorative objects they contained that touched a nerve. Indeed, this historically grounded view of the relationship between architecture and cubism reveals the centrality of decorative art, later universally vilified by modern architects of the postwar period (Le Corbusier in particular) whose work has since come to be identified with cubism. Cottington's essay explores the larger social and political discourses that structured French debates about the decorative arts in the years before World War I and indicates how these issues ought to inform our understanding not only of the objects displayed in the Maison Cubiste but also of cubism in general as a historical phenomenon forged out of multiple, diverse, and occasionally contradictory interests.

In Prague, a group of artists and architects associated with the Group of Plastic Artists and the journal *Umělecký měsíčník* developed a much more substantial connection between French cubist painting and architecture. As Irena Žantovská Murray discusses, Czech cubism encompassed not only painting, sculpture, and the decorative arts, but also architecture. The Czech proponents of cubism (Pavel Janák, Vlastislav Hofman, Josef Chochol, and Josef Gočár) realized more than forty buildings in addition to designing ceramics, glassware, furniture, and metalwork, and they produced an important body of theory to underpin their enterprise. In the early 1990s the scope and richness of the Czech cubist achievement were documented and celebrated in ten international exhibitions, yet as Murray points out, the "question of how Czech cubist architecture related to the spatial explorations of cubism in French and Czech painting remains only partially formulated." Examining the journal and notebooks of Pavel Janák, one of the principal protagonists of the movement, Murray explores the ways in which the Czech reception of French cubism was informed and transmuted by late nineteenth-century Austrian and German theories of artistic perception, indigenous Bohemian architectural traditions, and the imbricated fabric of the city of Prague itself.

Architecture and cubism coincided in a very different manner in Robert Delaunay's prewar cubist paintings, which prominently featured images of the Parisian medieval church of Saint-Séverin and the modern iron framework of the Eiffel Tower. Kevin Murphy offers a reading of these paintings that explores the formal and ideological links that contemporaries made between such monuments of Gothic architecture and modern engineering. Murphy shows how these structures functioned analogously as models for the transformation of spatial experience, not only in cubist paintings but also in Raymond Duchamp-Villon's facade for the Maison Cubiste and in the sculptor's other engagements with architecture.

Architecture is also a ubiquitous image in the work of Fernand Léger, who spent several years as an architectural draftsman before launching his career as a painter. Despite this early professional experience, Robert L. Herbert argues, the buildings that are visible in Léger's paintings and the frequent invocations of architecture in his writings function metaphorically rather than literally. They refer not to actual buildings but instead to a complex set of ideas about painting that were integral to Léger's artistic and intellectual development, especially during the teens and twenties. Herbert shows that in his cubist and postcubist paintings, Léger understood architecture, in its relation to color, as assuming the position traditionally occupied by drawing, that is, as a manifestation of form structured by geometry. Moreover, Léger, like his friend and colleague Le Corbusier, forged an analogy between modern architecture and machinery by presenting them both in terms of a shared foundation in classical geometry. But Herbert also demonstrates that Léger's ideas about architecture were thoroughly conditioned by his aspirations to social engagement; fearing that the radically stripped-down, white architecture pioneered by Le Corbusier and other modern architects was in danger of becoming elitist, Léger longed for mural commissions that would enable him to enliven those white wall surfaces with bright colors and thereby address a broad public audience through his art.

Jay Bochner plots the intersection of "figurative languages culled from three media"—poetry, painting, and architecture—in an attempt to reclaim the architectural figure in the construction of the signifier. Examining in turn compositional strategies in cubist paintings and in poems by Gertrude Stein, Blaise Cendrars, and Mina Loy, and correspondences between cubist architecture (here defined by "the use of the basic cube as a model") and poems by William Carlos Williams and Ezra Pound, Bochner constructs what he calls "a sort of triple representation, a cubist portrait of cubism."

The metaphorical operations of architecture intersect with those of cubism in Paul Overy's examination of how vanguard artists and architects conceptualized the cell as the fundamental unit of both formal investigation and building production in the years following World War I. Positing cubism broadly "as a kind of shorthand for whole areas of early modernist experimental painting, sculpture, and construction," Overy notes the proliferation of cubic, boxlike forms in modern architecture and draws a connection with paintings based on the use of "repetition and gridding as ways of building up the whole from its parts, of achieving unity in diversity." The cell functions as a fundamental conceptual link between the ways cubic form has been articulated in the realms of painting and architecture. Overy develops this line of thought by pointing to numerous evocations of the cell as both a biological entity and a basic architectural unit by painters and architects of the 1920s. He argues that in this double sense of the term the cell played a key role in the work of Piet Mondrian, Theo van Doesburg, Gerrit Rietveld, and Le Corbusier, among others. The cell, they believed, could be related to the family as a simple organism from which the complex whole of society is generated; at the same time the cell could be understood as the simplest architectural structure at the core of modern architectural and urban development. For Overy, the relationship between cubism and architecture becomes meaningful when we abandon a literal or historical definition of cubism and focus instead on the conceptual links between modern painters and architects, so many of whom took the cell as a model for utopia: "The controlled environment of the artist's studio, or the family cell, could form the prototype for the future. This idea was not derived from cubism, but it accorded with ideas about repetition and gridding that were derived from formal procedures that had developed out of cubism."

Beatriz Colomina frames the question of architecture's relationship to cubism in a similarly dialogical manner, focusing on the "significance of cubism for architecture." She discovers "an overdetermined fascination" with cubism in architectural discourse and suggests that this may derive from the notion, embedded in the discourse of the cubist artists themselves, that cubism is "already architectural." Her own interrogation of the issue leads her to posit a phenomenological link between architecture and cubism, manifest primarily in the work of Le Corbusier. Both cubism and modern architecture, she suggests, participate in a specific model of perception—mobile, cinematic, mutable—identified with the city and metropolitan life. But the strongest bond between cubist painting and modern architecture, Colomina argues, "is to be found in their customers." The best example is Le Corbusier's client Raoul La Roche, who, by collecting cubist and purist art and commissioning purist architecture in which to display it, fostered the production of "cubist" space, where visual and phenomenal/spatial experience merge in the *promenade architecturale*.

The cubist garden, cultivated by Gabriel Guevrekian, Pierre Legrain, and Paul and André Vera in the first decades of the twentieth century, extended the abstract, orthogonal order of the modern architectural interior beyond the house itself and into the landscape. The connection to cubist painting, Dorothée Imbert argues, was superficial, a matter of imitation rather than principle. Pictorially conceived, the cubist gardens were "dynamic in composition" but "static in time," the vegetation immutable, fully mature when planted and not intended to grow. Cubist gardens, Imbert demonstrates, were often short-lived. They were designed, therefore, to be perceived and appreciated in two-dimensional representations—photographic reproductions—rather than experienced directly as spatial constructs. Like cubist paintings, therefore, the cubist garden signified rather than configured a new

conception of spatial experience.

Like Overy, but far more emphatically, Yve-Alain Bois condemns the historicist definition of cubism as a movement played out in the public arena. Rejecting as merely "cubistic" the work of Gleizes, Metzinger, and their colleagues who showed their paintings in the Paris salons, Bois defines cubism proper as narrowly as possible in terms of the work of Picasso in particular and, to a lesser extent, of Braque, Léger, and Gris. As a corollary to this equation, Bois regards the Maison Cubiste as a misguided attempt at "cubistic" architecture; he also rejects any connection between cubist painting and the "cubic" architecture of Adolf Loos or J. J. P. Oud, for example, who developed their distinctive architectural language without reference to cubist painting. The only architecture that qualifies as "cubist" in Bois's estimation is that of Le Corbusier, whose treatment of space in his 1926–1927 villa at Garches, for example, shares the "structuralist logic" of such works by Picasso as *Guitar*, the sculpture of 1912 in which empty space is articulated as a positive sign. Extrapolating from this example, Bois argues that the relationship between architecture and cubism is not formal or morphological but "would have to be found . . . at the structural level of cubism's formation as a semiological system." Bois claims that because Le Corbusier, like Picasso, manipulated architectural form in an exploration of the interchangeability of its signifying capacities, it is appropriate to describe him as a "cubist" architect.

Like Bois, Bruno Reichlin applies the logic of structural linguistics to a close reading of Le Corbusier's purist paintings of the 1920s, and their relationship to his architecture of the same period. Expanding on Rowe and Slutzky's notion of phenomenal transparency, Reichlin shows that the antiperspectival, denaturalized spatial composition, and the formal ambiguities resulting from the use of a pictorial device described (by Le Corbusier and Ozenfant) as "the marriage of

objects in sharing an outline" in the paintings, translated into an architecture characterized by "a plurality of views, itineraries, and readings." Citing Bois's work on the semiology of cubism, Reichlin finds the link between Le Corbusier's purist architecture and cubist painting to lie in the semiological multivalency explored by Picasso in his synthetic cubist collages and *papiers collés* of 1912–1914. Reichlin argues that Le Corbusier's *plans libres*, like Picasso's small sculptures, "resemanticize" the architectural sign, so that "only the ensemble of spaces, elements, and accidents reveal the rules — the syntax — that structures them."

Detlef Mertins carefully reconsiders Sigfried Giedion's seminal *Space, Time and Architecture*, the original discursive site of the relationship between architecture and cubism. Mertins reconstructs the history of Giedion's "representation of cubism's trajectory into modern architecture" and sets it within the broader context of the reception of cubism in German architectural culture, the art criticism of Adolf Behne during and immediately after World War I, the early postwar experiments of Gropius and others at the Bauhaus, and Giedion's own critical writing of the 1920s and 1930s. Examined within the context of German intellectual traditions and aesthetic theories, Giedion's understanding of the relationship between architecture and cubism, Mertins concludes, was "historically and conceptually legitimate." Moreover, Mertins claims that Giedion had a much more complex and sophisticated conception of transparency than the paired images used to illustrate this concept in *Space, Time and Architecture* would suggest. "It was not simply a transparency of substances, as Rowe and Slutzky later presumed. Rather, it was a transparency of consciousness engendered by works of art and architecture that for him mediated between inner and outer worlds — their status as objects recalibrated to the new technologies of vision as well as

industrial production." Viewed from this perspective, Mertins argues, Rowe and Slutzky's critique of Giedion and the distinction they draw between literal and phenomenal transparency (based on objectivist aesthetics of subject reception) appear both "inadequate and forced." Giedion, he concludes, aimed to account for the purist architecture of Le Corbusier as well as the "constructivist" architecture of Gropius and, like Rowe and Slutzky, to "grapple with the problematic ambiguities and indeterminacies of perception and cognition on the basis of modern psychology" as well.

Together, the essays in this volume clearly indicate that though there were many points of intersection — historical, metaphorical, theoretical, ideological — between cubism and architecture in the early years of the twentieth century, there was no simple, direct link between them, and the links that did exist were themselves mediated by other practices. Most often we find that the connections between cubist painting and modern architecture are construed analogically, that is, by reference to shared formal qualities (fracture, fragmentation, spatial ambiguity, overlap, transparency, multiplicity) or by analogy to contemporary representational techniques or procedures in other media such as film, technical drawing, poetry, photomontage. The significance of cubism for architecture, the essays suggest, was as a method of representing modern spatial experience, of submitting the ambiguity and indeterminacy of that experience to the ordering impulses of art. Whether these conclusions would hold true for more recent developments in architecture is a question that lies outside the historical framework of this volume — but one that deserves to be answered in full. Such a project would have to examine the materiality of post–World War II architecture in relation to cubism understood not as a historical movement or particular set of objects but rather as an intellectual construct, an aesthetic discourse, an idea.

NOTES

We wish to thank Mary McLeod for her critical reading and important suggestions for improving this essay.

1. As Sokratis Georgiadis pointed out in his *Sigfried Giedion: An Intellectual Biography*, trans. Colin Hall (Edinburgh: Edinburgh University Press, 1993), 137–138, though written in the period 1938–1941, *Space, Time and Architecture* engaged ideas that were current in the previous two decades. "Giedion's theoretical approach was not based on the state of architectural thought of the Thirties but reached back to that of the first and second decades of this century. The discoveries in the field of painting—the 'optical revolution' of Cubism—was [*sic*] considered particularly important in this context. This book no longer displayed the social involvement that had decisively shaped the first CIAM period of 1928–1935. What was being built was the foundation of the belief that modern architecture principally implied a major formal change." In his essay in this volume, Detlef Mertins discusses the context within which Giedion's ideas regarding the relationship between cubism and architecture, published in 1941, had been formulated in Germany in the 1920s. For Giedion's association with Alexander Dorner, director of the Provinzialmuseum, Hannover, and the impact of Dorner's "space-time" theory of architecture, developed in the 1920s, on Giedion's conception of space-time in his text of 1941, see Joan Ockman, "The Road Not Taken: Alexander Dorner's 'Way Beyond Art'," in Robert Somol, ed., *The Origins of the Avant-Garde in America, 1923–1949: The Philip Johnson Colloquium* (New York: The Monacelli Press, 1997).

2. Sigfried Giedion, *Space, Time and Architecture: The Growth of a New Tradition* (1941; Cambridge: Harvard University Press, 1976), 493.

3. Ibid., 439.

4. Ibid., 494–495.

5. Henry-Russell Hitchcock, *Painting toward Architecture* (New York: Duell, Sloan and Pearce, 1948). Until the early 1960s, this book was the only work in English (after *Space, Time and Architecture*) to deal exclusively with the connection between modern painting and architecture. The programmatic purposes of the exhibition included promotion of the Miller Company, a manufacturer of lighting equipment, and its collection of abstract art from which the works exhibited at the Museum of Modern Art were drawn. The exhibition was intended to be instrumental in another way as well, its purpose being to show not only abstract painting that had already influenced modern architecture, but also "contemporary abstract painting and sculpture of potential value to contemporary architects" (n.p.).

6. Ibid., 22–23.

7. Ibid., 24.

8. Joan Ockman, "Introduction," in Joan Ockman, ed., *Architecture Culture 1943–1968: A Documentary Anthology* (New York: Rizzoli, 1993), 17.

9. Colin Rowe and Robert Slutzky, "Transparency: Literal and Phenomenal," *Perspecta* 8 (1963), 45–54. The essay was republished in German as *Transparenz*, with commentary by Bernhard Hoesli, Le Corbusier Studien 1 (Basel and Stuttgart: Birkhäuser Verlag, 1968). This version contains lengthy

commentary (in German) by Hoesli, who had taught with Rowe and Slutzky at the University of Texas, as well as footnotes (in English) with portions of the original manuscript that had been deleted from the *Perspecta* article. The *Perspecta* version of the essay was republished in Colin Rowe, *The Mathematics of the Ideal Villa and Other Essays* (Cambridge: MIT Press, 1976).

In his commentary, Hoesli (pp. 46–47) dealt at length with Hitchcock's introduction to *Painting toward Architecture*, the central tenet of which (that "abstract art . . . makes available the results of a kind of plastic research that can hardly be undertaken at full architectural scale"), Hoesli maintained, had been held by two generations of historians of modern architecture. Rowe and Slutzky's treatment reflected not only a change of mood but also a radically different approach to the question itself, which was no longer considered historically but in terms of precisely defined conceptual terminology and close formal analysis.

For the School of Architecture at Austin during this period and the context within which Rowe and Slutzky's essays took shape, see Alexander Caragonne, *The Texas Rangers: Notes from an Architectural Underground* (Cambridge: MIT Press, 1994), esp. 157–173.

10. Rowe and Slutzky, "Transparency," 45. See György Kepes, *Language of Vision* (Chicago: Paul Theobald, 1944), and László Moholy-Nagy, *Vision in Motion* (Chicago: Paul Theobald, 1947).

11. Rowe and Slutzky, "Transparency," 46.

12. Ibid., 46–54.

13. Colin Rowe and Robert Slutzky, "Transparency: Literal and Phenomenal . . . Part II," *Perspecta* 13/14 (1971), 287–301, rpt. in Ockman, ed., *Architecture Culture*, 206–225. According to Ockman, both parts of the essay were written in the winter of 1955–1956 and submitted to the *Architectural Review*, which she notes "rejected them, presumably for their anti-Gropius bias." Apparently, before it was published in *Perspecta*, the essay (in manuscript form) circulated in architecture schools during the late 1950s and early 1960s. We are indebted to Mary McLeod for this reference.

14. Rowe and Slutzky, "Transparency, Part II," 288.

15. Ibid., 297–298. Colin Rowe had addressed the issue of cubism and modern architecture in an article, "Mannerism and Modern Architecture," published in *Architectural Review* in 1950, five years before "Transparency" was written. In this text, Rowe related cubist and mannerist compositional strategies, an approach developed further in "Transparency, Part II." Rowe also evinced a more favorable view of both Giedion and Gropius in this earlier treatment. When it was republished, however, in *The Mathematics of the Ideal Villa and Other Essays*, 29–57, Rowe added in a prefatory note: "This little piece, particularly in its discussion of Cubism, has been painful to me since before the day of its publication" (29). Ockman, *Architecture Culture*, 205, notes that Slutzky, perhaps as a result of his contact with Albers at Yale in the early 1950s, was "critical of Bauhaus orthodoxy and influenced by Gestalt studies in visual perception."

16. Rosemarie Haag Bletter, "Opaque Transparency," *Oppositions* 13 (Summer 1978), 121–126.

17. Ibid., 126. Bletter concludes: "Phenomenal transparency is, then, quite useful in helping us comprehend some works of Le Corbusier, but the overall analysis of Rowe and Slutzky is too erratic to make for workable categories of architectural examination. While we may not agree with Giedion's definitions of modern architecture, literal and phenomenal transparency in no way provide us with a new general definition."

18. The New York Five included Peter Eisenman, Michael Graves, Charles Gwathmey, John Hejduk, and Richard Meier. Their designation derived from the publication of their work in *Five Architects: Eisenman, Graves, Gwathmey, Hejduk, Meier* (New York: Oxford University Press, 1975), for which Colin Rowe wrote the introduction.

19. Hoesli, in Rowe and Slutzky, *Transparenz*, 48.

20. For example, see ibid., 48–71.

21. Colin Rowe and Fred Koetter, *Collage City* (Cambridge: MIT Press, 1978); Robert Slutzky, "Aqueous Humor," *Oppositions* 19/20 (Winter/Spring 1980), 29–51. For a recent discussion of *Collage City* and cubism, see Mark Linder, "From Pictorial Impropriety to Seæming Difference," *ANY*, no. 7/8 (1994), 24–27.

22. Daniel-Henry Kahnweiler, *The Rise of Cubism*, trans. Henry Aronson (New York: Wittenborn, Schultz, 1949). For a recent presentation of the movement that privileges as "true Cubism" the work of the canonical "four masters" over the "so-called Cubism" of other "minor and theoretically minded artists," see Douglas Cooper and Gary Tinterow, *The Essential Cubism: Braque, Picasso & Their Friends 1907–1920*, exh. cat. (London: Tate Gallery, 1983), esp. the introduction, 10–14.

23. John Golding, *Cubism: A History and an Analysis 1907–1914*, 3d ed. (Cambridge: Belknap Press of Harvard University Press, 1988), 90.

24. Robbins's principal scholarly contributions to this debate include: "From Symbolism to Cubism: The Abbaye of Créteil," *Art Journal* 23 (Winter 1963–1964), 111–116; "Albert Gleizes: Reason and Faith in Modern Painting," in *Albert Gleizes 1881–1953: A Retrospective Exhibition*, exh. cat. (New York: Solomon R. Guggenheim Museum, 1964), 12–21 (this text and the related exhibition, also organized by Robbins, grew out of research for his dissertation, "The Formation and Maturity of Albert Gleizes: A Biographical and Critical Study, 1881 through 1920," Ph.D. diss., New York University, 1975; Robbins, ed. and intro., *Jacques Villon*, exh. cat. (Cambridge: Fogg Art Museum, 1976); "Jean Metzinger: At the Center of Cubism," in *Jean Metzinger in Retrospect*, exh. cat. (Iowa City: University of Iowa Museum of Art, 1985), 9–23; and "Abbreviated Historiography of Cubism," *Art Journal* 47 (Winter 1988), 277–283.

25. See for example the programmatic essay Le Corbusier (as Charles-Edouard Jeanneret) coauthored with Amédée Ozenfant, *Après le cubisme* (Paris: Editions des Commentaires, 1918); and the journal they coedited, *L'Esprit Nouveau*, 1920–1925. Their engagement as purist painters and theorists with cubist painting is discussed by Christopher Green, *Cubism and Its Enemies: Modern Movements and Reaction in French Art, 1916–1928* (New Haven and London: Yale University Press, 1987), 89–91.

26. See Robbins, "Abbreviated Historiography."

27. Rosalind Krauss, "The Motivation of the Sign," in Lynn Zelevansky, ed., *Picasso and Braque: A Symposium* (New York: Museum of Modern Art, 1992), 273.

28. Here Krauss takes issue with the position most forcefully represented by Picasso scholar Patricia Leighten, who has literally read the newsprint in Picasso's *papiers collés* of 1912–1913 and discovered that more than half of those images contain references to contemporary European political events. Leighten uses this information to support her contention that Picasso was a politically engaged artist who consciously sought to articulate his anarchist beliefs, even in these small-scale, intimate cubist works. See Patricia Leighten, "Picasso's Collages and the Threat of War, 1912–13," *Art Bulletin* 67 (December 1985), 653–672.

29. "Discussion," in Krauss, "The Motivation of the Sign," 287. This statement was made in the context of an exchange between Krauss and Leighten that followed the original presentation of Krauss's essay at a symposium at the Museum of Modern Art, New York, in November 1989.

30. David Cottington, "What the Papers Say: Politics and Ideology in Picasso's Collages of 1912," *Art Journal* 47 (Winter 1988), 351.

31. Robin Evans, *The Projective Cast: Architecture and Its Three Geometries* (Cambridge: MIT Press, 1995), 63.

32. Ibid.

33. Ibid., 58; cf. Giedion, *Space, Time and Architecture*, 852–853.

34. In particular, the work of Peter Eisenman, Bernard Tschumi, Zaha Hadid, Coop Himmelblau, and the other architects included in the 1988 exhibition at the Museum of Modern Art. See Philip Johnson and Mark Wigley, *Deconstructivist Architecture* (New York: Museum of Modern Art, 1988).

35. Evans, *The Projective Cast*, 94, 83–105.

1.

DAVID
COTTINGTON

THE MAISON CUBISTE
AND THE MEANING OF MODERNISM IN PRE-1914 FRANCE

The Maison Cubiste (figs. 1.1 and 1.2) has had a poor
deal from historians of cubism. Regarded almost from
the first as a curiosity *sans issue*, chronicled with indif-
ference in the standard history as a distraction from
cubism's main concerns, it has been at best sidelined
and at worst ignored in accounts of the movement, with
few exceptions.[1] Part of the reason for this neglect is
not hard to understand. With the ascendancy, first, of
the interpretation—and resulting history—of cubism
presented by Kahnweiler in the aftermath of the First
World War and, subsequently, of Greenbergian mod-
ernism in the aftermath of the Second, decoration was
for fifty years a negative quality, a pejorative term
indeed, for modernist artists and art historians, and the
significance of decorative art initiatives by artists has
been correspondingly minimized. Thus the collabora-
tion, in 1912, of some of the leading members of the
cubist circle in the ambitious ensemble of domestic
architecture, interiors, and furnishings that was the
Maison Cubiste has had little bearing on the conven-
tional understanding of their ideas or achievements.

 Such an explanation is incomplete, however, for it
takes no account of the architectural ambitions of the

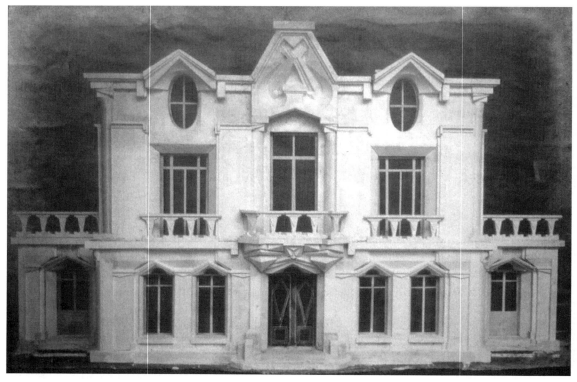

1.1 Raymond Duchamp-Villon (1876–1918); unknown photographer. Facade of the Maison Cubiste, model, 1912. Photo in Archives André Mare, Paris.

project, and architecture, at least, cannot be placed beyond the pale of modernism. In this case the neglect has less to do with modernist ideology than with the preoccupations of the pre-1914 avant-garde; in the Paris of that *avant-guerre*, architecture was not seen as integral to the project of cubism either by the majority of cubists themselves or by the movement's critics. The architectural elements of the Maison Cubiste ensemble seem, indeed, to have been virtually invisible to its viewers at the Salon d'Automne of 1912. Despite the fact that Raymond Duchamp-Villon's ground-floor facade and entrance (see frontispiece) provided the only means of access not only to the cubists' ensemble

but to all of those on exhibition that year and was thus unmissable, a survey of the critical responses to the Maison Cubiste reveals a remarkable paucity of comments on these architectural elements of it. The ensemble was certainly the focus of attention; Roger Allard noted, two weeks after the Salon opened, that during that time it had been more insulted than a cubist painting. The attention and the invective were mainly directed, however, at the interiors, or at objects within them.[2] Duchamp-Villon's contribution was not without mention, and critics both hostile and supportive made passing reference to it, but little more;[3] even Gustave Kahn's lengthy *ex post facto* reflection on the project,

1.2 André Mare (1885–1932); unknown photographer. *Salon bourgeois*, Maison Cubiste, Salon d'Automne, Paris, 1912. Photo in Archives André Mare, Paris.

published early the following year, gave the architectural elements only marginal consideration and dwelt overwhelmingly on the decorative ones.[4]

The case of the Maison Cubiste therefore presents something of a paradox. While cubism since the First World War, as the essays in this book demonstrate, had a rich and varied relationship with architecture, but only (for the cubists themselves) a peripheral relationship with decorative art, the first cubist house showed how little cubism, in its original manifestation, had to do with architecture; decorative art, by contrast, was a burning issue. It is the purpose of this essay to explore that paradox, and to show that, far from being without

consequence for cubism, the Maison Cubiste stands at the intersection of some of the key concerns of the movement in pre-1914 Paris.

It is not, of course, strictly true that the earlier cubist milieu was uninterested in architecture. The participation of Auguste Perret in both the fairly inclusive banqueting circle of the *dîners de Passy* hosted by the magazine *Poème et Drame* from 1912[5] and the small grouping who spent Sunday afternoons at the house of the Duchamp brothers in Puteaux from the same year, as well as Duchamp-Villon's acknowledged indebtedness to his ideas,[6] indicate otherwise. But the fact that he was the only architect member of these circles is

revealing of the institutional and the discursive factors that otherwise separated the cubist avant-garde from the architectural profession. In institutional terms Perret was an unusual architect, having left the Ecole des Beaux-Arts before completing his course in 1895, and having designed buildings independently of the latter since 1890. This independence brought his professional experience closer to that of the artistic avant-garde of Paris, who were trained, if at all, in unofficial academies such as the Julian and the Grande Chaumière in Montparnasse, and financed—if at all—by the new dealer-critic network,[7] than to the experience of most architects, for whose training the Ecole was paramount and whose professional establishment depended upon its imprimatur. Perret's ideas on architecture, moreover, appeared to overlap in important respects with the concerns of the cubists, as Duchamp-Villon's writings, especially his 1913 essay on the Eiffel Tower, indicate. The enthusiasm this text displays for the rationalism of iron and steel construction and the functionalism of engineering, materials, and practices that stood outside what Duchamp-Villon termed the "public aesthetics" of most contemporary architects and critics, was indebted to the example and the teaching of Perret, and Duchamp-Villon greatly admired the latter's Théâtre des Champs-Elysées.[8]

Perret's membership in the Passy and Puteaux milieux (and within these, his closeness to Duchamp-Villon) was thus, I would suggest, the exception that proved the rule; other than Perret, no architect was closely related to the cubist avant-garde before 1914, and other than Duchamp-Villon, no member of that avant-garde was tempted to extend cubist ideas on painting and sculpture into the field of architecture. This contrasted clearly, by 1912, with the relationship between cubism and the decorative arts. The notion of the decorative purpose of art had been gaining ground since before the turn of the century; expressed

both in the growth of interest in *la peinture décorative* and in the willingness of artists to collaborate with decorators, or to become decorators themselves, this development drew the attention of some within the cubist milieux. André Mare's friend Ami Chantre suggested why, in an essay of 1913:

> There is . . . a close connection between the malaise of which contemporary painting seems unable to rid itself, and the happy vitality of decorative art. Honest artists . . . too prudent to venture along the cubist road, which is rocky and probably leads nowhere, and despairing of finding elsewhere that new classicism which certain devotees, of whom I am one, still await, are renouncing painting. . . . They are picking up the tools abandoned by the artisan in preference for machines, and in place of decorating our walls, they are furnishing our houses.[9]

Chantre's essay is less valuable for its explanation of, than for its testimony to, this growth of interest in decorative art on the part of fine artists, and in the relation between the two; the reasons were considerably more complex than the simple matter of aesthetic preference he describes.

The interest was both profound and widespread in France around 1910. The profundity came partly from a perception that the decorative art industries in France were in a condition of crisis, as a result of their declining international competitiveness. As Nancy Troy and others have shown, this perception was sharpened by the exposure of representatives of French craft industries to the work of their Bavarian counterparts at the 1908 Munich Ausstellung, and heightened to the point of alarm by the exhibition of this work at the 1910 Salon d'Automne in Paris, but it had been

dawning for some years as a spate of international exhibitions (in Turin, Liège, London, St. Louis, Milan, and elsewhere) revealed the progress made in other countries.[10] By 1907 politicians were calling for a similar exhibition in Paris to showcase, but also to stimulate, French decorative arts production.[11] When in January 1909 the well-respected critic and experienced arts administrator Roger Marx added his influential voice in support of such an exhibition,[12] this campaign gathered momentum with a speed that indicates the breadth of concern over the issue. By early 1911 three of the leading decorative arts associations—the Union Centrale, the Société d'Encouragement à l'Art et à l'Industrie, and the Société des Artistes Décorateurs—had joined in formally adopting the project, making broad suggestions as to the shape it should take and establishing a *commission d'étude* to develop detailed proposals.[13] Two months later the *commission* presented its report, this time in the name not only of these three associations but also of other leading arts bodies, including the Société des Artistes Français, the Société Nationale des Beaux-Arts, the Salon d'Automne, and the Union Provinciale des Arts Décoratifs, as well as more than fifty individuals from the decorative arts establishment.[14] It thus represented a broad consensus of opinion and carried enough weight to be taken seriously by politicians of all parties; its arguments were repeated in Chamber debates over the following year and received formal all-party support in a vote of July 1912.[15] This report seems to me to have been a strategic document in the decorative arts debate, and I should like to look closely at the arguments in it, behind which the consensus was drawn up.

These were chiefly two. The first was a statement of that concern for France's competitiveness already noted. The 1911 report declared that the issue was one of national honor: having allowed other countries both to topple it from its leading position in the international market for decorative art and to challenge its reputation as the initiator of progress in that field, it was imperative for France to hold an exhibition as soon as possible, the aim of which would be to stimulate the realization and diffusion of modern French styles. The emphasis must be on "modern"; we owe it to ourselves, the commission argued, to renew our traditions and remain creators, not to decline into a people of mold-makers and copyists.[16] If the terms of this argument have recently become familiar, those of the report's second argument have not. Yet it adumbrated the other reason why contemporary interest in the decorative arts was so profound: the realization that these could have a social purpose. The exhibition, it was claimed, would stimulate not only modern but also democratic works that would satisfy everyday needs as well as the caprices of luxury. Decorative art, said the commission, has been for too long, and falsely, seen as a luxury. In truth, every object that we use daily and that can be decorated should be; through industrialized mass production, modern decorative work could be made inexpensively. An exhibition would encourage such manufacture and, by creating an art *à bon marché*, would put some joy, tidiness, and, not least, beauty into the most modest homes.[17] This argument was made forcefully and repeatedly in the report, a fact that serves to remind us of the depth of contemporary concern over what was referred to as "the social question."

Yet while these two arguments provided the means to marshal an impressively broad consensus behind the campaign for an exhibition, they also harbored a variety of positions within the decorative arts debate and give us a misleading impression of agreement on the issues involved. If we look at them more closely, we shall see that they articulated a distinct and sometimes conflicting set of views and anxieties of a social kind: about progress, about tradition, about democracy and

social order as well as patriotism. The debate effected
a kind of brokerage between aesthetic and ideologi-
cal—sometimes explicitly political—allegiances that
we need to explore if we are to understand what it was
really about, and what meanings the Maison Cubiste
project held for those involved.

Within the economic nationalist argument, the
perception that France needed to regain its preemi-
nence through the creation of modern styles of decora-
tive art held a central place. It was also agreed that the
only alternative to this was a continuation of the copies
and pastiches of old styles. But there was severe criti-
cism of the art nouveau of the turn of the century for
its excess of modernity, for what G.-Roger Sandoz, of
the Société d'Encouragement à l'Art et à l'Industrie,
in 1913 called its "macaronic exaggerations";[18] in
1909 the critic Camille Mauclair criticized that rage
for renewal of decorative art for having resulted in
a "hysterical, comical, lamentable, useless style ...
pretentious and fantastic trash in whose obsolete
models the Faubourg Saint-Antoine now revels,"[19] and
condemned art nouveau as a false start. More moder-
ately, in his report to parliament in July 1912 on the
exhibition project, socialist *député* Roblin noted art
nouveau's efforts to escape the past but criticized its
excessive search for originality, which was not in the
French tradition.[20] This was the key: renewal meant
not abandonment of, but reattachment to, traditional
aesthetic values. The question was, which ones?

The answer varied. For André Vera, a young critic,
friend of André Mare, and future garden designer writ-
ing in late 1911, the problem with art nouveau lay in
the age itself, in democracy and universal suffrage that
had brought an invasion of mediocrities and social
envy.[21] Against the overweening vulgarity that was the
cultural corollary of these, his generation looked to the
classicism of the seventeenth century, chiefly for its
rationalism and intelligence that were beyond the reach

of the crowd and accessible only to an elite, but also
out of national pride in cultural forms that were the
patrimony of the race. Their concerns were to renew
those traditional forms, however, not simply to repeat
them, and Vera championed a decorative style that
"follows on from the last traditional style we have, that
is, the Louis-Philippe style";[22] developed under a bour-
geois monarchy, it was appropriate to contemporary
tastes as well as needs. He favored in furniture princi-
ples of rational construction, simplicity, and reliance on
the beauty of materials that he saw as "eminently
architectural."[23]

Some of Vera's thinking in 1911 drew on argu-
ments for a return to the example of the *grand siècle*
that were put forward by young followers of Charles
Maurras and other ideologues of Action Française in a
debate over the meaning of classicism that paralleled
that over the decorative arts in the pre-1914 period,
and that acted as a focus for intellectuals on the politi-
cal right; his evident elitism and contempt for democra-
cy also suggest an alliance with them.[24] Sometimes the
debates overlapped; Maurice Denis, declared supporter
of Action Française and leading spokesperson for a
return to classicism in painting, replied to the call for a
reconciliation between art and industry with views that
paralleled Vera's. The great French decorative styles of
the past had owed nothing to the people and everything
to an audacious aristocracy, he claimed; they had been
imposed by an elite blessed with superior taste. Any
reconciliation of this source of France's superiority
with industrial production was impossible.[25] Denis
clearly assumed that decorative art was about *objets
d'art* and the luxury trades, not objects of everyday
use. Other contributors to the debate, while not neces-
sarily sharing his politics, made similar assumptions;
thus René Lalique, for whom the lack of progress in
France was due simply to the caution of dealers and
collectors, in 1909 looked only to enlightened patrons

and true amateurs among the rich bourgeoisie for a solution.[26] Likewise G.-Roger Sandoz's 1913 survey of the progress of French *artistes décorateurs* concluded that this was due to the patronage of a few *mécènes*, among them the comtesses de Béarn, Greffuhle, and de Polignac.[27]

But there were other aspects of Vera's thinking that pointed elsewhere. His readiness to modernize, his acknowledgment of Louis Philippe, and his espousal of qualities of simplicity and *matière* suggest at the same time a different understanding of classicism that equated it with a broader French tradition, inclusive of the Revolution as well as Louis Quatorze, and that stressed values of *terroir* and nation. Articulated by Maurice Barrès in his *Scènes et doctrines du nationalisme* of 1902, this more encompassing notion provided a rallying point for a wide spectrum of republican opinion during the following decade. In the decorative arts debate it was represented by an attachment to provincial traditions of simplicity and economy. Thus Roger Marx, writing in the fall of 1912, argued for the use of simple forms as giving the most durable pleasure to both the heart and the mind; the naive charm of a piece of vernacular pottery was more lasting, he suggested, than the "parasitical enrichments" of luxury ware. And he welcomed the efforts of a new generation to return to that simplicity and clarity which constituted the very foundations of the national tradition.[28]

Marx's emphasis on provincial values came in his book *L'art social*, published posthumously in 1913 (he died early that year). It was received widely and warmly; in its collection of essays he summarized and clarified with the authority of his experience arguments that had set the terms of reference for a good deal of critical writing on decorative art over the previous few years. Thus Frantz Jourdain in 1909,[29] after putting much of the blame for the crisis in design upon artists for having been hypnotized by luxury objects and

having forgotten the people, declared that one day France would return to that popular tradition of good sense and truth that had produced masterpieces in every epoch; in his Salon d'Automne catalogue preface the following year the critic Léon Werth appealed to the sense of harmony, simplicity, and rationalism of the native tradition.[30] In his 1912 report to parliament, *député* Roblin spoke up for artisanal virtues, for the characteristics of the "saine tradition française": fitness for purpose, order, measured grace and charm;[31] the following year Gustave Kahn saw classical, provincial, rural influences, echoes of the customs of old France, in the work of young designers.[32] The argument had a broader cultural resonance, too, connecting with contemporary regionalist aspirations, as Marx acknowledged; the national tradition, he stated, was enriched by local accents and their survival was vital; for the republic, having forged the regions of France into a unity, to lose the distinctive character of each of its provinces would be to lose its greatest riches.[33]

But this emphasis also had explicit political connotations; for the qualities of such a classicism stood as metaphors for other, social values. The championing of the virtues of provincial culture stood in close and clear relation to the social ideals of the Radical Party—the hegemonic political grouping of the pre-1914 Third Republic—and to their growing strength among rural and small-town voters, while the concern, which Marx articulated, to "give back to rural and popular industries their former place of honor" coincided exactly with the Radicals' keynote 1907 manifesto.[34] In their commitment to keeping French industrialization within bounds and their promotion of measures to support and sustain rural communities, the Radicals were the inheritors of the mantle of Jules Méline, the former premier whose 1905 book, *Le retour à la terre et la surproduction industrielle*, was widely read. Méline blamed industrialization for draining the

countryside of its inhabitants (the number of peasant proprietors had shrunk by more than half in the forty years to 1902), and he declared that the time had come for an agricultural renaissance and a halt to industrialization. "There can be no doubt," he wrote, "that there is a spirit abroad leading our countrymen into new fields. The reaction against the town is growing stronger, while the call of the country daily gathers strength."[35]

The widespread support for such views as Méline's has been seen by modern economic historians as one reason for France's slow rate of economic growth in this period compared with that of other countries. As Richard Kuisel noted, the countryside for most French people served as a social ballast in a changing world; few saw any need to hurry headlong after industrialization and urbanization as the British, Germans, and Americans had done.[36] In effect Méline's emphasis was profoundly antimodern. The tariffs to protect agriculture and uncompetitive industries that he had introduced when in government in the mid-1890s sought to preserve the status quo, to forestall adaptation to modern economic conditions; as Tom Kemp noted, their appeal was directly nationalist and conservative and rallied the support of those who had most to fear from change.[37] The Radical government's consolidation of these tariffs in 1910 signaled a similar distrust of economic modernization, and it was this, I would suggest, that found expression in the provincial classicism articulated by Marx and many others.

Equally clear in its political connotations was the other argument around which the 1911 report grouped its consensus: that an exhibition would further the democratization of decorative art. Like that for economic nationalism, it encompassed a wide spectrum of positions. Most broadly held was a perception that the hierarchical distinction between fine and decorative, major and minor arts was obsolete. This perception was

fostered, as Michael Orwicz has shown, by the short-lived administrative reforms of Gambetta's government of the early 1880s, as a means of buttressing the young Third Republic against the political right; through measures to promote the unity of the arts Antonin Proust, Gambetta's arts minister, had hoped to dismantle the Academy and its anti-republican influence.[38] Although Proust's reforms had been abandoned with Gambetta's fall, the perception that these cultural hierarchies were obsolete had been given momentum by the decision of the Société Nationale des Beaux-Arts to allow the exhibition of decorative art in its salons from 1890, and sharpened by that of the young Salon d'Automne to end the distinction between types of art in its catalogue from 1906. By 1911 it had been reaffirmed as government policy: interviewed in April of that year by Le Matin, three ministers—Steeg and Dujardin-Beaumetz of the Beaux-Arts administration and Massé from Commerce—condemned both the aristocratic prejudice that had established such a cultural hierarchy and the disastrous consequences it had had for decorative art.[39] While no longer in such need of defenses against the forces of reaction as they had once been, the Radicals wished to foster art forms appropriate to a democratic republic.

More urgently required than defenses against the right in 1911, in fact, were those against the left. The complacency of the bourgeoisie was shaken by the growing strength of the socialist movement around the turn of the century; both inside and outside parliament the response of liberal republicans was to seek common cause with representatives of the working class, and the decade after 1900 saw a variety of initiatives in class collaboration; on a governmental level, the Bloc des Gauches marshaled Socialist support for the Radical cabinets of Waldeck-Rousseau and Combes, while outside parliament educational initiatives such as the *universités populaires*, and cultural ones, of which the

Société de l'Art pour Tous was the best known of many, extended the spirit of interclass camaraderie that had been forged in the Dreyfusard cause across a broader front.[40] Here too, it was recognized by many, decorative art could play its part in making the benefits of the liberal republic more visible and tangible to the working class. The beginnings of such *art social* initiatives occurred in the 1890s; Debora Silverman has indicated the connections that existed in that decade between a concern to infuse the products of daily use with a modern spirit and the concept of an organic society propounded by the solidarists around Léon Bourgeois's government.[41] But the explicitly political character of such emphases has perhaps not been sufficiently understood. As Sanford Elwitt has argued, solidarism was part of a generalized political strategy aimed at fixing the pattern of labor-capital relations and forestalling the eruption of industrial and social unrest. The *universités populaires* and cultural associations like Art pour Tous were, among other things, means to that end, elements of a powerful current of corporate and social paternalism that also embraced similar initiatives in other arenas: workers' housing cooperatives, profit-sharing schemes, garden cities, societies to promote popular hygiene.[42]

With the collapse of the Bloc des Gauches in 1905–1906, many of these initiatives foundered as their working-class members withdrew inside the stockade of syndicalism; as union militancy and strike action mushroomed alarmingly in the five years that followed, those efforts that could still be promoted without such members were left to continue the work of republican defense. In this context, the *art social* emphasis took on special importance, and we can understand more easily the support of that broad consensus that we have noted for the 1911 report, with its commitment to the democratization of decorative art, as a conveniently double-edged sword. Most influential

in its promotion, as he had been in the 1890s, was Roger Marx; his 1909 call for a decorative arts exhibition included a widely quoted declaration of the need for *art social*. "When an art is intimately joined to the life of an individual or the collective," he wrote, "only the designation *art social* is appropriate for it. The benefits of its inventions cannot be limited to a single class, for it serves all without distinction of rank or caste; it is the art of the hearth and the garden city, of the manor house and the school, of the precious jewel and of humble, popular pottery; it is also the art of the soil, the race, and the nation."[43] Alongside this implicitly Barrésian note, Marx sounded an explicitly solidarist one: it was the sentiment of solidarity, he claimed, that had awakened society's generous instincts and its sense of a duty to improve the human condition. Quoting Charles Gide, the solidarist economist, he asserted that this duty entailed disseminating not only hygiene and health but also beauty throughout society.[44] As with his ruralist emphasis, this argument echoed the program of the 1907 Radical manifesto, with its prioritizing of social policies and its rhetoric of rights and duties, with a clarity that would not have been missed at the time.

The warmth with which Marx's collection of essays on *art social* was greeted when it was posthumously published in 1913 is a measure not just of his standing but, more important for us, of the breadth of support for the movement he represented. Although the newspaper *La France* on the right could not stomach its populism, from the *Journal des Débats* in the center right to *L'Humanité* on the parliamentary left reviewers were able to see things they could endorse.[45] There were limits to such approval, though, on the left as well as the right, and in a number of ephemeral literary magazines allied to the syndicalist movement a critique of *art social* was elaborated, examination of which helps bring that movement into

sharper ideological focus. For Jean-Richard Bloch, writing in his magazine *L'Effort* in 1910 and 1911, *art social* was a notorious lie, a profitable pose, and the idea of art for all, of taking art to the people, was offensively condescending. What he sought was art *by* all.[46] Over the next two years Bloch developed a theory of art that was anti-elitist and collectivist and was grounded in the culture of the organized working class. From a similar perspective came criticism of recent developments in the decorative arts. In late 1912 and early 1913 Charles Le Cour and Jean Lurçat presented a harsh assessment, in *Les Feuilles de Mai*, of the modern style created by the bourgeoisie, and of its consequences for the decorative art industries.[47] The bourgeoisie had wanted to realize its own modern style that would be the latest ornament to its rule; ignoring the time-honored artisanal skills of the people, they had created a class of *dessinateurs* who were neither artists, since they had no independent vision, nor artisans, since they had no trade. The result was pastiche and modishness: pastiche of bourgeois styles of the past such as Louis-Philippe, and modishness for its own sake. Audacity was in the air, they observed; cubism was the great novelty of painting, now novelty furniture was needed. There was a willful misuse of materials, in the misguided belief that these were only beautiful when they had been carefully camouflaged or tortured. Artisans, by contrast, never abused their materials; they knew them, as peasants knew their land, and treated them with a sensitivity and honesty that were completely lacking among the haughty caste of decorators. Too bad for them, said Le Cour and Lurçat; "The decorator has tried to dominate his material without understanding it. In return, it has broken his back. And we applaud."[48]

With this reference to cubism, which is probably also a reference specifically to the ensembles of the Maison Cubiste, this essay at last reaches its raison

d'être. It ought to be clear, however, that what has preceded it has been more than a preamble. We need to be aware of the nuances and implications of the positions within the decorative arts debate that have been outlined above, if we are to understand in turn what the Maison Cubiste project could have meant at the time. So let us look at that project in the context of these positions.

From the invaluable archives held by the family of André Mare it is evident how completely the initiative for the Maison Cubiste was his, and how carefully he attempted to guide and unify the contributions of his collaborators.[49] It was not only the initial idea that, as Léger made clear in a letter to him of August 1912, was Mare's, but the direction of the entire project. Duchamp-Villon, de La Fresnaye, and Laurencin acknowledged this in correspondence with him,[50] while Maurice Marinot was quite specific about the extent of such direction, writing Mare in February 1912 to say that he had received his letter about the need to be closely united, and that since Mare was the principal author of the project, he would welcome some indications from him as to the character of the glassware he required. Mare duly obliged in his reply a few days later, stressing again that if an effort like this was to make headway and obtain some return, absolute unity and perfect cohesion among collaborators was an urgent requirement.[51]

For this reason my focus is on André Mare himself, his designs and ideas. Much is quite familiar: as Nancy Troy has noted, having arrived in Paris from Normandy with his friend Léger in 1903 to study painting, Mare opted around 1910 to make a career of designing furniture and interiors[52]—probably in the wake of the panic reaction of French observers to the 1908 exhibition of decorative ensembles in Munich, thus at least partly in patriotic response to Frantz Jourdain's call for new French designers who

could rival the German work. After some anonymous work for André Groult's ensemble in 1910, Mare showed two ensembles on his own behalf at the 1911 Salon d'Automne: a study and a dining room. From this beginning, his aesthetic allegiances were clearly declared: on one level to the work of the salon cubist movement—signaled in the participation in one or both ensembles of de La Fresnaye, Laurencin, Léger, Villon, and Duchamp-Villon—and, among designers, to the *coloriste* camp of ex-painters; on another level, to the provincial classicism championed, as we have seen, by Roger Marx and others. Both were remarked upon by Louis Vauxcelles, for whom the dining room evoked the interior of a Norman farmhouse inhabited by a "gentleman-farmer artiste," and he observed with approval that in this Mare "had sought to revive the decorative motifs of a provincial tradition unvaried for centuries." The result was an "entirely French art, strongly flavored by its Normandy *terroir*," its sincerity and naïveté suggestive of artisanal qualities, "the hand of a good workman."[53]

We should note these terms of approval, for in the light of that set of affiliations that I outlined above it is clear that the reference is not simply to French tradition per se, in counterposition to that of Germany, but to a specific choice of tradition, one with particular social and political connotations. In other words, the values promoted were not only national but also social: those of the countryside against those of the city, of the region against the metropolis—or against the concept of the nation itself, in some versions of the regionalism already discussed. The critic Maignan argued for the former values, coincidentally, in an article published that same fall in *L'Art Décoratif*; bitterly criticizing the political, commercial, and cultural hegemony of the centralized state and its capital, Paris, he demanded a redress of the balance in favor of the provinces. There would not be a viable modern French decorative art

capable of renewing the old craft *métiers*, he declared, until there flourished a modern Norman style, a modern Breton style, and their equivalent in every other province.[54] The coincidence of timing of this publication and Mare's salon entry is interesting, but perhaps no more than that; while regionalist cultural politics were represented in the Puteaux circle in which Mare and his friends began to meet at this time, in the person of the critic Olivier-Hourcade—who early in 1912 founded a magazine, *La Revue de France et des Pays Français*, to promote them—there is no indication that Mare's own provincialist affiliation was so extreme.[55]

That it was a conscious and deliberate affiliation, however, seems clear from Mare's letter of February 1912 to Marinot, in which he offered the aesthetic guidelines that the latter had sought. The character of the Maison Cubiste ensembles was to spring directly from those of 1911, and Mare spelled out what he intended it to be: something very French, traditional, looking to motifs typical of French decoration from the Renaissance to Louis Philippe, its innovations rooted in these. The paragraph in question has been widely quoted in recent work, and such terms have been noted and discussed. Others have been overlooked, however; Mare talks also of wanting colors that are fresh, pure, and bracing, as opposed to the anemic, enervating color schemes he sees as typical of art nouveau; of a rendition of detail that would be vigorous, naive, gauche rather than artful.[56] The values implied by such preferences, the tradition chosen here, are surely those embraced by Vauxcelles and Marx: of the country against the city, innocence against decadence, the past against *modernité*.

Such qualities, as we know, were indeed remarked upon by sympathetic critics such as Gustave Kahn as characterizing the ensembles of the Maison Cubiste: "M. Mare has put us back in touch with a traditional art that opposes art nouveau. . . . He and his friends have

sought inspiration in that provincial aesthetic life of France that used to be everywhere but is now reduced to a few islands . . . they have embraced what is left to us of old provincial customs," wrote Kahn in reviewing the exhibit, and he praised the settees for their origins in popular art and the glassware for its illustrations of village life.[57] Moreover, he argued that the values implied were more than a matter of style: the provincial motifs, he explained, were at one and the same time responses on the part of artists to the spirit and needs of the present, and the embodiment of certain aesthetic constants that were themselves constitutive of a tradition.

There were not many such sympathetic responses to the Maison Cubiste, however, and although the qualities that Kahn endorsed were recognized by several critics, they were viewed through the prism of a hostility to cubism that from 1912 was based increasingly on xenophobia. Along with other hallmarks of cubist style, they were seen as decidedly outside French tradition. Emile Sedeyn's review is representative of many in its rejection of the ensembles for taking foreign influences to an extreme, in viewing as childish, primitive, and untutored those very qualities that Kahn and Vauxcelles saw as essentially French. "Decorative art has not only its cubists," he declared, "it has also its virtuosi, who play with it as a Neapolitan plays a guitar: without having learned how." Where Kahn had been ready not only to see harmony among the individual contributions but to celebrate this as representing a new and valuable principle of anti-individualist association, Sedeyn and several other critics saw disharmony, and equated the colors of the ensemble with the barbarities of "la palette munichoise."[58]

Recognizing the force of this charge of disharmony, Nancy Troy has offered a persuasive explanation, on two levels.[59] First, on that of commercial strategy, that the discordance between elements of the Maison

Cubiste, which—in tacit disagreement with Kahn, she acknowledges—was a means of attracting a class of clientele that could not afford to buy the whole ensemble but would buy items from it; second, on the level of aesthetic allegiance, that the juxtaposition of bright colors on cushions, upholstery, and wallpapers was an equivalent for the dynamic harmonies of cubist painting, while the disparate integrity of individual elements in the ensembles corresponded to the insistence by Gleizes and Metzinger in Du "cubisme" upon the essential independence of the work of art. The suggestion is ingenious, and offers a resolution of that apparent contradiction between what those artists said in their manifesto and their loan of paintings to the Maison Cubiste's salon bourgeois. It does not appear to be borne out by the available evidence, however. As noted earlier, Mare's correspondence indicates his determination to oversee all contributions and marshal them into a unity, and he does not imply that this was to be a unity of a particular, innovative kind. Moreover the explanation that Kahn offered for the bright color scheme, possibly after consultation with the ensembliers themselves, was a traditionalist one: that early French tapestries were once brightly colored (one had only to look on their reverse), that the reds, yellows, and blues that predominated were favored during the Empire (and even the Second Empire).[60] Such an explanation accords with Mare's consistent emphasis on the traditional sources of his design ideas of 1912. While it remains true that such intentions and rationalizations do not adequately account for the evident dynamism of the color scheme or the eclecticism of some of the furnishings, to interpret these qualities as entirely willed by Mare is perhaps to give him too much credit. Similarly, Troy's resolution of the Gleizes-Metzinger contradiction suggests a fundamental congruence between contributors to the cubist movement that not only does not appear to have

1.3 Albert Gleizes (1881–1953). *Les baigneuses,* 1912. Oil on canvas, 105 x 171 cm. Musée d'Art Moderne de la Ville de Paris.

existed, but whose absence was a significant feature of that movement, for reasons that will be outlined in what follows.

Where there was an evident congruence between Mare's project and some cubist painting is in terms of those provincial classicist affiliations traced above, and in the ambivalence that these imply toward the process of modernization. Gleizes's painting of early 1912, *Les baigneuses* (fig. 1.3), depicted a harmonious and balanced landscape in which industrial and urban elements were integrated with the surrounding countryside; Poussinesque in its organizing geometry and Claudian in its specificity of place, this was the landscape not of Arcadia but of France as Gleizes wished it to be. The formal innovations of cubism he

used expressively to unify both the gestures of the foreground figures and the swirls of background chimney smoke into a timeless and purportedly natural order. It could stand as a visual image of that France that Roger Marx and the Radicals, following Méline, wished to preserve. This reading is reinforced by the spate of statements that Gleizes published on cubism in late 1912 and early 1913 in the wake of his collaboration with Metzinger on *Du "cubisme."* In these he repeatedly stressed its links not simply with French classical tradition, but—in an emphasis that sharpened with each repetition—with a tradition represented by the cathedrals and the French *primitifs*. It is by looking at these works, he explained, not as picturesque curiosities but as the timeless masterpieces of our race

that the public will come to an understanding of the meaning of cubist pictures; rejecting the "detestable" influence of the Italian Renaissance in explicitly class terms, as the culture of the court and the aristocracy, he opposed to it what he saw as an artisanal tradition of image-making.[61] The relationship of this to Radical ideology is surely self-evident.

Le Fauconnier's most ambitious—and increasingly complex—paintings from 1911 and 1912, the decipher- ing of which has been helped immeasurably by Daniel Robbins's research and analysis,[62] seem to represent not just ambivalence toward modernity but hostility to it. After the celebration of preindustrial harmony and plenty of *L'abondance,* shown at the 1911 Salon des Indépendants (fig. 1.4), Le Fauconnier painted *Le chasseur* for that of 1912 (fig. 1.5). Here the figure of the hunter, based on his own appearance and thus perhaps standing for "the artist," is the formal and thematic source of the picture's disharmonious, indeed destructive, dynamism, in which the countryside is broken into isolated fragments of views by emblematic representations of modern technology; the painting suggests an equation between the hunter and the modern world of violence and metal, mediated by the (avant-garde) artist who has developed the visual language appropriate for its expression. As such it indicates a profound pessimism in the face of progress. This deepened in the following months, if the huge and complicated *Les montagnards attaqués par des ours* (fig. 1.6), shown—like the Maison Cubiste—at the 1912 Salon d'Automne, is anything to go by. In Daniel Robbins's persuasive reading, the bears, depicted savaging a hunting party picnic, represented for Le Fauconnier both brute instinct and the victims of mankind's bestiality. Given the work's repetition from *Le chasseur* of juxtapositions of modern technology and traditional rural community, we could be more specific: our modern civilization, Le Fauconnier seemed

1.4 Henri Le Fauconnier (1881–1946). *L'abondance,* 1910– 1911. Oil on canvas, 191 x 123 cm. Haags Gemeentemuseum.

to be implying, with its dynamic dislocation of a way of life grounded in centuries of tradition, must surely pro- voke a reaction from brute nature of such force that it will be destroyed by it.

Not all members of the salon cubist group shared such anxieties about modernity. Robert and Sonia Delaunay did not, despite a commitment to popular cul- ture and to the artisanal tradition of painting repre- sented by Henri Rousseau.[63] Even within the Puteaux circle, which came into its informal existence as the Delaunays and Le Fauconnier were moving away from the cubist movement, the attitude of Mare and Gleizes that I have outlined was in the minority. Léger, for all his close friendship with the former, showed no interest,

1.5 Henri Le Fauconnier (1881–1946). *Le chasseur*, 1911–1912. Oil on canvas, 203 x 166.5 cm. Haags Gemeentemuseum.

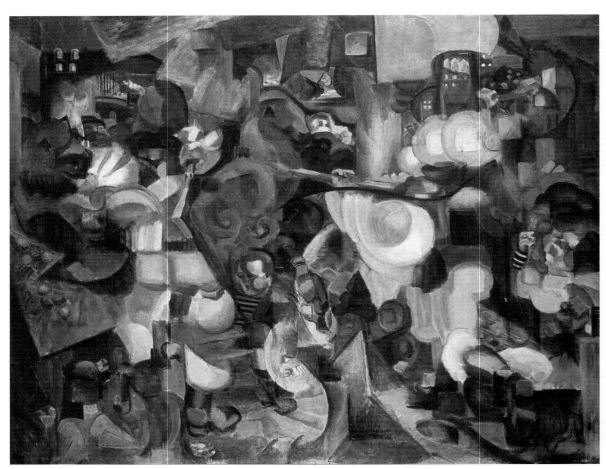

1.6 Henri Le Fauconnier (1881–1946). *Les montagnards attaqués par des ours,* 1912. Oil on canvas, 241 x 307 cm. Museum of Art, Rhode Island School of Design.

in his paintings or in his talking about them, in their ruralist nationalism: on the contrary, his Académie Wassilief lectures of 1913 embraced, as his *Fumeurs* of 1911–1912 inscribed, the dynamism of the interface between city and country. Raymond Duchamp-Villon's interest in the Gothic, moreover, was grounded in more than its nationalist connotations alone. While it is apparent from his writings that he responded to the nationalist appeal,[64] the example of Gothic structural principles pointed the way also, and more importantly, to the rationalism of modern functional construction and away from the contemporary obsession with stylistic pastiche. Finally Metzinger, who in many respects was the central figure in the circle, showed no interest in nationalism either, and it is significant that *Du "cubisme,"* published in the fall of 1912, made no reference to a specifically French tradition, for all Gleizes's insistence upon it in the weeks that followed.[65] As that axis within the Puteaux circle represented by Metzinger and Juan Gris among the artists, and Apollinaire and Raynal among the critics, gained the ascendancy, other concerns entirely—those of Montmartre cubism, centered on the experimentation of Picasso and Braque—came to dominate its discussions.

It is indeed because of that ascendancy, which contributed so much to subsequent assessments of cubism, that it seems to me so important to pay attention to the aesthetic differences that existed among members of the cubist movement and to recognize their ideological implications; to acknowledge that the cubist avant-garde did not stand in monolithic opposition to governmental, bourgeois, or otherwise official ideology by the simple fact of its avant-gardism. This avant-garde was not outside of bourgeois society, untouched by the political economy of the Radical republic, but was constituted within it and subject to its field of forces; members of the cubist movement

responded to those forces in different ways. For the milieu of Montmartre cubism, Kahnweiler's stable of artists and their *dénicheur*[66] patrons, the nationalism in all its shades that was part of the foundation of official ideology was unattractive: the self-conscious marginality of the Montmartre community itself and, more important, the émigré status of most of them led them to feel profoundly distanced from such nationalistic sentiment. Moreover, fundamental to the experimentation of Picasso, Braque, and (latterly) Gris, as I have argued elsewhere, was a Mallarmiste aestheticism for which popular culture was a challenge, and the populism of *art social* a threat.[67] The challenge presented by the former—by the rising tide of a commercialized, mass-produced, enticing yet disposable visual culture of the everyday—they acknowledged and met in the medium of *papiers collés*, by appropriating elements of it and "making them strange," reworking them in the codes of cubism; the threat represented, in *art social*, by an ideology that saw no tenable distinction between fine and decorative art, or between high culture and low, they refused largely by ignoring it.

The Maison Cubiste project stood in much more sympathetic relation to official ideology; as this essay has attempted to demonstrate, the aesthetic character that Mare made every effort to give it was consonant with key features of that ideology. And yet there was a contradiction in the project that marked the distance between them, as well as indicating why Duchamp-Villon's architectural initiatives remained undeveloped. For Roger Marx and the Radicals the stress on a provincial, artisanal tradition went hand in hand with a commitment to *art social*—to the industrialization of art, the revitalization of craft *métiers*, the dissemination of beauty. This was not so for Mare, nor for those of the Puteaux circle whose collaboration took the form of interior decoration, furniture, and *objets d'art*. Trained as painters, they had little or no craft skill and

did not try to make their own decorative work; it was made by Parisian craft workshops such as that of the *ébéniste* Hazeler. The work they designed for the Maison Cubiste was not inexpensive everyday ware suitable for mass production, but luxury ware for the comfortable middle class, involving intricate ornamentation and expensive materials such as exotic woods; and it sold: Charlotte Mare's unpublished memoirs[68] note that business was good for her husband from the very start, and many of the components of the Maison had already been purchased. *Un salon bourgeois* was an appropriate description for the main ensemble, not a mischievous one. It is true that sympathetic contemporary critics emphasized the democratic intentions of Mare and his associates: Kahn, while distinguishing their aesthetics from those of art nouveau, claimed for them a similar concern to create beautiful objects for everyday use; Léandre Vaillat went further, seeing in Mare's economy of means the achievement of "the chimera of furniture accessible to everyone, furniture that affirms with dignity the moderation of its owner," and he described at length the care with which Mare supervised the work of the *ébénistes*.[69] But their insistence on such points serves only to indicate the force of the current of support for *art social*; for observers with less sympathy for the efforts of the cubist *ensembliers* but more for artisanal skills and working practices— such as Le Cour and Lurçat—the ensembles of the Maison Cubiste were more noticeable for their extravagant use of floral motifs and varnished ripolin than for

economy or respect for *métier*. This was perhaps less the case, however, for Duchamp-Villon; not only was his contribution to the project of a different order, as both architecture and functional frame, from the luxury ware of the others, but his enthusiasm for engineering and for functional structures in modern materials suggests an interest in just that industrialization of art and democratization of beauty which they implicitly rejected.

This rejection was not only a refusal of that *art social* appeal, however; it amounted also to an acknowledgment of the pressures of debate within the Puteaux circle from 1912, and in particular of the force of the aestheticist critique of the attempt to democratize art. As such, this striking entry of cubism into the decorative art arena, while it registered the acknowledgment of most of the French members of the cubist movement of the imperatives of the decorative art debate, registered also the tensions among the interests and attitudes represented within the movement, and effected its own exclusions—such as Duchamp-Villon's more modernist emphases—as well as its appropriations of elements from wider discourses—such as that "provincial classicism" outlined here. Recognition of this equivocal character of the Maison Cubiste project, executed at a moment when the meanings of cubism were still the subject of contention, helps us to think through the ways in which those meanings were structured by wider social forces.

1.

NOTES

1. John Golding, *Cubism: A History and an Analysis 1907–1914* (London: Faber, 1968), 171–172. The principal exceptions are: Marie-Noëlle Pradel, "La Maison Cubiste en 1912," *Art de France* 1 (1961), 177–186; William C. Agee and George H. Hamilton, *Raymond Duchamp-Villon 1876–1918* (New York: Walker & Co., 1967), 64–69; Nancy J. Troy, *Modernism and the Decorative Arts in France: Art Nouveau to Le Corbusier* (New Haven and London: Yale University Press, 1991), 79–102; and Chika Amano, "Cubisme, décor et tradition vers 1912," *Histoire de l'Art* 16 (December 1991), 81–95.

2. Allard, *La Cote,* 14 October 1912. See other reviews by C.-A. Gautier in *L'Architecture,* 26 October 1912; G. Lecomte in *Le Matin,* 13 October 1912; E. Sedeyn in *Art et Décoration* 32 (November 1912); and L. Vauxcelles in *Gil Blas,* 5 October 1912; also M.-N. Pradel's survey of reviews of the ensemble in "La Maison Cubiste en 1912," 184–185.

3. E.g., Vauxcelles's (hostile) review in *Gil Blas,* 5 October 1912, and that of F. Roches (supportive) in *L'Art Décoratif* 28 (November 1912).

4. Gustave Kahn, "La réalisation d'un ensemble d'architecture et de décoration," *L'Art Décoratif* 29 (February 1913), 89–102.

5. The founder-editor of *Poème et Drame,* Henri Barzun, was close to the salon cubist milieu, and writings by Gleizes and Metzinger (including *Du "cubisme"*) were published in the magazine. For a list of banquet participants see *Poème et Drame* 1, no. 2 (January 1913), 64.

6. See Troy, *Modernism and the Decorative Arts,* 98.

7. For discussions of the role of unofficial academies and the dealer-critic system in the development of the avant-garde in late nineteenth- and early twentieth-century Paris, see Harrison C. White and Cynthia A. White, *Canvases and Careers: Institutional Change in the French Painting World* (New York: Wiley, 1965); Malcolm Gee, "Dealers, Critics and Collectors of Modern Painting: Aspects of the Parisian Art Market 1910–30" (Ph.D. diss., University of London, 1977); and David Cottington, "Cubism and the Politics of Culture in France 1905–1914" (Ph.D. diss., University of London, 1985), chs. 3 and 4.

8. Elsewhere in this volume, Kevin Murphy traces the genealogy of Duchamp-Villon's twin enthusiasms for Gothic and iron and steel architecture back to Viollet-le-Duc and Choisy. The essay on the Eiffel Tower was published in part as "L'architecture et le fer" in *Poème et Drame* 1, no. 7 (January-March 1914), 22–29. For the full text, in English translation as "The Eiffel Tower," see Agee and Hamilton, *Raymond Duchamp-Villon,* 114–118. For Duchamp-Villon's reference to the Théâtre des Champs-Elysées, see the manuscript note published in Pradel, "La Maison Cubiste en 1912," 179.

9. "Il y a . . . d'étroites relations entre le malaise dont n'arrive pas à se débarrasser la peinture d'aujourd'hui et la joyeuse vitalité de l'art décoratif. Les artistes probes . . . trop prudents pour s'engager dans les chemins rocailleux, et probablement sans issue, du cubisme, et désespérant de trouver ailleurs ce classicisme nouveau que quelques fervents, dont je suis, attendent encore, ils renoncent à peindre. . . . Ils ramassent les outils abandonnés par l'artisan qui préfère conduire des machines, et au lieu de décorer nos murs, ils meublent nos maisons." Ami Chantre, "Les relieurs d'André Mare," *L'Art Décoratif* 30 (December 1913), 251.

10. Troy, *Modernism and the Decorative Arts*, 57–61; Kenneth E. Silver, *Esprit de Corps: The Art of the Parisian Avant-Garde and the First World War, 1914–1925* (London: Thames and Hudson, 1989), 171–174; Cottington, "Cubism and the Politics of Culture," ch. 2.

11. C.-M. Couyba, "Rapport sur le Service des Beaux-Arts," Budget général de l'exercice 1907, rpt. in G.-R. Sandoz and J. Guiffrey, *Exposition française d'art décoratif. Copenhague 1908. Rapport général. Précédé d'une étude sur les arts appliqués et industries d'art aux expositions* (Paris: Comité Français des Expositions à l'Etranger, 1913), 152–153. This volume is an invaluable anthology of texts relating to the debate over the decorative arts in the decade before 1914.

12. Roger Marx, "De l'art social, et de la nécessité d'en assurer le progrès par une exposition," *Idées Modernes*, January 1909, rpt. in Sandoz and Guiffrey, *Exposition française d'art décoratif*, 154–160.

13. Ibid., 174–175.

14. Ibid., 186–204.

15. Ibid., 207–214, 224–241.

16. "Tomberons-nous à n'être plus qu'un peuple de mouleurs et de copistes? . . . Nous nous devons de renouer avec notre tradition et de rester des créateurs. Il est d'un devoir premier pour la République d'aider à la réalisation des styles modernes." Ibid., 188.

17. "On a trop considéré l'Art Décoratif comme l'art des industries de luxe. Conception fausse! Les objets les plus simples de nos usages peuvent être artistiques. . . . Industrialisées, fabriquées en séries, [les oeuvres de style moderne] se vendraient même moins cher que n'importe quelle oeuvre de style ancien. Grâce à cette Exposition, nous arriverons à créer un art à bon marché, un art vraiment démocratique, à la portée de tous, et qui mettra un peu de joie, de claire propreté, de la beauté enfin jusque dans les plus modestes foyers." Ibid., 192.

18. Ibid., 101.

19. "Un style extraordinaire, hystérique, bouffon, lamentable, inutilisable, qu'on baptisa 'modern-style' et 'art nouveau', une camelote fantastique et prétentieuse dont les modèles désuets font maintenant les délices des 'bronziers d'art' et du faubourg Saint-Antoine." Camille Mauclair, "Où en est notre 'art décoratif'?," *Revue Bleue* 8 (24 April 1909), 520.

20. Sandoz and Guiffrey, *Exposition française d'art décoratif*, 225.

21. André Vera, "Le nouveau style," *L'Art Décoratif* 27 (January 1912), 21–32.

22. Ibid., 31.

23. Ibid.

24. For an overview of this debate and its ideological ramifications, see Cottington, "Cubism and the Politics of Culture," ch. 2.

25. Maurice Denis, "Réponses aux propositions de Roger Marx," *Le Musée*, December 1909, rpt. in Sandoz and Guiffrey, *Exposition française d'art décoratif*, 167–168.

26. Ibid., 165.

27. Ibid., 116.

28. "Les formes simples sont les plus touchantes; le coeur et la raison s'y plaisent durablement; à travers le cours des âges, ils s'émeuvent au charme naïf d'une poterie populaire toute unie, pure de lignes et de contours; ils se lassent vite des enrichissements parasites où la vanité entraîne trop souvent la recherche du luxe." Roger Marx, *L'art social* (Paris: Charpentier, 1913), 33.

29. Replying to an *enquête* by Edouard Dévérin on "La crise de l'art décoratif en France," in *La Revue*, 15 June 1909, 437–438.

30. Société du Salon d'Automne, *Catalogue des ouvrages de peinture, sculpture, dessin, gravure, architecture et art décoratif* (Paris, 1910), 13.

31. Sandoz and Guiffrey, *Exposition française d'art décoratif*, 226.

32. Kahn, "La réalisation d'un ensemble d'architecture et de décoration," 92.

33. Marx, *L'art social*, 34–35.

34. Ibid., 36. On the Radicals' rural support, see Richard Kuisel, *Capitalism and the State in Modern France* (Cambridge: Cambridge University Press, 1981), ch. 1. On the 1907 manifesto, see Claude Nicolet, *Le radicalisme* (Paris: Presses Universitaires de France, 1957), 50–53.

35. Jules Méline, *Le retour à la terre et la surproduction industrielle* (1905), translated as *The Return to the Land* (London: Chapman & Hall, 1906), 157.

36. Kuisel, *Capitalism and the State*, 15.

37. Tom Kemp, *Economic Forces in French History* (London: Dobson, 1971), 242.

38. Michael R. Orwicz, "Anti-Academicism and State Power in the Early Third Republic," *Art History* 14 (December 1991), 571–592.

39. *Le Matin*, 11 April 1911.

40. On the Bloc des Gauches, see Madeleine Rebérioux, *La république radicale? 1898–1914* (Paris: Editions du Seuil, 1975), chs. 2 and 3. On educational and cultural initiatives see Cottington, "Cubism and the Politics of Culture," ch. 1.

41. Debora L. Silverman, *Art Nouveau in Fin-de-Siècle France: Politics, Psychology and Style* (Berkeley: University of California Press, 1989), 184–185.

42. Sanford Elwitt, *The Third Republic Defended: Bourgeois Reform in France 1880–1914* (Baton Rouge: Louisiana State University Press, 1986).

43. "Quand un art se mêle intimement à l'existence de l'individu et de la collectivité, la désignation d'*art social* est seule pour lui convenir; on ne saurait limiter à une classe le bénéfice de ses inventions; il se dédie libéralement à tous, sans distinction de rang ou de caste; c'est l'art du foyer ou de la cité-jardin, l'art du château et de l'école, l'art du bijou précieux et de l'humble poterie populaire; c'est aussi l'art du sol, de la race et de la nation." Roger Marx, "De l'art social" (1909), rpt. in Sandoz and Guiffrey, *Exposition française d'art décoratif*, 154.

44. Ibid.

45. *La France,* 20 March 1913; *Journal des Débats,* 16 February 1913; *L'Humanité,* 11 February 1913. I am indebted for these references, and for much more on Roger Marx besides, to Camille Morineau's "Roger Marx et l'art social" (Mémoire de maîtrise, Université de Paris IV, 1988).

46. See, e.g., Jean Richard Bloch, "Notre jeunesse," *L'Effort* 5 (7 August 1910), 4.

47. Charles Le Cour and Jean Lurçat, "Une renaissance des arts décoratifs," *Les Feuilles de Mai* 1 (November/December 1912–January 1913), 16–22, and "L'inopportunité d'un style décoratif français," *Les Feuilles de Mai* 3 (May 1913), 151–160.

48. "Le décorateur a voulu dominer sans comprendre. La matière, en retour, lui a brisé les reins. . . . Et nous applaudirons." Ibid., 157.

49. I am most grateful to Mme. Simonne Vène for her generosity in providing access to, and material from, these archives.

50. Letters to Mare from Léger (7 August 1912), de La Fresnaye, Duchamp-Villon, and Laurencin (not dated), in André Mare archives.

51. Letter from Marinot to Mare, 14 February 1912, and from Mare to Marinot, 20 February 1912. "C'est urgent pour qu'un mouvement porte et . . . rapporte, qu'il y ait unité absolue et cohésion parfaite dans les collaborations," Mare wrote.

52. Troy, *Modernism and the Decorative Arts,* 67, 96.

53. "André Mare est d'une juvénile audace. . . . Son art est dru, sain, loyal. . . . Art tout français, et qui sent son terroir normand. . . . La salle à manger, en merisier, évoque l'intérieur d'une ferme normande, où habiterait un gentleman-farmer artiste. Mare a cherché à raviver des motifs décoratifs provinciaux, et dont le thème n'a pas varié depuis des siècles. Tout cela, qui sent la main d'un bon ouvrier, est naïf et sincère." Louis Vauxcelles, "Au Salon d'Automne (II): L'art décoratif," *L'Art Décoratif* 26 (November 1911), 253, 256.

54. Maurice Maignan, "Cours de décoration, troisième leçon. Le millenaire normand," *L'Art Décoratif* 26 (September 1911), 65–80.

55. For an account of the relation between cubism and nationalism, however, which argues that the politics of the Puteaux group were based on an explicit celtism, see Mark Antliff, "Cubism, Celtism and the Body Politic," *Art Bulletin* 74 (December 1992), 655–668.

56. The paragraph in question is as follows:

Faire avant tout quelque chose de très *français*, rester dans la tradition = nous laisser guider par notre instinct qui nous force à réagir contre les erreurs de 1900 et cette réaction peut consister en ceci:

> 1 Revenir à des lignes simples, pures, logiques et même un peu froides alors que la période qui nous a précédés était horriblement tourmentée.
>
> 2 Revenir à des couleurs bien franches, bien pures, bien hardies, alors que toujours, cette même période précédente, s'est complue dans des tons lavés, décolorés, anémiés.
>
> 3 Avoir un dessin vigoureux et naïf = rendre le détail amusant sans qu'il s'impose, être plutôt gauche qu'habile.
>
> Pour la décoration, reprendre les motifs qui, depuis la Renaissance jusqu'à Louis-Philippe, n'ont pas changé. Leur donner une vie nouvelle, les approprier aux formes.

57. "Nous sommes mis par M. André Mare au courant d'un art traditionnel qui entre en lutte avec l'art nouveau. . . . [M. Mare] et ses amis ont . . . cherché leurs éléments dans la vie provinciale française, vie esthétique autrefois générale et aujourd'hui réduite à des îlots . . . ils se sont ralliés surtout à ce que l'ancienne vie provinciale leur avait laissé de général et de communément usuel." Kahn, "La réalisation d'une ensemble d'architecture et de décoration," 92, 95.

58. "L'art décoratif n'a pas seulement ses cubistes, il a aussi ses virtuoses, qui en jouent comme un napolitain joue de la guitare, sans avoir appris." Emile Sedeyn, "Au Salon d'Automne," *Art et Décoration* 32 (November 1912), 144. "La palette munichoise" was a reference to the exhibition of decorative art from Munich at the 1910 Salon d'Automne.

59. Troy, *Modernism and the Decorative Arts*, 83–88, 94–96.

60. Kahn, "La réalisation d'un ensemble d'architecture et de décoration," 98.

61. This argument was first made by Gleizes in an interview that formed the basis of André Tudesq's article "Une querelle autour de quelques toiles," in *Paris-Midi*, 4 October 1912. It was developed in his reply to an *enquête* on cubism, "Le cubisme devant les artistes," *Les Annales Politiques et Littéraires*, 1 December 1912, 474; and further elaborated in his article "Le cubisme et la tradition," *Montjoie!* 1 (10 February 1913), 4, and 2 (25 February 1913), 2–3.

62. Daniel Robbins, "The Formation and Maturity of Albert Gleizes" (Ph.D. diss., New York University, 1975), 111–112; Robbins, "Le Fauconnier and Cubism," in *Henri Le Fauconnier (1881–1946): A Pioneer Cubist* (New York: Salander-O'Reilly Galleries, 1990).

63. Robert Delaunay's commitment to artisanal culture and its painting traditions is clearly evident in his manuscript for a book on his friend Rousseau, planned after the latter's death in 1910 but never published; it is now in the Delaunay archives at the Bibliothèque Nationale, Paris. For an account of its contents see Cottington, "Cubism and the Politics of Culture," 222–225.

64. In an unpublished manuscript of 1912 Duchamp-Villon wrote: "One hears on all sides that we live in the most impoverished epoch of our history [with respect to the decorative arts]. . . . We are living on our glorious past like prodigal sons on the accumulated fortunes of their elders. . . . There is talk of holding an exhibition of modern decorative art in Paris. An initiative of this kind is a real contest in which the supremacy of artistic taste is at stake; we shall have to be ready to defend our once unassailable reputation." ["On s'est aperçu tout à coup de toutes parts que nous vivions dans l'époque la plus pauvre de toute notre histoire artistique à ce point de vue. . . . Nous vivons sur un passé glorieux comme les prodigues sur la fortune accumulée par leur aïeux. . . . On parle d'ouvrir à Paris en 1915 une exposition d'art décoratif moderne. Une manifestation de ce genre est un véritable concours où la suprématie du goût est en jeu; il faut que nous soyons en mesure de défendre notre réputation, jusqu'alors inattaquable."] Quoted in Pradel, "La Maison Cubiste en 1912," 179.

65. Metzinger had written explicitly about tradition a year earlier, in his article " 'Cubisme' et tradition," *Paris-Journal*, 16 August 1911. But this is notable for the absence of any of the nationalist inflection that Gleizes gave to his discussion of the subject. Metzinger's interest in classical qualities appears rather to have paralleled that of Picasso and Braque, as the paintings that he showed in the Salon d'Automne of that year— *Le goûter* and *Paysage*—indicate. In both, Metzinger dressed up motifs whose classical pedigree are obvious (*Le goûter* was immediately labeled the cubist *Gioconda* by the critics) in the trappings of a pedantic modernism, in an unintentional parody of the innovations of those artists.

66. The term was coined by André Level to describe those collector-dealers like himself who, possessed of "advanced" taste in contemporary painting but modest funds, enjoyed bargain-hunting for the newest work among the small galleries and bric-à-brac shops of Montmartre. See André Level, *Souvenirs d'un collectionneur* (Paris: A. C. Mazo, 1959).

67. David Cottington, "Cubism, Aestheticism, Modernism," in William Rubin and Lynn Zelevansky, eds., *Picasso and Braque: A Symposium* (New York: Museum of Modern Art, 1992). The term *Mallarmisme*, referring to the aesthetic ascribed to Mallarmé by his followers, was current around 1910; see, for example, Roger Allard, "Sur quelques peintres," *Les Marches du Sud-Ouest* 2 (June 1911), 60.

68. In the André Mare archives.

69. "Je crois que là se trouve réalisée la chimère du mobilier accessible à tous, le mobilier qui affirme dignement la modestie de son possesseur." Léandre Vaillat, "L'art décoratif. André Mare," *L'Art et les Artistes* 19 (August-September 1914), 293–294.

2.

IRENA ŽANTOVSKÁ MURRAY

THE BURDEN OF CUBISM:

THE FRENCH IMPRINT ON CZECH ARCHITECTURE,

1910–1914

In the wake of ten different exhibitions and their variants held in the Czech Republic, Western Europe, and North America between 1991 and 1993, Czech cubist architecture and design have emerged from almost eighty years of regional obscurity as a forceful aesthetic presence.[1] Following years of pioneering work by a small group of Czech art historians, each of these exhibitions has added to the surge of public and scholarly interest. Contributors to the publications that accompanied the exhibitions produced more than a thousand pages of texts and images to explicate the complex phenomenon that was (and is) Czech cubism.[2] These studies convincingly demonstrate that none of the artistic and political influences that shaped Czech cubism can be understood independently of the others, nor removed from the native soil in which the Czech version of cubism took root. Still, as part of the cultural palimpsest, the nature of the relationship between Czech and French cubism continues to challenge our understanding.

The present essay therefore begins by considering this recent scholarship regarding the intricate connections between Czech cubist architecture and its sources in France. In fact, these connections were more

problematic than was once thought. Cubism was a
burden to the Czechs in the double sense of the word:
in music, a burden is defined as a dominant theme or
refrain, and the influence of French cubism continued
to sound in modern Czech art long after the cubist
movement abated. At the same time, the all too fre-
quent comparisons to French cubism weighed heavily
upon most interpretations of the Czech movement. This
essay examines the impact of these cultural forces on
Czech cubist architecture and on the relationship of
theory to practice in the private notes contained in an
unpublished journal of one of the foremost theorists of
Czech architectural cubism, the architect Pavel Janák
(1882–1956).

The ten exhibitions and their related publications
covered a great deal of common ground. To a certain
extent this was inevitable, not only because there is a
limited amount of exhibitable material, but also
because many of the same scholars were involved in
the different venues. A fundamental difference was
that the exhibitions and publications associated with
the Vitra Design Museum concentrated deliberately
and exclusively on architecture and design, whereas
those generated by the Düsseldorf Kunstverein and the
Centre Georges Pompidou in Paris also included Czech
cubist painting and sculpture in order to make more
explicit the connection with French cubism.[3] The
combined impact of this broad sweep of Czech "cubis-
tiana" was to advance our understanding of what
the phenomenon of Czech cubism entailed and to
acknowledge its connections to artistic developments
elsewhere in Europe. But the thornier question of
how Czech cubist architecture related to the spatial
explorations of cubism in French and Czech painting
remains only partially formulated, primarily because
many existing personal documents of such "cubist"
architects as Pavel Janák and Vlastislav Hofman, in
particular, have not been fully explored.

Some of the more obvious difficulties in the
assessment of the French influence on Czech cubism
stem from the multitude of Czech artists' reactions to
cubism in France, from the time lag with which French
cubism began to manifest itself in the work of the
Czechs, and finally from the concomitant influence of
other, regionally closer artistic movements, such as
German expressionism. A good review of this problem-
atic is given by Miroslav Lamač, who takes care to
trace the development, over time, of individual Czech
artists who were attracted to cubism.[4] Furthermore,
nationalist and political forces in Central Europe came
into play here. In an essay published in the Düsseldorf
catalogue, Edward F. Fry for example points out how
the reaction to cubism in France differed from its
reception by the Czechs, who saw the cubist movement
primarily as an "opportunity to confront the most pro-
gressive aspects of art and thinking of the twentieth
century, and a chance to express solidarity with West-
ern Europe at the very time when the old ties between
Prague and Vienna were breaking up."[5] This confronta-
tion, as Fry further shows, evolved through a number of
stages, from early imitations and grafting of the ele-
ments of cubist style onto the regionally authentic
modes of plastic expression, to genuine efforts to come
to grips with the fundamental *ideas* and *intentions* of
French cubism. It involved a myriad of largely interper-
sonal engagements in the art world, some of which had
been instrumental in shaping the relationship between
Paris and Prague.

A principal example of such engagement was
Vincenc Kramář, a Prague historian and collector,
who played a key role in introducing French cubist
painting to Prague. Kramář was a Berensonian figure
whose acquaintance with Daniel-Henry Kahnweiler
led not only to personal introductions to Picasso,
Braque, Apollinaire, and other key figures in Paris,
but more significantly to the establishment of one of

the finest contemporary collections of early cubism outside France.[6] As Vojtěch Lahoda points out, the Vienna-trained Kramář viewed cubism as a means of reappraising the subject-object relationship, as "a new, clarified reality free of accidental distortions, a reality that conveys to us a new, deeper, more objective, effective, and inexhaustible . . . idea about the nature and structure of objects."[7] Kramář's influence as a collector, patron, critic, and theorist hinged on his deep conviction in the transforming potential of the new art, which resonated with his younger artist friends in Prague.

Integral to the Czech reception of French cubism was a feeling of "homelessness," of displacement in relation to the center. As Jiří Švestka, the Czech-born art historian and organizer of the Düsseldorf exhibition, suggests, the Czech painter Bohumil Kubišta expressed this feeling when he wrote from Paris to his friend and colleague Vincenc Beneš: "We are too wild for Prague—that's why it is difficult for us to find a base there. We are too much behind Paris where we have no base so far—we hang suspended between heaven and earth."[8] Yet the inroads into France by the Czech admirers of cubism, and, as significantly, those by French artists into Czech territory, were numerous and substantive. Visits, epistolary exchanges, and personal contacts with French artists, writers, critics, and art dealers resulted in a series of exhibitions in Prague in which modern French art, and more particularly cubist art, was publicized. Moreover, such links were expressed through an important body of writings by Czech artists on French modern art and its proponents.

In addition to the Munch exhibition of 1905, three international exhibitions held in Prague in the first decade of the century and organized by the Mánes Association of Plastic Artists, the umbrella group from which the cubist faction was to secede in 1911, prepared the ground: the Rodin exhibition of 1902,

an exhibition of French impressionist and postimpressionist painting in 1907, and the 1909 exhibition of the work of the sculptor Emile-Antoine Bourdelle.

Bourdelle's stay in Prague prompted the young Czech sculptor Otto Gutfreund (who was to have a profound influence on the theory of Czech cubist architecture) to leave for Paris to become Bourdelle's student at the Académie de la Grande Chaumière. As Gutfreund's diary attests, Bourdelle's work struck a responsive chord in Gutfreund, particularly the French artist's ability to work in relief, "to crowd figures into one plane, and to give them all equal plasticity, perhaps so that they correspond better to the architecture of the monument."[9] In Paris, Gutfreund began a parallel investigation of French Gothic architecture, which he pursued on journeys to the towns in the French countryside, to Rambouillet, St.-Denis, Amiens, and Chartres, among others. In a letter to his parents, he wrote: "The Czechs feel a kind of resistance to Gothic, perhaps because they only know the German style of it, which, compared to the French, seems both utterly conventional and rigid."[10] Gutfreund's enthusiasm for French Gothic architecture and sculpture was reinforced by his perusal of the sketchbooks of Villard de Honnecourt, which made a strong impression on him.[11]

The painter František Kupka is often mentioned as another possible link between the Czech and the French contemporary art scenes. Kupka's influence on the Czech cubists' concern with the aesthetic potential of mathematical systems has been a matter of continual speculation, as has his relationship to other members of the Section d'Or, in particular Raymond Duchamp-Villon.[12]

The Czech interest in French culture brought other supporters of modern art to Paris, most notably in 1910–1911 the brothers Karel and Josef Čapek, the art critic Antonín Matějček, and the painters Bohumil Kubišta, Václav Špála, and Emil Filla, among others. It

was in Paris that Kubišta wrote his essay on Cézanne, published by F. X. Šalda in the Czech journal *Novina* [News], and there also that Filla gathered material for his study of Honoré Daumier, published in *Volné Směry* [Free Directions]. Both Matějček and Kubišta were involved in choosing works of art for the 1910 Prague exhibition of Les Indépendants, an exhibition labeled "expressionist" by Matějček's review, in which the showing of Derain's controversial painting *Les baigneurs* (1908–1909) led to Filla's successful campaign to raise, among his fellow artists, the 800 crowns needed for the city of Prague to acquire the painting, which is today in the permanent collection of the Czech National Gallery.[13]

Petr Wittlich has shown how the "Derain affair" was magnified by the resounding impact of Filla's essay "On the Virtues of Neoprimitivism," illustrated with reproductions of paintings by Picasso and published in the art review of the Mánes Association, *Volné Směry*. "Filla's essay," Wittlich writes, "became a sort of summation and manifesto for the young artists, who were trying to sail between the Scylla of decorativism and the Charybdis of naturalism." Most importantly, it "proclaimed primitivism as a powerful contemporary movement, which one-sidedly and deliberately limited the painter's interest in revival of plastic form." Wittlich points out that Filla understood this new plastic form to evolve from a new understanding of nature that engages "the transformation of a multitude of forms and the complexity of shapes . . . and consists of a method of simplifying and reducing multineity [*sic*] into unity."[14]

Filla's essay polarized the Mánes members, many of whom reacted as strongly to Filla's views as to Picasso's work which illustrated them. Indirectly it provided a catalyst that helped to establish the first formal cubist group, since the skirmish led ostensibly not just to some canceled subscriptions but more

significantly, and after an acrimonious debate, to the secession of fifteen members—artists, architects, and theorists—from the association. The "burden of cubism" was upon them. In the spirit of promulgating the new art, they established a separate organization for themselves—the Group of Plastic Artists—and set out to publish their own review, *Umělecký měsíčník* [The Arts Monthly].[15]

Although frequently mentioned in the literature on Czech cubism, *Umělecký měsíčník* deserves deeper analysis for its role in advancing the ideas of Czech cubism and for indicating their multiple sources. First directed by the painter Josef Čapek and later by the architect Pavel Janák and the writer František Langer, *Umělecký měsíčník* adopted a deliberately international platform, and combined literary selections with art criticism, theater with architecture and music, exhibition reviews with art theory. The illustrative material, much of it supplied by Kahnweiler, was profuse. In its first volume, along with such key manifesto-essays as Janák's "Prism and Pyramid" and Hofman's "Spirit of Modern Creation in Architecture," there appeared as well a translation of Ardengo Soffici's seminal essay "Picasso e Braque" (originally published in *La Voce*), a review of the Salon d'Automne exhibition in Paris by painter Václav Špála, and reproductions of work by Cézanne, Derain, Braque, and Picasso, as well as by Rodin, Seurat, and Rousseau. As Lamač points out, the commingling of material showing or discussing modern art with that in which modern artists extolled the power of Gothic and baroque art, or explored non-Western and popular art, signaled simultaneously a broad, inclusive understanding of art and a strong antinaturalist platform.[16]

The second volume of *Umělecký měsíčník* reflected the growing disagreement between the proponents of what was often referred to as "new art" (identified with the work of Picasso and Braque), supporters of

"cubism" (a movement more closely identified with Gleizes and Metzinger), and finally the adherents of the idea that cubism was simply an option among many in modern art. In spite of the complex personal and intellectual rivalries, this last complete volume contained some of the most powerful essays connected with the history of Czech cubism: Gutfreund's "Plane and Space," Janák's "Renewal of the Facade," Kramář's "Chapter on -isms," Beneš's "New Art," and Rudolf Procházka's serialized review of the philosophical underpinnings of the new art, "Substantive Transformation of the Spiritual Nature of Our Times."[17] Beneš also published a strongly worded review of the "cubist exhibition," organized for the Mánes association by the French poet Alexandre Mercereau, in which the work of 35 French painters, notably excluding Picasso and Braque, was shown. Savaging Gleizes and Metzinger, whose work formed the core of the exhibition, for "their complete lack of understanding of the work of Picasso and Braque," Beneš explained the abiding interest Picasso's kind of cubism had for the remaining members of the Group of Plastic Artists: "The substance of all new and good art, as represented by Picasso and Braque, consists in greater richness, abundance, and perfection of its formal means . . . most often connected to the understanding of plasticity and spatiality. [The result is] an *enriched* two-dimensionality that implies not less, but rather more, than the third dimension."[18] In this last observation, Beneš came particularly close to the ideas elaborated by Janák in his journal.

Thanks to Kramář's relationship with Kahnweiler and his growing personal collection, more than a dozen of Picasso's and Braque's paintings were reproduced in the second volume of *Umělecký měsíčník*, alongside oils by Beneš and Filla, Gutfreund's sculpture, and architecture and applied art designed by Janák and Gočár. Simultaneously, the breakup of the Group of Plastic Artists and the growing disparity of views

became evident in the hostile tone of the editorial note that accompanied the second chapter of Gleizes and Metzinger's *Du "cubisme"*: "Since cubism is one of the phenomena present in what constitutes the course of new art, we give it attention and consider it opportune to inform the public about it. The best way to do so seems to be by way of an excerpt that underlines its sterile quality, similar to futurism."[19]

Despite disparaging comments about Gleizes and Metzinger, the Czechs shared the French artists' notion of the dynamism of form as expounded in *Du "cubisme."*[20] The lengthy, five-part discussion of modern philosophy since Kant that appeared in the second volume of *Umělecký měsíčník* ended with a manifesto that echoes Gleizes and Metzinger's text: "Modernity's effort to find a new expression of a new way of life is necessarily a struggle for a new form, a new plastic law articulated in the sense of a lasting cultural purpose."[21] Scholarship of the past decade stresses a link between the early, analytical phase of French cubism and the Czech approach to cubist painting in particular.[22] Initially, the Group's own program of exhibitions aligned itself decisively with the "new art." This began with its first exhibition in January 1912, which featured Czech cubist paintings in the company of cubist furniture, architectural projects, and applied art, all framed by a "cubist" installation by Pavel Janák; and it continued in the subsequent venues in which French cubist paintings and sculpture were shown alongside the work of the Czechs.[23]

It was the "off-center" position of the young generation of Prague artists, with their strongly developed sense of an indigenous cultural tradition, on the one hand, and their interest in the larger context of art, on the other, that, imbued with a high degree of poetic imagination, aided the syncretic and yet autonomous movement that was Czech cubism. Steeped in the Czech

tradition, in many cases in the Austro-German milieu, and looking toward France as a beacon of the new, the generation of artists born around 1880 seized on an opportunity to explore cubism less as a style or movement than as an important transitional stage leading to "an ideal spiritual art" as the ultimate expression of the new era.[24] Their position on cubism, and on modern art in general, was far from homogeneous: in fact, as of late 1912, a number of artists who had broken away from Mánes, including the Čapek brothers and architects Hofman and Chochol, left the Group of Plastic Artists because of their increasingly diverse positions on cubism and began publishing again in *Volné Směry* and elsewhere. For a brief moment, however, their effort to build a common platform for the many conflicting ideas surrounding cubism had yielded some important results.

Miroslav Lamač makes especially clear the significant distinctions between Czech cubism and its French counterpart. First, Czech cubism transcended the boundaries of cubism as "gallery art" and expanded it to include architecture and design. The Vitra catalogue offers a partial record of at least 40 realized architectural projects, close to 100 pieces of furniture, and some 70 examples of ceramics and metal objects. Second, in comparison to the French, the Czech proponents of cubism more vigorously emphasized, developed, and promoted an important body of theory that underpinned their enterprise, even though these theories were often at odds with practice, as evidenced in their design of buildings and even of applied art.[25] In his essay "Cubist Theories of Architecture," Rostislav Švácha has calculated that in the period 1909–1921 (that is, during both the early, prewar, "cubo-expressionist" period and the later, postwar, "rondocubist" or "national style" period), Janák, Hofman, Chochol, and—with a single contribution—the notoriously laconic Gočár, published over a hundred essays, manifestos, and polemical statements in both the professional and the popular press, in

which they often contradicted each other and sometimes even themselves.[26] While few of these writings directly addressed cubism, most of them explored issues related to the cubist discourse.

Pavel Janák's essays in particular reveal a process of continual invention and reassessment. "From Modern Architecture to Architecture" (1910) entailed a reevaluation of the principles taught by Otto Wagner, with whom Janák had studied in Vienna from 1906 to 1908. "The Spirit of Modern Creation in Architecture" (1912), "Notes on Furniture" (1911), and particularly the seminal "Prism and Pyramid" (1912) already explored subject-object relationships and other formal and spatial considerations relevant to cubism. Janák's descriptions of the empowering spatial capacity of the diagonal, and—even more importantly—of a dynamic, energy-imbued matter bursting with possibilities and re-formed, or even displaced, by its own inner forces, were embodied in his projects. The 1912 Design for a Monumental Interior (fig. 2.1), Janák's competition entry for a memorial to the fourteenth-century Czech warrior Jan Žižka (1913), and the 1914 sketch of a chair in Janák's journal show the decisive evolution of these ideas in his oeuvre.

In his often-invoked essay of 1913, "Renewal of the Facade," Janák took as his point of departure Riegl's notion of the polarity between the haptic and the optic principles as a basis for art analysis. Noting related observations by Schmarsow and Worringer, Janák applied Riegl's analysis to building typology defined by either the central plan or the longitudinal facade.[27] It was the optical—longitudinal—facade that, according to Janák, could best express the ideals of "new architecture." Here as elsewhere, Janák took a position divergent from that of Hofman, who sought to reveal the structural form as generated by the haptic principle—the central plan—in such projects as the pavilions for Ďáblice cemetery (1912–1913).

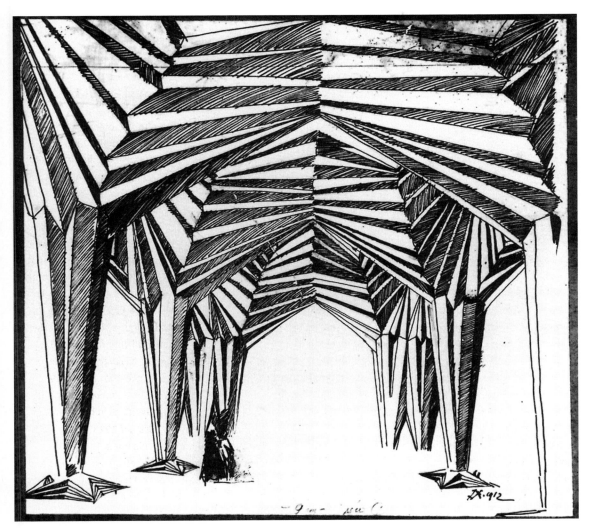

2.1 Pavel Janák (1882–1956). Design for a Monumental Interior, 1912. India ink, 39.5 x 42.5 cm. National Technical Museum, Prague.

2.2 Pavel Janák (1882–1956). Journal, 1912, pages J14 and J15. National Technical Museum, Prague.

Hofman's early architectural texts supported Janák's basic premise that a creative spirit is able to transform matter by imbuing it with motion; by the end of 1912, just as the situation within the Group of Plastic Artists became irrevocably polarized, the two architects increasingly sought different paths toward the new articulation of form.[28] According to Švácha, Hofman's preoccupation with form surpassed even that of Janák. However, my own investigation of Janák's journals and notebooks leads me to a different conclu-

sion.[29] Where Hofman did outstrip Janák was in his attention to the psychological aspects of modernity, and particularly in his exploration of the role of a spiritually based objectivity in the creative process.[30]

Hofman himself provided a synthetic view of his own theories in his essay "The Spirit of Transformation in Art," published in The Almanac of 1914. Here, he reiterated his conception of objective form within the interactive context of the surrounding environment. Hofman took care to point out that this new environ-

2.3 Pavel Janák (1882–1956). Journal, 1913, pages J70 and J71. National Technical Museum, Prague.

2.4 Pavel Janák (1882–1956). Journal, 1912, pages J58 and J59. National Technical Museum, Prague.

ment "in its very neutrality . . . becomes a functional stage for the possibilities of the new expression," and furthermore that the "connection with surrounding objects is the first differentiating trait of modern art."[31]

For his part, Josef Chochol, following his departure from the Group of Plastic Artists, evolved a strongly antidecorative stance. In his essay of 1913, "The Function of the Architectural Detail," he equated antidecorativism and modernity and, while exalting the heightened imagination inherent in the new art, emphasized its three-dimensional reality. "We are enthusiastic about total form," Chochol wrote, "felt and presented with excitement, form that is all-encompassing and has a total and instant effect. . . . Just as modern technical means enable us to glance quickly across a landscape and gain an extraordinarily concentrated and synthetic sense of it, we also try to reach the sense of this speed, even instantaneity, in a synthetically rendered work."[32]

Out of the debate over the representation of depth, the notion of superimposition assumed a fundamental role in Czech cubism, not only in the theories

of Czech cubist architects but particularly in the design of applied objects in the period before the First World War. In fact, the use of superimposition by the Czech cubist architects illustrates perfectly the process of appropriation and transformation of a concept derived from French painting as well as its transmutation within a regional context, as it was enriched by other sources closer to home. Its evolution is clearly articulated in the journal Janák kept during the early cubist period, between 1910 and 1914.[33]

Superimposition appears repeatedly in Janák's journal as a term conveying what he calls "the erection of content" as distinct from mere "growth" (fig. 2.2). Optically articulated (J1), superimposition is a means of making the internal content visible externally, a conception eloquently illustrated by Janák's drawing of, and commentary on, San Marco in Venice (fig. 2.3). In his interpretation, Janák attempts to understand the facade not structurally but rather as "a paraphrase of what is behind, i.e., a transposition of the real content behind the facade into the plane in such a way that each part is superimposed not on, but above, the other" (J70).

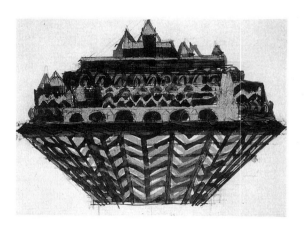

2.5 Pavel Janák (1882–1956). Design for a Covered Box, 1910. Graphite, india ink, and watercolor, 19 x 13 cm. National Technical Museum, Prague.

Closer to home, the graded, stacked, pyramidal form of the urban fabric of Prague reinforced the notion of superimposition that the cubists espoused. As we can see from Janák's journal, the city indicated a sequence for the imagination, a superimposition of forms within the overall figure, "always more telling if one sees first the facades of the houses, then their roofs, and finally the cathedral" (J59) (fig. 2.4). By comparison, a linear ordering lacked an expressive, dramatic quality. An earlier drawing of a decorative box (1910) illustrates how Janák articulated this idea plastically, trying to build an impression of continuous growth and movement from parts pushed up and above each other, an idea he later abstracted and simplified in his series of covered boxes (fig. 2.5).

Unpublished documents such as Janák's journals and notebooks, his published essay-manifestos, as well as his realized and unrealized projects, together with the record of his organizational and editorial activities, reveal some specific thoughts about the work of Picasso and Braque. While he published their work in *Umělecký měsíčník*, his only direct reference to Picasso's work was rather critical: "Even painting," he wrote in the journal, "often falls victim to the system of corporeality: it portrays truly plastically conceived things (Picasso), and it isn't optical enough."[34]

Janák's comments appear to support Švácha's premise that it was in the conception of the new architectural space that Janák, Hofman, and Chochol differed sharply. Until mid-1914, Janák advocated the artistic compression of such space into a relief, a form he saw as more creative artistically: "So far," he wrote, "we only know that to make cubic, three-dimensional space does not signify the creation of space, because that merely corresponds to reality, but rather to create always means to draw forth more than what was already there—to create volume and space through spatial interpenetration of surface planes."[35] Ultimately, as a "constructed essence of reality" and a "bearer of will," relief became for Janák the expression of "modern form" (J86) with its concomitant planarity determined by optical laws.[36]

By contrast, both Hofman and Chochol increasingly stressed the three-dimensional reality of architectural space as the sine qua non of their own artistic imaginations. In his 1913 review of the previous year's Salon d'Automne exhibition, entitled "The Substance of Architecture," Hofman considered the tenuous transfer of painterly principles to architectural projects such as the Maison Cubiste. "[Duchamp-] Villon's solution," Hofman wrote, "demonstrates the [architectural] use of new painterly means discovered by the cubists. It remains to be seen, however, if the inventions and means of painting are the only true source; in architecture and sculpture, these same means could easily collide with the laws and the very substance of architecture. . . . Should architecture take

its feeling for form solely from painting and use it only to create its own surface, it would fail at its original and ultimate goal: to create a new vocabulary, a fundamentally new understanding of space, and a new approach to mastering matter in all its inherent possibilities."[37]

While appreciative of the expressive qualities of Duchamp-Villon's project, Hofman remained critical of the sculptor's inability to transcend the "traditional principles of the baroque" and of the "post-and-lintel style."[38] Hofman's remarks here seem to be aimed as much at his estranged colleague Pavel Janák, whose 1913 remodeling of a house for Dr. Fára in the east Bohemian town of Pelhřimov was emblematic of the skillful application of Janák's theories of relief in a cohesive historical context. By maximizing the formal potential of the triangular gable and the interaction of forces within it, the original baroque house was transformed and, as it were, resculpted. The expressive force of its corner site and its vertical thrust were heightened, yet it remained perfectly integrated in the traditional urban fabric. In the case of the Maison Cubiste as in the Fára House, the designers had focused primarily on the facade and the entrance. In particular, Janák's treatment of the bow window and the corner room reflected his desire to convey the mobility of matter in space. Hofman's criticism of Duchamp-Villon for confusing the aims of different artistic media, and for equating sculpture with architecture, applied to Janák as well.

Scholars of Czech cubism regularly note that French cubist painting manifested its influence primarily in the surface articulation of the polygonal facades of Czech cubist buildings. In fact, however, the Czech cubist theories that underlay this feature derive almost wholly from German sources, which is not surprising given the pervasive presence of Germanic culture in Central Europe. In addition to certain contemporary

links (e.g., investigations of the power of the artist's will and feeling to transform pictorial space, the creative role of the visual and tactile intuitions, formal means of achieving spatial transformation, the dynamics of surface relationships, and the possibilities of integrating past cultures into the art of the present) to the writings of Riegl, Dvořák, Schmarsow, Lipps, and others, the Czech cubist sources extend back into the preceding century. My own reconstruction of some 200 titles that Janák read between 1911 and 1914 has revealed, for example, that he systematically studied certain nineteenth- and early twentieth-century German sources, particularly those illuminating the nature of Gothic and other historical styles.[39] Janák's extensive studies of the formal and spatial possibilities of the triangle had a vast literary underpinning in works in German by Georg Dehio, Friedrich Roeber, the Prague Benedictine monk Odilo Wolff, Alexander von Heideloff, Sulpiz Boisséré, and Carl Schnaase, among others.[40] Indeed, most titles on Janák's list confirm the later assessment by the Czech functionalist theorist and critic Karel Teige, who reproached the Czech cubists for their immoderate adherence to the German romantic legacy.[41]

The most plausible account of the origins of Czech cubist architecture still seems to be supported by the "off-center" theory: Czech architects experimented with cubism because it corresponded to their intuitive and psychological understanding of the profound changes in the world around them. They explored the legacy of their Viennese training and their Bohemian heritage, which they confronted with their extensive readings, their travels, and their encounters with modern art and with artists. It could be said that ultimately they sought expression through a synthesis unfettered by exclusive alliance with a single movement. The shock of major historical events—the Great War, the dissolution of the Austro-Hungarian empire, and the founding of the

Czechoslovak Republic—drastically altered the course of further development, and Czech architects emerged in the 1920s with individual solutions that differed substantially from their earlier engagement with cubism.

The Czech cubist experiment in architecture was, on the whole, a complex balancing act, which, unlike other reform movements in the early twentieth century, did not operate by rejection, elimination, and virulent opposition, but rather strove to make abstract, to "syncretize," and to "collage" an abundance of new possibilities of representation. Central to the group was the emphasis on poetic imagination, on a form of spiritual excavation and projection, as well as the desire to soften the dividing lines between the different artistic media and to eliminate the wall separating "art" from "craft." For Janák, Hofman, Chochol, and Gočár, the four early proponents of cubism in architecture, designing a building or an ashtray was always Architecture—the scale was as monumental in one as in the other; the material was almost irrelevant. As Milena Lamarová has frequently pointed out, the issue for the Czech architects was not that of material but of *matter* itself and its transformation from a condition of stasis to one of dynamic kinesis. "They spoke of the 'simplicity of the inner concentration of matter,' which

they saw as a universal arch-matter, a magmatic substance of inorganic nature bursting with inner energy in need of discovery, set in motion, imbued with rhythm, catapulted into space and capable of siphoning space explosively inside to the point of disintegration."[42]

Tellingly, the 1992 exhibition at the Centre Georges Pompidou in Paris emphasized the plurality of its title, "Cubismes tchèques," to describe the complex phenomenon that, saturated with a multitude of contradictory, opposing forces and tensions, ultimately provided a fertile testing ground not just for cubism but for the single most influential generation of Czech architects in this century.

The recent upsurge of interest in Czech cubism, as attested by the exhibitions and publications discussed here, has permitted a more nuanced assessment of this exploratory movement. The relationship of Czech to French cubism has been shown as strong and genuine but only explicable within the larger context of European modernism. Further, the authentically regional aspects of Czech cubism have become more explicit. Ultimately, we are now in a better position to integrate this heightened understanding within the broad compass of modern architecture itself.

2.

NOTES

1. The chronology and scope of the different exhibitions devoted to Czech cubism are inevitably confusing: plans to hold these exhibitions were made independently by several different institutions, some of which used the same material. Not even a careful examination of the concomitant publications enables one entirely to disentangle the overlapping information. The defining distinction between the two exhibitions held in Düsseldorf and Paris respectively, and all the other venues, is that the former two included cubist painting and sculpture in addition to architecture and design, and were accompanied by independent publications.

Multiple versions of the architecture/design exhibition were organized by the Uměleckoprůmyslové Muzeum in collaboration with the Národní Technické Muzeum in Prague and the Vitra Design Museum in Weil am Rhein and shown successively in the Uměleckoprůmyslové Muzeum, Prague, May-June 1991; the Vitra Design Museum, Weil am Rhein, July-September 1991; the Kunstverein für die Rheinlande und Westfalen, Düsseldorf, September-November 1991 (as part of a larger Kunstverein exhibition; see below), Museo Español de Arte Contemporáneo, Madrid, December 1991–February 1992; the Centre National d'Art et de Culture Georges Pompidou, Paris, March-May 1992 (as part of a larger Centre Pompidou exhibition; see below); the Centre Canadien d'Architecture, Montreal, June-August 1992; the University of the Arts, Philadelphia, September 1992–December 1992; and the Cooper-Hewitt National Museum of Design, New York, April-July 1993. The original Czech catalogue, *Český kubismus: Architektura a design, 1910–1925*, was edited by Alexander von Vegesack and published in 1991 in Czech, German, and Spanish versions by the Vitra Design Museum in Weil am Rhein. An English translation published by Princeton Architectural Press in 1992 accompanied the North American versions of the exhibition.

The Düsseldorf exhibition was organized by the Kunstverein für die Rheinlande und Westfalen in cooperation with the Národní Galerie, the Uměleckoprůmyslové Muzeum, Národní Technické Muzeum, and the Ústav dějin umění, all in Prague, and with the Moravská Galerie in Brno. It was shown successively at the Kunstverein Düsseldorf, September-November 1991; the Národní Galerie, Prague, December 1991–March 1992; and the Moravská Galerie, Brno, September-November 1992. This exhibition was accompanied by the catalogue *1909–1925 Kubismus in Prag: Malerei, Skulptur, Kunstgewerbe, Architektur* (Düsseldorf: Kunstverein, 1991), edited by Jiří Švestka and Tomáš Vlček, and, at the venues in the Czech Republic, by a Czech version of the same catalogue.

The Paris exhibition, titled "Cubismes tchèques, 1910–1925, architecture, design, arts plastiques," was conceived by the Centre de Création Industrielle of the Centre Pompidou in collaboration with the Czech institutions named above. It was shown in Paris, March-May 1992, accompanied by the catalogue *Cubisme tchèque* (Paris: Flammarion/Centre Pompidou, 1992), by Miroslav Lamač et al. (see following note).

2. I have drawn significantly on three publications generated by the aforementioned exhibitions. Their rather complicated bibliographic and chronological genesis requires an explanation. *Czech Cubism: Architecture, Furniture, and Decorative Arts, 1910–1925*, edited by Alexander von Vegesack (New York: Princeton Architectural Press, 1992), constitutes the English-language version of the Vitra Design Museum's catalogue *Český kubismus*. Then, *Český kubismus 1909–1925: malířství, sochařství, umělecké řemeslo, architektura*, edited by

Jiří Švestka and Tomáš Vlček (Stuttgart: Gerd Hatje für Kunstverein für die Rheinlande und West-falen, 1991), is a Czech version of the Düsseldorf catalogue *1909–1925 Kubismus in Prag*. Finally, *Cubisme tchèque*, published to accompany the Centre Pompidou exhibition, is essentially a synthesis of the work of Miroslav Lamač, one of the most prominent Czech art historians of this century. It features a revision of Lamač's groundbreaking monograph in Czech, *Osma a skupina výtvarných umělců, 1907–1917* [The Group of Eight and the Group of Plastic Artists] (Prague: Odeon, 1988), accompanied by four additional essays by Czech and French scholars of cubism. Despite its synthetic character, Lamač's book is more anchored in the domain of cubist painting than the other publications mentioned above.

3. The texts of the attendant publications reflect these divergent conceptions. The focused nature of the Vitra/Princeton catalogue stems from the nine tightly written introductory essays which, for the most part, offer an analysis of both the historical context and period issues of Czech cubist architecture and design; the second part of the catalogue is devoted to a pictorial and textual record of close to 300 objects included in the varying exhibitions. The authors of the massive (454–page) Düsseldorf catalogue, a work of 24 different contributors, deliberately emphasized the plurality of Czech cubisms in relation to the original French movement; they organized the 55 essays and the briefer "excursus" to recreate the intricate web of densely layered geographical, intellectual, and political connections and intersecting relationships characteristic of Czech cubism in Central Europe. Significantly, in the preface to the catalogue and the exhibition, the authors stated without equivocation that, by including architecture and applied art with painting and sculpture, they aimed "to emphasize the original intentions of Czech cubism by bringing together examples of mutual influences and interpenetrations throughout all the different spheres [of art]." Furthermore, the authors rightly emphasized that such an approach was but a continuation of the documented tradition of Czech cubist exhibitions from the period before the First World War. The thrust of the Düsseldorf exhibition, assembled from a broad variety of public and private collections, was to emphasize the "distinguishing aspects of Czech cubism, i.e., the symbolic, expressive, and existential character of the movement and its theoretical underpinnings."

4. Miroslav Lamač, "Le cubisme tchèque. La phase cubo-expressioniste dans la peinture, la sculpture, l'architecture et les arts appliqués," in Lamač et al., *Cubisme tchèque*, 90–123.

5. Edward F. Fry, "Český kubismus v evropském kontextu" [Czech Cubism in the European Context] in Švestka and Vlček, eds., *Český kubismus 1909–1925*, 12.

6. For a discussion of the Kramář-Kahnweiler relationship, and the details of Kramář's Paris acquisitions from Kahnweiler, Ambroise Vollard, Clovis Sagot, and Bertha Weil, see Vojtěch Lahoda, "Vincenc Kramář a kubismus," in Švestka and Vlček, eds., *Český kubismus 1909–1925*, 64–70.

7. Ibid., 68.

8. Bohumil Kubišta, *Korespondence a úvahy* [Correspondence and Reflections] (Prague: n.p., 1960), 127. Quoted in Jiří Švestka, "Český kubismus—dilema rodící se středoevropské avantgardy" [Czech Cubism—A Challenge of the Central European Avant-garde], in Švestka and Vlček, eds., *Český kubismus 1909–1925*, 16.

9. For letters and diaries from Gutfreund's stays in Paris, see *Otto Gutfreund: zázemí tvorby* [Otto Gutfreund: Creative Sources], ed. Jiří Šetlík (Prague: Odeon, 1989). For a summary of Gutfreund's contribution, see Jiří Šetlík, "The Contribution of Otto Gutfreund to the Phenomenon of Czech Cubism," in von Vegesack, ed., *Czech Cubism*, 84–89.

10. *Otto Gutfreund: zázemí tvorby,* 96.

11. Švestka and Vlček, eds., *Český kubismus 1909–1925,* 398. The sketchbooks were brought to Gutfreund's attention by the Czech art historian Antonín Matějček, who had first perused them in the Bibliothèque Nationale. Probably at Gutfreund's instigation, Janák included Villard de Honnecourt's sketchbooks among his readings from the cubist period. See also Irena Žantovská Murray, "Sources of Cubist Architecture in Bohemia: The Theories of Pavel Janák" (master's thesis, McGill University, 1991), 79.

12. Mentioned by, among others, Jana Claverie, "Aux sources du cubisme tchèque," in Lamač et al., *Cubisme tchèque,* 236. Somewhat cryptically, Janák noted Duchamp-Villon and Mare, among others, in his journal on Christmas Eve 1912 (J74). Reproductions of the Maison Cubiste later accompanied Vlastislav Hofman's 1913 review of the 1912 Salon d'Automne in "K podstatě architektury" [The Substance of Architecture], *Volné Směry* 17 (1913), 53–56.

13. See "Chronology of Events," in Švestka and Vlček, eds., *Český kubismus 1909–1925,* 398.

14. Petr Wittlich, "The Road to Cubism," in von Vegesack, ed., *Czech Cubism,* 24. The reference is to Emil Filla, "O ctnosti novoprimitivismu" [On the Virtues of Neoprimitivism], *Volné Směry* 15 (1911), 62–70.

15. *Umělecký měsíčník. Časopis Skupiny výtvarných umělců* (Prague: SVU, 1911–1914). Volume 1, 1911–1912, volume 2, 1912–1913, volume 3, no. 1 only, 1914.

16. Lamač et al., *Cubisme tchèque,* 147.

17. Otto Gutfreund, "Plocha a prostor" [Plane and Space], *Umělecký měsíčník* 2 (1912–1913), 240–243; Pavel Janák, "Obnova průčelí" [Renewal of the Facade], *Umělecký měsíčník* 2 (1912–1913), 85–93; Vincenc Kramář, "Kapitola o -ismech" [Chapter on -isms], *Umělecký měsíčník* 2 (1912–1913), 115–130; Vincenc Beneš, "Nové umění" [New Art], *Umělecký měsíčník* 2 (1912–1913), 176–187; Rudolf Procházka, "O podstatné proměně duchovní povahy naší doby" [Substantive Transformation of the Spiritual Nature of Our Times], *Umělecký měsíčník* 2 (1912–1913), 80–83, 131–135, 212–216, 244–247, 308–315.

18. Vincenc Beneš, "Kubistická výstava v Mánesu" [Cubist Exhibition in Mánes], *Umělecký měsíčník* 2 (1912–1913), 326–331.

19. Albert Gleizes and Jean Metzinger, "O kubismu" [Of Cubism], translated by St. Wirth, *Umělecký měsíčník* 2 (1913), 60–62.

20. "Composer, construire, dessiner, se réduisent à ceci: régler sur notre propre activité le dynamisme de la forme." Quoted from A. Gleizes and J. Metzinger, *Du "cubisme"* (1912; rpt. Sisteron: Editions Présence, 1980), 51.

21. Procházka, "O podstatné proměně duchovní povahy naší doby," 315.

22. See in particular Lamač et al., *Cubisme tchèque,* 40–145.

23. For an informative overview of the exhibition activities of the Mánes Association and the Group of Plastic Artists, see Pavel Liška, "Významné pražské výstavy v letech 1911–1922" [Important Prague Exhibitions, 1911–1922], in Švestka and Vlček, eds., *Český kubismus 1909–1925,* 78–85.

24. Miroslav Lamač, "Český kubismus a svět" [Czech Cubism in the World], in Švestka and Vlček, eds., *Český kubismus 1909–1925,* 58.

25. See, among others, Vojtěch Lahoda, "Kubistické teorie českých malířů" [Cubist Theories of Czech Painters], and Rostislav Švácha, "Kubistické teorie architektury" [Cubist Theories of Architecture], in Švestka and Vlček, eds., *Český kubismus 1909–1925,* 106–115 and 202–211.

26. Švácha, "Kubistické teorie architektury," 202.

27. See Žantovská Murray, "Sources of Cubist Architecture in Bohemia," 55–64.

28. Švácha, "Kubistické teorie architektury," 207.

29. In his journal of 1910–1914, Janák devoted a full year to the investigation of the formal potential of the triangle in particular, but also of other geometrical forms. As well, he investigated the role of these different geometrical forms in urban design.

30. Vlastislav Hofman, "Duch moderní tvorby v architektuře" [Spirit of Modern Creation in Architecture], *Umělecký měsíčník* 1 (1912), 127–135.

31. Vlastislav Hofman, "Duch přeměny v umění výtvarném" [The Spirit of Transformation in Art], in *Almanach na rok 1914,* 49. The latter publication was a group effort involving the Čapek brothers, Hofman, and the poets Otakar Fišer and S. K. Neumann, among others.

32. Josef Chochol, "K funkci architektonického článku" [The Function of the Architectural Detail], *Styl* 5 (1913), 93–94. Here quoted from von Vegesack, ed., *Czech Cubism,* 18.

33. Janák journal, 27 October 1911–25 September 1914, Janák Papers, National Technical Museum, Prague (hereafter cited as "J" followed by relevant page number). Published with the English translation as part of Žantovská Murray, "Sources of Cubist Architecture in Bohemia," pages J1–J91 (original unpaginated, numbering my own).

34. Here Janák may have been referring to Picasso's *Head of a Woman,* painted in 1907 and acquired by Kramář from Ambroise Vollard in 1911 (J37).

35. Janák, "Obnova průčelí," 94, quoted from Irena Žantovská Murray, *The Intrepid Form: Czech Cubism, Architecture and Design, 1910–1925* (Montreal: Canadian Centre for Architecture, 1992), n.p.

36. Žantovská Murray, "Sources of Cubist Architecture in Bohemia," 34.

37. Hofman, "K podstatě architektury," 54.

38. Ibid., 56.

39. Žantovská Murray, "Sources of Cubist Architecture in Bohemia," 68–77.

40. Ibid., 42–46.

41. Karel Teige, *Moderní architektura v Československu* [Modern Architecture in Czechoslovakia] (Prague: Odeon, 1930), 96. In Teige's view, the "decadent Gothic soul—not the soul of the Gothic master-builders, but the soul perpetuated by romantic literature" was embodied in Czech cubist architecture.

42. Milena Lamarová, "Portrét mladého architekta v prostoru roku 1913" [The Portrait of a Young Man in Space], in Švestka and Vlček, eds., *Český kubismus 1909–1925*, 98.

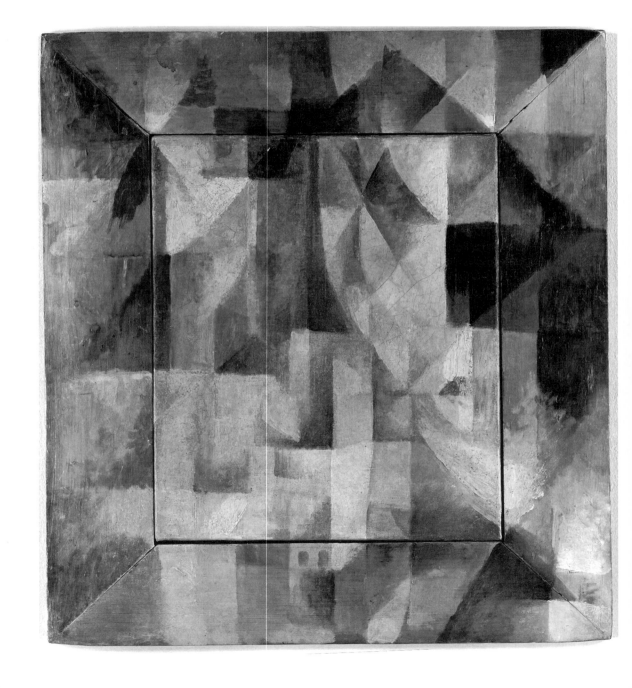

3. KEVIN D. MURPHY

CUBISM AND THE GOTHIC TRADITION

3.1 Robert Delaunay (1885–1941). *Simultaneous Windows on the City*, 1912. Oil on canvas, 45.7 x 40 cm. Hamburger Kunsthalle.

Between 1909 and 1914, certain cubist artists asserted in writings, architectural projects, and paintings a relationship between Gothic architecture and modernism. This affinity between cubism and a historic architectural style has not been attended to because it is a difficult theme to accommodate within the prevailing account of cubism, which emphasizes a development toward "the artists' creation of a new phenomenological reality, the independent work of art ... free from the burden of representation."[1] As early as 1912, Albert Gleizes and Jean Metzinger portrayed cubism as a radical break with artistic tradition, and particularly with the perspectival rendering of three-dimensional space on a flat surface. Cubist strategies for constructing illusionistic space relied instead on the juxtaposition of planar forms shading off into their surroundings, and on the combination of multiple views of a given object in a single canvas.[2] Thus a recourse to history might appear to transgress cubism's salient features. However, as the work of several of the cubists suggests, Gothic architecture could in fact be understood as promoting an experience of space that was consistent with the spatial effects of cubism.

The characterization of cubism as discontinuous with tradition, even "revolutionary," has overshadowed the attempts that have been made to situate the works of Picasso and Braque within certain artistic traditions. Despite Braque's several paintings from 1909 of the medieval castle at La Roche-Guyon, and critical efforts to relate Picasso's work to both the Gothic and classicist strains in French art, the two "true" cubists are more often valorized precisely for the degree to which their works overturned established conventions. Indeed, the fact that cubist artists other than Picasso and Braque more regularly thematized historic architecture in their painting and sculpture has been partly responsible for their marginalization in some of the scholarship.[3]

References to Gothic architecture surface in the work of Robert Delaunay and the "Puteaux cubists" (including Albert Gleizes, Jean Metzinger, and Raymond Duchamp-Villon, who regularly met in the Puteaux studios of Duchamp-Villon and his brothers). These artists forged a group identity as cubists while distinguishing themselves from Picasso and Braque in part through their participation in the annual salons and other public exhibitions held in Paris in the years immediately preceding World War I. A recuperation of some of the ways in which cubism responded to historic architecture belongs to a reassessment of the movement that attempts to redirect attention to "precisely those [artists] who were labeled 'cubists' during the Salon des Indépendants of 1911" but who have been neglected in the dominant accounts of cubism. This discussion of the role of Gothic architecture in cubism can be considered a contribution to the recovery of the narrative content of cubist art generally.[4] However, my intention is not simply to point out representations of medieval architecture in cubism; I want to argue further that for some cubists, actual Gothic monuments offered a model for how the representation of three-dimensional space on a flat surface could be transformed.

That architecture bears a significant relationship to cubism is not a new claim. As early as 1910 Braque was reported to have likened the cubist use of multiple perspectives to conventions for representing architecture in plan, elevation, and section.[5] In his influential *Cubism and Abstract Art* of 1936, Alfred H. Barr, Jr., suggested that architecture may have contributed to the development of analytical cubism by Picasso and Braque beginning around 1909. According to Barr, their progressive dissolution of objects into facets bore at least a superficial comparison to paintings by Cézanne in which "the shapes of the houses resemble Picasso's geometricizing technique."[6] The vernacular buildings shown by Cézanne as unornamented boxes jostling one another in the *Town of Gardanne* (c. 1885–1886), illustrated by Barr, inspired the further reduction of objects to their original geometric forms until, eventually, the shapes "may be considered not a breaking down, or analysis, but a building up or synthesis" in synthetic cubism.[7]

In this way architecture was connected however shakily, through Cézanne, with the origins of cubism. Inversely, in one of the founding texts on the development of modern architecture, *Space, Time and Architecture* (1941), Sigfried Giedion claimed that cubist painting had played an important role in the evolution of recent architecture. Giedion argued that cubism had disrupted the traditional conception of space by rendering objects from multiple points of view: "Thus, to the three dimensions of the Renaissance which have held good as constituent facts throughout so many centuries, there is added a fourth one—time." Citing Barr's account of cubism, Giedion went on to describe how objects were broken into "angular facets" that then became assimilated to "one of the constituent facts of space-time representation—the plane." These

planes, "interpenetrating, hovering, often transparent, without anything to fix them in realistic position," Giedion saw as a challenge to "the lines of perspective, which converge to a single focal point."[8]

Giedion's particular understanding of the role of cubist painting in inspiring modern architecture was eventually disputed by Colin Rowe and Robert Slutzky in their seminal essay, "Transparency: Literal and Phenomenal" (1963). Although they affirm that paintings such as Cézanne's *Mont Sainte Victoire* of 1904–1906 and analytical cubist compositions of 1911–1912 presented objects in space in ways that were significant for Le Corbusier's architecture of the 1920s, Rowe and Slutzky maintained that the literal transparency presented in these images was only part of the story; they identified two different kinds of transparency in cubist painting: "Literal transparency . . . tends to be associated with the *trompe-l'oeil* effect of a translucent object in a deep, naturalistic space; while phenomenal transparency seems to be found when a painter seeks the articulated presentation of frontally aligned objects in a shallow, abstracted space." The authors reject Giedion's correlation of the transparency achieved by literally transparent materials like glass (as in Gropius's Bauhaus building) with the effects produced by the emphasis on planes in analytical cubist painting. Instead, they cite Le Corbusier's Villa Stein–de Monzie at Garches (1926–1927) as a more rigorous approximation of the techniques of gridding and planar articulation observable in analytical cubist painting.[9]

In positing relationships between architecture and cubism before the First World War, these influential and interrelated texts by Barr, Giedion, and Rowe and Slutzky all betray a preference for painterly, visual aspects of cubism—the "analytical," "synthetic," and "phenomenal"—over more direct references to architectural themes. For instance, Rowe and Slutzky use as an example of "literal transparency" Robert Delaunay's

painting *Simultaneous Windows on the City* of 1912 (fig. 3.1) in which the artist "accepts with unrestrained enthusiasm the elusively reflective qualities of his superimposed 'glazed openings'." In contrast to Delaunay, who in this account seems to enjoy the possibilities of the literally transparent glass, Juan Gris is praised for having taken a less obvious approach in which he "intensified some of the characteristics of Cubist space" through "a transparency of gridding" in such works as *Still Life* of 1912.[10]

Though Giedion and Rowe and Slutzky provide densely argued accounts of the relationship between modernist architecture and cubist painting, some obvious intersections are entirely neglected. For instance, Delaunay's series of paintings of the late Gothic church of Saint-Séverin in Paris was begun in 1909, at the moment (according to Barr) that analytical cubism came into being.[11] Likewise neglected in the literature on cubism are Raymond Duchamp-Villon's projects for architectural sculpture of 1912–1916. These works thematized the dialectic between history and modernity through the image of Gothic architecture, but they have been overlooked because they do not conform to definitions of cubism that are based on the paintings of Picasso and Braque and that penalize explorations of narrative or historical content.

While the early literature on cubism minimized the role of historical models in the development of modernism, more recent scholarship has drawn attention to the Puteaux cubists' engagement with French cultural traditions. In particular, the Gothic heritage appears to have had a political meaning for the Puteaux cubists on the eve of the First World War. According to Mark Antliff, they embraced the Gothic as a cultural component of their engagement with the leftist Celtic League and their reaction against a rightist nationalist discourse promoted by the Action Française that claimed the origins of French culture in

classicism.[12] At the same time, the cubists appealed to history by using traditional formal vocabularies to reinvigorate the production of decorative arts in France, as Nancy Troy has shown in her analysis of the Maison Cubiste exhibited at the Salon d'Automne of 1912.[13] Among the participants in the Maison Cubiste was painter Albert Gleizes, who wrote in 1913 that the origins of cubism were to be found in "the sources of our [French] national tradition," which he equated with Gothic art, "the vigorous rosebush which has blossomed into the roses of our cathedrals."[14] Although the interiors of the Maison Cubiste were not modeled on Gothic precedents, and the furniture bore no stylistic traces of cubist painting, Raymond Duchamp-Villon's facade design did evoke the visual effects of late Gothic vaulting as well as the formal characteristics of cubist painting.

In order to appreciate the significance of the intersection in the Maison Cubiste facade of architecture, cubism, and the Gothic, it is essential to consider the contemporaneous work of another cubist painter engaged with these same themes: Robert Delaunay. While fulfilling his military service requirement in Laon in 1906, Delaunay discovered two themes, the tower and the city, that were to be central to his work for at least the next ten years. Delaunay himself emphasized the important role played by his paintings of the towers of the medieval cathedral of Laon (fig. 3.2) in his "movement toward the destruction of the old pictorial means."[15] Continuing the process after his return to Paris, he painted the series of eleven large oils of the Eiffel Tower, the towers of Notre-Dame, and the apse of the late Gothic church of Saint-Séverin.

Of these, the Eiffel Tower series is certainly the best known. As rendered by Delaunay, the motif has conventionally been understood as an unambiguous emblem of modernity. Yet, at the moment at which he began the series, the tower appears to have been considered an obsolete relic of a bygone era. Prior to the Universal Exposition of 1900, proposals were made to build a more classical structure to cover up its lower sections. Not only had the frank expression of metal become undesirable in exposition architecture, but public fascination with the Eiffel Tower had diminished as well. Fewer than half as many people (just over a million) visited the Eiffel Tower during the 1900 exposition as had during the 1889 exposition, and between 1901 and 1910 it had fewer than 200,000 visitors per year. Only the use of the tower for radio transmissions saved it from demolition, and it was the interception from the tower of a crucial German military communication during the First World War that renewed public esteem for the structure.[16] Thus for Delaunay, the Eiffel Tower appears to have belonged to 1889, not the present. This helps to explain his inscription on his first study of the structure, "Universal Exposition [of] 1889, The Tower addresses the universe,"[17] which clearly historicizes the tower by associating it with the world's fair for which it was originally erected. The Eiffel Tower series cannot therefore be seen simply as Delaunay's tribute to modernity; these works must be considered along with the Laon and Saint-Séverin series as indications of his exploration of the formal means of painting. Significantly, that process was grounded in the representation of architecture.

Between 1909 and 1910, Delaunay began no fewer than seven paintings of Saint-Séverin[18] in which he explicitly addressed the possibility of a modernist practice inspired by the Gothic architectural tradition. The elements of the building may well have contributed to this endeavor. For instance, in the first version of Saint-Séverin, a work dating from 1909, light passes

3.2 Robert Delaunay (1885–1941). *Les tours de Laon*, 1912. Oil on canvas, 162 x 130 cm. Musée National d'Art Moderne, Centre Georges Pompidou, Paris.

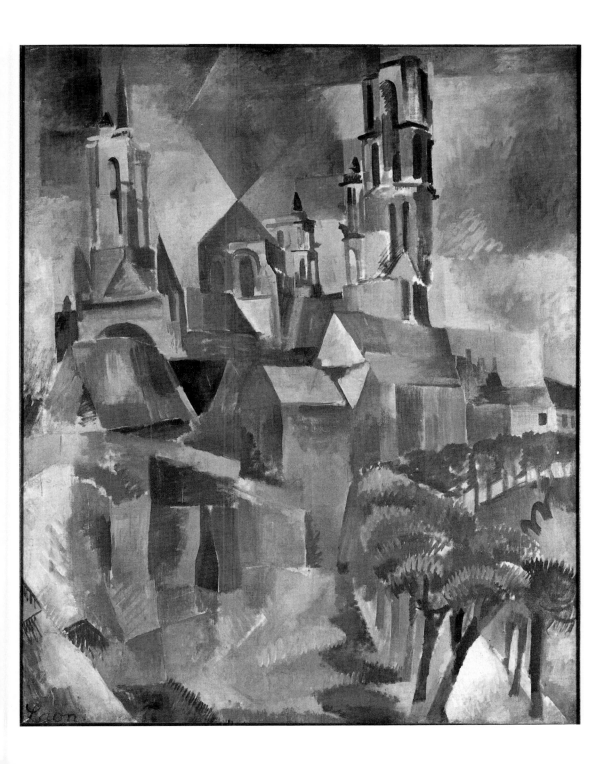

through the stained glass windows to break the floor into a series of brightly colored, undulating planes. Likewise, the tracery in the one visible window, as well as the vaults themselves, dissolve the forms into overlapping triangular planes. In the third painting of the church, also from 1909 (fig. 3.3), the floor swells upward in a series of jagged projections, but the subdued palette does not suggest light transformed by stained glass. Delaunay is also less concerned here to render the particular details of the building, and he accentuates the scale and upward thrust of the column on axis as well as the vaults into which it explodes. Despite their differences, these paintings of Saint-Séverin show how the very forms of the late Gothic building provided Delaunay with an ideal opportunity to experiment with depictions of objects fractured in space.

If the paintings Delaunay produced during the five years preceding World War I represent an attempt to render the relation between the Gothic and the modern, why did he choose as his subject the minor church of Saint-Séverin rather than the more canonical Gothic monument, Notre-Dame de Paris, nearby on the Île de la Cité? Sherry Buckberrough's suggestion that Saint-Séverin's proximity to his Latin Quarter studio was a factor is unconvincing.[19] It is more likely that Delaunay was interested in the unique formal qualities of Saint-Séverin, particularly the small scale of the nave and the easy visibility of the complex ribbed vaults in the ambulatories on the south side of the church, begun in 1489.[20]

The novelist and art critic Joris-Karl Huysmans, who was baptized at Saint-Séverin in 1848 and main-

tained a lifelong interest in the building, contributed to renewed public awareness of the church through his book of 1898, *La Bièvre et Saint-Séverin*. Huysmans first related its Gothic structure to natural forms, describing a vault of the chevet as a tree supported by a twisted trunk (column) and a "petrified rain of branches" (structural ribs).[21] As Michel Hoog has noted, Delaunay's depictions of Saint-Séverin frame the twisted column on axis in the chevet, celebrated by Huysmans, with the tilting vaults of the south ambulatory.[22] Even much later writers have described the vaults of Saint-Séverin as being like "prisms."[23] The architecture was thus consistently viewed as possessing formal qualities that would have attracted an artist associated with cubism. Delaunay's paintings of Saint-Séverin accentuate not only the prismatic but also the organic qualities of the building, recalling Huysmans's description of the building as a living organism capable of stimulating an emotional response in the viewer.

Delaunay's treatment of the interior of Saint-Séverin participates in a general emphasis on planarity evident in cubist works from 1909 onward. A decade earlier, Huysmans had already described the vaulting not dispassionately (as an antiquarian might) but instead as unstable, even threatening. One is even tempted to see parallels between Delaunay's formal treatment of Gothic architecture and Huysmans's praise for the disruption of normative perspectival representation and perception in his criticism of the works of visual artists.[24]

Both Delaunay and Huysmans approached Saint-Séverin as a means of enlisting architecture in the modernist project of questioning the nature of representation. Duchamp-Villon's juxtaposition in the facade of the Maison Cubiste of a traditional architectural vocabulary with modernist sculpture engaged in a comparable process (see fig. 1.1), which has also perplexed critics until recently. In 1960 Reyner Banham

3.3 Robert Delaunay (1885–1941). *Saint-Séverin, no. 3*, 1909–1910. Oil on canvas, 114.1 x 88.6 cm. Solomon R. Guggenheim Museum, New York. Gift, Solomon R. Guggenheim, 1941.

commented that "the one surviving record . . . of the Cubist architecture of Raymond Duchamp-Villon [the Maison Cubiste] suggests that his ideas lay a long way from the progressive trends of the time of its conception, 1912. It is little more than the routine structure of a symmetrical villa in the Mansardic tradition tricked out with fans of prismatic mouldings instead of Rococo (or even Art Nouveau) details."[25] In Barr's chronology, 1912 marked the beginning of synthetic cubism; no wonder that Banham regarded Duchamp-Villon's flirtation with history as retrograde in comparison. Recent scholarship has shown, however, that Duchamp-Villon's use of historical markers in the facade of the Maison Cubiste was not an anomaly in an otherwise modernist composition, but instead was integral to a larger strategy through which the Puteaux cubists sought to position themselves with respect to a continuous national tradition of French painting, decorative arts, and architecture.

Duchamp-Villon was well aware of contemporary discussions of French decorative arts and how they might be rejuvenated by recourse to history. Addressing the problem in 1912, he wrote that "we live in the poorest period of our entire artistic history from this point of view" and lamented the lack of progress in the decorative arts over the previous fifty years. Further, he politicized the question when he speculated: "They talk of opening an exposition of modern decorative art in Paris in 1915. This kind of demonstration is a veritable competition in which the supremacy of taste is at stake; we must be prepared to defend our reputation, unassailable until now."[26]

By 1913 it was clear to Duchamp-Villon that the French decorative arts could find a way out of the "disarray" of competing styles only by following the lead of painting, particularly the work of Cézanne.[27] He regarded the geometrized treatment of form that had been pioneered by Cézanne and further developed

by the cubists as the basis for the revival of decorative arts and architecture. His discussion of the relationship, between modernist painting and the other arts was part of an explanation of his own architectural sculpture in which Duchamp-Villon made clear that he saw his work as an extension of cubist painting, although he never explicitly described his sculpture as "cubist."[28]

Duchamp-Villon's attempt to translate the strategies of cubist painting into three dimensions—especially his effort to emphasize planarity in architecture—was bound to border on the ridiculous. In order to problematize the position of the viewer while continuing to do something "very French" and traditional, he was forced to exaggerate the scale of the cubistic ornament. The cornices above the windows and doors of the Maison Cubiste appeared to be composed of overlapping planes and were perceived by viewers as unstable, potentially dangerous.[29] Although there is no reason to believe that Duchamp-Villon was thinking of Delaunay's paintings or Huysmans's descriptions of Saint-Séverin while he was designing the decorative motifs of the Maison Cubiste, his work does create an architectural equivalent of the shifting, unstable planes that Huysmans evoked in his writing and that ten years later became a salient characteristic of cubist painting.

That Duchamp-Villon's cornices may have been inspired by late Gothic vaults is suggested by a subsequent design for architectural sculpture, his 1914 project for the sculptural program for the new campus of Connecticut College in New London (fig. 3.4). The Gothic context of his project might be seen as an indication of his growing commitment to French cultural traditions in light of the approaching war. However, as I have argued elsewhere,[30] the selection of the Gothic style for Connecticut College was the choice of the architectural firm that was responsible for the plans and elevations of the buildings. From the outset, Duchamp-Villon's contribution was limited

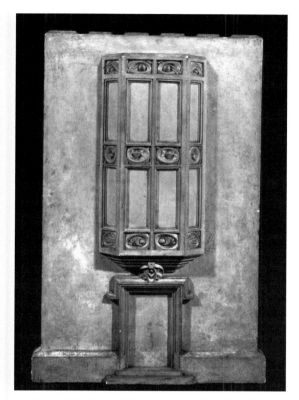

3.4 Raymond Duchamp-Villon (1876–1918). Project for Campus of Connecticut College, New London, plaster model, 1914. 55.9 x 34 cm. Philadelphia Museum of Art: Purchased.

to designs for sculpture, where it was incumbent on him to address the relationship between the style of the decorative motifs and that of the architectural structures beneath.

The architects of Connecticut College consistently favored what they called the "collegiate Gothic," an idiom in widespread use in buildings for American educational institutions in the early twentieth century. The principal characteristics of the style, in this instance, were its basis in masonry construction and a simple handling of the stone that allowed for carvings over

windows and doors but relied primarily on the contrast between walls and openings to establish interest on the facades. Apparently, the roots of the collegiate Gothic style were to be found in the secular medieval architecture of England rather than in French cathedrals and churches. When Duchamp-Villon submitted a model of one of the dormitories in May 1914, he sent with it illustrations of English manor houses—such as those at Bradfield, Cullompton, and Sutton Place—that were characterized by geometric ornamentation.

On an early sketch for the project, Duchamp-Villon noted the necessity of illustrating the relationship of his designs to "the Gothic spirit." In March 1914 he wrote that, "as concerns the relationship between my sculpture and the Gothic style, I think that without changing anything about it, it can be adapted to the spirit of that period."[31] Indeed, Duchamp-Villon had articulated the correspondence between the Gothic and modernism in an essay on the Eiffel Tower that was published in 1914 as "L'architecture et le fer."[32] In this essay he campaigned against what he perceived as a widespread disdain for metal architecture. The polemic he established between exhausted classicism, exemplified by Jacques-Ange Gabriel's Ecole Militaire from 1751–1772, and the possibilities of metal architecture, of which Contamin and Dutert's Galerie des Machines and the Eiffel Tower (both 1889) serve as examples, was a familiar one by 1913.[33] It had also become common by this date to associate medieval masons with modern engineers on the grounds that both had escaped a stultifying academic architectural training, and instead operated solely according to the principle of structural rationalism. Duchamp-Villon asks, "Is there not a surprising similarity between the conceptions of engineers working in steel and those of medieval masons?" Further on he elaborates: "Do we not find in both the same boundless ambition always to achieve the greater, the taller, the more

daring? Across from Gothic Notre-Dame, the true
tower of modern Paris rises on the Champ de Mars.
Both works, the tower and the nave, are born of the
same desire to build and both fulfill a similar dream
of superhuman exaltation."[34]

Duchamp-Villon's primary images—the tower and
the nave—correspond exactly to the motifs through
which Delaunay approached the relationship between
the medieval and the modern. But even more recently,
the connection between Gothic and modern architec-
ture had been addressed by Apollinaire in a lecture
entitled "Le sublime moderne" presented in Rouen on
the occasion of the third exhibition of the Société
Normande de Peinture Moderne, an organization to
which many of the Maison Cubiste collaborators
belonged. The ideas expressed in Apollinaire's lecture
of 23 June 1912 are thought to have corresponded
closely to his essay of 6 June, "The Renaissance in the
Decorative Arts." Here he claims that a "modern style"
did exist but was to be found "not so much in the
façades of houses or in furnishings as in iron construc-
tions—machines, automobiles, bicycles, and airplanes."
The "renaissance" to which Apollinaire's title refers is
in the "art of interior decoration . . . based on an imita-
tion of Louis-Philippe furnishings"; but it is in fact
metal constructions—like the Eiffel Tower—that he
claims will terminate the succession of historic revivals
and culminate in a truly modern architecture.[35]

Apollinaire expressed this admiration for the
Eiffel Tower at the very moment when it was derided
by many, and Duchamp-Villon's essay was written in
explicit opposition to those who would disparage the
tower. Fortunately, Eiffel had left other monuments
that could be used to secure his place in the develop-
ment of modern architecture. To this end Duchamp-
Villon underscores the two great functions of metal in
nineteenth-century engineering: tower-building and
spanning. He champions Eiffel not only as the designer

of the tower for the 1889 exposition but also as the
"genius" who "launched [the Garabit Viaduct] between
two mountains, spanning in one stroke a space where
the Arc de Triomphe could be placed on the towers of
Notre-Dame." Duchamp-Villon continues:

> To adapt a technique to the nature and
> proportions of the surrounding countryside
> is to solve architectural problems. Eiffel,
> perhaps without suspecting so, at that
> moment as well as later, obeyed exigencies
> of formal order controlled and supported
> by the logic of materials. This is the best
> situation for the preparation and completion
> of a masterpiece—this ignorance of classified
> artistic ideas and laws, which allows the
> artist the joy of creating according to a
> preconceived ideal.[36]

The belief that the sources of modern architecture
were to be found in metal engineering structures
rather than in conventional masonry architecture had
been expressed earlier, between 1863 and 1872, by
Eugène-Emmanuel Viollet-le-Duc in his *Entretiens sur
l'architecture*. In the first volume Viollet described the
period since the French Revolution as a transitional
one which in the realm of architecture had produced
only "pastiches or hybrid works, without character,
impossible to classify." The death of architecture, he
told his readers, was due to indiscriminate aping of the
details of buildings from the past and a corresponding
loss of any kind of underlying principle.[37] In the second
volume he proposed a solution to the sterility of
modern architecture: a new architecture based on the
principles of the Gothic but incorporating new materi-
als, especially iron. However, Viollet cautioned, "If iron
is destined to take a place in our constructions, let us
study its properties, and use them frankly, with that

rigorous judgement that masters of all periods have introduced into their works."[38]

The *Entretiens* not only identified iron as the material that would be central to the future development of architecture, but also positioned the engineer of the nineteenth century—in opposition to the architect—as heir to the structurally rationalist medieval mason. However, Viollet-le-Duc asserted that in fifty years the professions of architect and engineer would be one, thus ending a professional distinction that was firmly entrenched in French architectural culture. In only one instance, Viollet suggested, had an architect and engineer cooperated in a building project that pointed toward future aesthetic developments: Victor Baltard and F.-E. Callet at Les Halles Centrales in Paris (1853–1858). In this structure Viollet-le-Duc saw a direct correspondence between form and function, and between the building and the historical moment that had produced it.[39]

Viollet-le-Duc succeeded in establishing the idea that modern architecture and modernity should be fundamentally connected. He also effectively secured a place for Les Halles in the sequence of buildings in which nineteenth-century technological innovations, new economic relations, and functional requirements were supposedly expressed without recourse to classical formulae. Subsequent architectural commentators, even when they disputed the prominence Viollet accorded to the Gothic, invariably began their list of modernist monuments with Les Halles, as the writings of Auguste Choisy and Duchamp-Villon illustrate.

Choisy's writings were undoubtedly known to Duchamp-Villon through his friend Auguste Perret, who became aware of the classical rationalist tradition through Choisy. In his influential *Histoire de l'architecture*, first published in 1899, Choisy "powerfully advanced the claims of the Classical Rationalists against the monopolistic pretensions of the French Gothic Rationalist school" exemplified by Viollet-le-Duc.[40] Notwithstanding this opposition to Viollet, Choisy concluded his account with a brief discussion of architecture since the Revolution in which he claimed that a "new society" had developed a new architecture through the example of contemporary engineering. According to Choisy, the nineteenth century had been forced to rely on the past in architectural design while waiting for "an original idea." One had eventually emerged in the form of iron constructions. Les Halles Centrales, according to Choisy, proved that this new technology had taken its place among the elements of architecture. To this example Choisy added Henri Labrouste's reading room at the Bibliothèque Nationale (completed 1869), which was notable for its combination of iron skeleton and enameled domes.[41]

Duchamp-Villon's version of the development of architectural modernism, contained in "The Eiffel Tower," synthesizes the thinking of Viollet-le-Duc, Apollinaire, Choisy, and Perret. As we have seen, for Duchamp-Villon, as for Viollet-le-Duc, the basis of modern architecture was to be found in the Gothic principles that were later absorbed by Eiffel and other engineers. Like Choisy, Duchamp-Villon also credited Labrouste with having arrived at an "elegance and simplicity, impossible to achieve in other materials" with his designs for the reading rooms in both the Bibliothèque Nationale and the Bibliothèque Sainte-Geneviève (1843–1850). Not surprisingly, Duchamp-Villon singled out "Baltard who knew how to give to the Halles, solely through the logical development of their use and needs, the appearance of a mysterious organism always on the alert, containing during the night the activity of the city in order to return it sharpened anew for the morrow." Here again is an idea indebted to Viollet-le-Duc: that Les Halles as a structure is a perfect response to its function and its place in the city. But lest we forget that his conduit to

Viollet was Perret, Duchamp-Villon concludes his account with the emergence of reinforced concrete. With his reference to "the few examples of liberated architecture which Paris owes to it," Duchamp-Villon undoubtedly alludes to Perret's use of concrete in his block of flats at 25 bis, rue Franklin (1902–1903), his Garage Ponthieu (1905–1906), and most obviously, his Théâtre des Champs-Elysées (1913).[42]

The Eiffel Tower was the structure in which the connection between the Gothic and the modern was most often apprehended. Even critics of the tower used the metaphor of the soaring medieval church or cathedral to suggest the dominant presence of Eiffel's work in the Parisian cityscape: "la flèche de Notre-Dame de la Brocante" ("the spire of Our Lady of the Scrap Heap") is the derisive description with which Huysmans expressed his disdain for the Eiffel Tower.[43] To others, the tower represented the continuity of structural rationalism from the medieval period through the nineteenth century. But for Delaunay, the network of metal elements that made up the Eiffel Tower also produced visual experiences that were sympathetic with cubist art. For instance, in *Champ de Mars, the Red Tower* (1911 [reworked before 1923], fig. 3.5) Eiffel's masterpiece topples amidst a cityscape in which traditional masonry buildings are likewise fractured into unstable planes. Delaunay's Eiffel Tower is not the product of Viollet-le-Duc's nineteenth-century engineer carrying on the rationalist tradition of the medieval mason: both the structure and its viewer are destabilized by Delaunay's formal means.

French interest in the Gothic has often been said to consist mainly in a concern with structure, a point of view most often identified with Viollet-le-Duc.[44] However, the fascination that the church of Saint-Séverin held for Huysmans and Delaunay suggests that there were others in France who did not consider the late Gothic as an aberration of the structural rationalism

that had informed the style since its inception, but who instead responded positively to the spatial experiences it offered. Duchamp-Villon also perceived that the Gothic could inspire a translation of cubist planes into three-dimensional sculpture, although he perpetuated the notion of a rationalist trajectory that connected the medieval mason and the modern engineer.

Among the claims consistently made for cubism is that it challenged existing means of representing objects in space. The means by which synthetic cubism accomplished this are well established. Less fully integrated into our understanding of cubism is the way in which Gothic architecture provided a model not only of how the depiction of space could be rethought, but also of how the very experience of architectural space could be transformed. Robert Delaunay's depiction of Saint-Séverin was instrumental in the dissemination of this new spatial concept, possibly even inspiring the sets for Robert Wiene's expressionist film *Das Kabinett des Dr. Caligari* (1919). The cubistic prismatic forms of the medieval village in which the story unfolds, Anthony Vidler has argued, are not mere background but participate "in the very emotions of the film . . . *Caligari*, then, has produced an entirely new space, one that is both all-embracing and all-absorbing in depth and movement."[45]

One contemporary reviewer of German expressionist film explained how in *Caligari* and the subsequent works inspired by it, "The simple dynamics of normal architecture, expressed by verticals and horizontals, have been transformed into a chaos of broken forms, while movement has been made autonomous."[46] This statement could well be used to describe the common

3.5 Robert Delaunay (1885–1941). *Champ de Mars, the Red Tower*, begun in 1911, reworked before 1923. Oil on canvas, 162.6 x 130.8 cm. The Art Institute of Chicago, Joseph Winterbotham Collection, 1959.

objective of all the works examined here: a fundamental destabilizing of architecture and its audience. In the works of Delaunay, Huysmans, and Duchamp-Villon the building is no longer the inert object of a static and disembodied gaze; techniques of representation are employed by these artists to animate buildings and simultaneously to promote a kind of viewing that imagines a mobile subject entirely absorbed—as a body—in the process.

Just as canonical cubist painting overturned techniques of representation that had been in place since the Renaissance, so the works under discussion here called into question rationalist interpretations of the Gothic that had a long history in France. Moreover, in them a second way of representing objects as planes emerged concurrently with analytical and synthetic cubism. This "other" cubism overtly related the articulation of a new concept of architectural space to the example of the late Gothic style. In the romantic period medieval architecture was widely believed to produce sublime sensations in its viewers. In the cubism discussed here the Gothic tradition erupts into expressions of what Apollinaire believed should be the ultimate motivation of architects and engineers: "sublime intentions." For Apollinaire, Duchamp-Villon's work embodied this desire to "build the highest tower, prepare for ivy and time a ruin more beautiful than all others, to throw across a port or across a river an arch more audacious than a rainbow, to finally compose a lasting harmony, one more powerful than man has imagined."[47] Cubism and architecture, then, converged in a reworking of the Gothic tradition and culminated in a modern sublime.

3.

NOTES

1. Daniel Robbins discussing the methodology of Alfred H. Barr, Jr., in, "Abbreviated Historiography of Cubism," *Art Journal* 47 (Winter 1988), 277–283.

2. Albert Gleizes and Jean Metzinger, *Du "cubisme"* (1912), trans. T. Fisher Unwin, revised by Robert Herbert, in Fritz Metzinger, ed., *Du "cubisme", On "Cubism", Über den "Kubismus"* (Frankfurt: R. G. Fischer, 1993), 84–85; John Golding, *Cubism*, 3d ed. (Cambridge: Belknap Press of Harvard University Press, 1988), 10.

3. Golding writes that "Cubism was perhaps the most important and certainly the most complete and radical artistic revolution since the Renaissance," although he concedes that it owed "much to the art of the preceding fifty years" (*Cubism*, xiii). Douglas Cooper, *The Cubist Epoch* (London: Phaidon, 1970), designates the work of Picasso and Braque "true Cubism" and treats other cubists under the rubric of "The Cubist Movement in Paris." On Picasso's and Braque's relationship to tradition see Theodore Reff, "The Reaction against Fauvism: The Case of Braque," in Lynn Zelevansky, ed., *Picasso and Braque: A Symposium* (New York: Museum of Modern Art, 1992), 17–39, as well as the discussion that follows, especially 45ff.

4. Robbins, "Abbreviated Historiography," 282–283. Rosalind Krauss discusses what in her view constitute the limitations of studies of cubism that interpret the works in relation to the historical and material circumstances of their production in "The Motivation of the Sign," in Zelevansky, ed., *Picasso and Braque*, 273–275, and in the following discussion, 287–289. For the associations between cubist artists other than Picasso and Braque see Golding, *Cubism*, 27ff.

5. "To portray every physical aspect of such a subject, he said, required three figures, much as the representation of a house requires a plan, an elevation and a section." Gelett Burgess, "The Wild Men of Paris," *The Architectural Record* 27 (May 1910), 405.

6. Alfred H. Barr, Jr., *Cubism and Abstract Art*, exh. cat. (New York: Museum of Modern Art, 1936), 42.

7. Barr, *Cubism and Abstract Art*; quoted in Robbins, "Abbreviated Historiography," 280.

8. Sigfried Giedion, *Space, Time and Architecture: The Growth of a New Tradition* (Cambridge: Harvard University Press, 1941), 355–358. For a recent treatment of the cubist challenge to perspective see Martin Jay, *Downcast Eyes: The Denigration of Vision in Twentieth-Century French Thought* (Berkeley and Los Angeles: University of California Press, 1993), 159–162, 204–207.

9. Colin Rowe and Robert Slutzky, "Transparency: Literal and Phenomenal," written 1955–1956, first published 1963, reprinted in Colin Rowe, *The Mathematics of the Ideal Villa and Other Essays* (Cambridge: MIT Press, 1976), 159–183.

10. Rowe and Slutzky, "Transparency," 164. Although they date *Simultaneous Windows* to 1911, it is more commonly dated 1912.

11. Barr, *Cubism and Abstract Art*, 42, 46. On the Saint-Séverin series, see Guy Habasque, "Catalogue de l'oeuvre de Robert Delaunay," in Robert Delaunay, *Du cubisme à l'art abstrait*, ed. Pierre Francastel (Paris: SEVPEN, 1957), 252–258.

12. Mark Antliff, "Cubism, Celtism, and the Body Politic," *Art Bulletin* 74 (December 1992), 655–668.

13. Nancy J. Troy, *Modernism and the Decorative Arts in France: Art Nouveau to Le Corbusier* (New Haven: Yale University Press, 1991), ch. 2, esp. 79ff.

14. Albert Gleizes, "Le cubisme et la tradition," pts. 1–2, *Montjoie!*, 10 February 1913, 4; 25 February 1913, 2–3; quoted in Troy, *Modernism*, 92.

15. The "passage à la destruction des moyens picturaux anciens." Robert Delaunay, "Le petit cahier de Robert Delaunay," 1933, 1; published in Delaunay, *Du cubisme à l'art abstrait*, 72. Translations from the French are mine unless otherwise noted.

16. Joseph Harriss, *The Tallest Tower: Eiffel and the Belle Epoque* (Boston: Houghton Mifflin, 1975), 173; Jean des Cars and Jean-Paul Caracalla, *La Tour Eiffel* (Paris: Denoël, 1989), 88–89; François Landon, *La Tour Eiffel* (Paris: Ramsay, 1981), 74–76. Henri Loyrette writes that by 1900 "the Eiffel Tower was henceforth an anachronism; it was dated," in *Gustave Eiffel*, trans. Rachel and Susan Gomme (New York: Rizzoli, 1985), 167. I am also grateful to Kathleen Wilson for sharing her unpublished work on Delaunay and the Eiffel Tower with me.

17. "Exposition universelle 1889, La Tour à l'univers s'adresse." This inscription is noted in Delaunay, *Du cubisme à l'art abstrait*, 21.

18. Six drawings of the interior of Saint-Séverin have also been located. On the entire series, see Angelica Zander Rudenstine, *The Guggenheim Museum Collection, Paintings 1880–1945*, vol. 1 (New York: Solomon R. Guggenheim Museum, 1976), 80–84.

19. Sherry A. Buckberrough, *Robert Delaunay: The Discovery of Simultaneity* (Ann Arbor: UMI Research Press, 1982), 40. For a discussion of the Saint-Séverin series, see 40–45.

20. See Jean Verrier, *Saint-Séverin* (Paris: Editions du Cerf, 1948), and Roland Sanfaçon, *L'architecture flamboyante en France* (Québec: Presses de l'Université Laval, 1971), 90–95. On the controversial restoration of Saint-Séverin during the nineteenth and twentieth centuries, see the Archives de la Direction du Patrimoine, Paris, dossier 2166.

21. Joris-Karl Huysmans, *La Bièvre et Saint-Séverin* (1898; Paris: Plon, 1952), 196.

22. Michel Hoog, *Robert Delaunay, 1885–1941*, exh. cat. (Paris: Editions des Musées Nationaux, 1976), 45.

23. Sanfaçon, *L'architecture flamboyante*, 93.

24. As Richard Kendall has pointed out, Huysmans's commentary on a series of nudes exhibited in 1886 by Degas stressed both the "exactitude" and the "strangeness" ("la sensation de l'étrange exact") of the artist's vision. Huysmans endorsed Degas's abandonment of what Kendall calls "the logic of the camera or of the normal eye" and the painter's constitution of vision as "a selective, artificial system." Richard Kendall, "Degas and the Contingency of Vision," *Burlington Magazine* 130 (March 1988), 190–191. For Huysmans's criticism of Degas, also see Carol

Armstrong, *Odd Man Out: Readings of the Work and Reputation of Edgar Degas* (Chicago: University of Chicago Press, 1991), 157–210.

25. Reyner Banham, *Theory and Design in the First Machine Age* (London: The Architectural Press, 1960), 203.

26. "Nous vivons dans l'époque la plus pauvre de toute notre histoire artistique à ce point de vue." "On parle d'ouvrir à Paris en 1915 une exposition d'art décoratif moderne. Une manifestation de ce genre est un véritable concours où la suprématie du goût est en jeu; il faut que nous soyons en mesure de défendre notre réputation, jusqu'alors inattaquable." Quoted by Marie-Noëlle Pradel, "La Maison Cubiste en 1912," *Art de France* 1 (1961), 179. For an account of the political implications of early twentieth-century French decorative arts debates, see David Cottington's essay in this volume.

27. He described Cézanne as "le meilleur ouvrier de cette Renaissance française." Duchamp-Villon to Walter Pach, [1913]; Walter Pach Papers, Archives of American Art (hereafter AAA), roll 4217, frames 114–117.

28. To my knowledge, Duchamp-Villon used the terms "cubist" and "cubism" in writing on only one occasion, in April 1913, in correspondence with Walter Pach concerning the sale in the United States of "des toiles cubistes" in which he asked "va-t-on déjà faire un commerce de ce pauvre cubisme . . . comme de pommes de terre?" Duchamp-Villon to Pach, 18 April 1913; AAA, roll 4217, frames 132–133.

29. See Troy, *Modernism*, 80.

30. Kevin D. Murphy, "Cubism and the Collegiate Gothic," *Archives of American Art Journal* 32, no. 1 (1992), 16–21.

31. One of the notes on an undated (c. 1914) sketch for the Connecticut College project (Musée National d'Art Moderne, Centre Georges Pompidou, Paris) states that among the requirements of the submission was the demonstration of a "rapport avec l'esprit gothique." Also see Raymond Duchamp-Villon to Walter Pach, 17 March 1914, quoted in Pach, *Raymond Duchamp-Villon, sculpteur (1876–1918)* (Paris: Jacques Provolozsky, 1924), 20. Here, Duchamp-Villon writes, "En ce qui concerne le rapport de ma sculpture avec le style gothique, je crois que sans y rien changer, elle s'adaptera avec l'esprit de cette époque."

32. Raymond Duchamp-Villon, "L'architecture et le fer," *Poème et Drame* 7 (January-March 1914), 22–29.

33. Raymond Duchamp-Villon, "The Eiffel Tower," in William C. Agee and George H. Hamilton, *Raymond Duchamp-Villon 1876–1918* (New York: Walker & Co., 1967), 115.

34. Ibid., 115–116.

35. Guillaume Apollinaire, *Apollinaire on Art: Essays and Reviews, 1902–1918*, ed. Leroy C. Breunig, trans. Susan Suleiman (New York: Viking, 1972), 241. On the Société Normande, see Troy, *Modernism*, 97.

36. Duchamp-Villon, "The Eiffel Tower," 116–117.

37. "Des pastiches ou des œuvres hybrides, sans caractère, impossibles à classer." E.-E. Viollet-le-Duc, *Entretiens sur l'architecture*, vol. 1 (1863; rpt. Ridgewood, N.J.: Gregg Press, 1965), 450–452.

38. "Si le fer est destiné à prendre une place dans nos constructions, étudions ses propriétés, et utilisons-les franchement, avec cette rigueur de jugement que les maîtres de tous les temps ont mis dans leurs œuvres." Ibid., vol. 2 (1872; rpt. Ridgewood, N.J.: Gregg Press, 1965), 67.

39. Ibid, 74–75.

40. Peter Collins, *Concrete: The Vision of a New Architecture* (New York: Horizon Press, 1959), 197. The friendship between Duchamp-Villon and Perret is evidenced in part by the fact that both were involved in the organization Les Artistes de Passy in 1912; Golding, *Cubism*, 12–13 n.2.

41. Auguste Choisy, *Histoire de l'architecture*, vol. 2 (1899; Geneva and Paris: Slatkine, 1982), 762–764. On Choisy see Robin Middleton, "Auguste Choisy, Historian: 1841–1909," *International Architect* 5, no. 1 (1981), 37–42.

42. Duchamp-Villon, "The Eiffel Tower," 116. Following the appearance of this essay, Duchamp-Villon saw constructed only one other project for architectural sculpture, his temporary Théâtre aux Armées (1916), which is known only through photographs. One view is published in Judith Zilczer, "Raymond Duchamp-Villon: Pioneer of Modern Sculpture," *Philadelphia Museum of Art Bulletin* 76, no. 330 (Fall 1980), 5.

43. J.-K. Huysmans, "Le fer," in *Certains* (1889; rpt. Westmead, Hants.: Gregg International, 1970), 179.

44. This point of view is epitomized by Sir Nikolaus Pevsner, *Ruskin and Viollet-le-Duc: Englishness and Frenchness in the Appreciation of Gothic Architecture* (London: Thames & Hudson, 1969).

45. Anthony Vidler, "The Explosion of Space: Architecture and the Filmic Imaginary," *Assemblage* 21 (1993), 47–48. Delaunay's *Saint-Séverin, no. 1* was included in a Blaue Reiter exhibition at the Galerie Thannhäuser, Munich, in December 1911–January 1912; Habasque, "Catalogue," 252. In a 1913 article in *Der Sturm*, the architect Bruno Taut invoked the work of Delaunay (as well as that of Léger, Kandinsky, and others) as a model for architecture: "The architect must also recognize that architecture embraces from the outset the preconditions which the new painting has created: freedom from perspective and from the narrowness of a single viewpoint." Quoted in Iain Boyd White, *Bruno Taut and the Architecture of Activism* (Cambridge: Cambridge University Press, 1982), 29.

46. Rudolf Kurtz, *Expressionismus und Film* (1926), quoted in John D. Barlow, *German Expressionist Film* (Boston: Twayne Publishers, 1982), 39.

47. "L'architecte, l'ingénieur doivent construire avec des intentions sublimes: élever la plus haute tour, préparer au lierre et au temps une ruine plus belle que les autres, jeter sur un port ou sur un fleuve une arche plus audacieuse que l'arc-en-ciel, composer en définitive une harmonie persistante, la plus puissante que l'homme ait imaginé." Guillaume Apollinaire, *Les peintres cubistes*, ed. L. C. Breunig and J.-Cl. Chevalier (1913; Paris: Hermann, 1965), 95.

4.

ROBERT L. HERBERT

"ARCHITECTURE" IN LÉGER'S ESSAYS, 1913–1933

4.1 Fernand Léger (1881–1955). *Animated Landscape,* 1921. Oil on canvas, 65 x 50 cm. Private collection.

Fernand Léger (1881–1955) used the words "architecture," "architectural," and "architect" as praise words throughout his life, more frequently than any other European painter of his generation except El Lissitzky (who was initially trained in architecture). Léger worked as an architectural draftsman for several years before turning to painting, so it is no surprise that his essays of 1913 and 1914 are already full of references to architecture, although most of his prewar contemporaries saw music as the sister art of preference. After World War I his constant attention to architecture found more echoes among his peers, for then, as we have learned from Kenneth Silver,[1] architecture was associated with postwar reconstruction, and there were painters throughout Europe who wished to be "constructors."[2] Images of buildings and cities, rich in both formal and allegorical meanings, rise up prominently in many of Léger's paintings of the early 1920s. These include two variants of a composition celebrating urban architecture, *Architecture* and *La gare,* and a whole series of "Paysages animés" where men with cattle or dogs stand in front of what we could call "billboard architecture" (fig. 4.1).[3]

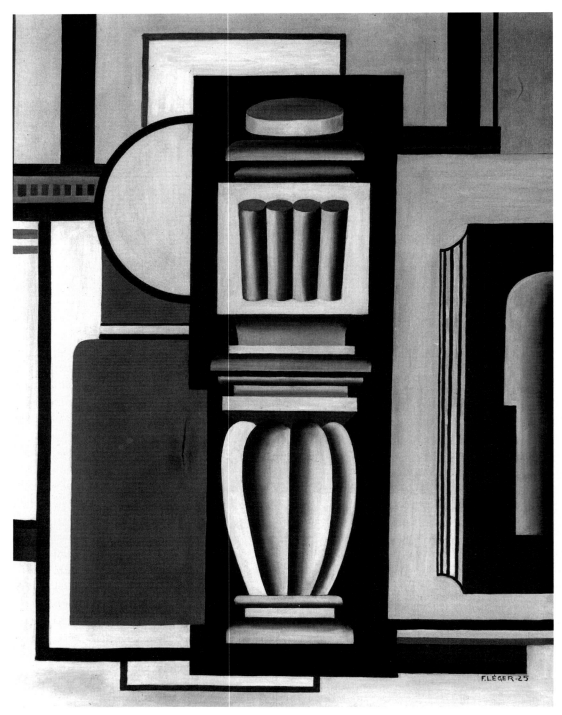

4.2 Fernand Léger (1881–1955). *The Baluster*, 1925. Oil on canvas, 129.5 x 97.2 cm. The Museum of Modern Art, New York. Mrs. Simon Guggenheim Fund.

The best-known tokens of Léger's proximity to architecture are the paintings he lent in 1925 to Le Corbusier and to Rob Mallet-Stevens for their model rooms in the Art Déco exposition (figs. 4.2 and 4.3). For another artist these might have been mere gestures of camaraderie, but for Léger they had deeper meaning. He believed that architects needed painters to enliven their walls, and this belief was central to his abundant writings. Not only did he refer often to architecture, but he published an essay on polychromed architecture in 1924 and addressed architects of the CIAM (Congrès International d'Architecture Moderne) in 1933.[4] And Léger himself built architecture of a certain kind: the sets for stage presentations and films that he began in 1922 and continued to design for the rest of his life. The ideas he shared with Le Corbusier, with whom he had a lifelong friendship, are particularly extensive, and would alone reward the efforts of a modern Plutarch in search of meaningful "parallel lives."[5] In this essay, however, I want to limit myself largely to Léger's conception of architecture as he refined and extended it in his writings from 1913 to 1933. The word is in quotation marks in my title because it is not really buildings that Léger means when he uses the word, but a complex of ideas about painting, suitable to a painter's outlook.[6]

In its simplest expression, "architecture" for Léger meant a supply of surfaces for a painter to decorate. When mentioning architecture, he wrote almost solely of surfaces and linear patterning. Le Corbusier naturally talked of building in terms of plans, which take primacy, and three-dimensional volumes. Léger never mentioned plans, however, and conceived of volumes and masses not as constituents of buildings but as the painter's mobile pictorial elements.[7] "I group contrary values together; flat surfaces opposed to modeled surfaces; volumetric figures opposed to the flat façades of houses; molded volumes of plumes of smoke opposed to active surfaces of architecture." (FL, 29, 1923). He frequently referred to the Gothic without regard for its three-dimensional play of pierced walls, vaults, and buttresses, but—repeatedly using the phrase "Gothic façades"—as a phenomenon of surface rhythms.

If "architecture" in the real world ideally meant surfaces for his activity as painter, in the world of his paintings it was treated as the equivalent of "drawing" in the age-old opposition of drawing and color. He believed that like drawing, architecture is a manifestation of form that can exist without color (although in an impoverished state). Form, in turn, is based upon geometry for this cubist painter once trained as an architectural draftsman, so another reason for linking pictorial structure with architecture is his belief that geometry underlay both. Furthermore, since machinery, like architecture, is constructed in three dimensions and is based on geometric form, it, too, is pulled into Léger's web of associations. Drawing embodies the action of constructing buildings, machinery, and paintings, and for this activity geometry is the least common denominator. It stands for measurement, and measurement is nothing other than the imposition of order, an enterprise traditionally considered masculine, as distinct from color, treated as feminine. We can see this triple linking of architecture with geometry and with the machine in this often-cited passage in which architecture is actually reduced to "line":

> I would, then, bring about a new architectural order: *the architecture of the mechanical.* Architecture, both traditional and modern, also originates from geometric forces.
>
> Greek art made horizontal lines dominant. It influenced the entire French seventeenth century. Romanesque art emphasized vertical lines. The Gothic achieved an often perfect balance between the play of curves and straight lines. The Gothic even achieved this amazing thing: moving architectural surfaces. There are Gothic façades that shift like a dynamic picture. It is

the play of complementary lines, which inter-
act, set in opposition by contrast.

One can assert this: a machine or a
machine-made object can be beautiful when the
relationship of lines describing its volumes is
balanced in an order equivalent to that of earli-
er architectures. (FL, 53, 1924)

As his leading example of balanced lines in a
machine, Léger then mentions the evolution of the auto-
mobile. Although he had referred to autos before the
war, his comparison with "earlier architectures" echoes
Le Corbusier's analogy between the evolution of the
motorcar and that of Greek architecture.[8] Léger's
thoughts, however, were not focused on architecture at
all but on the pictorial values of machinery. He contin-
ues: "Every machine object possesses two qualities of
materials: one, often painted and light-absorbent, that
remains static (an architectural value), and another
(most often bare metal) that reflects light and fills the
role of unlimited fantasy (pictorial value). So it is light
that determines the degree of variety in the machine
object" (FL, 54, 1924). Static form, even if colored, is
"architectural," but reflected light is transient, mobile,
and evocative, therefore pictorial (and feminine!).

In welcoming the advent of painted machinery,
Léger thoroughly conflated architecture and the
machine: "polychromed mechanical architecture"
["architecture mécanique polychrome"] (FL, 54,
1924). It is a conception that parallels Le Corbusier's
famous dictum "The house is a machine for living in,"
but it is, once again, a painter's way of thinking.
Le Corbusier, although he likens buildings to machines,
did not elevate pieces of machinery to the status of
architecture. Léger did so because for him "architec-
ture" is essentially geometric form; the geometry of
modern machinery therefore qualifies.

Léger's conflation of architecture, geometry,
industrial forms, and modernity appears in his frequent
references to that quintessential modern surface, the
billboard. Even before World War I he praised the
billboard because it "brutally cuts across a landscape"
and destroys "the whole sentimental literary concept"
that was cherished by do-gooders who wish to protect
the landscape (FL, 12, 1914). In aggressive masculine
terms—his "principle of contrast" opposes elements
that he glosses as male and female—he sees the bill-
board as the embodiment of the dynamism of industrial
society. It is a manufactured object, whose essence is
geometry, that must dominate nature which is not
only feminine but outmoded by modernity. "The con-
temporary environment is clearly the manufactured
and 'mechanical' object; this is slowly subjugating
the breasts and curves of woman, fruit, the soft land-
scape—inspiration of painters since art began."[9]
Although his paintings evoke billboards only after the
war, already in 1914 he envisioned them and urban
poster-walls as ideal surfaces for artists. They could
enliven "those interminable walls of governmental and
other buildings [which] are the saddest and most sinis-
ter surfaces I know of. The poster is a piece of modern
furniture that painters immediately know how to use"
(FL, 13, 1914).

Léger's "billboard" paintings of the early 1920s
were not to Le Corbusier's liking, and they show his
distance from the purists. Le Corbusier and Ozenfant
thoroughly subordinated color to architecture because
intense hues ("disturbing elements")[10] acquired an
autonomy of their own and destroyed the "wall." The
architect, as "Monsieur X" in a pseudonymous 1923
interview with Léger, brought out their disagreement.
He did not want independently colored compositions on
his walls, and only accepted whole colored walls as
integral building units (moreover, he favored whitewash).
In the same issue of L'Esprit Nouveau, Le Corbusier
and Ozenfant argued against the "screaming of frescoes
in apartments or in public places where dignity should
reign," and stated that the only place for a poster is

4.3 Robert Mallet-Stevens (1886–1945). Hall of the model of an ideal French embassy, with painting by Léger at left, 1925. 25 x 32.5 cm. Archives d'Architecture Moderne, Brussels.

the street.[11]

Léger's frequent references to billboards confess his ambition to paint on a public scale. He was always conscious of the distinction between easel paintings and the murals to which he aspired.[12] He separated the two as "art object" and "ornamental art." An easel painting is a mobile object separate from architecture, an autonomous entity like a sculpture or other object, literally an "art object."[13] With naïve frankness he said

that "to me, 'the opposite of a wall' is a picture, with its verve and movement. For example, in a flat, I'm satisfied if my picture controls the room, if it dominates everything and everyone, people and furniture."[14] Incorporating volumes and referential imagery, an easel painting is a self-contained world in which the whole of modern life could find place. For wall paintings, by contrast, the architecture provides the volumes, and the people who use the spaces provide the moving

objects. Architecture, wall painting, and people together form a whole experience. "I have collaborated in doing some architectural designs, and have then contented myself with being decorative, *since the volumes were provided by the architecture and the people moving around*. I sacrificed volume to surface, the painter to the architect, by being merely the illuminator of dead surfaces" (FL, 63, 1925). Wall paintings could therefore be flat and static, and such statements as this make it clear that Léger's most abstract paintings of the middle 1920s, like the one he lent Mallet-Stevens (fig. 4.3), were conceived as mural pictures, lacking the autonomy of easel paintings. They are, in other words, rather special pictures and do not negate the view that in twentieth-century terms Léger was a realist.

Léger perpetuated, in modern terms, the "mural aesthetic" that was most famously embodied in the second half of the nineteenth century in the paintings of Puvis de Chavannes and the writings of Charles Blanc.[15] His use of the word "traditional" confesses his awareness of this continuity when he defines "ornamental art" as "dependent on architecture, its value rigorously relative (almost traditional), accommodating itself to the necessities of place, respecting live surfaces and acting only to destroy dead surfaces" (FL, 64, 1925). "Live surfaces" are those whose colors, textures, or positions require nothing else for a satisfying experience; "dead" ones are those that call out for a painter. Even before the First World War, that is, before the more radical architecture of the 1920s, Léger saw that modern architecture was redefining its surfaces by stripping them of representational elements. Gothic architecture, he wrote, was rich in ornamental and representational surfaces, which were no longer needed once Gutenberg's movable type provided another medium for cultural texts (FL, 9, 1913: he cites Hugo). Now, in the modern era, color photography, cinema, and popular art forms have "rendered superfluous the development of visual, sentimental, representational, and

popular subject matter in pictorial art" (FL, 9, 1913). Architecture, so stripped, confines itself "to its own means—the relationship between lines and the balance of large masses; the decorative element itself is becoming plastic and architectural. *Each art is isolating itself and limiting itself to its own domain*" (FL, 10, 1913).[16]

Although he acknowledged the autonomy of each art, in reality architecture's "dead surfaces" made desirable a collaboration of architect and painter (Léger only occasionally mentions sculptors, and never stucco workers or decorators). After he abandoned the dynamic cubism of 1917–1919 in favor of the more stately rhythms of the "return to order," he referred to himself as the "colorist-doctor" who would bring calm and beauty to the "badly orchestrated" intensity of modern cities and factories. Not only did the street need color, but so did contemporary buildings, inside and out.

Léger hoped that the stripped surfaces of advanced architecture would provide painters with their opportunities, but he sensed competition with the architects who wanted too exclusive a role. Le Corbusier, as we have seen, disliked the "disturbing element" of strong color. In 1924, writing of the vanguard's efforts, Léger said, "The struggle is sharpest between the manufactured object or the art object (a picture, a relief) and the desire of modern architects to absorb them by their reduction to no more than a means of action in an organized ensemble."[17] Painters, he felt, should have a role, for two reasons. One was his preference for artistic collaboration, which suited an era alert to the shortcomings of individualism. The other was his belief that painters were specialists in color and the best equipped to contribute to "polychromed architecture." In a statement published in 1930, he placed contemporary architecture, the beacon of "true plastic Rationalism," at the center of modernity (which he conceived as "northern," in distinction to the "Oriental, Mediterranean and Latin civilizations"), but said that its destruction of the past was now complete, and therefore that a "new

equilibrium" was necessary, implying that painters should become involved.[18]

In 1933 Léger went further, warning architects that in their zeal to overcome the past they had gone too far. Their clean surfaces spoke for an isolated elite, not for society. "Le mot 'urbanisme' veut désormais dominer la question esthétique. Urbanisme, c'est social. Vous entrez dans un domaine tout autre, un domaine où vos formules pures et radicales vont avoir à lutter."[19] Something must replace the surfaces that have been stripped away, surfaces that once bore textures and forms that communicated with ordinary mortals. "Et vos pierres, vos ciments, vos métaux sont matière morte, si elles réfusent de partager avec la couleur." Architects should mingle with ordinary people, "marcher dans la même boue et la même poussière." If they do, they will discover that color is "la matière première aussi nécessaire à l'homme que l'eau et le feu. Un beau rouge, un beau bleu, c'est aussi nécessaire à la vie qu'un beafsteck." Architects must therefore invite the participation of painters, for "c'est à nous tous que doit revenir l'honneur de dresser face au ciel le Monument Moderne attendu. C'est le but de l'effort collectif."

Léger's concern for the collective, his anti-individualism, was a consistent feature of his thought. In his first published essay, he repeatedly used the term "collective," which characterized "the greatest epochs of the past" (FL, 8, 1913). In that essay and later, he associated collective effort with the Gothic era, an idea traceable to the nineteenth century, particularly to John Ruskin, an idea that had been sustained by the international arts and crafts movement. For such French artists as J. F. Millet, Camille Pissarro, and Claude Monet, the Gothic was associated with "nature" and with a specifically national tradition. It was opposed to the Italian Renaissance (can we imagine Monet painting a classical facade?), which they believed responsible for introducing an individualism

that undermined the more social, collaborative, popular, and "primitive" art of the Middle Ages. Thanks to the recent work of Mark Antliff,[20] we can see that in 1913 Léger lined up with the artistic left, whose Celtic nationalism was opposed to the Italianate classicism of rightists like Charles Maurras.

In the 1920s, dislike of the Renaissance continued to be a constant theme of Léger's writings, despite his adherence to the "return to order" which is commonly associated with a classicizing tendency. Classicism itself was the reigning style of the hated Ecole des Beaux-Arts, symbol of outmoded authority, and reason enough for Léger to prefer its apparent opposite, the Gothic.

> The Italian Renaissance (the *Mona Lisa*, the sixteenth century) is considered by the whole world as an apogee, a summit, an ideal to strive for. The Ecole des Beaux-Arts bases its reason for existence on the slavish imitation of that period. *This is the most colossal error possible.* The sixteenth century is a period of nearly total decadence in all the plastic areas.
>
> It is the error of *imitation*, of the servile copy of the subject, as opposed to the so-called primitive epoch that is great and immortal precisely because it invented its forms and methods. (FL, 57, 1924)

Invention, imagination, and collaboration among artists were found in "primitive" epochs like the Gothic and, in modern times, in areas located in the north rather than the south. The idea of a progressive "northern" spirit, with its embarrassing overtones of ethnic prejudice, pervades Léger's writings, beginning in 1913: "northern artists will still tend to seek their dynamic means through the development of color while southern painters will probably give great importance to forms and lines" (FL, 7, 1913). The north was not only more

imaginative and pictorial than the static south but was also more inventive, and hence it originated the industrial revolution which was bringing about profound and welcome changes. The machine, for example, is an object of higher consequence than the "beautiful subject" of the Renaissance. Although "the Oriental, Mediterranean and Latin civilizations" had created great works,

> the taste for simplicity, for precision, for clarity is absolutely western property, true plastic Rationalism does not come from the Mediterranean or from the Orient, *it comes from the North.* The North, younger, more rapid, less subtle, knows how to see with clarity the real problem of construction required by modern life. . . . If architecture is willing (and it is) it will not permit in the interior any objects, but those which have the same spirit. . . . The decorative muddle which began with the Italian Renaissance is the decadent fact which has been prolonged in bourgeois art up until now. The new Northern architectural order is in radical reaction against this state of affairs.[21]

Obviously Léger regarded his paintings as objects "which have the same spirit" as modern architecture. For that reason, his highest aspiration was toward mural paintings, for these took their place in an architectural ensemble, eminently social both because they were based upon collaboration and because they were offered to the public. By contrast, easel pictures bespoke the individual, both the artist who made them, isolated from the rest of society, and the private collector who purchased them. As we know, Léger was obliged to continue painting easel pictures, and only slowly in subsequent years did he win a few commissions for art of public scale. In 1933, in the depths of the Depression, his yearning for public surfaces to paint had a distinct poignancy. He needed to sell paintings to make a living, and he thought of architecture, in a self-serving fashion, as a set of surfaces that he could activate. Nonetheless Léger was not one to regard individual initiative and collective good as incompatible, and there is much that is noble in those lectures addressed to architects in 1933.

> In the past, pictorial art was closely bound up with architecture—mosaics, frescoes. The painter-artist submitted to architectural limitations. This was the *great* order in antiquity, which I hope to see revived. Of course the creative position is no longer the same as it was then. The extreme freedom in *easel painting* has permitted some mistakes, but also wonderful inventiveness.
>
> Architectural necessities restrict us to a given dimension. Individualism must suffer. You must work in collaboration. The simplified and rational architecture that is going to conquer the world must serve as a possibility for reviving this collective art that created immortal masterpieces before the Renaissance. . . . I ask the distinguished architects here to be kind enough to remember that I am their friend, that I deeply admire their architectural and social work, and that, among modern painters, I am perhaps the one who has the closest *contact* with the new builders. But I do not forget that I am a painter and I must tell them several small truths or what I think are such. If they are "moved" to respond, I cannot ask anything more. (FL, 94–95, 1933)

4.

NOTES

In the present essay and accompanying notes, references to Léger's writings are indicated by FL, followed by a page number and the year of the essay; this refers to the English-language anthology *Functions of Painting by Fernand Léger*, ed. Edward F. Fry, trans. Alexandra Anderson (New York: Viking, 1973). A concordance of the essay titles and page numbers in this anthology follows:

3–10 "The Origins of Painting and Its Representational Value" [Les origines de la peinture et sa valeur représentative], *Montjoie!* I, nos. 8, 9–10 (1913).

11–19 "Contemporary Achievements in Painting" [Réalisations picturales actuelles], *Soirées de Paris* 3 (June 1914).

20–23 "A Critical Essay on the Plastic Quality of Abel Gance's Film *The Wheel*" [Essai critique sur la valeur du film d'Abel Gance, *La Roue*], *Comoedia*, 16 December 1922.

24–27 "Notes on Contemporary Plastic Life" [Kurzgeffasste Auseinandersetzung über das aktuelle künstlerische Sein], *Das Kunstblatt* 7 (1923).

28–30 "Notes on the Mechanical Element" (unpublished, 1923).

35–47 "The Spectacle: Light, Color, Moving Image, Object-Spectacle" [Le spectacle], *Bulletin de l'Effort Moderne* 7, 8, 9 (1924).

48–51 "*Ballet mécanique*" (previously unpublished, date unknown).

52–61 "The Machine Aesthetic: The Manufactured Object, the Artisan, and the Artist" [L'esthétique de la machine: l'objet fabriqué, l'artisan et l'artiste], *Bulletin de l'Effort Moderne* 1, 2 (1924), first published in *Der Querschnitt* 3 (1923).

62–66 "The Machine Aesthetic: Geometric Order and Truth" [Conférence sur l'esthétique de la machine, au Collège de France], in Florent Fels, *Propos d'artistes* (Paris, 1925).

72–73 "The Ballet Spectacle, the Object-Spectacle" [Le ballet-spectacle: l'objet-spectacle], *Bulletin de l'Effort Moderne* 12 (1925).

74–77 "Popular Dance Halls" [Les bals populaires], *Bulletin de l'Effort Moderne* 12, 13 (1925).

78–80 "The Street: Objects, Spectacles" [La rue: objets, spectacles], *Cahiers de la République des Lettres, des Sciences et des Arts* 12 (1928).

81–83 "Abstract Art" [De l'art abstrait], *Cahiers d'art* 6, no. 3 (1931).

84–90 "New York" [New York, vu par Fernand Léger], *Cahiers d'art* 6, nos. 9–10 (1931).

90–99 "The Wall, the Architect, the Painter" [Le mur, l'architecte, le peintre], text of lecture, Kunsthaus Zürich, May 1933.

1. Kenneth Silver, *Esprit de Corps: The Art of the Parisian Avant-Garde and the First World War, 1914–1925* (Princeton: Princeton University Press, 1989).

2. For example, in praising Léger, Carl Einstein used the terms "architectonic," "architectural," "engineer," and "collective." Carl Einstein, "Fernand Léger," in *Fernand Léger*, exh. cat. (New York: Société Anonyme, 1925), 5–7.

3. *Architecture*, 65 x 92 cm., formerly Zoubaloff collection, and *La gare*, 81 x 116 cm., formerly Louis Carré. There are more than a dozen pictures of 1921–1922 bearing the generic title of "Paysage animé."

4. The first of these is "Architecture polychrome" in *L'Architecture Vivante*, Autumn/Winter 1924, 21–22, translated by Charlotte Green in John Golding and Christopher Green, *Léger and Purist Paris*, exh. cat. (London: Tate Gallery, 1970), 95–96. The second was published as "Discours aux architectes" in *Annales Techniques* (Athens) 2: 44–46 (15 October–15 November 1933), 1159–1162 (the editors list Léger as a member of CIAM). I owe knowledge of this text to Matthew Affron, "Fernand Léger and the Spectacle of Objects" (Ph.D. diss., Yale University, 1994). According to Simon Willmoth, the longer text, "The Wall, the Architect, the Painter" in FL 90–99, which incorporates portions of the "Discours," was the text of a lecture given at the Kunsthaus Zürich in May 1933. See Simon Willmoth, "Le mur, l'architecte, le peintre; Fernand Léger et ses collaborations artistiques 1925–1955," in *Fernand Léger*, exh. cat. (Villeneuve d'Ascq: Musée d'Art Moderne, 1990), 45–58.

5. A sustained comparison of Léger and Le Corbusier is long overdue, but would require a separate essay. The greater fame of the architect's writings has made most observers give him priority. Only in Ruth Ann Krueger Meyer, "Fernand Léger's Mural Paintings 1922–1955" (Ph.D. diss., University of Minnesota, 1980), are the differences between the two, despite shared concepts, given due credit. The love affair with geometry and the hegemony of "constructivism" that marked the postwar years constituted a huge reservoir of ideas both men dipped into, and we must resist crediting one artist or the other with their origin. Moreover, Léger's essays of 1913 and 1914 already had in germ many of his key ideas, including the significance of modern machinery and the advent of stripped-down architecture.

6. The most detailed discussions of Léger's concern for architecture in the years before 1933 are in Christopher Green, "Painting for the Corbusian Home: Fernand Léger's Architectural Paintings 1924–26," *Studio International* 190 (September-October 1975), 103–107; Christopher Green, *Léger and the Avant-Garde* (New Haven: Yale University Press, 1976); and Meyer, "Fernand Léger's Mural Paintings." Meyer's account is more convincing, partly because she pays more attention to Léger's wall paintings in relation to a more exacting reading of contemporaneous documents. Green stresses Le Corbusier's influence on Léger and diminishes the differences that Meyer astutely outlines. Meyer also supplies new dates, orientations, and interpretations of a number of Léger's paintings of the 1920s, correcting Green in a number of instances. For Léger's architectural paintings after 1933, see Meyer, and Willmoth, "Le mur,

l'architecte, le peintre," although the latter does not add significantly to the materials and ideas that Meyer lays out. By stressing Léger's writings of the 1930s, Willmoth gives the impression that the artist's key ideas developed then, although they were already in place a decade earlier. The much greater accessibility of Green's and Willmoth's publications has meant that Meyer's fine dissertation is not justly appreciated. Because of her substantial reading of Léger's paintings and projects, I feel free to concentrate upon his essays. She uses them wisely, but does not focus upon them, and does not fully analyze the multiple meanings of "architecture" for Léger.

7. In 1923 Léger surprised the filmmaker Marcel l'Herbier by presenting designs for *L'inhumaine* that were entirely flat, without indication of three dimensions: Giovanni Lista, "De l''objet-spectacle' au 'théâtre du peuple,'" in *Fernand Léger,* exh. cat., 59–86.

8. "Des yeux qui ne voient pas [III]: Les automobiles," *L'Esprit Nouveau* 10 (July 1921), 1139–1150. There is little doubt that Le Corbusier's ideas on the machine reinforced Léger's. It is probably he whom the painter meant when, years later (exact date unknown), he wrote about his film of 1924: "*Ballet Mécanique* dates from the period when architects talked about the machine civilization" (FL, 48, wrongly dated "c. 1924").

9. "Correspondence," *Bulletin de l'Effort Moderne* 4 (April 1924), translated by Charlotte Green in Golding and Green, *Léger and Purist Paris,* 85–86. (Dated 1922 in the *Bulletin,* the letter had already been published in *Valori Plastici* in 1919.) An even more flagrant example of masculinist language is found, appropriately enough, in a love letter of 1933 to Simone Herman from Athens, when Léger describes the Acropolis as "l'entourage des belles collines ondulées et femelles comme des silhouettes de cuisses de seins la volupté de cela et au centre, la volonté géométrique de cette architecture": *Fernand Léger, lettres à Simone,* ed. Christian Derouet (Paris: Musée National d'Art Moderne, 1987), no. 46 ("the surroundings of beautiful undulating and female hills like silhouettes of hips, of breasts, the voluptuousness of that and in the center the geometric will of this architecture").

10. "Le purisme," *L'Esprit Nouveau* 4 (1920), 369–386, trans. and ed. Robert L. Herbert in *Modern Artists on Art* (Englewood Cliffs, N.J.: Prentice-Hall, 1964), 70.

11. Meyer, "Fernand Léger's Mural Paintings," 99f. and passim, makes these distinctions between Léger's and the purists' conception of colored walls, and cites the relevant passages of these texts from *L'Esprit Nouveau* 19 (1923). To show how controversial was Léger's posterlike color, she also cites Waldemar George, who said that he "punches holes, cuts it up, fragments and destroys the flat harmony of the wall surface" (from "Le Salon des Indépendants: La sculpture," *L'Amour de l'Art* 3 [February 1923], 463–466).

12. Meyer, "Fernand Léger's Mural Paintings," was the first to deal extensively with Léger's ambitions as a muralist. Willmoth, "Le mur, l'architecte, le peintre," writing about the artist's many mural projects after 1933, says that there was not all that much difference between easel and wall paintings. However, he bases his contention almost solely on the fact that the same *motifs* can be found in both forms, and does not discuss other features that maintain the distinction.

13. See Matthew Affron, "Fernand Léger and the Spectacle of Objects," *Word and Image* 10 (January–March 1994), 1–21.

14. Léger, "Correspondence," trans. in Golding and Green, *Léger and Purist Paris*, 85.

15. Reyner Banham, *Theory and Design in the First Machine Age* (London: Architectural Press, 1960), passim.

16. To be noted here is the continuity of Léger's ideas, for this prewar idea of "stripped" surfaces predicts, as it were, the architecture of the 1920s. We should not credit Le Corbusier or Mallet-Stevens with an "influence" on Léger when it is so obviously a case of shared ideals.

17. Léger, "Architecture polychrome," trans. in Golding and Green, *Léger and Purist Paris*, 95.

18. A statement provided in the spring of 1930 to the short-lived group Cercle et Carré. It is translated in Meyer, "Fernand Léger's Mural Paintings," as Appendix A, but not discussed there.

19. This and the following citations are from the "Discours aux architectes," 1160, 1162. I give the original French (the lecture has not been translated) as samples of Léger's style, whose particular flavor is lost in translation. See Mark Wigley, *White Walls, Designer Dresses: The Fashioning of Modern Architecture* (Cambridge: MIT Press, 1995), which came to my attention too late to be incorporated into the present essay.

20. Mark Antliff, *Inventing Bergson: Cultural Politics and the Parisian Avant-Garde* (Princeton: Princeton University Press, 1993).

21. From Léger's statement for *Cercle et Carré* (15 March 1930), trans. in Meyer, "Fernand Léger's Mural Paintings," 296.

5. JAY BOCHNER

ARCHITECTURE OF THE CUBIST POEM

I happened recently upon a figure, which I should like to put forward as the first cubist house. ⌐┐ It dates from about 1500 B.C. It is probably not a house as seen from the street, but a floor plan of a single room. Still, the proportions already suggest this house is a cube. By showing the inside space it emphasizes the sense of "home," which comes from the idea of a retreat, a protection, instead of showing us what the roof might look like as in a "house," which comes from the idea of covering. And, as to the shape it gives us, clearly it is not a mere square; it has an opening, and a short extension of one wall that signals an open door, assuredly, but also a screen function, to keep the sand from blowing in no doubt, and a place to sit outdoors at one's door, with everything that might imply in terms of observing and welcoming; all of which is to say that additional expectations about climate and community have already intervened in this primitive representation, which could have been no more than a square. This combination of door and screen, this early economy of design, is also a harbinger, for this essay, of the enclosing wall materializing into a plane, a new self-consciousness about walling in or out, and of the dismissal of the corner as an end; more of that later.

As it happens, the doorway is open in more ways than one, as is the whole representation; in particular, for my purposes, the house is open to language. It only reveals itself as a house when we dig out its past. That was not its purpose, around 1500 B.C.; it was in fact the letter *B* in its first recognizable form as a component of an alphabet. And this letter is called *Bêt*, or *house* in Pre-Canaanite, later in Hebrew and Arabic.[1] So the home has itself slid into writing, and I suppose that the job I am proposing in this essay could be summarized as reclaiming the house in the construction of the signifier.

As with this house, the term *cubism* as applied to a certain family of paintings is not a great descriptor, despite the fact that we so often seem to agree on what we mean when we use it. It wasn't very good when it got its start around 1908, with Louis Vauxcelles presumably quoting Matisse; Cendrars saw it crumbling in 1919; and Le Corbusier—still Jeanneret—was already speaking of "après" in 1918 even though he and Ozenfant had not yet become purists.[2] It fails us today as soon as we look too closely at what it is supposed to convey. My interest is to wonder what artists and writers must have thought they were doing, as they began. Painting cubes in two dimensions? But that could be done without challenging perspective. Perhaps cubes in multiple planes; but then should we imagine that Gertrude Stein is writing up words as cubes in planes? That does not seem helpful in explaining how she was doing in language what Picasso was doing in painting. Michel Décaudin, in his "petite" history of literary cubism, suggests Vauxcelles may have had the recently invented bouillon cubes on the brain.[3] There is quite a distance between standing in front of a painting and calling it "cubes" by association and actually meaning, upon reflection, that the artist is projecting in two dimensions all the planes of three in order to suggest the fourth. In any case, even Linda Henderson's

massive demonstration of the importance of theories of the fourth dimension does not pretend that such concerns were operative at the outset.[4] This essay no doubt proposes too much: what can be seen in the cubist painting and transformed into principles for poetry; what can be discerned in the Bauhaus cube that can also be seen as functioning in a poem by Blaise Cendrars or William Carlos Williams (and without concern, in this essay, for matters of influence); finally, what else we see poetry doing with such precepts, in the way of making a contribution to our understanding of cubism as a general movement in the arts. Some good reasons why I probably can't do these things may be found in Wendy Steiner's "A Cubist Historiography."[5]

We effect, then, a proliferation of explanatory analogies, of figurative languages culled from three media, to see what sort of light can be thrown on one of them in particular, poetry, and upon all three by cross-dissemination. Done well enough it will be a sort of triple representation, a cubist portrait of cubism.

ANALYTICAL

As Mark Roskill makes abundantly clear,[6] much of what we think about cubism today, even in some of our most sophisticated discussions, was established within a few years of the first so-called analytical paintings by their first commentators. These commentators, Vauxcelles, Apollinaire, Salmon, Metzinger and Gleizes, to a degree the American Max Weber, and a bit later the dealer Kahnweiler, had timely agendas: to lend intellectual respectability to the new art by associating it with Bergson, Einstein, or other mathematicians and philosophers who were in the news. But if we look at the early evolution of cubism from the point of view of poets writing at the time we can sometimes see past or under these polemical interpretations, which continue

to dictate what we think today. For example, the fracturing into planes, meant to present us with the house, and later the guitar or head, from all its sides, as if we had walked around the subject taking still photos as we circled, that faceting demonstrated for the proselytizers how the artists were projecting the fourth dimension into a medium hitherto only able to deal with varieties of space (but see Henderson for the fourth dimension considered, at the time, as another aspect of space). Now, there is no similar exclusion of time in writing; the linear forever reasserts itself even in its deconstruction. But the lesson of apparent naivete, or childishness, or untutored expression that we may find in any of the poets I will discuss below prompts us to look at painting with fresh eyes. Imagine, then, Renaissance perspective abolished in Braque's 1908 *Les maisons à l'Estaque* not in terms of Ouspensky's "higher" space or Einsteinian physics but more immediately in terms of a rejection of advanced drawing classes, and a return to the isometric perspective of pre-Renaissance and much children's drawing.[7] Is it coincidental that the earliest cubist paintings were of houses, the loci of the architect's need to show more than proper perspective permitted? Perspective hid things. The extreme tilting upward of the perspective merely recovers from the background what we know is there, though Renaissance laws told us the eye couldn't see it, or not well. A new reality recovered the truth of a very old one which was not as interested in foregrounding, or in the presumably airtight logic of the limited eye; no doubt the "naive" Le Douanier deserves some credit here (he is reported to have declared to Picasso at the dinner the latter threw for him that they were the two greatest painters, "You in the Egyptian style, I in the modern"). Another contemporary source for the pre-Renaissance projection, uncredited as far as I can ascertain, would have been Alfred Jarry and Remy de Gourmont's revival and discussions of

medieval imagery in their periodical *L'Ymagier*; Ezra Pound and especially Cendrars were great fans of de Gourmont, and Jarry was practically a god for the avant-garde in France at the time. And of course there was Cézanne, and African sculpture, which prompted one to see the charm of untutored sketches in one's own portfolio.

It is the isometric projection that, as a generating principle, suddenly throws the background up and toward the front, throws front and back objects into a heap of equally valuable planes, each object now to be redrawn in relationships rather than as distinguishing itself in separation. The guitar is now enmeshed in the cubist background, which absorbs it in various pieces; and the background is continuous with the guitar so that *where* the guitar is, though obscure, is as important as *what* it is, which is equally obscure. The viewer is not permitted this guitar alone, as the artist refuses to foreground its singularity. Further, as we move just a year or two into the truly analytical phase of cubism, the phase of Picasso's 1911 *La pointe de la Cité* or Braque's 1910–1911 oval *Guitar*, the viewer can hardly have this guitar at all. But has it disintegrated into the distance, or has context been entirely foregrounded?

You will have perceived that I can present this meshing as quite the opposite, ideologically, of the sorry sense of fragmentation that is attributed to cubism, and to modern art and literature in general, as a translation of the loss of identity endemic to twentieth-century consciousness. Indeed the subject has been fragmented, is no longer rationally coherent, feels itself dissolving, and Renaissance perspective, as it is being denied relevance in 1910, is by that same act confirmed as rational and individualizing, though absent. But do the paintings or the poetry have to be read with that sense of pessimism, of doom, or do those feelings of loss not belong more narrowly to the politicized interpretation of modernism? The medieval gave no depth to

the subject that it could not give equally to its sur-
roundings; this signals equality of nature, community,
and subject. Analytical cubism disseminates nothing
but angles and straight lines, a fragmented rationality
that also prevails throughout environment and subject,
as if all were contaminated with man-made geome-
tries; but with such energy, such unruliness, that it is
not clear that the effects of modernity are all so delete-
rious. The cubist painting can also be seen as conveying
enthusiasm about modernity as it pervades nature,
community, and subject. It is a joyful dismantling in
which geometry is unruly.

In 1938 Stein wrote in her book on Picasso that
the first reason for the making of cubism was that, in
terms of composition, "each thing was as important
as any other thing."[8] Stein obviously understood this
recovery of the background in painting; though her
comment comes much later, she had already practiced
the prescription, with a vengeance, in her first pub-
lished text, "Pablo Picasso." If it were not for the title
one would never know the "subject" at all, which may
have been Stein's discreet or unconscious way of side-
stepping praise for the painter in order to substitute
her own claim to notoriety; Picasso will find all the
foregrounding he will get in pronouns like "someone"
or "he" and "him" and most conspicuously "one," a
dubious singularity. The text *names* no one, names noth-
ing, but *points* at the same few things as relentlessly as
my two-year-old grandson:

> One whom some were certainly following
> was one who was completely charming. One
> whom some were certainly following was
> one who was charming. One whom some
> were following was one who was completely
> charming. One who some were following
> was one who was certainly completely
> charming. . . .

This one was working and something
was coming then, something was coming out
of this one then. This one was one and
always there was something coming out of
this one and always there had been some-
thing coming out of this one. This one had
never been one not having something com-
ing out of this one. This one was one having
something coming out of this one. This one
had been one whom some were following.
This one was one whom some were follow-
ing. This one was being one whom some
were following. This one was one who was
working.[9]

As we observe the slight progress between these
two separate paragraphs we see that Stein is indeed
saying something, that she is able to contrast and subtly
vary ideas about followers and the artist working, but
only in contrast to a great homogenizing of pronominal,
prepositional, and progressive-form verbal back-
grounds. These tools of the writer's trade, as necessary
as they are vague and repetitive, function in like manner
to the half-formed boxes and aborted angles of the full-
blown analytical cubist painting. They also appear to be
the signs of a language of poverty, even of impotence,
the discourse of a failure to find control of naming; or,
again, a language of purposeful avoidance, as in this
distant and certainly accidental cousin sentence found
recently in a news report of a guilty party claiming
complete innocence: "I never did anything in any way
to provoke anybody."[10] But the poverty resides more in
our interpretation than in the artist's practice. The real
work being done in Stein's text is an experiment in
which repetition as sameness (a repeated call or hope
for confirmed solidity) and repetition as variation (the
highlighting of small, vivifying differences) are played
off against each other. Terms are so reduced in this

laboratory, in perspective and in sophistication, that every slight variation is visible—since nothing else is.

On the larger scale of the whole text (only a bit over two pages, but I wonder if anyone can sustain discernment to the end), there is a reasonably definite progression; I cite the last lines of each of the last five paragraphs (these five constitute about one-half of the complete text):

> This one was one who was working.
> This one was one who was working.
> . . . but was needing to be working so as to be one working.
> This one certainly was not completely working.
> He was not ever completely working.[11]

The barely foregrounded constants are the adverbs "completely" and "certainly"; in the opening paragraph cited earlier we see these adverbs jockeying and eventually catching up with each other at the end. But over all in the narrative, that is to say in this narrative which we agree has disappeared, Picasso goes from one who really works and whom all follow to one who is never far from playing. And Stein, too, is having fun working, ingeniously combining and recombining her few basic blocks while she courts her own followers.

Though Stein has always appeared unique and unassimilable to any mainstream, her experiments could easily have arisen from a scrutiny of the very sophisticated writing of a Henry James, the younger brother of her favorite professor at Harvard. By the time James reaches his later style, his convoluted sentences seem to be fascinated by the same discovery of difference in repetition that prompted Stein to write "before the flowers of friendship faded friendship faded": "It was the truth, vivid and monstrous, that all the while he had waited the wait was itself his portion. . . . He had justified his fear and achieved his fate; he had failed, with

the last exactitude, of all he was to fail of."[12]

James's foregrounding of verbal sounds is occasional, and always supports narrative meanings under strange pressures. Still, a sort of verbal baroque is assaulting representation. In "Pablo Picasso" Stein has drastically distilled James's rhetoric, to retain mainly the ubiquitous cement of syntax, without his fear, fate, or fail. But shortly, in *Tender Buttons* of 1914, she reverses the procedure, to retain the nominative blocks alone while ruining the usefulness of connectives since the blocks no longer lock together:

> A CUTLET.
> A blind agitation is manly and uttermost.
>
> COLD CLIMATE.
> A season in yellow sold extra strings makes lying places.
>
> PEELED PENCIL, CHOKE.
> Rub her coke.
>
> DINING.
> Dining is West.[13]

Nouns, verbs, adjectives are solid, full of presence as words, but they are not positioned to signify; they go nowhere unless it be back to themselves. Mina Loy wrote in her "Gertrude Stein":

> Curie
> of the laboratory
> of vocabulary
> she crushed
> the tonnage
> of consciousness
> congealed to phrases
> to extract
> a radium of the word[14]

This process, and effect, might be likened to the scattering of violin parts, wedges of fruit, or parts of the face in the cubist paintings of the analytical phase, except that such a convenient analogy obscures this one essential: no item as represented by a word is fragmented in Stein. Quite the contrary, all objects, as represented by whole words, remain whole. Granted, it feels like the syntax of the statements has given way, as one might argue the old syntax of perspective has collapsed in Braque or Picasso, but not out of any great failure of its own in Stein; on the contrary, the syntax is largely intact, it just doesn't function because the words, while clear, are wrong for each other; they have become recalcitrant to association and now claim a degree of independence. As you leave a word in *Tender Buttons,* trusting to the sequence of reading, it refuses to accompany you into the rest of the sentence. Some new meaning about words is to emerge from this stalling of meaning in which every word stays in its place while no sentence gets us anywhere. Or, if no new meaning, then the word materialized into an object in itself. This is a major violation, possibly more disturbing than such a loss of representation in painting, so encompassing is language as a system we never live outside of. In art you can become more painterly, but in writing to be more wordy would mean quite the reverse of what Stein does. Still, she is either making words only themselves, wordy things, or she is confirming the signified as living without signification.

It is not clear how such powerfully concrete indecision should be termed cubist. Perhaps the most obvious tack is to call it fragmentation. Yet Stein seems to have performed opposite operations within fragmentation. While "Pablo Picasso" is all transparency, stalling in *Tender Buttons* affirms the opacity of words as much as it denies their relations. The term fragmentation has enabled critics to relate fracturing of faceting in painting to dislocations of sense in poetry; to sustain the comparison, the painter's fragmentation of space is seen to be emulated in poetry by a fragmentation of time.[15] But fragmentation has been too easily generalized and made to include more territory than is useful for illuminating differences. Rather than seeing each artistic medium destroying its own natural abilities to represent, or glorifying its complete incompletion, we might conceive of each attempting to extend its techniques into the facilities of the others as a claim upon a wider context. One can watch poetry in 1912 looking for space, or spaces, just about the time pictures began to appropriate writing. Such incorporation of other modes is the reverse of fragmentation as disintegration.

Poetry quite literally incorporated space into its lines by manipulating type and type setting, things poets had become more conscious of since Mallarmé's *Un coup de dés,* but also because they had come to be more involved with the actual printing of their work.[16] An early example in English is Mina Loy's "Virgins Plus Curtains Minus Dots," first published in 1915:

> See the men pass
> Their hats are not ours
> We take a walk
> They are going somewhere
> And they may look everywhere
>
> Men's eyes look into things
> Our eyes look out
>
> Some behind curtains
> Throb to the night
> Bait to the stars
>
> With the door locked
> Against virgins who
> Might scratch[17]

This is fragmentation of a sort: a space or blank, a separation. It is also a stalling, a breath, and as such is returned to time—it is unlikely that continuity can ever be wholly denied in print. The delay gives us time to wonder about a different direction: virgins who might—what? They have been oppressed and duly passive up until the end. But they might—pause, the musical silence—surprise the men, even with violence (a less liberating interpretation is possible though, that they can do no worse than this typically female scratching). Meanwhile, a second break with time has been effected, probably the more radical or "cubist" one. We are encouraged to change the direction of our reading by the proximity of a piece of the next line; that is, we can read "We" and "They" as a grouping, for stronger contrast of what the predicates tell us each sex can do. The same goes for "Men's eyes" and "Our eyes." The reason this is a more radical writing is that it must be seen, not only heard. The page of visible type rewrites the poet's voice, and so-called fragmentation can be a way of engaging the reader's senses in new combinations.

Stein did not play with visual space at all, which seems surprising considering how far she went. She left the visual to the painters. The spaces she toyed with were metaphorical, and she found them in the reader's habits of linguistic behavior. Perhaps the reader expected "Dining is best," not completely lucid yet closer to models *Tender Buttons* had already set in motion. But no model in the book really gains much permanence, unless it be a model of openness to rhyming that must double as punning, though a punning on words not necessarily spelled out. All spaces were in the reader's mind.

On the other hand, Apollinaire went quite entirely into space, writing *calligrammes* in which the words of the poem move on the page into the shape of what they are describing. The problem with this, and a possible

reason for Stein's resistance to such procedures, is that the shape on the page is entirely illustrative and does not really add anything to the language, except to make it more difficult to read, even though that is not at all the point. Apollinaire's verses are rarely more poignant, or powerful, or expressive *because* of their disposition in picture form. I should not say there is no charm at all to any of the *calligrammes*, but in general his "drawing" fails to engage language because it is not *more* than a copy of it, or not enough more. Apollinaire went yet further in a 1917 poem, "Pablo Picasso" (fig. 5.1).[18] The whites on the page are not pauses with sense for the reading, and we can say the poem is truly fragmented because there is no reason for the breaches *as far as the language is concerned*. The words as a field draw a picture, in silhouette, as an interruption in a text that is otherwise not enhanced. If anything, the words are meant to merely have shape. At least in the *calligrammes* proper, words espoused forms they represented.

Certainly the most spectacular and successful yet still accessible use of space and typography is Cendrars's *Prose du Transsibérien et de la petite Jehanne de France* of 1913, a poem that was almost immediately stripped of all its visible cubism by its first commercial publication.[19] In its first appearance it cohabited with an almost entirely abstract *pochoir* painting by Sonia Delaunay, to be absorbed simultaneously with the poem; in Apollinaire's *Les Soirées de Paris* it was billed as "le premier poème simultané," and thus was the term launched. Poem and painting run side by side, each about 18 centimeters wide, and together stretched out, as the accordion-folded sheet was opened, to 2 meters in length. When it was first read publicly it hung on a wall and the reader began on a stool, to end on her knees.

Cendrars himself assisted in the printing. Many type faces and sizes were used, the largest fonts to periodically emphasize a recurring motif. The text was set in different colors, lines might be one word long or

PABLO PICASSO

Voyez ce peintre il prend les choses avec leur ombre aussi et d'un coup d'œil sublimatoire
Il se déchire en accords profonds et agréables à respirer tel l'orgue que j'aime entendre
Des Arlequines jouent dans le rose et bleus d'un beau-ciel Ce souvenir revit
les rêves et les actives mains Orient plein de glaciers L'hiver est rigoureux
Lustres or toile irisée or loi des striés de feu fond en murmurant.
Bleu flamme légère argent des ondes bleues après le grand cri
Tout en restant elles touchent cette sirène violon
Faons lourdes ailes l'incandesce quelques brasses encore
Bourdons femmes striées éclat de plongeon-diamant
Arlequins semblables à Dieu en variété Aussi distingués qu'un lac
Fleurs brillant comme deux perles monstres qui palpitent
Lys cerclés d'or, je n'étais pas seul! fais onduler les remords
 Nouveau monde très matinal montant de l'énorme mer
 L'aventure de ce vieux cheval en Amérique
 Au soir de la pêche merveilleuse l'œil du masque
 Air de petits violons au fond des anges rangés
Dans le couchant puis au bout de l'an des dieux
Regarde la tête géante et immense la main verte
L'argent sera vite remplacé par tout notre or
Morte pendue à l'hameçon... c'est la danse bleue
L'humide voix des acrobates des maisons
Grimace parmi les assauts du vent qui s'assoupit
Ouis les vagues et le fracas d'une femme bleue
Enfin la grotte à l'atmosphère dorée par la vertu
Ce saphir veiné il faut rire!
Rois de phosphore
La danse des sous les arbres les bottines entre des plumes bleues
Le cadre bleu dix mouches lui fait face quand il songe à toi
 tandis que l'air agile s'ouvrait aussi
 Au milieu des regrets dans une vaste grotte.
 Prends les araignées roses à la nage
 Regrets d'invisibles pièges
Paisible se souleva mais sur le clavier l'air
Guitare - tempête musiques
O gai trémolo ô gai trémolo
Il ne rit pas ô gai trémolo
Ton pauvre l'artiste-peintre
L'ombre agile étincellement pâle
Immense désir d'un soir d'été qui meurt
Je vis nos yeux et l'aube émerge des eaux si lumineuses
J'entendis sa voix diamants enfermer le reflet du ciel vert et
 qui dorait les forêts tandis que vous pleuriez
L'acrobate à cheval le poète à moustaches un oiseau mort et tant d'enfants sans larmes
Choses cassées des livres déchirés des couches de poussière et des aurores déferlant!
 GUILLAUME APOLLINAIRE

5.1 Guillaume Apollinaire (1888–1918). "Pablo Picasso," 1917. Page from SIC (Paris, May 1917).

Et nous nous aimerons bien bourgeoisement près du pôle
Oh viens!

<div align="center">

Jeanne JEANNETTE *Ninette nini ninon nichon*
Mimi mamour ma poupoule mon Pérou
Dodo dondon
Carotte ma crotte
Chouchou p'tit-cœur
Cocotte
Chérie p'tite-chèvre
Mon p'tit-péché mignon
Concon
Coucou
Elle dort.

</div>

Elle dort
Et de toutes les heures du monde elle n'en a pas gobé une seule
Tous les visages entrevus dans les gares
Toutes les horloges
L'heure de Paris l'heure de Berlin l'heure de Saint-Pétersbourg et l'heure de toutes les gares

5.2 Blaise Cendrars (1887–1961). *Prose du Transsibérien et de la petite Jehanne de France*, detail, 1913. From *Fine Art Print* 13, no. 3 (July 1987).

more than the width of the page could contain, the left margin could move to the center or a section could adhere only to the right. One passage centers lines that recite a slang-laden lullaby in the shape of advertising copy on old posters. As the lullaby winds down, the text narrows to a calm; but then the same "Elle dort" starts up in a different mood at the left margin (fig. 5.2).[20]

The text of *Le Transsibérien* looks more cubist, in a literal sense, on its own. Sonia's *pochoir* makes the whole production less angular. The same year Apollinaire had difficulty incorporating the work of Sonia's husband, Robert, into his introduction of cubism to the public, and he had come up with the term "cubisme orphique."[21] In their own minds Robert, Sonia, and Cendrars were working on "le simultané" ("mot invariable," declared Robert). It came late, and was hardly as convenient to pronounce, but simultanism would have served better than cubism to describe cubism.[22] Indeed *Le Transsibérien* calls upon us to see everything at once, to discover, as Robert Delaunay and Cendrars

frequently described it, lyrical depth through contrast. The train narrative, as text alone, is fragmented, since the ride is discontinuous and spliced with flashbacks, stories, reflections, the Jehanne story, and the sudden flash forward to Paris at the end. The whole production, with its elaborate typography and companion painting, is further dislocated, or enriched. This art of profusion, which gaily combines various perspectives as one sort of cure for the narcissism of the single, symbolist view, engenders new pressures on the lines of demarcation, on all those whites between and around the words, lines, and groupings, on the places that separate background from object and one medium from another, picture from word. The joints of this poem, the places of interplay, are the locus of its *simultané* cubism, an art of juxtaposition.

In English poetry the great proponent of discontinuity as juxtaposition, as opposed to discontinuity as fragmentation, was Ezra Pound. Eliot was more prone to take the other tack. Near the end of *The Waste Land*

he summed up his activity as a poet thus: "These frag-
ments I have shored against my ruins." This line can
serve as the keystone for the modernist view of a soci-
ety surviving as no more than the leftover shards of
an earlier, integrated culture. Pound, on the other hand,
while sharing a similar cultural perspective, wanted
the luminous moment to emerge out of this all-but-
invisible space in the juxtaposition of two seemingly
unrelated images or perceptions. Thus his famous 1916
illustration of the haiku form:

> The apparition of these faces in the crowd;
> Petals on a wet, black bough.[23]

The *simultané*, or juxtaposition, works with fragments
but is the contrary of fragmentation. The machine
age, which fosters speeding from one thing to the next,
eliminates the voyage, or the narrative, and brings a
conversation in Paris flush up against one in Berlin or
St. Petersburg without the connective. The diachronic,
single-minded narrative is stalled, to open the page to
a single moment in many narratives, the juxtaposition
creating their synchronicity, the poem's special
luminosity; as in this mix of voices in Cendrars's 1914
Panama:

> Ce petit train que les Soleurois appellent
> un fer à repasser
> Je téléphonerai à mon consul
> Délivrez-moi immédiatement un billet
> de 3e classe
> The Uranium Steamship Co
> J'en veux pour mon argent[24]

The corollary of juxtaposition is, then, ellipsis. There is
no extended conversation, just as there is no completely
visible violin in the cubist painting, but synecdoche, a
well-chosen indication that is enough to tell us what we
are missing but also encourages other connections in
the simultaneous planes, for example that the scroll on
the head of the violin is much like the design on the
arm of a chair. In this application synecdoche points in
two directions: back to the invisible body to which it
should be attached, and on to other bodies the artist
visualizes for it. The poem, also, leaves off completed
descriptions, and in their stead makes new combina-
tions, new alliances: "Du rouge au vert tout le jaune se
meurt," opened Apollinaire in "Les fenêtres," starting
from a painting by Robert Delaunay, and Cendrars
wrote in 1919, as Léger drew his portrait:

> La peinture devient cette chose énorme
> qui bouge
> La roue
> La vie
> La machine
> L'âme humaine
> Une culasse de 75
> Mon portrait[25]

Here the ellipses are jump cuts that track the meta-
morphosis of forms in the act of painting. As poet
portrays artist portraying poet we are treated to the
unusual spectacle of cubist juxtapositions materializ-
ing in both a poem and a drawing at the same time.
The last line is a bemused return to the comforts of art
on home ground, but with brand-new baggage.

With an increasing loss of context the poem's
ellipses and juxtapositions can come perilously close
to making it nonsense; the reader cannot fill the
voids behind the pieces, as in a 1914 poem by Cendrars
called "Titres":

Formes sueurs chevelures
Le bond d'être
Dépouillé
.
L'esprit nouveau
Les accidents des féeries
400 fenêtres ouvertes
L'hélice des gemmes des foires des menstrues[26]

But while we experience great trouble putting all these pieces together, the title and the last two lines make it clear we are reading headlines; anarchy here is imitative of the front page's assault on our consciousness, so many separate stories and types of discourse in a single, wide spread, such mutual irrelevance or providential relation. At the same time we recognize a collage in the Cendrars poem, and a collage of print at that (actually, as the first line is a quote from Rimbaud, not all this print is news). While there is no dearth of collage in Cendrars, as well as other forms of appropriation (he probably wrote the first "found" poem), the effect is much different from what can be obtained visually, and this is ironic if we consider that much collage in cubist painting was made with print. Appropriated print disappears in print, while the newspaper in Braque is both shocking next to paint and has suddenly imported narrative into otherwise mute and timeless projections.

In other words, when a poet wrote collage it was not to acquire another medium for his production, although by representing texts clearly foreign to his own voice he was putting some Other's language into his own. Painting, on the other hand, more clearly appropriated the Other's body with the Other's different medium. This was especially striking in the painter's use of such things as imitation wood; the artist no longer imitated, by his own hand, wood grain, nor glued real wood onto his canvas, but cut in a real fake. It was

a paradoxical operation for artists accused of not representing the real, as seen. But games with wallpaper, which of course was real wallpaper, did not extend outside of the visual, whereas play with print reflected both on its visual appearance, as typeface, and on its verbally communicated meaning. This is true of the incorporation of longer articles, though when they were used upside down they tended to turn into wordless fields, into just the idea of print; it is true of headlines, and that might bear some interesting comparisons with Cendrars's "Titres"; and it is most true of the smallest snippets of print, which could send out meaning in all directions, and beginning with the ubiquitous *Journal*, which was *Jour, Jou[e]* (play or cheek), *Urn[e]*, *Ur[i]n[er]*. . . . Such shorter words were painted into paintings before collage was used, but with actual collage language is not represented but appropriated, a big difference. The newspaper's juxtaposed stories, lurid or exciting, sententious or plainly absurd, all proclaim their authenticity in their own voices, as if "as if" no longer applied to art.

Since collage was harder to delineate within a single poem, text against text, Cendrars scissored and glued bigger pieces. "Mee Too Buggi" is made of statements lifted from an account of Captain Cook's travels by the ship's doctor. In that poem Cendrars retained only what the natives had to say, so as to deliver, and create, a story missed by its own Eurocentric narrator. In "Dernière heure" he only slightly modified a newspaper story (at the end he writes "copié dans *Paris-Midi*").[27] Here Cendrars frees an American Western one-reeler from its French journalistic rewrite. What the poet shares with the cubist painter is the sharpened presence of Otherness, a distancing from the authorial hand that paints or writes, while, along with this greater anonymity, the hand can intervene, recolor, reshape, reproject. In both media cubism as collage grows into an art of radically juxtaposed news; new

5.3 Blaise Cendrars (1887–1961), author; Sonia Delaunay (1885–1979), designer. Project for a poster advertising Zénith watches, 1914. Collage, 66 x 81.5 cm. Musée National d'Art Moderne, Centre Georges Pompidou, Paris. Donation de Mme Sonia Delaunay et M. Charles Delaunay, 1964.

meanings arise from the borders between unlikely bedfellows in the daily life of modernity, or the daily life of modern fictions. Further, it is curious to see analytical cubism shade into synthetic, dispersal shade into construction, just as language enters the picture, as if to coopt print could reduce or call to order everything that had been disseminated among other conflicting perspectives.

SYNTHETIC

Cendrars produced two spectacular examples of word and picture in even closer simultaneity than the contrasts of *Le Transsibérien*, pages on which word and picture are one medium. One is a project for an advertisement for watches manufactured by the Zénith company, a short poem in which words are treated identically to colored swatches by Sonia Delaunay, and her swatches treated like letters (fig. 5.3). The narrative is

visualized and, in a way, the colors narratized. The text reads: "Record. Midi bat sur son enclume lumière. Zénith" ("Record. Noon strikes its anvil of light. Zenith"). The other example is his and Léger's cover for *La fin du monde filmée par l'Ange Notre-Dame* of 1919; the design was actually Cendrars's (fig. 5.4). Here the letters, brutally drawn as industrial stencils, are entirely in charge of organizing the page visually, with two huge letters, *N* and *E*, as visual and orthographic keystones for most of the scattered words (*N* is shared by five words, *E* by six). Title, author, publishing house, and address are all drawn into a visually constructed poem, the cubist effect enhanced by the radical intrusion of film-making into the apocalypse: LA FIN / DU MONDE / FILMÉE / PAR L'ANGE NOTRE-DAME / ROMAN DE / BLAISE CENDRARS / AUX EDITIONS / DE LA / SIRENE / RUE LA / BOETIE / 12 BIS / PARIS / MCMXIX. This picture-poem-film of the end of the world is billed as a novel, too; as if visual media and writer's genres are themselves on the way to the apocalypse, or at very least all together recast to modernist specifications.

5.4 Blaise Cendrars (1887–1961), author; Fernand Léger (1881–1955), designer. Cover of *La fin du monde filmée par l'Ange Notre-Dame* (Paris: Editions de la Sirène, 1919). Bibliothèque Nationale de France, Paris.

It would not be new, nor specific to cubist poetry, to imagine writers composing as if they were building, but to turn the poetic voice over to visualization on the page was a new and radical move. E. E. Cummings wrote: "The day of the spoken lyric is past. The poem which has at last taken its place does not sing itself; it builds itself, three dimensionally, gradually, subtly, in the consciousness of the experiencer."[28] Furthermore, as the poets visualized language, they operated from impulses that they shared with other artists including architects who, under the joined influences of artistic cubism and modern industrial techniques and materials, were also putting radical questions to their own traditions.

For simplicity what I will call cubist architecture is the use of the basic cube as model for the visual design of the house. While cubist artists were complicating their representations with forms that, while basic, hardly seemed natural, the architect was reducing to an immediately comprehensible essential. The shock was not obscurity but disclosure. It was essentially on the outside that the architects reasserted this basic cube, which is to say the assault took place on the public grounds of appearance. And what was particularly radical or offensive about this appearance was its plainness, not so much that it was largely a cube but that it seemed *nothing but* a cube. The prime element of this effect of "nothing but" was the elimination of the slanted and visible roof, which was flattened not only because the builder *could* flatten it but because he chose to. The house no longer rises or soars, it has no meeting point or crest, nor does it cap or contain living, or wear a hat proudly. There is a loss of bourgeois dignity, of station or transcendence, and one may unceremoniously walk or lounge on this roof. Such a reduction appears to stifle the personality of a house, to erase the figuration of mind and body; one may, after all, psychoanalyze a house, inside and out.[29] Poetry, too, produced

examples of this utter simplicity in which part of the cubist shock was that there didn't seem to be enough material for the experiencer to experience; and another shock, or insult, would be to tell him to look harder, as in William Carlos Williams's "The Red Wheelbarrow" of 1923:

> so much depends
> upon
>
> a red wheel
> barrow
>
> glazed with rain
> water
>
> beside the white
> chickens[30]

Certainly not all, not even most cubist poetry can look so simple, nor could multiple projections or points of view, manipulated syntax, juxtaposition, and simultaneities easily resolve into such clear-minded minimalism. But crucial to generating a new and modern complexity was a reexamination of the basic building blocks, and first of all the word. Williams's early minimal poems transferred all the power back to the clean use and unadorned expressivity of common words. Pound's famous dictum "Make it new" encompassed, among the "few don'ts of an Imagiste," the "direct treatment of the thing" and "to use absolutely no word that does not contribute to the presentation."[31] Upon these orders, the poets proceeded to a general house-cleaning, of which they were entirely conscious. Williams on Marianne Moore:

> Miss Moore gets great pleasure from wiping
> soiled words or cutting them clean out,
> removing the aureoles that have been pasted
> about them or taking them boldly from greasy

contexts. For the compositions which Miss Moore intends, each word should first stand crystal clear with no attachments; not even an aroma. . . . A word is a word most when it is separated out by science, treated with acid to remove the smudges, washed, dried and placed right side up on a clean surface. Now one may say that this is a word. Now it may be used.

Or Moore on Mina Loy :

[one recalls] a sliced and cylindrical complicated yet simple use of words.

Or Moore on Cummings:

His mark of economy has left its mark on us, making verbosity seem suicidally crass.[32]

The cleansing of the word was accompanied by a concomitant dismissal of dross and the call for the honest use of only the best materials. The new concreteness could be obscure for lack of explanatory filler, but the poem was pristine and luminous. Like the plain white wall of the cube house with its simply set, large square windows (and later the walls of pure glass), the words of the poems became visible as materials to the degree that the materials became the meaning (I will save for my conclusion the poem's other "materials," its contents).[33]

The architect's cube developed very quickly out of its box in the work of Gropius and Le Corbusier, but retained the play of planes that generated the emphasis on massing. The cube was meaningful on all its sides, the facade being to that essential degree dismissed. In the past, emphasis on the facade had made the building interesting in front, in only two dimensions. With its dismissal one could still not "see" the mass from the

street or the garden alone, but now the front sent the mind around and through to the other surfaces. Ornament, which was in the first instance composed of the special features of the facade, all but vanished, while in its place the smallest detail of functioning elements became magnified and had to be treated with new care. Symmetry, as for example identical windows in equal numbers on either side of a centered door, was dismissed in favor of balance; windows and door as grouped or matched subtractions in the expansive massing of the sheer wall. The distribution of forms and volumes, with complication, became a truly three-dimensional rhythm, as in the heady Rietveld Schröder House of 1924.[34] The corner no longer presented the same problem of treatment; quoins did not have to look like they could hold the building up or properly frame a dignified facade, marking it off from the drudgery of the side walls. Instead, corners became only their own necessity, the meeting place of planes that might stop there or might appear not to, as in Wright's feeling of extension or Gropius's Fagus Works where, already in 1911–1913, window meets window without pier so that the walls never make it to the corner at all.

The poem also, in its own way with materials, was massed: it was what Williams called a "field of action."[35] Part of this effect came from the new suddenness of its start; the point of entry threw off its seemliness, any formality to its welcome, and any sense of capital-P Poetry. The facade, part propriety and part announcement, was bypassed in favor of a disarming plunge into an emotional field, so that the reader is thrown into the whole poem before she understands what she has begun:

What about all this writing?

O "Kiki"
O Miss Margaret Jarvis
The backhandspring

I: clean
 clean
 clean: yes . . New-York

Wrigley's, appendicitis, John Marin:
skyscraper soup –

Either that or a bullet![36]

To start, the poem has already begun, with no narrative
"Once upon a time." The perspective itself is a query, as
is the voyage. At times a poem can be no more than one
sentence without preamble, as above but longer; at
other times a long sentence, having already developed
odd turns and red herrings, ends wrong, or nowhere, as
in Williams's "The Old Men" of 1917, where "Old men
who have studied" acquires two more subordinate
clauses but no principal one before the period 15 lines
later.[37] In this manner a statement turns into a state, a
field that forces the rules of sequence and endings. In
some cases the poem cannot be entered at all through
the front door, but two unreadable narratives must be
produced together, in the mind, after decoding:

 l(a

 le
 af
 fa

 ll

 s)
 one
 li

 ness[38]

The headlong rush of the poem to put the reader
at the end before her confusion about the beginning can
be resolved is encouraged by redrawing the poetic line

itself, now much shorter. Statements are begun only to
be truncated, enjambment becomes the rule rather
than exceptional. The line is not the same regulator, as
meter, rhyme, scannable rhythm, and contained sense
are all now in slippage. The symmetries of traditional
verse, caesura and rhyme applied to ample, finished
ideas, give way to a precarious balancing act of phrases
that refuse completion on cue, at line endings. These
ancient stops, where each line used to make its case
before we faced the next, are very much like the cube's
corners, in that they become the somewhat slighted
servants of the new massing. Indeed, the term "line
ending" no longer applies, as these corners look both
ways. Closure is not at issue, but instead the contrasts
of redrawn groupings. Williams often verbalized his
concern for these corners, which he termed "edges." In
the above-cited review of a Moore volume he spoke of
her two essential elements, "the hard and unaffected"
word, "then its edge-to-edge contact with the things
that surround it." Earlier, in a poem that was a transla-
tion of a 1914 cubist collage by Juan Gris, Williams
began:

 The rose is obsolete
 but each petal ends in
 an edge, the double facet[39]

Here we watch a line end in "ends in," while its expect-
ed "edge" comes only later. Between "in" and "an
edge" the poem turns a corner belonging to both of the
two lines; one line, and some statement, about "petal"
ends with "in," but the full sense has not yet set, while
the sense of "edge" is carried forward past its comma
to be, also, equated with a "double facet." This corner
connects the planes more than it separates them, but
then, paradoxically, bears the greater pressure of the
poet's work with contrast. Indeed, as with the build-
ing's planes, neither line would be able to stand without

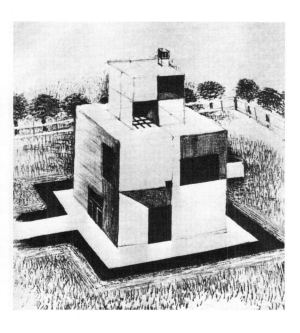

5.5 Johannes Itten (1888–1967). *White Man's House*, 1920. Lithograph, 30 x 24 cm. Graphische Sammlung der Staatsgalerie Stuttgart.

the corner's looking both ways. The contrast can alienate the rose from its familiar appurtenances, yet also connect the same rose to something radically Other:

> – The edge
> cuts without cutting
> meets – nothing – renews
> itself in metal or porcelain –

The edge is the difference of collage, as Williams well knows since he is writing about one. By moving the edges around, avoiding the conventional endings, sending the observer of facades around the corner, he brings a contrast of materials into privileged focus.[40]

As the facade goes, so goes ornament. No more coaxing rhetoric, no idle talk, unless such talk is the subject of the poem, only Moore's "a place for the genuine" ("Poetry"). Honesty with materials uncovers some hard core of truth, as Cummings explains it at the end of his "Picasso" of 1923:

> Lumberman of The Distinct
>
> your brain's
> axe only chops hugest inherent
> trees of Ego, from
> whose living and biggest
> bodies lopped
> of every
> prettiness
>
> you hew form truly[41]

What can look like prettiness here is fun, with words, with pauses, and ultimately with Picasso himself. It is the high style of respect that is most vigorously dismissed, to be replaced with all sorts of other languages: urban vernacular (as I write that word I am reminded that cubism in architecture was headed quite the other way, to the International Style), quotidian anguish, jokes and laughing, children's play, surreal dream. Especially, these languages mix; cubist simultaneity makes that contribution to modernism's assault on the sublime, that it has them converse together, as

on a cafe terrace:

> Tu parles, mon vieux
>
> Je ne sais pas ouvrir les yeux?
> Bouche d'or
> La poésie est en jeu[42]

The new honesty also calls for avowals; if the dialogic cacophony will not fit into the old forms there is a gain in saying so, a new form of intimacy or frankness with the reader:

> "Pardonnez-moi de ne plus connaître l'ancien
> jeu des vers"
> Comme dit Guillaume Apollinaire[43]

lines in which Cendrars makes his rhyme (and one for Apollinaire!) despite the disclaimer.

Cubist architecture also rewrites space, which is no longer just room. The Victorian clutter and comfortable sense of accretions, collectibles, and substantial furniture in cozy or dark corners, these are all evacuated to leave the squared, naked expanse of interior spaces cleanly cut from the mass of the full cube itself. Already Johannes Itten's 1920 image, that ur-cube house (fig. 5.5), is complicated by large window areas that, with shading, notch out whole quarters of one wall. The master is Le Corbusier, with his levitated mass of the famous Villa Savoye cut into patio and roof garden on the inside, with glassed-in rooms surrounding, and yet the extensive hollowing-out only to be guessed at from the outside. The earlier Esprit Nouveau cube house for the 1925 Exposition des Arts Décoratifs was a more visible demonstration of the cube trading blocks of space with the outside, to create spaces rather than places for furniture. One side wall was entirely covered with the two letters *E* and *N*, creating a trompe-l'oeil of cubist massing and hollows to match the actual hol-

lowing of the front with its "outside" tree inside.[44]

The spacing in the cubist poem also works inside and out. I've spoken of spacing within lines in Loy: hesitations, breathers, readers' choices. The new short line creates a thin column, somewhat to the left of center like a spine of language for the wide page, which has become too big a mass to be mere background. We sense greater delicacy and poise in this constructed page where not to speak carries weight. At an early stage in his career Mallarmé had written in apprehension of this empty page that his pen hesitated to soil: "le vide papier que la blancheur défend," but it was he, no doubt armed with this consciousness of a counter-language in the blank sheet, who eventually went the furthest. An "espacement de la lecture" he called it in his introduction to *Un coup de dés jamais n'abolira le hasard*.[45] Cendrars's *Transsibérien*, actually published before Mallarmé's poem could be properly read straight across two pages at a time, does a very different job, distributing its text in large blocks, while Mallarmé's appears scattered all over the field. In that sense the earlier poet's cubism is more pronounced. On the other hand, Cendrars wrote with all the languages of modernity, as I have referred to them in the discussion of ornament, whereas Mallarmé delved yet deeper into high symbolist rhetoric, a facade so elaborate that the edifice was all but inaccessible. But neither early Cendrars nor late Mallarmé quite predict the sense of a spine of text on a body of white that predominates later productions, from Cendrars to Williams, Loy, Moore, and Cummings. What I would compare to Le Corbusier's deceptive cube of inner and outer massed spaces is, for example, Williams's "Red Wheelbarrow," where the effect of balance between visualized silence and visualized speaking is alternately precarious or confident, depending on just where the edges make their cuts or joints. Such edges do not only come between words, but between words and eloquent silence.

In poetry, ornament cannot be entirely removed from line and field, the plane and space of architecture. While the first materials are the words themselves as I have discussed them, they now convey sensual meanings that are images and that function as metaphors. We should be careful here. Language projects mental pictures without effort, almost too generously. "The Red Wheelbarrow" proposes, by strict cleanliness of its terms, to make its imaged objects powerfully present, all the elements, no matter how simple, full of the lives of themselves. Williams effects a showing forth, but that is only half of what Pound meant when he proclaimed the tenets of an *Imagiste*; he was indeed protesting the current mistiness, but also reaffirming the essential primacy of metaphor, in which the image represents as well as it presents: "An 'image' is that which presents an intellectual and emotional complex in an instant."[46]

This "image," a metaphor really, is not the same as the overt equivalence a certain building might make, for example a sailors' chapel in the shape of a boat. Such a use of a "source metaphor," like the *calligramme*, is somewhat redundant to the poet, if not comical. Nor can the poet use the architect's "intangible" metaphors; Aalto's "individuality" or "community" are abstractions,[47] whereas in language metaphor supplies quite the opposite, the images of concrete reality that serve to replace abstractions; these would be death to a poem. Such has always been the use of metaphor in poetry, but what happens after Pound and with cubist poetry as I have been presenting it is that suddenly the distance we perceive as natural, or natural enough, between the two halves of metaphor, between abstract idea and concrete image (or tenor and vehicle), has been unnaturally increased, and without benefit of explanatory transition. The joinery is radical, a yoking together of what appears disparate.[48] We no longer cross natural bridges but leap the abrupt banks of the collage:

Soleil cou coupé (Apollinaire, 1913)

When the evening is spread out against the sky
Like a patient etherized upon a table (Eliot,
1915)

[I]
Stack noons
Curled to the solitaire
Core of the
Sun
. . . .
In some
Prenatal plagiarism
Foetal buffoons
Caught tricks (Loy, 1917)

His true Penelope was Flaubert (Pound, 1920)

Bent resolutely on wringing lilies from the
 acorn (Pound, 1920)

 [a mussel shell]
 opening and shutting itself like
an
injured fan. (Moore, 1921)

The dwarfs, those little hot dogs (Anne Sexton,
1971)[49]

While it is inevitable that figurative language will always be in danger of turning ornamental, that is not the effect of the radical images I offer above because we do not sense a mere descriptive or elaborative function in the image. Yvor Winters said of Loy: "She moves like one walking through granite instead of air, and when she achieves a moment of beauty it strikes one cold."[50] The language of another world has been

unexpectedly welded to the proposed subject of the poem. In my example from Marianne Moore's "The Fish," an underwater scene with mussels has turned into an eighteenth-century salon, with miffed lady; it is all done in two words, "injured fan." There is a great deal of ellipsis and compression here, as in the other examples. The poem splices subject, or self, and Other together to impose a radical proximity. The edges of ellipsis, if I may call them that, constitute a difficult passage where the reader is on her own. She must work, in parentheses as it were, at the ways in which Flaubert can be called Penelope. The collage that lives in the radical image is thus an education in reading that also turns out to be an education in reading different languages or discourses, such as fairy tale and soft porn in Sexton's "Snow White and the Seven Dwarfs." Ellipsis wrenches an uneasy synthesis: Grimm + Nathan's = Coney Island; of the mind, of course.

This rush of worlds across the edges of ellipsis is a job wonderfully performed in cubist poetry and for which I have not proposed an architectural equivalent. Indeed, cubist architecture is remarkably unified, from one plane around the corner to the next, and one must look forward to the postmodern mix for yoked architectural discourses. But something else happens with the radical image of the period, and which parallels my view of language invading the cubist painting in the transition from analytical to synthetic; for now modern architecture invades poetry as one of those new worlds poetry requires, along with the machine, in order to take a modern measure of desire, which must have seemed in shock at the beginning of the century:

> Clean is he alone
> after whom stream
> the broken pieces of the city —
> flying apart at his approaches

and

> Where shall I have that solidity
> which trees find
> in the ground?
>
> My stuff
> is the feel of good legs
> and a broad pelvis
> under the gold hair ornaments
> of skyscrapers.[51]

I can't claim it is specifically cubist architecture that enters poetry, since for the most part the poetry came first. But it is the whole modernity of the architect and the engineer's world that serves to radicalize the metaphor, making the poem into a cubist one. Especially the new city, here the New York of straight lines in high buildings and long streets at right angles, invades the language of nature and human bodies. I note, in the second excerpt above, how the woman is not compared to a skyscraper but abruptly turned into one. As we finish reading, the image of buildings rushes back over the whole poem; the skyscraper is eroticized and the woman adds that eroticization to her own.

Skyscrapers figure heavily in the architecture of American cubist poetry, as above. Two earlier constructions in particular, structural harbingers of modernism, recur, one in Paris, one in New York. Hart Crane, for example, attempted an (admittedly) Apollinaire-like epic using the Brooklyn Bridge as controlling metaphor. He was following Whitman, John Marin, and Frank Stella, to name only the best known. In his "Proem: to Brooklyn Bridge" from *The Bridge* (1930) he caught the office worker eyeing the bridge of passages while he remained hostage to technological bewilderments:

As apparitional as sails that cross
Some page of figures to be filed away;
– Till elevators drop us from our day . . .

Down Wall, from girder into street noon leaks,
A rip-tooth of the sky's acetylene

(note that the sky, that is to say nature and not the ele-
vator or Wall Street buildings, handles the blowtorch).
In Paris, both Apollinaire and Cendrars very early
"chantaient la Tour," as the latter had it, and in fact they
tossed it back and forth between them (and with
Robert Delaunay who dissolved it in *Les fenêtres* or cut
up its full height to fit his canvas):

> Bergère ô tour Eiffel le troupeau des ponts bêle
> ce matin
> (Apollinaire, 1913)

> Il faut jouer à saute-mouton
> A la brebis qui broute
> Femme-tremplin
>
> On passe sous la Tour Eiffel – boucler la boucle
> – pour retomber de l'autre côté du monde
> (Cendrars, 1914)[52]

Apollinaire takes the tower as a shepherdess for the
city's bridges, and turns modernity into an Arcadia.
Cendrars has us playing leapfrog, then suddenly leaping
across the world via the wireless aerial atop the tower.
In an earlier poem by Cendrars the tower itself
becomes all the worlds its radio reports; then, to finish,
it metamorphoses into other punned meanings, like the
cubist painters' ubiquitous "journal":

> Gong tam-tam zanzibar bête de la jungle
> rayons-X express bistouri symphonie
> Tu es tout
> Tour
> Dieu antique
> Bête moderne
> Spectre solaire
> Sujet de mon poème
> Tour
> Tour du monde
> Tour en mouvement[53]

In such work the new architectural wonder has become
a constitutive part of the cubist poem, a far cry from
an ornament. This functional skeleton, the tower, does
not remain on its side of the border in the metaphor,
but crosses into the subject which incorporates it in the
full sense of that word, bringing it into its own body;
the subject now writes with the same machined direct-
ness:

> Phares Blériot
> Mise en marche automatique
> Vois
>
> Mon stylo caracole
>
> Caltez![54]

Cendrars's fast-edited imagery was a model for the
cinema's use of technology, as well as a model for film
editing, as one may see in Abel Gance's *La roue* or
Léger's *Ballet mécanique*.[55] The poet was using all
of the camera, not just replacing the paintbrush with its
lens.

CODA

The pen found new strengths in an industry-driven reconstruction of metaphor, but also brought old and necessary strengths of desire-driven language into a modernized environment. In cubist poetry the lump of concrete or headlamp could only be half of the picture; the two-part image could never shed the subject's voice, even when the voice seemed entirely made over, almost robotic. This necessity for a singer contrasts with the threatened impersonality of cubist architecture, what Matthew Nowicki termed "functional exactitude," complete reduction of the house to its mechanical necessities.[56] Fritz Neumeyer has contrasted Mies van der Rohe's early confidence in the rational plan to mass-produce the cube house with his almost immediate disenchantment in the "exclusive" reliance on "'mathematical means'."[57] The voice of poetry could not but speak the other necessity; an unusually polemical example shows Williams correcting another but similarly rationalist credo:

A Foot-note

Walk on the delicate parts
of necessary mechanisms
and you will pretty soon have
neither food, clothing, nor
even Communism itself,
Comrades. Read good poetry![58]

But even if the writer says nothing so explicit, not even Cendrars's charmingly naive-sounding "This is my portrait" or "[tower] subject of my poem," the very desire to make art humanizes the mechanically driven poem. Joseph Hudnut wrote: "Space, structure, texture, light [the spiritual elements revised by modernism]—these are less the elements of a technology than the elements of an art . . . , the images out of which poets build their invisible architectures."[59] And more recently, Anthony

Antoniades recommends to the young architect the work of poets who search deep in their environment, their people, and themselves, and who are brief and precise.[60]

As mere box, the cube was not more than a slice off a square-ended bar, every fine plane an edge where only repetitions met more bouillon cubes. Ultimately the cube house of a victorious rationalism would have to turn out to be the single letter in an alphabet of only one letter. But the poem, like the painting, in acquiring the cube just as quickly forced it to face other bodies off its limits, and, to begin with, forced it to confront the subject's desiring. In a last example, a cubist poem inscribes a friend's painting with a precision instrument, but one that measures the refusal of passion to be measured off neatly:

Sur un Portrait
 de
Modigliani

Le monde intérieur
Le coeur humain avec
 ses 17 mouvements
 dans l'esprit
Et le vaetvient de la
 passion[61]

My opening picture-cum-letter, the ancient "Bêt" or house-signifier, already predicts this necessity. The house, to come into signification, must open the walls of "functional exactitude," extending this wall into the wilderness, breaching that one to leave access to the garden or to encourage ingress of garden and wilderness both. These two small details of design, invoked so long ago, make what might be a perfect box constructed against the elements into a proper desiring system for body and soul, make the perfect, dumb cube into a language friendly to the circulation of functions and desiring.

5.

NOTES

1. Michael Roaf, *Cultural Atlas of Mesopotamia and the Ancient Near-East* (New York: Facts on File, 1990), 150.

2. Louis Vauxcelles, referring to Braque's paintings on exhibit at Kahnweiler's gallery, *Gil Blas*, 14 December 1908; or to some of the same paintings at the Salon d'Automne of 1908, when Matisse was on the jury, *Gil Blas*, 25 May 1909. There, Vauxcelles wrote "bizarreries cubiques"; Matisse is supposed to have called the compositions "petits cubes." Blaise Cendrars, "Pourquoi le 'cube' s'effrite," one of a series of essays on painters in *La Rose Rouge*, no. 3 (15 May 1919), 33–34; rpt. in *Aujourd'hui* (1931) and in *Oeuvres complètes*, vol. 4 (Paris: Denoël, 1962), 185–188. Also in Cendrars, *Modernities and Other Writings*, ed. and trans. Monique Chefdor and Esther Allen (Lincoln: University of Nebraska Press, 1992). Charles-Edouard Jeanneret and Amédée Ozenfant, *Après le cubisme* (Paris: Editions des Commentaires, 1918); nevertheless, there is a purist manifesto of sorts in this volume.

3. Michel Décaudin and Etienne-Alain Hubert, "Petite historique d'une appellation: 'cubisme littéraire'," *Europe*, nos. 638–639 (1982), 8.

4. Linda Dalrymple Henderson, *The Fourth Dimension and Non-Euclidean Geometry in Modern Art* (Princeton: Princeton University Press, 1983), 58.

5. Wendy Steiner, "A Cubist Historiography," in Peter Steiner et al., eds., *The Structure of the Literary Process: Studies Dedicated to the Memory of Felix Vodicka* (Amsterdam: Benjamins, 1982), 521–545.

6. Mark Roskill, *The Interpretation of Cubism* (Philadelphia: Art Alliance Press; London and Toronto: Associated University Presses, 1985); or see the earlier Leo Steinberg, "What about Cubism" (in "The Algerian Women and Picasso at Large"), in *Other Criteria: Confrontations with Twentieth Century Art* (New York: Oxford University Press, 1972), 154–173.

7. I am working here from comments by Rudolf Arnheim, *Art and Visual Perception: A Psychology of the Creative Eye* (Berkeley: University of California Press, 1974), 261ff.

8. Gertrude Stein, *Picasso* (1938; rpt. Boston: Beacon Press, 1959), 12. Also see Marjorie Perloff, "'A Fine New Kind of Realism': Six Stein Styles in Search of a Reader," in *Poetic License: Essays on Modernist and Postmodernist Lyric* (Evanston: Northwestern University Press, 1990), 145–159. On p. 148 Perloff quotes Stein's 1931 *How to Write*: "in composition one thing was as important as another thing."

9. Stein, "Pablo Picasso," *Camera Work*, special number between nos. 39 and 40, August 1912; rpt. in Jacqueline Vaugn Brogan, *Part of the Climate: American Cubist Poetry* (Berkeley: University of California Press, 1991), 33.

10. Montreal *Gazette*, 12 March 1993, A5. It is quite to the point that reading Stein prompts one to find such sentences all around.

11. Stein, "Pablo Picasso," in Brogan, *Part of the Climate*, 34–35.

12. Gertrude Stein, *Before the Flowers of Friendship Faded Friendship Faded* (Paris: Plain Editions, 1931). Henry James, "The Beast in the Jungle" (1903), in *The Short Stories of Henry James* (New York: Random House, 1945), 597.

13. Gertrude Stein, *Tender Buttons: Objects, Food, Rooms* (New York: Claire Marie, 1914), 21, 22, 29, 56. Same pagination in the Sun & Moon edition (Los Angeles, 1990).

14. Mina Loy, "Gertrude Stein" (1929?), in *The Last Lunar Baedeker*, ed. Roger L. Conover (Highlands, N.C.: The Jargon Society, 1982), 26.

15. For example, Andrew Taylor has made this parallel in order to sustain his discussion of the cubist long poem: "Imagism, Cubism and the Long Poem," *Meanjin* 37 (1978), 362–369.

16. See Hugh Kenner, "Modernism and What Happened to It," *Essays in Criticism* 37 (April 1987), 97–109.

17. Mina Loy, "Virgins Plus Curtains Minus Dots," in *Lunar Baedeker*, 36, 38.

18. Guillaume Apollinaire, "Pablo Picasso," *SIC*, no. 17 (May 1917), n.p. Oddly, *Calligrammes*, published in 1918, does not contain this poem.

19. Blaise Cendrars, *Prose du Transsibérien et de la petite Jehanne de France*, one sheet 2 meters long by 0.36 meters wide, folded in 10 x 19 cm. (Paris: Editions des Hommes Nouveaux, 1913). Text alone with standard justified margins at left in Cendrars, *Du monde entier* (Paris: Gallimard, 1919).

20. Blaise Cendrars, *Le Transsibérien* (1913; rpt. Paris: Seghers, 1966). From the proof sheets, unpaginated fold-ins.

21. Leroy C. Breunig and J.-Cl. Chevalier, introduction to Guillaume Apollinaire, *Les peintres cubistes* (1913; rpt. Paris: Hermann, 1965), 27.

22. Steinberg, "What about Cubism," 165ff.

23. Ezra Pound, *Selected Poems* (New York: New Directions, 1957), 35.

24. Blaise Cendrars, *Le Panama ou les aventures de mes sept oncles* (1918), in *Complete Poems*, trans. Ron Padgett, intro. Jay Bochner (Berkeley: University of California Press, 1992), 250: "That little train the Solothurnians call 'the steam iron'/ I'll call my consul/ Send me over a 3rd-class ticket immediately/ The Uranium Steamship Co./ I want my money's worth," ibid., 39.

25. Cendrars, "Construction" (no. 19 in *19 Poèmes élastiques*), in *Complete Poems*, 273: "Painting becomes this great thing that moves/ The wheel/ Life/ The machine/ The human soul/ A 75 mm breech/ My portrait," ibid., 80.

26. Cendrars, "Titres" (no. 16 in *19 Poèmes élastiques*), in *Complete Poems*, 272: "Shapes Sweats Tresses/ The Leap of Being/ Stripped/ . . . / The New Spirit/ Accidents in Fairyland/ 400 Open Windows/ The Propeller of Gems of the Runs of Menses," ibid., 77.

27. Cendrars, "Mee Too Buggi" and "Dernière heure" (nos. 17 and 10 in *19 Poèmes élastiques*), *Complete Poems*, 272, 267.

28. E. E. Cummings, unpublished notes, Houghton Library, Harvard University; cited in the introduction to his *Tulips and Chimneys* (original 1922 typescript), intro. Richard Kennedy (New York: Liveright, 1976), xiv.

29. See, for example, Gillo Dorflès, "'Innen' et 'Aussen' en architecture et en psychanalyse," *Nouvelle Revue de Psychanalyse* 9 (Spring 1974), 229–238.

30. William Carlos Williams, "The Red Wheelbarrow," in *Collected Poems*, vol. 1: 1909–1939, ed. Walton Litz and Christopher MacGowan (New York: New Directions, 1986), 224.

31. Ezra Pound, "A Few Don'ts of an Imagiste," *Poetry* 1 (March 1913), 200. Curiously, these precepts, which are certainly Pound's, appear in a part of the article written by F. S. Flint.

32. Williams, "Marianne Moore" (1931), in *Selected Prose* (New York: New Directions, 1954), 128; Moore, "'New' Poetry since 1912" (1926), in *Complete Prose of Marianne Moore*, ed. Patricia C. Willis (New York: Viking, 1986), 121; Moore, "E. E. Cummings, 1894–1962" (1963), in *Complete Prose*, 562.

33. While this heightened value of materials may appear among poets before cubism entered architecture, at least one architect had already spoken for it. Frank Lloyd Wright's words, in his 1901 lecture at Hull House (Chicago), are modernist, or cubist, in this sense, while also providing a very American link between the arts and crafts movement and American modernism: "The beauty of wood lies in its qualities as wood, strange as that may seem. The machine at work on wood will itself teach us . . . that certain simple forms and handling serve to bring out the beauty of wood, and to retain its character. . . . In itself wood has beauty of marking, exquisite texture, and delicate nuance of color that carving is likely to destroy." From his "The Art and Craft of the Machine," rpt. in Lewis Mumford, ed., *Roots of Contemporary American Architecture* (New York: Grove Press, 1959), 178–179.

34. See Paul Overy, Lenneke Büller, Frank den Oudsten, and Bertus Mulder, *The Rietveld Schröder House* (Cambridge: MIT Press, 1988).

35. Williams, "The Poem as a Field of Action" (1948), in *Selected Essays*, 280–291.

36. Williams, no. 16 in *Spring and All* (1923), in *Collected Poems*, 1:200.

37. Williams, "The Old Men," in *Collected Poems*, 1:96.

38. Cummings, "l(a" (*95 Poems*, 1958), in *Complete Poems: 1913–1962* (New York: Harcourt Brace Jovanovich, 1972), 673.

39. Williams, ["The Rose"] (*Spring and All*, 1923), in *Collected Poems*, 1:195.

40. For other analyses of this poem as it relates to artwork see Bram Dijkstra, *Hieroglyphics of a New Speech: Cubism, Stieglitz and the Early Poetry of William Carlos Williams* (Princeton: Princeton University Press, 1969), 173–176; and Charles Altieri, *Painterly Abstraction in Modernist American Poetry* (Cambridge: Cambridge University Press, 1989), 236–240.

41. Cummings, "Picasso," *Tulips*, 89. Poem later moved to *XLI Poems* (1925); in *Complete Poems*, 195.

42. Cendrars, "Aux 5 Coins" (1914; no. 13 in *19 Poèmes élastiques*), in *Complete Poems*, 270: "At The Five Corners" [name of a cafe], "You said it, buddy/ I didn't know how to open my eyes?/ Golden tongue/ Poetry is in play," ibid., 73.

43. Cendrars, *Le Transsibérien* (1913), in *Complete Poems*, 244: "'Pardon my forgetting how to play the ancient game of Verse'/ As Guillaume Apollinaire says," ibid., 26.

44. Curious coincidence, this play with the letters *E* and *N* as in the Cendrars and Léger collaboration on the book *La fin du monde* in 1919. *L'Esprit Nouveau* began publishing the following year, and Le Corbusier owned a copy of the book, given to him by Léger in 1920 and which he positioned on the coffee table in his rue Nungesser et Coli apartment for publicity photos 15 years later. There are all sorts of connections, personal, professional, and artistic, between Cendrars and Le Corbusier, beginning with their birth, under other names, in the same Swiss town a few hundred meters and a few days apart; Raphaëlle Desplechin and Jay Bochner, "Blaise Cendrars et Le Corbusier" (lecture with slides), Le Tremblay sur Mauldre (France), 15 May 1994 (publication forthcoming).

45. Stéphane Mallarmé, "Brise Marine" (1865), in Anthony Hartley, ed., *The Penguin Book of French Verse: 3, the Nineteenth Century* (Harmondsworth: Penguin, 1965), 188: "... the empty paper, defended by its own whiteness ...," ibid. Mallarmé, *Un coup de dés jamais n'abolira le hasard* (first published in *Cosmopolis*, London, 1897), published in its proper shape across left- and right-handed pages by Gallimard (Paris: Editions NRF, 1914). Reproduced in Bernard Weinberg, *The Limits of Symbolism* (Chicago: University of Chicago Press, 1966), paginated separately 1–11, between pages 246 and 247.

46. Pound, "A Few Don'ts," 200.

47. Anthony C. Antoniades, *Poetics of Architecture: Theory of Design* (New York: Van Nostrand Reinhold, 1990), 55–56.

48. In English literature studies there is a history to this modern yoking together, which is a revival, in spades, of the seventeenth-century "metaphysical" image, defined in particular by Samuel Johnson as "a kind of *discordia concors*; a combination of dissimilar images, or discovery of occult resemblances in things apparently unlike. The most heterogeneous ideas are yoked by violence together" (Samuel Johnson, "Life of Cowley," in *Lives of the English Poets* [1779–1781]). In Eliot's view, between the time of Donne and that of his own early writing, English poetry had lost the "wit" to produce such imagery, a loss he called a "dissociation of sensibility" (T. S. Eliot, "The Metaphysical Poets" [1921], rpt. in *Selected Essays 1917–1932* [New York: Harcourt Brace, 1978], 247). Eliot took this phrase from de Gourmont. So, discontinuity in metaphor would arise not so much from the extravagant imagination of the poet as from the shortened reach of modern readers.

49. Apollinaire, "Zone," in *Alcools*, trans. William Meredith, intro. and notes Francis Steegmuller (New York: Anchor, 1965), 14: "Decapitated sun—," ibid., 15. T. S. Eliot, "The Love Song of J. Alfred Prufrock" (text generally available), lines 2 and 3. Loy, "Love Poems," in *Lunar Baedeker*,

100, 105. Pound, "Hugh Selwyn Mauberley: Life and Contacts," in *Selected Poems*, 71. Moore, "The Fish," in *Complete Poems* (New York: Macmillan/Viking, 1967), 32. Sexton, "Snow White and the Seven Dwarfs," in *Transformations* (1971), more accessible in Donald McQuade et al., *The Harper American Literature*, vol. 2 (New York: Harper and Row, 1987), 100.

50. Yvor Winters, "Mina Loy," *The Dial* 80 (1926), 496–499.

51. William Carlos Williams, from *Spring and All* (1923) and "Drink" [1916], both in *Collected Poems*, 1:201–202 and 1:53.

52. Apollinaire, "Zone," 2: "Shepherdess, ô Eiffel Tower, your flock of bridges is bleating this morning," ibid., 3. Cendrars, *Le Panama* . . ., 255: "We must play leap-frog/ Froggy went a-courting/ Springboard woman// You go under the Eiffel Tower — looping the loop — to come down on the other side of the world," 45.

53. Cendrars, "Tour" (1913), no. 2 in *19 Poèmes élastiques*, in *Complete Poems*, 261: "Gong tom-tom Zanzibar jungle animal rays express scalpel symphony/ You are everything/ Tower/ Ancient god/ Modern animal/ Solar spectrum/ Subject of my poem/ Tower/ World tour tower/ Moving tower," ibid., 56–57.

54. Cendrars, "F.I.A.T." (1914), no. 12 in *19 Poèmes élastiques*, in *Complete Poems*, 269: "Blériot headlights/ Self-starter/ See/ My pen is frisky/ Beat it!" ibid., 72.

55. See Standish D. Lawder, *The Cubist Cinema* (New York: New York University Press, 1975), chs. 4, 5, 7; and Claude Leroy, "7 Fragments d'un Léger par Cendrars," *Europe*, nos. 638–639 (1982), 137–143. Interesting to note that Eisenstein's first Hollywood project was a novel by Cendrars.

56. Matthew Nowicki, "Function and Form" [1951], in Mumford, ed., *Roots of Contemporary American Architecture*, 416.

57. Fritz Neumeyer, "Nexus of the Modern: The New Architecture in Berlin," in *Berlin, 1900– 1933: Architecture and Design*, ed. Tilmann Buddensieg, trans. John Gabriel (New York: Cooper-Hewitt Museum; Berlin: Gebr. Mann Verlag, 1987), 69, 71.

58. Williams, "A Foot-note" [1933], in *Complete Poems*, 370.

59. Joseph Hudnut, "The Post-Modern House" (from *Architecture and the Spirit of Man*, 1949), in Mumford, ed., *Roots of Contemporary American Architecture*, 314.

60. Antoniades, *Poetics of Architecture*, 110.

61. Cendrars, "Sur un portrait de Modigliani" (1917); not collected as a poem. To be found in the unpaginated opening documents to his *Du monde entier au coeur du monde: Poèmes* (Paris: Denoël, 1957): "On a Portrait by Modigliani" "The world inside/ The human heart with/ its 17 piece movement/ in the spirit/ And the backandforth of passion" (my translation).

6. PAUL OVERY

THE CELL IN THE CITY

"Architecture and Cubism" suggests a subtler play
of interactions than "Cubism and Architecture": a
charting of the multiplicity of different ways in which
modernist architecture might seem to have drawn on
cubism and the early twentieth-century modernist visu-
al arts movements that succeeded it. I take it that
cubism is used here as a kind of shorthand for whole
areas of modernist experimental painting, sculpture,
and construction rather than to signify a particular
type of avant-garde painting produced in Paris before
the First World War. Early uses of the term "cubist
architecture" implied an architecture of "cubic" (i.e.,
boxlike or crystalline) forms, rather than one that
exploited the ambiguous play between flatness and
illusions of shallow space that has generally been rep-
resented as the most important cubist device. But even
this is too literal a reading, implying a purely visual
and formal relationship. What modern architects found
compelling and useful in cubism and related early
twentieth-century modernist art movements were the
possibilities for using structure as symbolic form, of
repetition and gridding as ways of building up the
whole from its parts, of achieving unity in diversity.

6.1 Le Corbusier (1887–1965). *Immeubles-villas,* perspective with photomontage of the Pavillon de l'Esprit Nouveau, Paris, 1922–1925. From Le Corbusier, *Almanach d'architecture moderne* (Paris: G. Crès, 1925), p. 149.

In this essay the word "cell"—so frequently found in the literature of modernist architecture—is used to investigate aspects of the relationship between the theory and practice of painting on one hand and architecture on the other in the second and third decades of the twentieth century. *Cell*—or its German and French equivalents *Zelle* and *cellule*[1]—as employed in modernist architectural discourses encompasses at least two distinct but related meanings: a sense of the biological unit of living matter, "the ultimate element in organic structures; a minute portion of protoplasm, enclosed usually in a membrane,"[2] and the more specifically architectural usage of "one of a number of small apartments, as in a monastery, a nunnery, a prison,[3] occupied by a single person."[4]

It will be clear from the following quotations that Le Corbusier and other modernist architects and writers frequently collapse the two meanings—institutional and biological—in constructing a model for architectural form or as the basis for a theory of urbanism. In *Urbanisme* (1924) Le Corbusier writes: "Let us analyze the needs of the family (*i.e.* a 'cell'): also, what is necessary for a given number of such cells in their mutual relation to each other, and let us see how many cells can usefully be combined together to make a manageable colony in the way an hotel or a village is manageable; a community which would be a clear organic unit in the urban scheme."[5] A very different kind of urban theorist, Ludwig Hilberseimer, wrote in 1927 in *Grossstadtarchitektur*:

The architecture of the metropolis depends essentially on the solution given to two factors: the elementary cell and the urban organism as a whole. The single room as the constituent element of the habitation will determine the aspect of the habitation, and since the habitations in turn form blocks, the room will become a factor of urban configuration, which is architecture's true goal. Reciprocally, the planimetric structure of the city will have a substantial influence on the design of the habitation and the room.[6]

Similar uses of the word frequently appear in the writings of the early historians of the modern movement. This is a relatively late example from the work of Sigfried Giedion, but there are many earlier instances: "Modern architecture had to begin with the single cell, with the smallest unit, the low-cost dwelling, which to the last century had seemed beneath the talents and attention of the architect."[7]

Le Corbusier's interest in the monastic cell dates from 1907 when he visited the monastery of Ema, near Florence. He returned there in 1911, at the end of his "Voyage d'Orient." The experience was to remain of crucial importance to him for the rest of his life. In *Précisions* (1930) he recalled:

In the musical landscape of Tuscany I saw a modern city crowning a hill. The noblest silhouette in the landscape, an uninterrupted crown of monk's cells; each cell has a view on the plain, and opens on a lower level on an entirely closed garden. I thought I had never seen such a happy interpretation of a dwelling. The back of each cell opens by a door and a wicket on a circular street. The street is covered by an arcade: the cloister.

Through this way the monastery services operate—prayer, visits, food, funerals.[8]

In the account written shortly after he had returned from the voyage but not published until 1966, Le Corbusier wrote, enraptured, of the cell where he had stayed at Mount Athos: "my whitewashed room, where I slept on a wide bench rolled up on the most marvelous Bosnian or Walachian rug, blooming with colors. From the window lodged at the end of a deep splay, three times, I watch at dawn the light invade this endless space, while below, at the foot of the walls, the olive trees looked like tiny lichen."[9] Le Corbusier came to consider the monk's cell a model for the unit from which a new architecture might be built. In *Précisions* he claims that the monastery at Ema was an inspiration for the *immeubles-villas* conceived in 1922 (fig. 6.1), the designs for collective apartment blocks based on a repetition of the standardized living unit, the Maison Citrohan, slotted into a grid like monastic cells, which were to be the basis of the Unités d'Habitation built after the Second World War. "One day in 1922, I talked about it [the monastery] to my associate Pierre Jeanneret; on the back of a restaurant menu, we drew up spontaneously the *immeubles-villas*; the idea was born. A few months later their detailed plans were shown at our big stand on city planning at the Salon d'Automne ('A Contemporary City of Three Million Inhabitants')."[10]

After the Second World War, Le Corbusier was to design the Dominican monastery at La Tourette. According to Peter Serenyi, Le Corbusier considered "the home as a monastic cell, created, ideally at least, for the single individual." Serenyi claims that "the family, as a small, intricate social group, has no place in Le Corbusier's art or mind," and argues that he never thought "of the family as a complex unit made up of various, different, and unique members, precariously

held together by loyalty and livelihood."[11] As we can see from my earlier quotation, Le Corbusier did refer to the family as a cell in the zoological or botanical sense in *Urbanisme* in 1924. However, Serenyi is no doubt correct in describing Le Corbusier—at least at this stage in his career—as essentially concerned with the *single individual* and suggesting that he saw the community as a collection of individuals, rather than of nuclear or extended *families*: "Still living under the impact of World War I in a city hostile to his art, Le Corbusier—an uprooted, single, lonely man himself—wanted . . . to create a new collective world order based on harmony and equilibrium. It was a vain and desperate effort, to be sure, but it emanated from the same human need that has inspired thinkers from Plato to our own day to arrest change in an all too rapidly changing world."[12] Such words could also be applied to Mondrian, whose utopianism was quite close to that of Le Corbusier[13] and who created a living and working environment for himself in his Paris studio that has often been likened to a monastic cell (fig. 6.2).

One might also compare with Serenyi's comments El Lissitzky's 1929 judgment on Le Corbusier: "Given the fact that the society for which he builds has long since lost its traditional housing culture—without proposing a new one—Le Corbusier invents a non-existent culture in his studio; in his role as the artist in isolation, he has designed houses that are disorientating to the user, and which he himself would never inhabit." Lissitzky claims that the reason for this is "the architect's antisocial nature, the great distance that separates him from the expectations of the vast mass of people. He has affinities neither with the proletariat, nor with industrial capital."[14]

The reference to Mondrian above perhaps reveals something of my intention, which is to compare the cell in the work of modernist artists with its use as a theoretical and structural concept by modernist architects like Le Corbusier and Hilberseimer. Although artists employ the term less often in their own writings than do architects, a similar contraction of the two meanings of the word is also implicit in their work and practice—in particular in the way they manipulate the space of the studio, which functions not only as the site of the artist's work but as a utopian model, as a "cell" in the double meaning of the word discussed above. It has often been observed that Le Corbusier, who also practiced as an artist, modeled his early villas on the form of the typical Parisian studio, with its double-height living spaces.[15] For Le Corbusier the notion of the monk's cell and the biological cell as the nucleus of the community and as the basis of both architectural form and urban structure is further collapsed and conflated with the idea of the artist's studio. One of his early houses was a studio for Amédée Ozenfant (1923). The La Roche house (1923), designed for the collector Raoul La Roche, extends this further by adding an art gallery to the studio/cell. The artist's studio had already become by the end of the nineteenth century as much a place for *viewing* art as for making it, a site for its consumption as much as for its production. This was one of the prime functions of both Mondrian's and Brancusi's Paris studios.[16] By examining the extent to which the idea of the cell (in this double sense) pervades and structures the postcubist works of Mondrian and van Doesburg and the early architecture of Gerrit Rietveld, I hope also to throw some new light on the key role this notion plays in early twentieth-century modernist art and architecture.

Mondrian lived and worked in Paris from 1912 to 1914, producing a number of paintings generally described as cubist or cubist-influenced.[17] In 1914 he painted several works based on urban facades, a nearby church, and buildings covered with scaffolding or with advertising billboards. Like the prewar works of Delaunay and Léger, these are among the relatively few

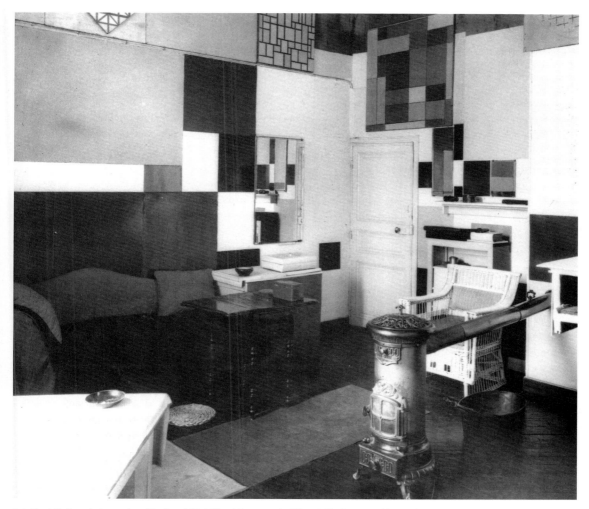

6.2 Paul Delbo, photographer. Studio of Piet Mondrian, rue du Départ, Paris, 1926. Haags Gemeentemuseum.

major works associated with cubism that address the notion of Parisian modernity in terms of structural representations of the fabric of the city, rather than evocations of the studio interior and the bohemian cafe by means of devices and tropes of abstracted still life and incorporated fragments of printed ephemera (newspapers, advertisements, labels, tickets, and packaging).

At the outbreak of war Mondrian was visiting Holland and was forced to remain there for the duration. Here he came into contact with the work and ideas of van Doesburg and Bart van der Leck and produced his first abstract works. Although the relationship between painting, architecture, and the applied arts was one of the major issues debated in *De Stijl* from its inception

in late 1917, Mondrian showed little interest in this until the later years of his association with De Stijl, which ended around 1925.[18] His interest was perhaps at its height at the time when he was on the point of severing that association and in great competition with (and increasingly antagonized by) van Doesburg.

In "Les Grands Boulevards," a short piece of "imaginative" writing composed in February 1920, not long after his return to Paris in summer 1919, Mondrian described "the cubist on the boulevard. Courbet in his studio and Corot in a landscape . . . everything in its place."[19] "The cubist on the boulevard" suggests the Baudelairean *flâneur*, evoked a decade later by Walter Benjamin, a reference that characterizes much recent revisionist art historical discussion of the work of Manet, Degas, and other artists of the impressionist and postimpressionist circle.[20]

Although the discussion of the urban *flâneur* has not been extended in the same terms to the works of the cubists, consideration has increasingly been given to what constitutes the "subject matter" of the cubist paintings and collages of Braque, Picasso, and Gris — no longer viewed from formalist perspectives as near-abstractions but as investigations of notions of representation and as bearers of meaning.[21] The hermetic quality of these works evokes the studio interior rather than a more public space; these images have generally been read as referring to the spaces of the bohemian (i.e., artistic) interior and the studio, less often to those of the cafe.[22] The city outside, the urban world beyond, appears to be represented almost entirely by means of linguistic signs, through the devices of stenciled lettering or collaged newsprint, deployed within the largely self-referential world of the images themselves. Occasional oblique references to the Parisian modernity of the boulevard and the department store can be identified, for example in Picasso's *Au Bon Marché* (1913).[23] This too is achieved primarily through

indexical signs — a collaged piece of packaging with the name of the department store — rather than by iconic representations or symbols.[24]

Perhaps the idea of "the cubist on the boulevard" was Mondrian's own particular self-projection. Back in Paris after mid-1919, he may have thought of himself as some kind of latter-day *boulevardier*.[25] But it is doubtful whether at this juncture he would have represented himself as a cubist.[26] "Cubist" as used by Mondrian in this experimental piece of imaginative writing is probably a kind of shorthand for "modernist artist" — rather as "cubism" is often used loosely to represent a series of current debates concerning early twentieth-century visual culture. The term itself suggests something geometrical and austere, cell-like and private, even if the spatial ambiguities of cubist devices appear to deny the suggestion of three-dimensional space. (That very denial is itself a reaffirmation of the austerity and nonphysicality of cubist space.) The juxtaposition of cubist and boulevard in Mondrian's text remains incongruous, but provocative.

Van Doesburg — who was still on good terms with Mondrian at this time — stayed in his Paris studio at 5, rue du Coulmiers in the spring of 1920 and appears to have encouraged him to write "Les Grands Boulevards." In a letter to Oud, van Doesburg wrote:

> I am sitting across from Piet [Mondrian], who is deeply absorbed in his Boulevard chronicle. It took considerable persuasion on my part, for, while liking the idea, he had many reservations. This afternoon, happily, we were on the Boulevard des Capucines, where we observed the working of the incredible machine that is Paris. It was a beautiful spring day, and we sat outdoors. One could cross the Place de l'Opéra only with the greatest caution, but Mondrian did as calmly as if he were in his atelier.[27]

One could cross the Place de l'Opéra only with the greatest caution, but Mondrian did as calmly as if he were in his atelier. Surely this is precisely the characterization of the twentieth-century *flâneur*? And if we turn van Doesburg's comment around, then we can also consider the idea of Mondrian's studio as the microcosm of the city—the cell in the city—a site where the artist can practice and perfect his outward behavior and body language in preparation for the public world outside.

It is clear that Mondrian himself had been giving a great deal of thought to the idea of the artist's studio at this time. Shortly after moving to rue du Coulmiers in November 1919 he had begun to arrange it as a personal "designed environment" by pinning up painted rectangles on the wall.[28] This was to be the first of a number of careful alterations to his studios, the most famous of which was at rue du Départ. On 4 December 1919 Mondrian had written in a letter to van Doesburg that he had been to see "Courbet's famous *Atelier*."[29] Two months later he was to write in "Les Grands Boulevards" of "the Cubist on the boulevard. Courbet in his studio and Corot in a landscape."

The following June a correspondent for the Dutch newspaper *Het Vaderland* visited Mondrian in the rue du Coulmiers studio, and described in some detail the ways in which the artist had organized and decorated it. The article began:

> Paris June 1920—Whitsun. A brilliantly sunny day, under a blazing blue sky. Dense Sunday crowds through the Porte d'Orléans. The cafés spill out onto the pavements. Close by the ancient ramparts (where the poorest of the poor pluck their spring flowers) is where Piet Mondrian lives. A street with picturesquely neglected gardens, a verdant courtyard, a dark staircase—and the painter comes towards me in his overall. What a difference to Kees van Dongen's house. True both have furnished their own apartments, but at Van Dongen's one is staggered by a drunken riot of colours and cushions through which it takes a while to distinguish in the blue cigarette smoke the graceful lines of a Parisian gesture. Mondrian's, however, is a severe, businesslike room flooded with limpid, cool light, where the painter, deaf to the Whitsuntide jollity around him, grapples with his material in monklike solitude in his quest for his lofty, highly controversial ideal.[30]

The solitude of the artist's studio is represented as "monklike" (two paragraphs later, the journalist will refer to "Mondrian's ascetic cell"). It is a place from which the outside world—"the Whitsuntide jollity"—is excluded: a functional "businesslike room flooded with limpid, cool light" in contrast to the studio of the then much better known Dutch painter van Dongen, which the journalist represents in typically Orientalist terms as "decadent" and "luxurious": a "drunken riot of colours and cushions." Where van Dongen's studio is in a fashionable "artistic" suburb, Mondrian's is at the Porte d'Orléans, on the periphery of Paris,[31] near the old ramparts of the city, close to the area known as the *zone militaire*, a site of contestation in the years immediately following the First World War.[32] The journalist emphasizes this contrast by drawing attention to Mondrian's utilitarian working clothes: "the painter comes towards me in his overall." He also describes the artist as "deaf to the Whitsuntide jollity around him." This is clearly a different perception of Mondrian from van Doesburg's calm negotiator of the traffic in the Place de l'Opéra five months earlier: Mondrian the professional in his workplace, as opposed to Mondrian the

would-be *boulevardier*. The article was one of three on Mondrian's studio published in Dutch newspapers in the early and mid-1920s,[33] revealing the extent to which the artist's studio—although represented as a "private" space like that of the monk's cell—was actually being produced during this period as a very public and social space where identities and personas were negotiated and tried out through the media of journalism and photography.[34]

Mondrian's organization of his studios at rue du Coulmiers and rue du Départ,[35] and of later studios in Paris and New York, has frequently been interpreted as the construction of a kind of utopian model or "ideal architecture." In the essay "Home—Street—City" (1926), which perhaps most clearly states his views on the relationship between architecture and painting at the time,[36] he argued that modern civilization had produced the idea of the "individual" and the "privacy" of the "home."[37] Mondrian claimed that, while at present the realization of the utopian city is impossible, the home could be the site of renewal: "not as a place of separation, isolation, or refuge, but *as a part of the whole, as a structural element of the city*"—i.e. as the cell from which the totality of the city could eventually be constructed.[38]

Yve-Alain Bois has written of Mondrian's notion of "the interior as ersatz," of the studio (or home) as "a world in itself."[39] But Mondrian's attitude to the studio-home was ambiguous. He clearly saw the home, and presumably also the studio—the model from which, by implication, the new idea of the home derived—as sites where the forces of the vanguard could be concentrated in anticipation of the renewal of the exterior architectural environment in the distant future.[40] Nevertheless he emphasized that it should *not* be a rejection of the world of the street.[41]

On the one hand, Mondrian's studio can be represented as continuing and concentrating the tendencies toward interiority in late nineteenth- and early twentieth-century painting and the emphasis on the interior in architectural schemes and idealized projects during the same period. On the other hand, it could also be represented as a site that focuses awareness of the world outside—the studio's "Other." The Dutch journalist, writing in 1920, had described the experience of emerging into the "real" world of the city outside. As he descends into "the maw of the Métro," Mondrian's studio suddenly begins to make sense and his "laboratory experiments" suddenly seem "to assume real shape": "Rectangular the long tubes, rectangular the trains gliding in and out of them; the very walls, also rectangular, are divided into coloured planes by red and green advertisements, almost in accordance with M[ondrian]'s recipe."[42]

The rue du Départ, as its name indicates, was situated along the departure side of the old Gare Montparnasse, immediately adjacent to the platforms. Mondrian's studio window looked directly onto the tracks. Ben Nicholson described it as "an astonishing room: very high and narrow . . . with a thin partition between it and a dancing school and with a window on the third floor looking down onto thousands of railway lines emerging from and converging into the Gare Montparnasse."[43] Mondrian wrote to van Doesburg:

> You write about the noise of the trains; yes, it is sometimes irksome, but it is very beautiful when I work. It is only when I don't work, when I want to sleep for example, that it is horrendous. At least with the windows open. . . . At any rate this noise is better than the screaming of children, for example, or the talking of neighbors in the house, as in my previous studio.[44]

The cell was clearly embedded in the fabric of the city. In its seclusion, it also suggested the presence of the city *beyond*.

However, Mondrian's conception of the home was not precisely the same as that of the studio, even if his studio represented for him *his* home. While the studio was the site where the artist could experiment with color and form, a utopian model for the architectural environment of the future, the home was to be the working model: the cell from which the new city could be constructed in close combination with the street.

> The home can no longer be sealed, closed, separate; nor can the street. While fulfilling different functions, home and street must form a unity. To achieve this, we must cease regarding the home as a box or a void. The idea of the "home"—"Home, Sweet Home"—must be destroyed at the same time as the conventional idea of the street.[45]

When "Home—Street—City" appeared in its French version in the magazine *Vouloir* in early 1927, it was illustrated with Mondrian's unexecuted designs for a room for the German collector Ida Bienert (fig. 6.3), generally known as *Salon de Madame B . . . à Dresden* (1926). Apart from three set designs for a play by Michel Seuphor that was never performed, this was the only three-dimensional design that Mondrian produced for a location outside the confines of his own studio.[46] The commission had come through Lissitzky and his future wife Sophie Küppers.[47] Judging from the drawings Mondrian made, the room seems rather bleak and impersonal—comparable to the boxlike void from which he wished to escape. When Lissitzky saw photographs of Mondrian's designs he wrote in a letter to Küppers that he had "expected something clearer" and that it was "really a still-life of a room, for viewing

6.3 Piet Mondrian (1872–1944). *Salon de Madame B . . . , à Dresden*, geometric perspective, 1926. Ink and gouache on paper, 37.5 x 56.5 cm. Staatliche Kunstsammlungen, Dresden.

through the key-hole."[48] The almost full-scale realization of Mondrian's design made at the Pace Gallery, New York, in 1970, although inaccurate, seems to have confirmed these qualities.[49]

Mondrian wrote of his designs to Oud: "Without the preparatory study of my own interior, I wouldn't have been able to do it."[50] Descriptions of Mondrian's own studio by those who visited it suggest a more open and alive space than the design for the Bienert room. Nevertheless, these often repeat the comparison with the monk's cell of the Dutch journalist's report. Nicholson compared it to a "hermit's cave" and described the contrast between the bustle and noise of the street outside the Gare Montparnasse, where he paused to take a coffee at a pavement cafe after visiting the artist, and the remembered light and stillness in the studio. Nicholson recalled

> sitting at a café table on the edge of a pavement almost touching all the traffic going in and out of the Gare Montparnasse, and sitting there for a very long time with an astonishing

feeling of quiet and repose (!)—the thing I remembered most was the feeling of light in his room and the pauses and silences during and after he'd been talking. The feeling in his studio must have been not unlike the feeling in one of those hermit's caves where lions used to go to have thorns taken out of their paws.[51]

The several drawings made by Mondrian for the Bienert room include two isometric projections. These were probably a response to the spectacular colored axonometric drawings that van Doesburg and the young Dutch architect Cornelis van Eesteren had shown at the De Stijl exhibition in Paris at Léonce Rosenberg's Galerie de l'Effort Moderne in 1923.[52] Although Mondrian had helped in preliminary negotiations for the De Stijl exhibition,[53] none of his own work had been shown, for nothing he had done so far would have fulfilled the criteria for the exhibition, which was limited to architectural and interior projects[54]—except perhaps his reorganization of his studio. However, he does not seem to have had enough confidence in this as an independent work to make public any representations of it until 1926–1927, when he had the studio photographed and sent prints to a number of publications.[55]

"Home—Street—City" was written partly as a rejoinder to van Doesburg's development of the dynamic diagonal in his architectural and coloristic schemes and later in his paintings, and his justification in a number of articles published in *De Stijl* of this rejection of the orthogonal principle that had become one of the main tenets of De Stijl.[56] This provocative activity on the part of van Doesburg had largely contributed to Mondrian's break with De Stijl in 1925.[57] To the polarized masculine and feminine elements—signified for Mondrian by the horizontal and vertical—van Doesburg contrasted the diagonal which, one might argue, "stands for" both male and female, or the conjunction of male and female.

6.4 Unknown photographer. Studio of Theo van Doesburg, Meudon, c. 1931–1932. From Stedelijk van Abbemuseum, *Theo van Doesburg, 1883–1931* (Eindhoven, 1968), fig. B63, p. 96.

Perhaps it was this inferred sexual aspect of the diagonal that most disturbed Mondrian, although he justified his opposition in other terms. For the diagonal destroys the integrity and purity of the monklike cell.[58] Visitors to Mondrian's studio noticed that he had erotic photographs of naked young women pinned up on the walls of his bedroom at rue du Départ, which doubled as a kitchenette and living space and immediately adjoined the studio.[59] Significantly, these were not pinned on the walls of the studio itself—as they might have been in the studio of some pop artist of the 1950s

or 1960s—for this would have destroyed the ascetic image of the studio as cell and constituted a threat to its integrity and purity.

In their later years both Mondrian and van Doesburg had become increasingly preoccupied with, and physically occupied, "a cell in the city"—although Mondrian for much longer than van Doesburg. Mondrian's final New York studio at 15 East 59th Street seems to conform precisely to this description.[60] The cell in the city is the "machine célibataire à habiter" that was to become the prototype for so much modernist architecture. Van Doesburg was not a bachelor and by an unkind irony was to live with his wife Nelly in their duplex cell in Meudon for only a few weeks before his death in early 1931 (fig. 6.4).[61] In a manifesto published posthumously in the memorial issue of *De Stijl* in 1932, van Doesburg concludes that the artist's studio must resemble a medical laboratory, possessing the atmosphere of high mountains where the cold kills the microbes.[62] The studio house at Meudon was to be a "white cell" in which van Doesburg could shut himself away from contamination, literal and metaphorical. (He was suffering from the acute asthma that was shortly to kill him.) "Looking around us, we see only manure, and it is in manure that filth and microbes live," he wrote in 1930.[63] His call for "white painting" in the same manifesto seems to represent a yearning for the purity and cleanliness of the sanatorium, an extreme version of the "cult of hygiene" that characterized much international modernist architecture in the late 1920s and early 1930s.[64] It may be germane that six months before his death van Doesburg was converted to Catholicism.[65] Part sanatorium, part hermit's cell, the Meudon studio house is like a small monastic building that would create "a direct relationship with God," as van Doesburg had written twelve years before about his interior designs for Oud's De Vonk hostel in Holland.[66]

6.5 Gerrit Rietveld (1888–1964) with Truus Schröder (1889–1985), architects; Frank den Oudsten, photographer. Schröder House, Utrecht, 1924, exterior (restored 1974, 1985–1987). Photograph 1987.

Issues and debates around notions of the "home" and the "cell" circulated and intersected at various points and places in the 1920s. In Utrecht in 1924–1925, at the time when Mondrian and van Doesburg's differences were at their height, Gerrit Rietveld and his client Truus Schröder were engaged in another dialogue concerning the cell and the home, and through this addressing the triadic relationship home-street-city. When he collaborated with Schröder on the design of the Schröder House in 1924 (fig. 6.5), Rietveld was clearly aware of van Doesburg and van Eesteren's models and drawings for the Maison Particulière and the Maison d'Artiste exhibited at the Rosenberg exhibition in Paris.[67] His design has sometimes been considered as a realization in built form of these "ideal" projects. But it also owes a great deal to his own earlier experiments with furniture design. And the ideas for a flexible interior that could be open and closed in a variety of different ways—appropriate to different needs and situations—seems to have been the particular contribution of his client, who was credited as co-architect when the building was published in *De Stijl* and *L'Architecture Vivante*.[68]

Schröder had recently been widowed, with three children to bring up. Although she was left relatively well off, the house was built very cheaply, seemed deliberately to abjure luxury, and was—even by Dutch standards—extremely austere in its specifications and finish. Schröder's own bedroom was so tiny that there was no space for anything else but the bed—a nunlike cell (fig. 6.6). Yet, as is well known, the house, which was altered and added to at various times by Rietveld and Schröder, was the product of an unusual and extremely close architect-client relationship.[69]

As a young man Rietveld seems to have had ambitions as a painter. He painted at least one portrait commission and exhibited paintings in 1912 at the Utrecht art society Kunstliefde (Love of Art), where Mondrian and van der Leck also showed their work.[70] However, Rietveld was not able to develop a career as an artist because of the economic necessity of supporting a wife and five children. Instead he returned to the craft of furniture-making (to which he had been apprenticed in his father's workshop at the age of twelve), later becoming a designer, and finally, with the Schröder House (his first building), turned to architecture. Many years later he wrote that architects were often "failed painters."[71] He was specifically referring here to van Doesburg, but no doubt was also remembering his own early experience and disappointments.

The Schröder House has often been discussed in terms of the relationship between modernist painting and architecture.[72] Both van Doesburg and van der Leck—with whom Rietveld was later to collaborate on interior designs for the showrooms of the Dutch furniture retailer Metz—offered their services as collaborators in the color design for the Schröder House.[73] Rietveld, however, preferred to do this himself, adding small touches of red, yellow, and blue to a color scheme in which grays and off-whites predominate (Mondrian called these the "non-colors"). However, unlike the

6.6 Gerrit Rietveld (1888–1964) with Truus Schröder (1889–1985), architects; Frank den Oudsten, photographer. Schröder House, Utrecht, 1924, view from the bathroom into Truus Schröder's bedroom (restored 1985–1987). Photograph 1987.

villas of Le Corbusier, the Schröder House was not based on the traditional artist's studio with its double-height living space. Nor was it intended as a machine in which to view works of art. Nevertheless, Schröder did acquire a number of paintings, including one by van der Leck,[74] and occasionally used to place pictures by artist friends for sale in a small window on the ground floor.[75] A room on the ground floor originally intended to be a garage was used by Rietveld during the first seven years of the house's occupation as an atelier for his practice as an architect and designer, and Schröder collaborated with him on a number of projects at this time and continued to do so until the 1950s.[76]

Despite these connections with the production and reception of painting, architecture, and design, the Schröder House appears in many ways to conform more to the notion of the "family" cell referred to by

Le Corbusier in the passage from *Urbanisme* quoted at the beginning of this essay. The house was designed for a family of growing children whose changing needs partly determined the flexible nature of the interior.[77] And this in turn was given symbolic representation in the exterior planes, which create the impression that they could be slid back and forth like the movable partitions in the interior. The house was designed for a family without a father, where women seem to have dominated,[78] and where the absent figure of the father was perhaps compensated for by that of the architect himself. The Schröder "family" cell was used as a model by Rietveld in unrealized designs for social housing in the later 1920s and 1930s, and in realized designs by other Dutch architects of the Nieuwe Bouwen who incorporated the idea of the flexible interior with sliding partitions into social housing built in Rotterdam and other Dutch cities in the 1930s.[79]

For Lissitzky the Schröder House seemed to function as a more satisfactory model than Le Corbusier's villas, as a cell in the city in which the furniture and built-in furniture designed by Rietveld himself were like cells within a cell—houses and streets represented symbolically inside the home: "The entire upper floor presents itself as one huge room in which the furniture, with the exception of the chairs, is closely arranged: cupboards, beds, sofa-beds and tables are arranged like houses in a town in such a way that there are areas for movement and use as if they were streets and squares."[80] Thus, for Lissitzky, the Schröder House fulfilled a modernist reworking of Alberti's ideal that the house be a small city, and the city a large house (fig. 6.7).

In "Home—Street—City" Mondrian's penultimate paragraph reads almost like a description of the Schröder House: "Home and street must be viewed as the city, as a *unity formed by planes composed in neutralizing opposition that destroys all exclusiveness.*

The same principle must govern the interior of the home, which can no longer be a conglomeration of rooms—four walls with holes for doors and windows—but *a construction of planes in colour and noncolour unified with the furniture and household objects, which will be nothing in themselves but which will function as constructive elements of the whole.*"[81] Mondrian would have seen photographs of the Schröder House, but he never visited the house or mentioned it in his published writings; he met Rietveld briefly if at all.[82] The essay ends immediately after the above quotation with a flight of utopian fancy: "And man? Nothing in himself, he will be part of the whole; and losing his petty and pathetic individual pride, he will be happy in the Eden he will have *created.*"[83]

The cell was seen as a model for utopia, the unit from which the greater whole could be constructed, by architects as different as Le Corbusier and Rietveld, and by artists who ultimately found themselves diametrically opposed like Mondrian and van Doesburg. The controlled environment of the artist's studio, or the family cell, could form the prototype for the future. This idea was not derived from cubism, but it accorded with ideas about repetition and gridding derived from formal procedures that had developed out of cubism. The cubism of Braque and Picasso, and to an extent that of Gris, was an art that was self-referential and studio-bound. It was an art of the interior, in which the exterior world must be inferred from the cues and clues offered within a self-contradictory system. In this sense cubism itself was also an art rooted in the notion of the cell in the city.

6.7 Gerrit Rietveld (1888–1964) with Truus Schröder (1889–1985), architects; Frank den Oudsten, photographer. Schröder House, Utrecht, 1924, interior of upper floor (restored 1985–1987). Photograph 1987.

6.

NOTES

I would like to thank Tag Gronberg for her help in making a number of critical suggestions at various stages in the writing of this essay.

1. The German and French words have a similar range of meanings to the English "cell."

2. *Shorter Oxford English Dictionary* (Oxford: Clarendon Press, 1970). Cf. *Chambers Twentieth Century Dictionary*, new ed. (Edinburgh and London: W. and R. Chambers, 1972): "a unit-mass of living matter, whether walled or unwalled, by itself or associated with others in a higher unity."

3. Architectural historians and critics have recently posited the ideas of Michel Foucault on the prison and Bentham's utopian, or rather dystopian, notion of the Panopticon as the basis for analyses of post-Enlightenment architecture. Cf. Robin Middleton, "Sickness, Madness and Crime as the Grounds of Form," *AA Files* 24 (Autumn 1992), 16–30; (Part Two) 25 (Summer 1993), 14–29.

4. *Shorter Oxford English Dictionary*.

5. Le Corbusier, *The City of To-morrow and Its Planning*, trans. Frederick Etchells (London: Architectural Press, 1971), 215.

6. Ludwig Hilberseimer, *Grossstadtarchitektur* (Stuttgart, 1927), quoted in translation by K. Michael Hays, "Reproduction and Negation: The Cognitive Project of the Avant-Garde," in Beatriz Colomina, ed., *Architectureproduction* (New York: Princeton Architectural Press, 1988), 173.

7. Sigfried Giedion, *Architecture, You and Me: The Diary of a Development* (Cambridge: Harvard University Press, 1958), 27.

8. Le Corbusier, *Precisions on the Present State of Architecture and City Planning*, trans. Edith Schreiber Aujame (Cambridge: MIT Press, 1991), 91. Originally published as *Précisions sur un état présent de l'architecture et de l'urbanisme* (Paris: G. Crès, 1930).

9. Le Corbusier, *Journey to the East*, ed. and trans. Ivan Žaknić, trans. in collab. with Nicole Pertuiset (Cambridge: MIT Press, 1987), 185. Originally published as *Le voyage d'Orient* (Paris: Forces Vives, 1966).

10. Le Corbusier, *Precisions*, 91.

11. Peter Serenyi, "Le Corbusier, Fourier and the Monastery of Ema," *Art Bulletin* 49 (December 1967), 277–286.

12. Ibid., 283–284.

13. Ozenfant and Le Corbusier had attacked De Stijl painting, comparing Mondrian's abstract paintings with the realist work of the nineteenth-century French *pompier* painter Manessier. [Ozenfant and Le Corbusier], "L'angle droit," *L'Esprit Nouveau* 18 ([1923]), n.p. Nevertheless, Mondrian came to admire Le Corbusier's work and ideas. He toured the Villa Stein–de Monzie at Garches (and probably other Le Corbusier villas) with the architect's assistant Alfred Roth in 1928. See Yve-Alain Bois and Nancy Troy, "De Stijl et l'architecture à Paris," in *De Stijl et l'architecture en France* (Liège and Brussels: Pierre Mardaga Editeur, 1985), 85, n.130. Mondrian wrote to Roth on 16 June 1933, "the work of Le Corbusier is among the best I know that has been

done, isn't it?" Cited in Alfred Roth, *Begegnung mit Pionieren: Le Corbusier, Piet Mondrian, Adolf Loos, Josef Hoffmann, Auguste Perret, Henry van de Velde* (Basel and Stuttgart: Birkhäuser Verlag, 1973), 174.

14. El Lissitzky, "Idoli i idolopokonniki," *Stroiltelnaia Promyshlennost* 7, 11–12 (1929), 854–858, quoted in translation in Jean-Louis Cohen, *Le Corbusier and the Mystique of the USSR: Theories and Projects for Moscow, 1928–1936* (Princeton: Princeton University Press, 1992), 108. Lissitzky had visited Le Corbusier's Villa Stein–de Monzie in the company of Mondrian and the Dutch architect Mart Stam—probably on the same occasion described above in the preceding note. See Sophie Lissitzky-Küppers, *El Lissitzky* (London: Thames and Hudson, 1992), 87.

15. Nancy Troy has drawn attention to the complex social and aesthetic role of the studio in the late nineteenth century: "The dual role of the artist's atelier as both a private and a public space, where art was first created and then shown, made it a particularly appropriate forum for the promotion of advanced aesthetic ideas. Indeed, during the latter half of the 19th century, the artist's house, with the studio as its focal point, had been much copied by patrons who wanted their own homes to express the artistic tastes they acquired on visits to actual studios." Nancy Troy, *The De Stijl Environment* (Cambridge: MIT Press, 1983), 166. Often this was a case of wealthy manufacturers or financiers wanting to buy into what they imagined to be the free and easy (and sexually promiscuous) bohemian lifestyle of the artist.

16. For Brancusi's studio, see Anna C. Chave, *Constantin Brancusi: Shifting the Bases of Art* (New Haven: Yale University Press, 1993), 272–284.

17. Apollinaire wrote in a review of the 1913 Salon des Indépendants in *L'Intransigeant* on March 8: "The highly abstract Cubism of Mondrian, a Dutchman (we know that Cubism has penetrated the museum in Amsterdam; while in France our young painters are being ridiculed, in Amsterdam they are exhibiting the works of Georges Braque, Picasso, etc., next to those of Rembrandt)—Mondrian, an offshoot of the cubists, is certainly not their imitator. He seems to have been influenced above all by Picasso, but his personality has remained wholly his own. His trees and his portrait of a woman reveal an intellectual sensibility. This kind of Cubism is heading in a direction different from that currently pursued by Braque and Picasso, whose experiments with materials are proving extremely interesting." (Translated in Guillaume Apollinaire, *Apollinaire on Art: Essays and Reviews 1902–1918*, ed. Leroy C. Breunig, trans. Susan Suleiman [London: Thames and Hudson, 1972], 289.) Cubist work had been shown in Amsterdam in the Moderne Kunstkring (Modern Art Circle) exhibition at the Stedelijk Museum in October 1911. Mondrian was on the steering committee of the Kunstkring and helped organize the show.

18. Els Hoek has argued: "Mondrian and [the architect J. J. P.] Oud met for the first time (and probably the last) in summer of 1920. It is understandable that van Doesburg did not encourage a meeting between these two important contributors to *De Stijl*, because Mondrian displayed little interest in architecture. However, when van Doesburg came to Paris in February 1920, he noticed that in the meantime Mondrian had enthusiastically begun to experiment with colors in his studio, and consequently he advised Oud to visit Mondrian on his summer trip to France." Els Hoek, "Piet Mondrian," in Carel Blotkamp et al., *De Stijl: The Formative Years 1917–1922*, trans. Charlotte I. Loeb and Arthur L. Loeb (Cambridge: MIT Press, 1986), 70.

19. Piet Mondrian, "Les Grands Boulevards," trans. in Harry Holtzman and Martin James, eds., *The New Art, the New Life: The Collected Writings of Piet Mondrian* (London: Thames & Hudson, 1987), 128.

20. See Walter Benjamin, *Charles Baudelaire: A Lyric Poet in the Era of High Capitalism* (London: New Left Books, 1973). Pierre Missac's paraphrase of some of Benjamin's notes for his *Passagenarbeit* [Arcades Project] on the relationship between the interior (or room) and the city as an urban landscape for the delectation of the *flâneur* (Benjamin described this as "botanizing on the asphalt") seems relevant to Mondrian and his organization of his studio as a "cell in the city." Pierre Missac, *Walter Benjamin's Passages* (Cambridge: MIT Press, 1995), 176. See also Walter Benjamin, *Gesammelte Schriften,* ed. Rolf Tiedemann and Hermann Schweppenhäuser, vol. 5, *Das Passagen-Werk*, ed. Rolf Tiedemann (Frankfurt am Main: Suhrkamp Verlag, 1982).

21. See, for example, Lynn Zelevansky, ed., *Picasso and Braque: A Symposium* (New York: Museum of Modern Art 1992).

22. "The banal yet very personal objects that are the motifs of [Picasso's] and Braque's Cubism constituted a studio world that gradually incorporated an iconography drawn from the more gregarious milieu of the café." William Rubin, *Picasso and Braque: Pioneering Cubism* (New York: Museum of Modern Art, 1989), 17. Braque and Picasso began to make paintings in 1911 at Céret in the south of France that contain references to cafes rather than studio interiors. "The iconography of the collages from autumn to winter, 1912, is more strictly that of the Paris café than the collages of 1913 and 1914": Patricia Leighten, "Picasso's Collages and the Threat of War, 1912–13," *Art Bulletin* 67 (December 1985), 667. Juan Gris, who also worked at Céret, began to introduce elements derived from the cafe in 1912–1913.

23. Ludwig Collection, Aachen.

24. This particular work also includes an iconic image, the figure of a woman taken from a newspaper advertisement.

25. "I am very happy to be here again, because I feel strongly the seriousness of a big city. In Holland everything is childish." Mondrian to van Doesburg, 1 August 1919, Van Doesburg Archive, Rijksdienst Beeldende Kunst, The Hague, box 11, no. 76.

26. The year after composing "Les Grands Boulevards" he wrote to Oud on 17 August 1921: "You write so cautiously of a new and purer art that is to evolve from Cubism. Wouldn't it have been better to name Neo-Plasticism directly as the principle of *all expression* (of our time)? We can speed the new only by starting from the fixed principle that Neo-Plasticism discovered in painting. If we of De Stijl fail to unite on this *one thing*, then everything will go very slowly." (Quoted in translation in Holtzman and James, eds., *The New Art, the New Life*, 165.)
 Mondrian refers to Oud's lecture "Over de toekomstige Bouwkunst en hare architectonische mogelijkheden" [On Building in the Future and Its Architectural Potentialities] of February 1921, published in *Bouwkundig Weekblad* 42 (11 June 1921). This has been described by Reyner Banham as "the first major theoretical pronouncement by any of the leading architects of the mainstream of development in the Twenties": Reyner Banham, *Theory and Design in the First Machine Age* (London: Architectural Press, 1967), 157. See also Paul Overy, *De Stijl* (London: Thames & Hudson,

1991), 158. Oud had referred to cubism as one of the main sources of modern architecture in a much earlier article, "Over Cubisme, Futurisme, moderne bouwkunst, enz." [On Cubism, Futurism, Modern Construction, etc.], *Bouwkundig Weekblad* 37 (16 September 1916), 156–157.

27. Letter from van Doesburg to Oud, 4 February 1920, quoted in translation in Holtzman and James, eds., *The New Art, the New Life*, 124. "Les Grands Boulevards" was published at the end of March 1920 in *De nieuwe Amsterdammer*, a Dutch magazine of which van Doesburg was the art correspondent.

28. Mondrian wrote to van Doesburg on 4 December 1919: "I can't use paint on the wall and have instead affixed some painted cardboard. But I have now clearly seen that it is indeed possible to achieve N[ew] P[lasticism] in the room. Of course I've also had to paint the furniture. I don't regret the trouble it's taken because it has a favorable effect on my work." (Quoted in translation in Troy, *The De Stijl Environment*, 64.) The work Mondrian painted after he began to arrange his studio in this way became increasingly asymmetrical, moving further and further away from the device of an underlying grid that had been apparent in the works he produced in the Netherlands shortly before returning to Paris in 1919.

29. Quoted in translation in Holtzman and James, eds., *The New Art, the New Life*, 128.

30. "A Visit to Piet Mondrian" (from our correspondent), *Het Vaderland*, 9 July 1920, Evening Edition A, translated in Herbert Henkels, *From Figuration to Abstraction* (London: Thames & Hudson, 1987), 24. The journalist was probably W. F. A. Roëll, the newspaper's Paris correspondent. See "Mondrian ↔ architectuur," in Carel Blotkamp, *Mondriaan in detail* (Utrecht and Antwerp: Veen/Reflex, 1987), 60.

31. However, at the end of the following year Mondrian was to move back to a studio block in Montparnasse. On returning to Paris in July 1919 he had reoccupied the studio he had rented before the war, at 26, rue du Départ, behind the Gare Montparnasse, which belonged to the Dutch painter Conrad Kickert. In November 1919, having to find new accommodation as Kickert wished to repossess the studio, he moved to rue du Coulmiers; at the end of 1921 he moved back to the building at 26, rue du Départ, to a studio two floors above Kickert's.

32. The *zone militaire* was only declassified in 1919, after modern artillery like the German "Big Bertha," which could project an explosive shell over a distance of 25 miles, had made it obvious that such defenses were now obsolete. There were heated debates in the French Parliament and in architectural and urbanistic circles about how this urban/suburban no-man's-land might best be used. See Jean-Louis Cohen and André Lortie, *Des fortifs périfs: Paris, les seuils de la ville*, exh. cat. (Paris: Picard Editeur, Editions du Pavillon d'Arsenal, 1991), 113–154.

33. The other two articles were "At Piet Mondrian's" (from our own correspondent), *Nieuwe Rotterdamsche Courant*, 23 March 1922, Evening Edition B, and "At Piet Mondrian's: The Crystal-Clear Studio—An Apology for the Charleston" (from our special correspondent), *De Telegraaf*, 12 September 1926. The two articles are translated in Henkels, *From Figuration to Abstraction*, 26–30, 30–32. The three articles were clearly done with Mondrian's cooperation and

although published anonymously were probably all written by the same Dutch journalist, W. F. A. Roëll.

34. Mondrian engaged the photographer Delbo to take a number of photographs of his studio at rue du Départ from different angles in 1926. He also invited André Kertèsz to take several photographs the same year. There are also earlier photographs of the studio; it is not known who took these. On several occasions Mondrian provided photographs of the studio to art publications at this time. He clearly considered its reproduction important and was to allow this and subsequent studios to be photographed on a number of occasions. (See note 54.) "Mondrian wanted the photographs to strengthen the image of his studio as a 'cell', 'laboratory', in which the environment of the future is researched." Herbert Henkels, "Mondrian in His Studio," in Henkels, *From Figuration to Abstraction,* 187.

35. Mondrian remained in the rue du Départ studio from late 1921 until 1936. It was demolished in 1940—by a kind of irony, as Harry Holtzman has pointed out—for "urban renewal." (See Harry Holtzman, "L'atelier de New York," in *L'atelier de Mondrian: Recherches et dessins* [Paris: Macula, 1982], 87.) A full-size reconstruction was built for the exhibition "Mondriaans Atelier Aardsch Paradijs" [Mondrian's Studio: Earthly Paradise] at the Beurs van Berlage, Amsterdam (17 December 1994–5 February 1995).

36. Mondrian informed Oud on 22 May 1926 that he was planning to write the essay that became "Home—Street—City" for *i10*: "Myself I'm going to write on Neo-Plast[icism] in society, something I've been intending to do for a long time." Letter collection Fondation Custodia, Institut Néerlandais, Paris, quoted in *i10*, exh. cat. (Paris: Institut Néerlandais, 1989), 69. The essay appeared in the first issue of *i10* in January 1927 under the title: "Neo-Plasticisme: De woning—de straat—de stad." The French version "Le home—la rue—la cité" appeared in *Vouloir* 25 in early 1927. There are a number of errors in the French text. See introduction and notes to the reprint of a corrected French text by Yve-Alain Bois in *L'atelier de Mondrian,* 63–70.

37. Piet Mondrian, "Home—Street—City," translated in Holtzman and James, eds., *The New Art, the New Life,* 207. Mondrian used the English word "home" in the French version of the text.

38. Ibid., 208 (emphasis in original). Cf. "To defeat the still so powerful influence of the past, *we must concentrate first and foremost on the plastic expression of the home,* on the dwelling and its rooms, and we must leave the technical problems of construction to the engineers" (ibid., 209; emphasis in original).

39. Yve-Alain Bois, "Mondrian and the Theory of Architecture," *Assemblage* 4 (October 1987), 116, 119.

40. Cf. Piet Mondrian, "De realiseering van het Neo-Plasticisme in verre toekomst en in de huidige architectuur (Architectuur begrepen als onze geheele [niet natuurlijke] omgeving)," *De Stijl,* March and May 1922 issues. Translated as "The Realization of Neo-Plasticism in the Distant Future and in Architecture Today (Architecture Understood as Our Total Nonnatural Environment)," in Holtzman and James, eds., *The New Art, the New Life,* 164–172.

41. Neoplasticism, he declares, "is more at home in the Métro than in Notre Dame, prefers the Eiffel Tower to Mont Blanc." Mondrian, "Home—Street—City," 211. Mondrian later painted a number of works to which he gave the titles of streets or thoroughfares, for example *Place de la Concorde* (1936) and *Broadway Boogie-Woogie* (1944).

42. "A Visit to Piet Mondrian," translated in Henkels, *From Figuration to Abstraction*, 25.

43. Ben Nicholson, letter to John Summerson, 3 January 1944, quoted in John Summerson, *Ben Nicholson* (West Drayton: Penguin Modern Painters, 1948), 12.

44. Undated letter (c. 1921), in Van Doesburg Archive, The Hague, quoted in English in Bois, "Mondrian and the Theory of Architecture," 129 n.96.

45. Mondrian, "Home—Street—City," 211.

46. Ida Bienert, the wife of a wealthy Dresden industrialist, was a close friend of Walter Gropius; her daughter was a student at the Bauhaus. Bienert had bought two paintings by Mondrian from his exhibition at the Kühl und Kühn gallery in Dresden in 1925, including one of his diamond paintings. In these works, of which Mondrian painted only a small number, the square canvas is hung on the diagonal while the lines and rectangular planes within the painting remain orthogonal in orientation, composed of horizontals and verticals. For Mondrian's diamond paintings see E. A. Carmean, *Mondrian: The Diamond Compositions*, exh. cat. (Washington: National Gallery of Art, 1979).

47. It is uncertain why Mondrian's design was not executed, or whether the commission was given to another designer.

48. Letter of 2 March 1926, translated in Lissitzky-Küppers, *El Lissitzky*, 74. Marcel Duchamp's final work, *Etant donnés* (1946–1966), only shown after his death, was literally "a still-life of a room, for viewing through the key-hole"—not a cell to be surveilled through a spy hole, but an erotic landscape to be gazed at voyeuristically through a peephole in a door.

49. Exhibited at the Pace Gallery, New York, 11 April–16 May 1970. See *Mondrian: The Process Works*, exh. cat. (New York: Pace Gallery, 1970), 5, 16 (color illustration).

50. Undated letter (early 1926), Fondation Custodia, Institut Néerlandais, Paris, quoted in translation in Troy, *The De Stijl Environment*, 220 n.66.

51. Letter quoted in Summerson, *Ben Nicholson*, 12–13. It was Nicholson who arranged for Mondrian to move to London in 1938. Nicholson found Mondrian a studio in Hampstead and organized support for the artist. Mondrian moved on to New York in 1940 at the invitation of Harry Holtzman after a bomb fell near his London studio.

52. Troy has argued: "By 1926 a kind of rivalry had developed between the two artists, who were in the process of redefining their relationship to one another. Although van Doesburg's painting style had for many years been largely indebted to Mondrian, in the sphere of interior design van Doesburg was both more sophisticated and far more experienced than Mondrian (who was, of course, aware of van Doesburg's architecture-related work)." Troy, *The De Stijl Environment*, 149.

53. The Rosenberg exhibition consisted of photographs and models of projects designed by archi-
tects associated with De Stijl and of a number of color schemes for buildings. Van Doesburg
exhibited color designs for a diploma project for a university hall by the young Dutch architect
Cornelis van Eesteren in 1923, illustrated and discussed in Evert van Straaten, *Theo van Doesburg:
Painter and Architect* (The Hague: SDU Publishers, 1988), 146–151. He also collaborated with van
Eesteren on designs for three "ideal" architectural projects especially conceived for the show,
which have subsequently been represented as among the most celebrated unbuilt projects of early
twentieth-century modernism: the Hôtel Particulier, the Maison Particulière, and the Maison
d'Artiste (illustrated and discussed in van Straaten, 108–113, 114–137, 138–143). The exhibition
was reconstructed under the title "De Stijl et l'architecture en France" at the Institut Français
d'Architecture, Paris, in the winter of 1985–1986; see the related publication, Yve-Alain Bois and
Bruno Reichlin, eds., *De Stijl et l'architecture en France* (Liège: Mardaga, 1985).

54. These had a powerful impact on the architectural avant-garde in France, especially Le Corbusier
and, to a lesser extent, Robert Mallet-Stevens. See Yve-Alain Bois and Nancy Troy, "De Stijl et l'ar-
chitecture à Paris," Bruno Reichlin, "Le Corbusier vs De Stijl," and Bruno Reichlin, "Mallet-Stevens
vs De Stijl," in Bois and Reichlin, eds., *De Stijl et l'architecture en France*, 25–90, 91–108, 109–121.

55. The first publication of Mondrian's studio seems to have been in *Das Werk* 7 (1926), 209. Later
photographs were published in *Das Kunstblatt* 14 (1930), 66 and *Cercle et Carré* 1, 3 (1930), n.p.
(See also note 34.)

56. The two essays "Schilderkunst—van kompositie tot contra-kompositie" and "Schilderkunst en
plastiek—over contra-kompositie en contra-plastiek" were published in *De Stijl*, series 13, 73/74:
17–18, 23–27, and *De Stijl*, series 13, 75/76: 35–43. These issues probably appeared in the summer
and autumn of 1926. The essays are translated as "Painting: From Composition towards Counter-
composition" and "Painting and Plastic Art" in Joost Baljeu, *Theo van Doesburg* (London: Studio
Vista, 1974), 151–156, 156–161.

57. Some recent critics have attempted to minimize this in comparison to other factors that played
a part in the breakup of Mondrian and van Doesburg's professional relationship. See Carel
Blotkamp, "Van Doesburg," and Els Hoek, "Mondrian," in Blotkamp et al., *De Stijl: The Formative
Years*, 30–31, 70–72. See also Carel Blotkamp, *Mondrian: The Art of Destruction* (London:
Reaktion Books, 1994), 192ff.

58. Herbert Henkels has noted of the photographs by Delbo that Mondrian had taken of his studio
and later published: "But what the photographs show and don't show was entirely Mondrian's
decision. The objects in the room are arranged in such a way that their forms suggest a certain rela-
tionship between them. It is very curious to see how, in the foreground of these photographs, a table
or stove introduces a diagonal into the composition, thus serving a purpose rather like that of the
old-fashioned *repoussoir*." ("Mondrian in His Studio," in Henkels, *From Figuration to Abstraction*,
187.) Nevertheless, these may well reveal more than Mondrian intended. And the "unconscious"
diagonal does not so much form a *repoussoir* as the "return of the repressed."

59. Nelly van Doesburg, "Some Memories of Mondrian," in *Piet Mondrian: Centenary
Exhibition*, exh. cat. (New York: Solomon R. Guggenheim Museum, 1972), 70; cf. M. Van
Domselaer-Middelhoop, "Herinneringen aan Piet Mondrian," *Maatstaf* 7 (1959–1960), 290.

60. See Holtzman, "L'atelier de New York," 86–92.

61. Nelly van Doesburg continued to live in the Meudon studio until her own death in 1976.

62. Van Doesburg wrote: "Doubtless there is much to learn from a medical laboratory. Do not artists' studios usually smell like monkey-houses? The studio of the modern painter must reflect the ambience of mountains which are nine-thousand feet high and topped with an eternal cap of snow. There the cold kills the microbes." Theo van Doesburg, "élémentarisme (les éléments de la nouvelle peinture)," *De Stijl*, Van Doesburg Memorial Issue (1932), 17–19, trans. as "Elementarism (the Elements of the New Painting)," in Baljeu, *Theo van Doesburg*, 184–185. In his third article on Mondrian's studio, the Dutch journalist had written in 1926: "here, though, the atmosphere is so snowy, the air so glacially pristine" (Henkels, *From Figuration to Abstraction*, 30).

63. "Towards White Painting," *Art Concret* (April 1930), translated in Baljeu, *Theo van Doesburg*, 183.

64. Many early International Style buildings were sanatoria and hospitals. The best known are those designed by Jan Duiker (Zonnestraal, at Hilversum, the Netherlands) and by Alvar Aalto (at Paimio, Finland).

65. Van Doesburg Archives, The Hague, box 1.

66. Letter to the Belgian architect Huib Hoste dated 20 July 1918, quoted in Alan Doig, *Theo van Doesburg: Painting into Architecture, Theory and Practice* (Cambridge: Cambridge University Press, 1986), 59.

67. Although Rietveld had made the model for the Hôtel Particulier, he executed this in his workshop in Utrecht and does not seem to have gone to Paris for the Rosenberg exhibition. Nevertheless he would have been familiar with the other two van Doesburg/van Eesteren projects from photographs and descriptions.

68. The house was credited to "G. Rietveld & Schräder" in *De Stijl* 6, 10–11 (1924–1925), 160, and to "T. Schräder et G. Rietveld" in *L'Architecture Vivante* 5 (Autumn and Winter 1925), caption to plate 33. Schräder was Truus Schröder's maiden name. Later, with the institutionalization of modernism and its largely male "pioneers" and the construction of the Schröder House as an icon of modernism through exhibitions and the writings of modernist architectural and design historians, Schröder's name was omitted from the credits. For her role in the design see Lenneke Büller and Frank den Oudsten, "Interview with Truus Schröder," in Paul Overy et al., *The Rietveld Schröder House* (London: Butterworth Architecture; Cambridge: MIT Press, 1988), 42–103.

69. After his wife died in 1957, Rietveld lived in the Schröder House until his death in 1964. Schröder died there in 1985 at the age of 95.

70. Rietveld painted a posthumous portrait of one of the directors of the Begeer jewelry company, for whom he worked intermittently as a draftsman before the First World War. The portrait is illustrated in black and white in Marijke Küper, "Rietveld," in Blotkamp et al., *De Stijl: The Formative Years*, 261, fig. 245. Küper gives further details of Rietveld's early ambitions as a painter. He showed three or four paintings at the Kunstliefde members' exhibition in April-May 1912 (p. 261).

71. In 1951 Rietveld wrote (in English): "The three mentioned painters of 'De Stijl', V. Doesburg, V. d. Leck and Mondriaan are more than other painters *supposed to be connected with architecture*. V.[an] D.[oesburg] was a painter in such a manner that he came to architectural plans very soon. (Often architects are failed painters)!!" Letter to Mr. and Mrs. de Leeuw, 8 July 1951, quoted in Frits Bless, *Rietveld 1888–1964, Een biografie* (Amsterdam: Uitgeverij Bert Bakker; Baarn: Erven Thomas Rap, 1982), 53.

72. Rietveld may well have seen the Moderne Kunstkring exhibition in Amsterdam in 1911 where French cubist works were exhibited, and would certainly have known other cubist and postcubist work from reproductions and later exhibitions. His awareness of European modernist painting almost certainly had an impact on the design of the Red Blue Chair. Recent commentators have tended to trace the origins of this chair solely within the history and practice of architectural and furniture design: the influence of the work of Frank Lloyd Wright and H. P. Berlage, Rietveld's own craft practice as a furniture maker, and medieval and Renaissance carpentry techniques. See Carel Blotkamp, "Een Rietveld Meubel van omstreeks 1480," *Jong Holland* 4 (1989), 2–4. What is certain is that it is not, as Baroni argues, a design virtually without precedent. Daniele Baroni, *The Furniture of Gerrit Thomas Rietveld* (London: Studio Vista, 1978), 42. Rietveld could have known nothing of Russian avant-garde artwork at the time he made the prototype of the chair (c. 1918). But by 1923, when he designed the asymmetric Berlin Chair and the End Table, he would have known Russian work through reproduction and probably saw the First Russian Exhibition when it was shown in Amsterdam in early 1923. The Schröder House also appears to demonstrate an awareness of constructivist ideas in its design. Perhaps this is what made it so appealing to Lissitzky. For a recent discussion of the relationship of Rietveld's furniture to painting and sculpture, see Paul Overy, "Equipment for Utopia," *Art in America* 82 (January 1994), 35–42.

73. Van Doesburg wrote a postcard in March 1924 to Rietveld saying that he had heard that he had obtained "an ideal commission," adding wistfully: "I suppose you'll do the COLOUR yourself. I haven't heard anything from you on that score!" Van Doesburg Archive, The Hague, translated in Overy et al., *The Rietveld Schröder House*. The card is illustrated in Bertus Mulder, Gerrit Jan de Rook, and Carel Blotkamp, *Rietveld Schröder Huis 1925–1975* (Utrecht and Antwerp: A. W. Bruna & Zoon, 1975), 12.

74. This painting, *Composition* (1921), is now in the Centraal Museum, Utrecht.

75. Illustrated in Overy et al., *The Rietveld Schröder House*, 108, 109.

76. In these collaborative projects Schröder was often responsible—at least in part—for the color and interior design. See Marijke Küper and Ida van Zijl, *Rietveld Schröder Archief*, exh. cat. (Utrecht: Centraal Museum, 1988); Marijke Küper and Ida van Zijl, *Gerrit Th. Rietveld, 1888–1964: The Complete Works*, exh. cat. (Utrecht: Centraal Museum, 1992).

77. For further details see Paul Overy, introduction to Overy et al., *The Rietveld Schröder House*, 13–41.

78. Schröder seems to have been an exceptionally strong woman who projected her own lifestyle as an integral part of the house and its place in architectural history. See interview with Schröder by Frank den Oudsten and Lenneke Büller in Overy et al., *The Rietveld Schröder House*, 42–103.

Two of Schröder's three children were girls; one of these, Han Schröder, worked as an architect with Rietveld for some years after the war.

79. For example by J. van den Broek in his housing at Blijdorp in Rotterdam in 1932 and by Brinkman, van der Vlugt, and van Tijen, also in Rotterdam in 1933–1934. In the latter a model apartment was supplied with Rietveld furniture by Metz & Co.

80. Quoted in Theodore Brown, *The Work of G. Rietveld* (Utrecht: Bruna & Zoon, 1958), 58.

81. Mondrian, "Home—Street—City," 212. The emphases are Mondrian's own.

82. Mondrian had returned to work in Paris by the time Rietveld became associated with De Stijl in 1919. In 1955 the latter wrote of Mondrian, "I never met him." Gerrit Rietveld, "Mondrian en het nieuwe bouwen," *Bouwkundig Weekblad* 73 (15 March 1955), 127. However, in 1958 he informed the Centraal Museum, Utrecht, that he *had* met Mondrian. According to Bless, Rietveld's children confirmed this. The contact was probably very brief (Bless, *Rietveld*, 262 n.26). Mondrian was unenthusiastic about Rietveld's furniture, writing to van Doesburg in 1920 after seeing it reproduced in *De Stijl* that it seemed to him "still a bit forced." Letter dated 11 April 1920, Van Doesburg Archive, The Hague. Rietveld discussed Mondrian's influence on architecture in "Mondrian en het nieuwe bouwen"; this is discussed in detail in Bois, "Mondrian and the Theory of Architecture," 105–106.

83. Mondrian, "Home—Street—City," 212.

7.

BEATRIZ COLOMINA

WHERE ARE WE?

It is on those occasions when we find it particularly difficult to locate ourselves that we tend to engage the question of the frame. Where are we? A complicated question in the context of a discussion of architecture and cubism, since the question itself can be argued to be a cubist question. By breaking with the perspectival cone of vision, the splintering image of the cubist painting displaces the static viewer, it mobilizes the eye in a quasi-cinematic way. But the different angles of view are not presented in any sequence, they are juxtaposed. If they can be thought of as cinematic frames, these frames are collaged together much as in Man Ray's famous technique. The viewer does not know where he or she is. This displacement is made literal in Man Ray's film *Les mystères du château du dé* (1928), where at a certain point the visitors occupying Mallet-Stevens's Villa Noailles ask themselves the all too "human question: where are we?"[1] Likewise, Le Corbusier describes the experience of the inhabitants of Villa Savoye as that of disoriented visitors: "The visitors, till now, turn round and round inside, asking themselves what is happening, understanding with difficulty the reasons for what they see and feel; they do not find anything of

7.1 Le Corbusier (1887–1965), architect; unknown photographer. Villa Savoye, Poissy, service staircase, c. 1929. From Le Corbusier, "Défense de l'architecture," *L'Architecture d'Aujourd'hui* 4, no. 10 (1933), p. 56.

choreographing a spectacle, not a fixed image but an overlapping series of views. That this specific architectural effect can be associated with cinema is evident not only from looking closely at the precise organization of the space of Le Corbusier's houses (articulated around the *promenade architecturale*) or specific details such as the *fenêtre en longueur* (a clearly cinematographic frame),[3] but also from reading what he says about his architecture. He describes Villa Savoye, for example, in terms of the way it frames the landscape and the effect this framing has on the perception of the house itself by the moving visitor:

> The house is a box in the air, pierced all around, without interruption, by a *fenêtre en longueur*. . . . The box is in the middle of meadows, dominating the orchard. . . . The single posts of the ground floor, through a precise disposition, cut up the landscape with a regularity that has the effect of *suppressing any notion of "front" or "back" of the house, or "side" of the house*. . . . The plan is pure, made for the most exact of needs. It is in its right place in the rural landscape of Poissy. But in Biarritz, it would be magnificent. . . . I am going to implant this very house in the beautiful Argentine countryside: we will have twenty houses rising from the high grass of an orchard where cows continue to graze.[4]

what is called a 'house.' They feel themselves within something entirely new. And . . . they are not bored, I believe!" (fig. 7.1).[2]

Disorientation, in these canonic scenes, is not a negative quality; on the contrary, it is a sort of entertainment, something that has to be carefully constructed by the architect or film-maker—these two roles being here thoroughly entangled. If the displacement of the viewer is associated with entertainment, the modern house itself produces that entertainment by

The house is in the air. It has no front, no back, no side. The house can be in any place. The house, in a certain sense, is *immaterial*. That is, the house is not simply constructed as a material object from which certain views then become possible. The house is no more than a series of views choreographed for the visitor, the way a film-maker effects the montage of a film.

And if Le Corbusier is a cinematographer, his "films" dislocate the viewer. The inhabitants are multiply dispersed, first because they are disoriented—they do not know how to place themselves in relation to this house; it does not even look like a "house"—and then because the inhabitant is only a visitor detached from the house with the distance of a tourist. Someone who is always asking: "where are we?"

To return to the original site of this essay—a conference on architecture and cubism to which speakers were invited as visitors—literally tourists—to an institutional and intellectual space in which I felt, at least initially, somewhat disoriented, I ask myself the same question that Le Corbusier put in the mouths of the visitors to his houses: "Where am I?" What kind of view is possible from within the space of this conference? If I am to talk of cubism here, will I pro-duce a single perspectival view of cubism, like that produced by traditional historiography, or should it be a cubist view, a splintering of cubism itself? Will we find here anything of what is called cubism? Or will this be something entirely new? Are we no longer bored?

The conference is called "Architecture and Cubism," an old theme, but what exactly does it mean here? An homage to Daniel Robbins in the Canadian Centre for Architecture. A noted historian of cubism honored in a conference housed by the CCA. *Cubism in architecture*, then. In performing this act, in convening this symposium, the CCA follows what is now a well-established tradition. It is unclear exactly what kind of influence cubism had on modern architecture and, if any, how we are to read it; what is clear, but intriguing, is that architectural discourse has, almost from the beginning, "housed" cubism. Here are some examples:

•1908: Georges Braque, "Personal Statement." Considered by Edward Fry "the earliest published eye-witness account of cubism, and the earliest

recorded statement by a cubist on his art,"[5] Braque's statement was, symptomatically, first published in an architectural journal, more precisely a "professional" journal, *The Architectural Record* of New York, as part of an article entitled "The Wild Men of Paris." In it Braque refers to one of his drawings reproduced in the article, declaring that "it was necessary to draw three figures to portray every physical aspect of a woman, just as a house must be drawn in plan, elevation and section."[6] The cubist drawing is architectural? Or is it that the woman is a kind of building and therefore "The Wild Men of Paris" will draw her in plan, section, and elevation? Or is it that architecture is a kind of woman, hence the need to draw it from every angle? In this, the very first document of cubism, the strange alliances among cubism, architecture, and sexuality are already outlined.

•1918: Amédée Ozenfant and Charles-Edouard Jeanneret (later known as Le Corbusier), *Après le cubisme*. This manifesto, based on Ozenfant's earlier text, "Notes sur le cubisme" (1916), helped, according to several authors, to "popularize" cubism, despite the authors' attempts to transcend it.[7]

•1920–1925: Le Corbusier and Ozenfant, editors, *L'Esprit Nouveau* (28 issues). The journal was described by Reyner Banham as "the last but one and by far the most substantial of a series of attempts to found a Cubist magazine in Paris."[8]

•1925: Ozenfant and Jeanneret, *La peinture moderne*. This book, made up of a series of articles reprinted from *L'Esprit Nouveau*, constitutes what Fry called "the first critical and historical evaluation of cubism."[9]

• 1941: Sigfried Giedion, *Space, Time and Architecture*. Arguably the most influential account of modern architecture, this book portrays that architecture as the consequence of a new theory of space (derived from the sciences) and new ways of perceiving space (as represented by cubism). As cubism breaks with Renaissance perspective, argues Giedion, "it is impossible to comprehend the Savoie [*sic*] house by a view from a single point; quite literally it is a construction in space-time."[10] He repeatedly insists that the interpenetration of inner and outer spaces in modern architecture corresponds to the simultaneous presentation of the inside and outside of objects in cubism.[11]

• 1948: Henry-Russell Hitchcock, *Painting toward Architecture*. Stresses both the direct influence of painting on modern architecture and that of architecture on modern painting, particularly in what he calls the "architectonic phase of cubism."[12]

• 1960: Reyner Banham, *Theory and Design in the First Machine Age*. The very first lines of the book identify "a series of revolutionary gestures around 1910, largely connected with the Cubist and Futurist movements" as the "main point of departure for the development of Modern architecture."[13]

• 1963: first publication of Colin Rowe and Robert Slutzky's essay "Transparency: Literal and Phenomenal," written in 1955–1956 and circulated in manuscript form through schools of architecture in the years prior to its publication.[14] Subsequently translated into many languages, it became the single most influential text in reopening the debate on architecture and cubism. Thirty years later it is still required reading for students of architecture in the USA and abroad. While contesting earlier associations of cubism and modern architecture

based on the "literal transparency" of materials, the article goes on to reiterate that association on the basis of what the authors define as "phenomenal" transparency, a concept they borrow from György Kepes's *Language of Vision*: "Transparency implies more than an optical characteristic, it implies a broader spatial order. Transparency means a simultaneous perception of different spatial locations."[15]

• Until the mid-1980s, students of architecture at Cooper Union, under the influence of John Hejduk and Robert Slutzky, still performed such exercises as designing a "House in the intention of Juan Gris," or "in the spirit of Léger,"[16] exercises that presuppose the possibility of translating into architecture the researches of cubist painters of the early part of the century. While these kinds of exercises have since fallen out of favor, they are still part of isolated pockets of curricula all over the country.

These are only some of the milestones. It is difficult to find any history of modern architecture, regardless of its ideology, that omits cubism. It is as central to Manfredo Tafuri and Francesco Dal Co's *Modern Architecture* (1976) as to William J. R. Curtis's *Modern Architecture since 1900* (1982). The first major account of modern architecture to omit the word "cubism," whatever one can make of this absence, is Kenneth Frampton's *Modern Architecture: A Critical History* (1980). Picasso, Braque, Gris are not mentioned here either. There is plenty of "suprematism" and Malevich, however, perhaps reflecting the interests of a new generation of architects and critics.

And yet, when I ask my colleagues: cubism and architecture? they all answer "no relation." Stanislaus von Moos, for example, insisted that the precipitate analogies established by Giedion with respect to Walter Gropius's Workshop Building for the Bauhaus at Dessau

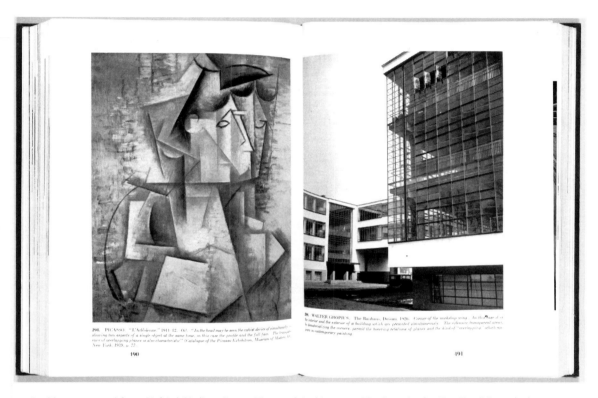

7.2 Double-page spread from Sigfried Giedion, *Space, Time and Architecture: The Growth of a New Tradition*, 3d ed. (Cambridge: Harvard University Press, 1954), pp. 490 and 491, showing Picasso's *L'Arlésienne* (1912; here dated 1911–1912) and Gropius's Workshop Building at the Bauhaus, Dessau (1925–1926).

(1925–1926) and Picasso's *L'Arlésienne* of 1912 were difficult to maintain today. Many people have demonstrated that one cannot establish such simplistic relations. Von Moos, who had been Giedion's secretary, remembered (as if in an afterthought) how much Giedion had insisted that in the layout of the book's last edition, images of those works were to be placed face to face (fig. 7.2). Even Giedion seems to have realized the fragility of his proposition (as if the argument would fall apart without the images).

Architectural discussion on the issue of cubism will pass again and again through this two-page spread of Giedion's book, even if only to contest it. Colin Rowe and Robert Slutzky write:

> In considering architectural rather than pictorial transparencies, inevitable confusions arise. For, while painting can only imply the third dimension, architecture can not suppress it. Provided with the reality rather than the counterfeit of three dimensions, in architecture, literal transparency can become

7.3 Revised version of chart prepared by Alfred H. Barr, Jr., for the jacket of the exhibition catalogue *Cubism and Abstract Art* (New York: Museum of Modern Art, 1936). The Museum of Modern Art, New York.

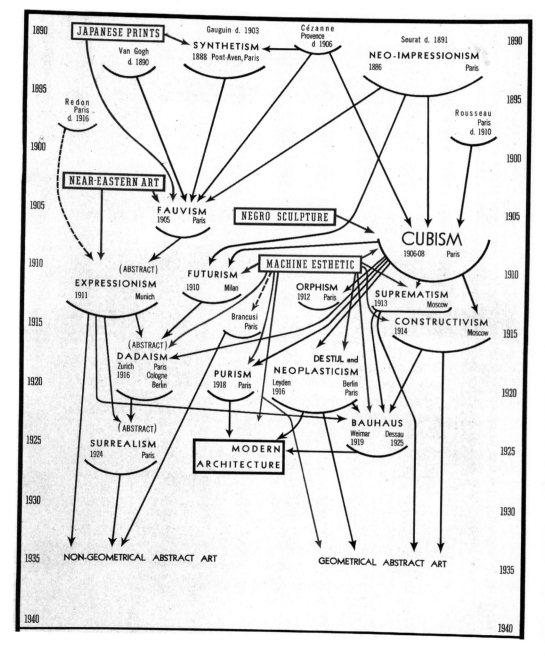

a physical fact; but phenomenal transparency will be more difficult to achieve—and is, indeed, so difficult to discuss that generally critics have been entirely willing to associate transparency in architecture exclusively with a transparency of materials. . . . Sigfried Giedion seems to assume that the presence of an all-glass wall at the Bauhaus, with "its extensive transparent areas," permits "the hovering relations of planes and the kind of 'overlapping' which appears in contemporary painting"; and he proceeds to reinforce this suggestion with a quotation from Alfred Barr on the characteristic "transparency of overlapping planes" in analytical Cubism.[17]

Likewise, Peter Collins raises serious doubts about the specific influence of cubism. While stating that "the dominant influence on architectural design during the second quarter of the century has undoubtedly been that of painting and sculpture," he nevertheless insists: "It would be an exaggeration to assume that the original Cubism of Picasso had any direct and immediate influence on architecture, for as Reyner Banham remarks in his *Theory and Design in the First Machine Age*: 'Attempts to compare buildings of the "International Style" with Cubist paintings are never very convincing.'"[18]

Collins's position is perhaps best summarized in a passage that addresses the issue of sculpture rather than architecture: "Cubist sculptors did not, as is sometimes suggested, create a new art of 'space-time.' High-relief sculpture, unlike painting, can never, from its very nature, be limited to a single view-point; hence it is absurd to state that the Belgian Cubist sculptor Vantongerloo 'demonstrated with prisms, slabs and hollows of his plastic of 1918 that contemporary sculpture, like painting, was not limited to a single point

of view.'"[19] Likewise, the multiple viewpoints required to comprehend any building defy a simple concept of "cubist" architecture.

Cubism is always invoked amid implausible grand statements about its cultural importance, as when Moholy-Nagy writes that cubism's role is "like Einstein in physics" and "Freud in psychoanalysis."[20] Leaving aside the discomfort that Einstein at least expressed about such associations—he qualified Giedion's remarks on the "parallelism" between relativity and cubism, for example, as nonsensical[21]—we could now turn Freud upon the architectural discourse on cubism itself and ask, "What is this relationship between cubism and architecture that is not there and yet is always there?" After all, it is not just my colleagues who think that there is "no relation." The whole discourse on cubism and architecture takes, as it were, the structure of disavowal; to paraphrase Freud: "I know that there is no relation, but nevertheless. . . ." One by one, each writer criticizes the previous ones for linking cubism and modern architecture, only to go on to establish yet another such link. The relationship is simultaneously affirmed and denied, or, more precisely, reaffirmed in the very act of denial. In denying the link, the historians echo Alfred Barr's *Cubism and Abstract Art* of 1936 (according to Fry, "the first serious attempt to deal with both cubism and its consequences in a systematic and historical fashion"),[22] whose famous diagram mapping the various movements (fig. 7.3) was unable to establish a direct line between cubism and modern architecture (the links between those two pass through "Purism," "De Stijl," "Suprematism" and "Bauhaus," or "Constructivism" and "Bauhaus"). But each historian gradually and emphatically draws a new line between them, a line whose status they themselves have already announced as illegitimate. Why then this desire to draw improper lines? Why the desire for an improper genealogy?

Perhaps this overdetermined fascination of architecture with cubism may have to do with the obvious sense that cubism is already architectural, if not too architectural; it deals with questions of space-time, cubes, inside-outside, and so on. *Architecture in cubism*, then. This obvious sense is, in fact, very much embedded in the discourse not just of the critics but of the cubist artists themselves. Moholy-Nagy, for example, writes: "The bizarre name 'cubism' originated with some Braque and Picasso landscapes which did not show much deviation from nature, except that windows and doors were left out of buildings. The resulting shapes were rather cube-like, hence the name."[23] And Pablo Picasso, when interviewed by Moholy-Nagy about *Guernica* in 1937, before the painting was placed in the Spanish Pavilion at the Paris World's Fair, said that he had attempted to render "*the inside and outside* of a room simultaneously."[24] Henry-Russell Hitchcock literally identifies the cubist painters as experimenting with "constructions": "Both the careful study of relations that went into their arrangement and the visual significance that was read into the results were of an order that transcended two dimensions and dealt in a non-perspective way with problems of depth and projection." The text goes on to identify the "architectonic" phase of cubism, linking it to Villa Savoye.[25]

The continuous reference to Le Corbusier is symptomatic. When architectural discourse refers to cubism, it is not to Raymond Duchamp-Villon's cubist house, considered by Banham as "little more than the routine structure of a symmetrical villa in the Mansardic tradition":

> The one surviving record (a photograph of a model and some interiors) of the Cubist architecture of Raymond Duchamp-Villon suggests that his ideas lay a long way from the progressive trends of the time of its

conception, 1912. . . . The fact that this no more than superficially Modern design was deemed worthy of illustration in Apollinaire's *Les Peintres Cubistes* suggests that the Movement as a whole was thoroughly out of touch with forward ideas in architecture—a point that is worth making in view of what has been so often said or implied about the connections between Cubism and the International Style.[26]

Likewise, Alfred Barr, in his introduction to Hitchcock's book, says that "'*modernistic*' cubist ornament of the 1920's was if anything worse than Gothic and Greek architectural cosmetics of the same decade."[27] When cubism is brought into architectural discourse it is usually as a way to discuss Le Corbusier's work. Peter Collins, for example, writes: "Cubism, in fact, was only of direct importance to architecture because it was developed by Le Corbusier into 'Purism': a type of painting which, by its interpenetration of contours, suggested what Giedion has called 'the interpenetrations of inner and outer space.'"[28] Yet again the argument takes the form of a disavowal. At the very moment that Collins is turning away from Giedion because of his particular reading of cubism in architecture, he comes back to him via Le Corbusier. Likewise, Slutzky and Rowe, after downplaying the influence of cubism in the Bauhaus building, state that they feel "obliged to look elsewhere,"[29] and they turn to Le Corbusier's Villa Stein–de Monzie at Garches.

If the significance of cubism for architecture is, according to most historians and theorists of architecture, to be found with Le Corbusier, what is normally omitted from these accounts is that Le Corbusier explicitly departed from cubism (his first text coauthored with Ozenfant was, after all, entitled *Après le cubisme*), repeatedly describing cubism as "too decorative,"

"too chaotic," "the troubled art of a troubled epoch," "individualistic," "romantic," "uncertain of its way," "ornamental," "obscure," "extremely confused," "nothing other than anarchy." Against the "chaos" of cubism, Ozenfant and Jeanneret would offer "order," "hierarchy," "rigor," "the laws of structure and composition," "efficiency," "precision," "standards," "universal values," "the right angle." The disorder of cubism would be tamed by modern rationality:

> The work of art must not be accidental, exceptional, impressionistic, inorganic, protestational, picturesque, but on the contrary, generalized, static, expressive of the invariant.
>
> For us it [purism] means purity. We use the word purism to express the characteristic of the modern spirit, the research of all efficiency. There is a tendency toward rigorous precision, the best use of force and matter. If we put the most modern art, cubism, in this atmosphere of science and industry, the discord is striking. . . .
>
> Geometry is the language of man. . . .
>
> Logic, born of human constants and without which nothing is human, is an instrument of control . . . it controls and corrects the sometimes capricious march of intuition and permits one to go ahead with certainty.[30]

The purists were concerned with establishing a new universality, a generic order, which was linked to their concern for communication: "Nothing is worthwhile that is not general, nothing is worthwhile that is not transmittable."[31] This sense of communication is in turn linked to a particular model of perception. In *La peinture moderne*, Ozenfant and Jeanneret

define the standard objects that they chose to represent in their paintings as "objects of the most perfect banality," which have "the advantage of a perfect readability and of being recognized without effort, they avoid dispersion, the deviation of attention."[32] A perceptual model of "invariable optical reactions," as Christopher Green has called them,[33] becomes the model for mass communication.

If Ozenfant and Jeanneret thought that cubism was a decorative art, it is ironic that Alfred Barr saw purist paintings as "decoration," a quality that he attributed precisely to their being "architectonic": "Purist paintings were designed architectonically so that they were appropriate decorations for the new architecture which Le Corbusier was just developing. . . . Purist painting, originally intended to be intelligible to a wide public, achieved its end obliquely through a brilliant poster by Cassandre for the *Wagon-Bar*."[34] Again communication. But the poster? Yet another reversal, inasmuch as Ozenfant and Jeanneret had themselves said that the aims of cubism would actually be better achieved with posters. But a reversal within a reversal since they admired Cassandre very much. In fact they published his posters in *L'Esprit Nouveau* before they knew they were by "Cassandre," before Cassandre was exhibited by Barr at MoMA (just before Barr published his book on cubism), that is, before Cassandre was acknowledged as an "artist."[35]

For Ozenfant and Jeanneret, on the other hand, nonrepresentational art was strictly decorative. They compare cubist paintings with wallpaper ("wallpaper resembles certain surfaces of Picasso")[36] and with tapestry ("There is no difference between the aesthetics of a tapestry and that of a cubist painting. . . . Despite their theories, the cubists have simply painted paintings composed as tapestries. . . . Cubism has done nothing other than to return the place of honor in painting to a very ancient system, the most ancient of

all, ornamental aesthetics").[37] Their precise under-
standing of decoration becomes clear in Le Corbusier's
book L'art décoratif d'aujourd'hui (1925), where he
associates decorative art with sexuality and death:
"We can see decorative art in its decline, and observe
that the almost hysterical rush in recent years towards
quasi-orgiastic decoration is no more than the final
spasm of an already foreseeable death."[38] Cubism was
understood as part of this catastrophe.

Despite Ozenfant and Jeanneret's low opinion of
cubism, or maybe because of it, their manifesto Après
le cubisme "helped," according to Peter Adam, "to
popularize the word 'cubist'": "It now entered the
vocabulary of society gatherings and, according to the
writer Maurice Sachs, was used for the most extraordi-
nary occasions: 'He is a bit Cubist'—describing a young
man with slight sexual deviance. One blamed Cubism
for the illegitimate child of a girl from a good family,
and someone who was a follower of Trotsky was
described as 'encore une Cubiste' (another Cubist)."[39]
So the category "cubist" is not simply given an illegiti-
mate genealogy by architectural historians, it is the
very figure of such deviations. But precisely how
much Ozenfant and Jeanneret's reading of cubism
contributed to this association of the term "cubist"
with deviance (sexual and political) is difficult to
ascertain. When they write: "Purism fears the bizarre
and the 'original,'"[40] they are only giving voice to wide-
spread sentiments. As Kenneth Silver has put it: "what
Purism feared was identical with the nation's fears;
that the bizarre and original were otherwise known as
revolution, anarchy, and individualism, which were also
considered anathema [in post–World War I France]."[41]
The explicit association of decoration and deviant sexual-
ity is not new either, nor can it be separated from the
political fears that Silver identifies. It brings to mind the
attack launched by Adolf Loos against the Secession,
the Deutsche Werkbund, the Wiener Werkstätte, and

all such "decorators."[42] In fact, entire passages in
Après le cubisme are reminiscent of Loos's famous
article "Ornament and Crime," first published in French
in Les Cahiers d'Aujourd'hui in 1913 and republished
in L'Esprit Nouveau no. 2. For Loos, "The lack of
ornament is a sign of intellectual power."[43] In another
text he writes: "The Critique of Pure Reason could
not have been created by a man wearing five ostrich
feathers on his hat, the Ninth Symphony did not spring
from one wearing a ring around his neck the size of
a dish."[44] But this intellectual power, which is presented
here as above the "brutalities" of the "savage," seems
in other passages to be an exclusively male attribute,
as when Loos writes: "Ornament at the service of
woman will last forever. . . . The ornament of woman . . .
answers, at bottom, that of the savage; it has an erotic
meaning."[45] The ornament, which for "the child, the
Papuan and the woman" is a "natural phenomenon,"
for modern man is a "symptom of degeneration":

> The first ornament that came into being, the
> cross, had an erotic origin. The first work of
> art, the first artistic action of the first artist
> daubing on the wall, was in order to rid him-
> self of his natural excesses. A horizontal line:
> the reclining woman. A vertical line: the man
> who penetrates her. The man who created it
> felt the same urge as Beethoven. . . . But the
> man of our time who daubs the walls with
> erotic symbols to satisfy an inner urge is a
> criminal or a degenerate.[46]

And when this "degeneration" becomes clearly
identified as homosexuality, Loos's tirade against orna-
ment is not only gender-loaded but openly homophobic.
The main target of his attack becomes the effeminate
architect, "the decorator" (the Secession and Werkbund
members), Joseph Olbrich, Kolo Moser, Josef Hoffmann:

all these "dilettanti," "fops," and "suburban dandies" who buy their "pre-tied ties in the woman's fashion displays."[47] Likewise, Le Corbusier and Ozenfant describe cubism's complicity in the effeminate realm of applied arts, wallpaper, fabrics, hat boxes, posters, embroidery, fashion, and so on:

> On the other hand, art criticism concluded its survey of cubism by enlisting agreeable consequences in the domain of the applied arts (the Salon d'Automne, that of the Decorative Arts, and much wallpaper, fabrics, hat boxes, etc.) And finally—oh yes!—in the poster, where it is deemed infinitely spiritual to see triumph, on a plane and level that are completely different and inferior, the physiologically true formulae, which in cubism were nothing other than the first means of expression of a spirit that sought to address the depths in ourselves. Same story in the theater, in the ballet, and in the music hall, where the previous events had put Monet at the service of the casinos, as Cézanne had been put to use by the posters of the railways, Egypt and Persia by the embroiderers and the couturiers.[48]

A rhetoric of masculine vigor is deployed against the subservient role of high culture in the service of decoration: "Art before the great Test was not alive enough *to invigorate* the idle, nor to interest the *vigorous*."[49] The "Test" that the vigorous figure is to survive is, of course, the war, but the war understood as a war against the forces of chaos, which is to say, in the end, the dangerous forces of decoration: "If the Greek triumphed over the barbarian, if Europe, inheritor of Greek thought, dominates the world, it is because the savages like loud colors and the noisy sound of tambourines which engage only the senses, while the Greeks loved the intellectual beauty that hides beneath sensory beauty."[50]

The rhetoric of vigor and the whole aesthetic regime it props up has to be understood in terms of this fear of the "bizarre and the original." The heroic male figure—energetic, cool and detached—is the figure of modernity. Architectural *order* here, the control of the senses, is first and foremost social control. Purism is puritanism, in the sense of a regime that maintains a clear distinction between straight sex and deviant sex. Neither Le Corbusier nor Loos is against sex. On the contrary, Le Corbusier employs the term "jouissance," with its irreducibly sexual meaning, to describe the much-needed transcendence over the basic "pleasures" of the senses. In *La peinture moderne*, Ozenfant and Jeanneret justify the need for painting on the grounds of its capacity to provide us "jouissance," something quite above the "pleasures" of a beautiful object.[51] Elsewhere, Le Corbusier discriminates between two kinds of pleasure:

> They say: "Beauty is pleasure; this is beautiful because I have pleasure; that is not beautiful because I don't have pleasure." . . . I cut a straight line in two: Pleasure?
> You confuse pleasure of the senses with delight of the spirit. . . . In every man there is a monkey; the monkey is always moving and distracted; we have to occupy the monkey; then the spirit liberates itself. In the medium of art there is the drum. The monkey is a musician, that is, his stomach is sensitive to the beat of the drum. . . . In music we have *syncopation*, excellent word; to perturb the movement of the heart, to syncopate the spectator; to intoxicate him, to intoxicate the monkey which is in everyone of us, then talk to the spirit. . . . PURISM. First of all,

to occupy the monkey. . . . Then to speak to the intellect.[52]

Cubism occupies the monkey but forgets to talk to the intellect. It wallows in sensuality. But if Ozenfant and Jeanneret thought of cubism as a deviant and decadent art, this is, ironically, precisely the way in which the historians of cubism have seen purism, as a "symptom of a crisis in cubism."[53] As Rosalind Krauss has put it: "Deviation, devolution, decline, détente . . . those are the terms of description that get applied to the cubism of the 1920s, to the late cubism of Picasso, Gris, and Léger, to the late arrival of the Purist credo of Ozenfant and Jeanneret/Le Corbusier."[54] Just as for the purists cubism is decorative, and for the art historians purism is architectural and therefore decorative, likewise for the purist cubism is deviant and for the art historian purism is deviant. Which leaves us with questions such as: is deviance from deviance straight? Is cubism positioned within a system of relative oppositions that keep reversing in some kind of pathological spiral, just as Freud's account of disavowal would suggest—a nervously oscillating economy that produces a much greater multiplicity of viewpoints on the same object than any of the standard theories of cubism have dreamed of?

To begin to understand how the sexual and political overdetermination of this scene affects the specific relation between cubism and architecture, one has to understand that this relationship never was one of cause and effect. While both cubism and modern architecture are organized around a particular model of perception, they did not produce it; rather, they participated in it. Jeanneret and Ozenfant were well aware of this. While clearly identifying modernity with a transformation of perception, they do not trace this transformation to changes in artistic forms of representation, but to the conditions of perception in

metropolitan life. In that respect they are close to Walter Benjamin who, in his extraordinary account of the transformations of life in the late nineteenth and early twentieth centuries, dismissed "art" as an irrelevant form of expression for that historical period. Likewise, Ozenfant and Jeanneret insist that "Art (in its current meaning) is almost totally foreign [étranger] to the modern spirit."[55]

This aspect of Le Corbusier has been particularly clouded in the criticism of his work because he was also a painter. Painting for him—how many times have we heard it?—was more important than his architecture. He painted in the mornings and did architecture in the afternoons. (Even a night person would agree that the afternoon is inferior time.) But when he writes his most art historical book with Ozenfant, La peinture moderne, he starts by interrogating the very need for painting today:

> Our civilization, rational, in its machinist stage, does it have a need for painting?
>
> Yes, because the plastic arts, together with music and poetry, constitute efficient means to distract us and to elevate us above the fatiguing reality. Moreover, they give our senses and our spirit extremely moving *jouissances* of such nature that they alone can provoke them.[56]

The function of art turns out to be to *distract* us from *tiring* reality in order that we can experience *jouissance*. It is difficult not to read these terms as referring to metropolitan life—art elevates us above the fatiguing everyday chaos. The decorative impulse of cubism imitates metropolitan disorder. The question mark about painting continues into the first chapter, entitled "Destination de la peinture," where Ozenfant and Jeanneret write: "Imitative art has been left

7.4 Amédée Ozenfant (1886–1966) and Charles-Edouard Jeanneret [Le Corbusier] (1887–1965), authors; unknown photographer. "The equipment of a dentist" and "Open filing cabinet." From Ozenfant and Jeanneret, *La peinture moderne*, Collection L'Esprit Nouveau, 2d ed. (Paris: G. Crès, 1925), pp. 67 and 69.

behind by photography and cinema. The press and the book operate much more efficiently than art relative to religious, moral, or political aims. What purpose remains assigned to the art of today?"[57] And again in the second chapter, "Nature et création," where they establish the point that the "natural spectacle does not satisfy our need for art": "Forgive me, but art is not a Kodak designed to summon up Mr. So-and-So's greater or lesser experiences, or a kind of Thomas Cook guidebook of beautiful journeys." They conclude once again that "the destiny of painting" is "to satisfy our superior needs."[58]

It is in the third chapter, "Formation de l'optique moderne," that the argument comes to a head. It is not painting that has shaped the way we see, it is the other way around: "Painting cannot approach our spirit other than through our eyes. Our eyes have been very refined by the *intensive spectacle of modern life*."

The modification of the external structure of our existence had profound effects, not on the fundamental properties of our sight but on the intensity and speed of our vision, its depth, the scope of its register, its tolerance of as yet unknown spectacles (the frequency of images, new color spectra in new relations, thanks to the invention of jarring synthetic colors, etc.); an education for the eye quite as much as for the ear: a peasant arriving in Paris is instantly stunned by the multiplicity and intensity of sounds that assail him; he is at the same time dazzled by the seeming cacophony of the images he must register at unaccustomed speeds. . . . It is not only the sights of the street that have changed us. Framing these sights at an ever-accelerating speed, shopfronts in rapid succession impose on us the countless objects turned out by modern industry, all characterized by the imperative of precision that is the fatal consequence of machinism.[59]

7.5 Le Corbusier (1887–1965), architect; Lucien Hervé, photographer. Villas La Roche–Jeanneret, Paris-Auteuil, 1923. From Le Corbusier and Pierre Jeanneret, *Oeuvre complète de 1910–1929*, new ed. (Zurich: H. Girsberger, 1937), p. 63.

In this chapter, illustrated with what Banham describes as "a purely futuristic set of images" (a car, New York by night, the skeleton of an airship hangar, the equipment of a dentist's surgery, a calculating machine, and a filing system), Jeanneret and Ozenfant make the argument that it is the city that has shaped our modern vision (fig. 7.4). In this they coincide with Benjamin, whose meticulous mapping of the transformation of per-

ception with modernity pays no attention to painting. He does talk about architecture, however. Quite aside from specific references to Loos, Le Corbusier, Gropius, and others, the city occupies a crucial role in Benjamin's writings: "People now have to adapt to this strange situation: big cities." What is "strange" about the city turns out to be the speed, the continuous movement, the sense that nothing stops. It is precisely with

this restless movement that a new form of perception arrives that has become the trademark of modernity. Perception is now tied to transience.[60]

For Benjamin, architecture provides the model of an (ancient) art whose reception occurs collectively and in a state of distraction. It is a form of reception that "finds in the film its true form of exercise." The "distracting element" in film is also "primarily tactile." It "hits" the spectator like a "bullet." Unlike painting "which invites the spectator to contemplation," the spectator before the "movie frame" can no longer do that: "No sooner has his eye grasped a scene than it is already changed. It cannot be arrested."[61]

This is the form of perception in big cities, in department stores, in trains—and perhaps in modern architecture. One of the links between cubism and modern architecture turns out to be the city. But perhaps the strongest bond between them is actually to be found in their customers. Several clients of Le Corbusier were art collectors. Among them was Raoul La Roche, a young banker, director of the Crédit Commercial de France, originally from Basilea, who was one of the major sponsors of *L'Esprit Nouveau* and who commissioned Ozenfant and Jeanneret to purchase for him a collection of cubist paintings (from the dealers Kahnweiler and Uhde) and who also bought paintings by Ozenfant and Jeanneret.[62] La Roche commissioned Le Corbusier to design a house in which he could display his paintings. As he wrote to Le Corbusier: "My house will form . . . a frame worthy of your painting on which still success has so far not smiled, at least in Paris. One only has to wait."[63]

Cubism in architecture, again. Modern architecture as a "frame" for cubist and purist paintings.

It is important to remember that the purists were among the first to "modernize" the frame. In a letter to Oskar Schlemmer from Paris in 1924, Willi Baumeister writes: "Dear Oscar, money = trade and change; change

is Paris where I've had news of this and that; trade is selling art to the dealer Léonce Rosahär [Rosenberg]. I have a few temperas which he liked. He took 10 on commission. Very low prices, he said that one has to start low in Paris. He doesn't want any canvases right now. He told me that Gleizes, whose work is more abstract, is selling nothing." The letter goes on about the artists whose work Baumeister had seen in Paris (Léger, Ozenfant, Jeanneret, Lipchitz, Picasso, Braque) and concludes: "I found the modern spirit in Léger's work, but it is at its purest in Jeanneret's architecture. The weight of tradition in those *baroque frames* that are still being used; even Léger has old frames (true, slightly simplified). On this point, only Ozenfant and Jeanneret do any better; they use very simple frames but which are not good in that the canvas is built in, which means that one side is always in shadow."[64]

If Jeanneret and Ozenfant modernize the frame, the La Roche house is used to reframe cubism. But what exactly is this architectural frame?

Square du docteur Blanche, a small cul-de-sac in Paris-Auteuil, an invaginated space, a street folded upon itself, a space halfway between a street and an interior, a private road. At the end of this dead-end street, number 8–10, Villas La Roche–Jeanneret, a "double house," "*deux maisons accouplées*," that Le Corbusier designed for Lotti Raaf and his brother, Albert Jeanneret, and for his patron Raoul La Roche, in 1923 (fig. 7.5). Is 8–10 square du docteur Blanche private or public? A house or an exhibit, an archive or a library, an art gallery or a museum? The dilemma was already present in the original program, since La Roche had an art collection to display in the house (fig. 7.6); indeed, he used to open the house to the public on Tuesdays and Fridays, as Green put it, "providing superb publicity."[65] But publicity for the architecture or for the paintings? Not only was the building commissioned to "house" the paintings, but visitors used to write their

names in a book by the door. Soon the issue of whether visitors were signing in for the paintings or for the house became blurred, at least for Le Corbusier, who later recommended to Madame Savoye that she leave a "golden book" by the entrance to her house too (even if she did not have an art collection displayed there): "You will see how many fine autographs you will collect. This is what La Roche does in Auteuil, and his Golden Book has become a veritable international directory."[66] Conflict arose between Le Corbusier and both La Roche and Ozenfant on precisely this issue: Le Corbusier wanted some of the walls to be kept free of paintings. He wrote to Ozenfant: "The La Roche house should not take on the look of a house of a (postage-stamp) collector. I insist absolutely that certain parts of the architecture should be entirely free of paintings, so as to create a double effect of pure architecture on the one hand and pure painting on the other."[67] La Roche responded to Le Corbusier's desire to exhibit the house itself: "I commissioned from you a 'frame for my collection'. You provided me with a 'poem of walls'. Which of us two is most to blame?"[68]

But where are we? How exactly are we meant to enter this frame that is itself an artwork on exhibit?

No traditional entry presents itself. The house is L-shaped. The "pavillon La Roche," behind a wire mesh security fence, closes the cul-de-sac, but since it is on pilotis the space of the street flows under the house. To the right, two small identical doors almost flush with the facade seem to say that there is nothing to be found behind them. The protruding belly of La Roche's gallery pushes the visitor away, back into the space of the street, while at the same time its curve points to the corner, to the hinge of the house where the fence has a small built-in door. Pass through it. Now you see the driveway sweeping toward you. Perhaps the entrance was not clear because we were expected, as in the other houses of Le Corbusier, to arrive by car. On the right,

the wall recedes, creating an entrance space. In the middle, hidden from the street, you finally see the door.

In the *Oeuvre complète*, Le Corbusier goes out of his way to describe the entry into this house. It turns out to be all a matter of vision:

> You enter: the architectural *spectacle* at once offers itself to the *eye*; you follow an itinerary and the *views* develop with great variety; you play with the flood of *light* illuminating the walls or creating *half-lights*. Large *windows* open up *views* on the exterior where you find again the architectural unity. In the interior the first attempts at polychromy . . . allow the "*camouflage architectural*," that is, the affirmation of certain volumes or, the contrary, their effacement. Here, reborn for our *modern eyes*, are historic architectural events: pilotis, the horizontal window, the roof garden, the glass facade.[69]

To *enter* is to *see*. Not to see a static object, a building, a fixed place, but architecture taking place in history, the events of architecture, architecture as an event. It is not so much that you enter architecture as that you witness architecture's entrance. The elements of modern architecture (pilotis, horizontal window, roof garden, the glass facade) are seen being "born" in front of your eyes. And by that act they make those eyes "modern."

Modern eyes move. Vision in Le Corbusier's architecture is always tied to movement: "you follow an itinerary," a *promenade architecturale*. About this Le Corbusier will become more explicit in his Villa Savoye at Poissy (1929–1931):

> Arab architecture gives us a precious lesson. It is appreciated by walking, on foot; it is by

7.6 Le Corbusier (1887–1965), architect; F. R. Yerbury/Architectural Association, photographer. Villas La Roche–Jeanneret, Paris-Auteuil, 1923, gallery with the La Roche collection in 1926–1928. From *Le Corbusier, Architect of the Century* (London: Arts Council of Great Britain, 1987), plate 54, p. 146.

walking, by moving, that one sees the order of architecture developing. It is a principle contrary to that of baroque architecture, which is conceived on paper, around a fixed theoretical point. I prefer the lesson of Arab architecture. In this house it's a question of a real architectural promenade, offering constantly changing views, unexpected, sometimes astonishing.[70]

The point of view of modern architecture is never fixed, as it is in baroque architecture,[71] or as in the model of vision of the camera obscura, but is always in motion, as in film or in the city. Crowds, shoppers in a department store, railroad travelers, and the inhabitants of Le Corbusier's houses have in common with movie viewers that they cannot fix (arrest) the image. Like the movie viewer that Benjamin describes ("No

sooner has his eye grasped a scene than it is already changed"),[72] they inhabit a space that is neither inside nor outside, public nor private (in the traditional understanding of these terms). It is a space that is not made of walls but of images. Images as walls. Or as Le Corbusier puts it, "walls of light."[73] That is, the walls that define the space are no longer solid walls punctuated by small windows but have been dematerialized, thinned down with new building technologies and replaced by horizontally extended windows, lines of glass whose views now define the space.[74] The walls that are not transparent now float in the space of the house rather than produce it. "Interrogated by Rasmussen about the entrance hall of the La Roche house, Le Corbusier answers that the most important element of the hall is the big window and for that reason he had prolonged the upper edge of the window to match the parapet of the library."[75] The window is no

longer a hole in a wall, it has taken over the wall. And if, as Rasmussen points out, "the walls give the impression of being made out of paper," the big window is a paper wall with a picture on it, a picture wall, a (movie) screen. Le Corbusier will literally describe the villa at Garches in these terms: "The facades are considered as carriers of light. Not one of them touches the ground. On the contrary, they are suspended from the cantilevered floors. Therefore, the facade carries neither floors nor the roof; it is nothing more than a veil of glass or masonry enclosing the house."[76]

Le Corbusier's definition of the primordial idea of the house — "The house is a shelter, an enclosed space, which affords protection against cold, heat, *and outside observation*" — would have been commonplace if it had not included the question of the view. Seeing, for Le Corbusier, is the primordial activity in the house. The house is a device through which to see the world, a mechanism for viewing. Shelter, separation from the outside, is provided by the window's ability to turn the threatening world outside the house into a reassuring picture. The inhabitant is enveloped, wrapped, protected by the pictures. But how constrained these early windows were, laments Le Corbusier: the window is the "most restricted *organ* of the house." (Significantly, he says "organ" rather than element, because the window is thought of first and foremost as an eye.) Today, the facade, no longer "constricted" by the old building technologies that made the wall responsible for bearing the load of the building,

> fulfills its true destiny; it is the provider of light. . . . From this emerges the true definition of the house: stages of floors . . . all around them *walls of light.*
>
> *Walls of light*! Henceforth the idea of the window will be modified. Till now the

function of the window was to provide light and air and to be looked through. Of these classified functions I should retain one only, that of being looked through. . . . *To see out of doors, to lean out.*" [77]

The modern transformation of the house produces a space defined by walls of (moving) images. This is the space of the media, of publicity. To be "inside" this space is only to see. To be "outside" is to be *in* the image, to be seen, whether in the press photograph, a magazine, a movie, on television, or at your window. It has less to do with a public space, in the traditional sense of a public forum, a square, or the crowd that gathers around a speaker in such a place, than with the audience that each medium of publication reaches, independent of the place this audience might actually be occupying. But, of course, the fact that (for the most part) this audience is indeed at home is not without consequence. The private is, in this sense, now more public than the public.

Likewise, the literal experience of the private domestic interior is no longer radically different from that of the city. Le Corbusier's interior spaces are those of the city. In this way, the mobile cinematic, if not metropolitan, sense of the house coincides with that of cubism. While the paintings were hung along the promenade of the La Roche house (and it is important to remember that this is the first promenade) in a precise way that was meant to demonstrate the triumph of purist painting over cubist painting, the house itself, its very promenade, remains closer to the sensibility of the cubist work it was meant at once to frame and to subordinate.

So where are we? It seems I have ended up, like so many historians of architecture, reestablishing the very link between cubism and modern architecture that I have called into question. But clearly the story does not

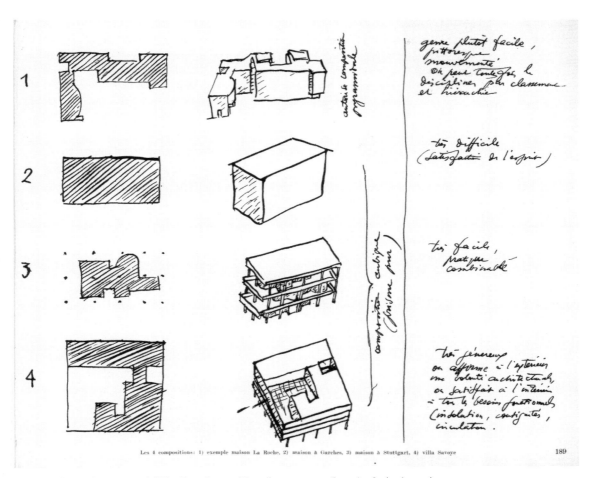

Les 4 compositions: 1) exemple maison La Roche, 2) maison à Garches, 3) maison à Stuttgart, 4) villa Savoye 189

7.7 Le Corbusier (1887–1965). "The Four Compositions," 1928–1929. From Le Corbusier and Pierre Jeanneret, *Oeuvre complète de 1910–1929* (Zurich: H. Girsberger, 1930, 1977), p. 189.

end here. There are many more angles needed to complete this painting. One of which is that, symptomatically, Le Corbusier will later describe the La Roche house as too complicated, too picturesque. In the "Four Compositions" of 1929 (fig. 7.7), he sets "maison La Roche" apart from "maison à Garches," "maison à Stuttgart," and "villa Savoye." While the last three qualify as "purisme pur," La Roche is considered as "genre plutôt facile," "pittoresque," "mouvementé."[78] Too easy, too pretty, too much movement, too many angles, too decorative. Too cubist, perhaps?

7.

NOTES

1. "Alors retentit pour la première fois, cette question, cette humaine question: où sommes-nous?" The setting for this movie is the "cubist" Villa Noailles in Hyères, designed and built by Robert Mallet-Stevens in 1922 for Charles, vicomte de Noailles, a collector of modern art who also commissioned this movie from Man Ray. About the film see Michel Louis, "Mallet-Stevens and the Cinema, 1919–1929," in Dominique Deshoulières and Hubert Jeanneau, eds., *Rob Mallet-Stevens, Architecte* (Brussels: Archives d'Architecture Moderne, 1980), text in French and English, 123–159. See also Richard Becherer, "Chancing It in the Architecture of Surrealist *Mise-en-Scène*," *Modulus* 18 (1987), 63–87.

2. Le Corbusier, *Précisions sur un état présent de l'architecture et de l'urbanisme* (Paris: G. Crès, 1930), 136.

3. For an extended argument on the relation between Le Corbusier's architecture and film see my *Privacy and Publicity: Modern Architecture as Mass Media* (Cambridge: MIT Press, 1994), particularly the chapters "Photography" and "Window."

4. Le Corbusier, *Précisions*, 136–138. Emphasis added.

5. Edward F. Fry, *Cubism* (New York: Oxford University Press, 1966), 53–54. The interview with Braque that contains his statement can be dated to the fall or winter of 1908.

6. Gelett Burgess, "The Wild Men of Paris," *Architectural Record* 27 (May 1910), 405.

7. See for example Susan L. Ball, *Ozenfant and Purism: The Evolution of a Style 1915–1930* (Ann Arbor: UMI Research Press, 1981), 62–68.

8. Reyner Banham, *Theory and Design in the First Machine Age* (New York: Praeger Publishers, 1960), 208.

9. Fry, *Cubism*, 176.

10. Sigfried Giedion, *Space, Time and Architecture: The Growth of a New Tradition* (Cambridge: Harvard University Press, 1941), 416.

11. "Around 1910 Picasso and Braque, as the consequence of a new conception of space, exhibited the interiors and exteriors of objects simultaneously. In architecture Le Corbusier developed, on the same principle, the interpenetration of inner and outer space." Ibid., 408.

12. Henry-Russell Hitchcock, *Painting toward Architecture* (New York: Duell, Sloan and Pearce, 1948), 22. The "architectonic phase of cubism" is, for Hitchcock, "the second stage of cubism, beginning about 1912, which is called synthetic."

13. Banham, *Theory and Design*, 14.

14. Colin Rowe and Robert Slutzky, "Transparency: Literal and Phenomenal," in Colin Rowe, *The Mathematics of the Ideal Villa and Other Essays* (Cambridge: MIT Press, 1976), 159–183. This essay was written in 1955–1956 and first published in *Perspecta* in 1963; it was translated into German as *Transparenz*, ed. B. Hoesli (Basel: Birkhäuser, 1968).

15. György Kepes, *Language of Vision* (Chicago: Paul Theobald, 1944), 77, quoted by Rowe and Slutzky in "Transparency," 161.

16. *Education of an Architect: A Point of View* (New York: Cooper Union, 1971).

17. Rowe and Slutzky, "Transparency," 166.

18. Peter Collins, *Changing Ideals in Modern Architecture, 1750–1950* (Montreal: McGill University Press, 1967), 279.

19. Ibid.

20. László Moholy-Nagy, *Vision in Motion* (Chicago: Paul Theobald, 1947), 116.

21. According to Arnold Whittick, when Erich Mendelsohn discovered that his name was not mentioned in *Space, Time and Architecture*, he ripped out pages from Giedion's book where relativity and cubism were brought into relationship with one another and sent them to Einstein. Einstein replied: "Nicht schwer ist's Neues auszusagen/ Wenn jeden Blödsinn man will wagen/ Dennseltner fuget sich dabei/Dass Neues auch Vernünftig sei. (There's ease in innovation's spread/ If thereby nonsense dare be said/ For seldom is there any chance/ Of new ideas *and* common sense.)" Arnold Whittick, *Eric Mendelsohn*, 2d ed. (London, 1956). Quoted in Sokratis Georgiadis, *Sigfried Giedion, an Intellectual Biography*, trans. Colin Hall (Edinburgh: Edinburgh University Press, 1993), 124–125.

22. Fry, *Cubism*, 176.

23. Moholy-Nagy, *Vision in Motion*, 116.

24. Ibid., 249.

25. Hitchcock, *Painting toward Architecture*, 22–23.

26. Banham, *Theory and Design*, 203.

27. Alfred H. Barr, Jr., foreword to Hitchcock, *Painting toward Architecture*, 9.

28. Collins, *Changing Ideals in Modern Architecture*, 279.

29. Rowe and Slutzky, "Transparency," 167.

30. Fragments extracted from Amédée Ozenfant and Charles-Edouard Jeanneret, *Après le cubisme* (Paris: Editions des Commentaires, 1918), and "Le purisme," *L'Esprit Nouveau* 4 (1920), 369–386.

31. Ozenfant and Jeanneret, "Le purisme"; English translation as "Purism," in Robert L. Herbert, ed., *Modern Artists on Art: Ten Unabridged Essays* (Englewood Cliffs, N.J.: Prentice-Hall, 1964), 60.

32. Amédée Ozenfant and Charles-Edouard Jeanneret, *La peinture moderne* (Paris: G. Crès, 1925), 168.

33. "A grammar and syntax of sensation is elaborated by the Purists as a foundation of art. Form, line and colour are seen as the elements of a language which does not change from culture to culture because it is based on invariable optical reactions." Christopher Green, "Purism," in Nikos Stangos, ed., *Concepts of Modern Art* (London: Thames & Hudson, 1981), 82.

34. Alfred H. Barr, Jr., *Cubism and Abstract Art* (1936; rpt. New York: Museum of Modern Art, 1966), 166.

35. "Actualités," *L'Esprit Nouveau* 25, signed P. Boulard (one of Le Corbusier's pseudonyms): "Le tumulte est dans les rues. Le Bûcheron pavoise au Boulevard Saint-Germain. En dix jours, le cubisme sur un kilomètre, s'étale et est présenté au populaire." The posters that Le Corbusier was here admiring were those of Cassandre. However, he did not know at the time, or did not acknowledge, their authorship. Instead he wrote to the company the posters were advertising, Le Boucheron, in an effort to obtain a publicity contract for *L'Esprit Nouveau*. See letters of 6 and 14 June 1924, in Fondation Le Corbusier, A1 (17). Of course, Cassandre's posters were not "art" for Le Corbusier, but one more instance of the beautiful objects the industrialized everyday life was producing. See Colomina, *Privacy and Publicity*, 217–219.

36. "Le papier peint . . . ressemble à certaines surfaces des Picasso." Ozenfant and Jeanneret, *Après le cubisme*, 46.

37. "Il n'y a pas de différence entre l'esthétique d'un tapis et celle d'un tableau cubiste. Y avait-il sujet à scandale? Malgré leurs théories, les cubistes ont simplement peint des tableaux composés comme des tapis. . . . Le Cubisme n'a fait que remettre en honneur dans la peinture un très ancien système, le plus ancien de tous, l'esthétique ornementale." Ibid., 15.

38. Le Corbusier, *L'art décoratif d'aujourd'hui* (Paris: G. Crès, 1925), 96. In English as *The Decorative Art of Today*, trans. James I. Dunnett (Cambridge: MIT Press, 1987), 96.

39. Peter Adam, *Eileen Gray: Architect/Designer* (New York: Harry N. Abrams, 1987), 94.

40. Ozenfant and Jeanneret, *Après le cubisme*, 60.

41. Kenneth Silver, *Esprit de Corps: The Art of the Parisian Avant-Garde and the First World War, 1914–1925* (Princeton: Princeton University Press, 1989), 231.

42. Ozenfant and Jeanneret were thoroughly aware of Loos. Not only did they republish his article "Ornament and Crime" in *L'Esprit Nouveau* no. 2 (1920), but in the archives of the journal one can find correspondence, other articles by Loos (already in French) that were never published, issues of *Das Andere*, etc.

43. Adolf Loos, "Ornament und Verbrechen" (1908); English translation as "Ornament and Crime," in *The Architecture of Adolf Loos: An Arts Council Exhibition* (London: Arts Council of Great Britain, 1985), 103.

44. Adolf Loos, "Die Überflüssigen (1908), in *Sämtliche Schriften, Adolf Loos*, vol. 1 (Vienna and Munich: Verlag Herold, 1962), 269.

45. Adolf Loos, "Ornament und Erziehung" (1924), in *Sämtliche Schriften*, 1:395–396.

46. Adolf Loos, "Ornament and Crime" (1908), in *The Architecture of Adolf Loos*, 100.

47. Adolf Loos, "Underclothes," *Neue Freie Presse*, 25 September 1898, translation in *Spoken into the Void: Collected Essays 1897–1900*, trans. Jane O. Newman and John H. Smith (Cambridge

MIT Press, 1982), 75. The "pre-tied ties" that Loos goes on and on about are cardboard-inset ties that Hoffmann will later accuse Loos of having used himself. See also "The Leather Goods and Gold- and Silversmith Trades," *Neue Freie Presse*, 15 May 1898, translation in *Spoken into the Void*, 7–9.

48. "Par ailleurs, la critique d'art terminait son bilan du cubisme par l'inscription à l'actif, d'agréables conséquences dans le domaine des arts appliqués (le Salon d'Automne, celui des Arts décoratifs et puis tant de papiers peints, d'étoffes, de cartons à chapeaux, etc.). Et enfin,—alors oui!—dans l'affiche où l'on trouve infiniment spirituel de voir triompher, sur un plan et un niveau tout à fait différents et inférieurs, les formules physiologiquement vraies qui dans le cubisme n'é-taient que le moyen premier d'expression d'un esprit qui entendait s'adresser au profond de nous-mêmes. Même aventure au théâtre, aux ballets et au music-hall, où l'événement antérieur avait fait mettre Monet au service des casinos, comme Cézanne avait été mis à celui des affiches de chemin de fer, la Perse et l'Égypte au service des brodeurs et des couturiers." Ozenfant and Jeanneret, *La peinture moderne*, 137.

49. "L'Art avant la Grande Epreuve n'était pas assez vivant pour tonifier les oisifs, ni pour intéresser les actifs." Ozenfant and Jeanneret, *Après le cubisme*, 11.

50. "Si . . . les Grecs ont triomphé des barbares, si l'Europe, héritière de la pensée des Grecs, domine le monde, c'est parce que les sauvages aimaient les couleurs criardes et les sons bruyants du tambour qui n'occupent que leurs sens, tandis que les Grecs aimaient la beauté intellectuelle qui se cache sous la beauté sensible." Ibid., 48.

51. Ozenfant and Jeanneret, *La peinture moderne*, I. Lacan has made the distinction between the meaning of *jouissance* and *plaisir*. There is no equivalent in English for *jouissance*: "in modern English, the word has lost the sexual connotations it still retains in French. (*Jouir* is slang for 'to come'.) 'Pleasure,' on the other hand, is preempted by *plaisir*—and Lacan uses the two terms quite differently. 'Pleasure' obeys the laws of homeostasis that Freud evokes in *Beyond the Pleasure Principle*, whereby, through discharge, the psyche seeks the lowest possible level of tension. '*Jouissance*' transgresses this law and, in that respect, it is *beyond* the pleasure principle." "Translator's Note" in Jacques Lacan, *The Four Fundamental Concepts of Psycho-Analysis*, trans. Alan Sheridan (New York: Norton, 1981), 281. It is interesting to note that Le Corbusier seems to be after the same differentiation between pleasure and *jouissance*, both in his writings about art and about architecture.

52. "On dit: 'Le beau, c'est le Plaisir; ceci est beau parce que j'en ai du plaisir; cela n'est pas beau parce que je n'en ai pas de plaisir.' . . . Je coupe une ligne droite en deux: Plaisir? Vous confondez plaisir des sens et délectation de l'esprit. . . . Dans chaque homme il y a un singe; le singe est remuant et toujours distrait; il faut occuper le singe; alors l'esprit se libère. Dans le moyen de l'art il y a le tambour. Le singe est musicien, c'est-à-dire que son ventre est sensible au bruit du tambour. . . . Dans le moyen de la musique il y a la syncope; mot excellent; perturber le mouvement du coeur, syncoper le spectateur, le griser, griser le singe que chacun a en soi avant de parler à son esprit. . . . PURISME. Tout d'abord—occuper le singe. . . . Ensuite parler à l'intellect." Vauvrecy, "Ce mois passé . . . ," *L'Esprit Nouveau* 9, 1011–1013.

53. "Purism was but one of several symptoms, appearing by the early 1920s, of a crisis in cubism." Fry, *Cubism*, 172.

54. Rosalind Krauss, "Léger, Le Corbusier, and Purism," *Artforum* 10, no. 8 (April 1972), 51.

55. "'L''Art' (acception actuelle) est presque totalement étranger à l'esprit moderne." Ozenfant and Jeanneret, *Après le cubisme*, 28.

56. "Notre civilisation, rationnelle, au stade machiniste, a-t-elle besoin de peinture? Oui, car les arts plastiques, avec la musique et la poésie, constituent le moyen efficace de nous distraire et de nous élever au-dessus de la fatigante réalité. Plus que cela, ils donnent à nos sens et à notre esprit des jouissances extrêmement émouvantes et d'une nature telle qu'eux seuls peuvent les provoquer." Ozenfant and Jeanneret, *La peinture moderne*, 1.

57. "L'art d'imitation est distancé par la photographie et le cinéma. La presse, le livre agissent plus efficacement que l'art à fins religieuses, moralisatrices ou politiques. Quelle destination demeure départie à l'art d'aujourd'hui?" Ibid.

58. "Pardon, l'art n'est pas le kodak chargé de rappeler à Monsieur ses petites ou ses grandes émotions vécues, ou le guide Cook des beaux voyages." Ibid., 39. "... satisfaire à nos besoins supérieurs." Ibid., 11.

59. "Les modifications du cadre extérieur de notre existence ont réagi profondément, non sur les propriétés fondamentales de notre optique, mais sur l'intensité et la vitesse fonctionnelle de notre vue, sa pénétration, l'extension de sa capacité d'enregistrement, sa tolérance à des spectacles autrefois inconnus (fréquence des images, nouvelles gammes de couleurs en rapports nouveaux dus à l'invention des violentes couleurs chimiques, etc.); il en est de l'éducation de l'oeil comme de celle de l'oreille: un paysan arrivant à Paris est de suite abruti par la multiplicité, l'intensité des bruits qui l'assaillent; il est en même temps comme ébloui par l'apparente cacophonie des images qu'il doit enregistrer avec une vitesse à laquelle il n'est pas entraîné. . . . Il n'est pas que les spectacles de la rue qui nous aient profondément modifiés. Faisant cadre à ces spectacles de vitesse toujours accélérée, les boutiques à la file les unes des autres nous imposent les innombrables objets de l'industrie moderne, tous caractérisés par cette impérative précision qui est la conséquence fatale du machinisme." Ibid., 63–65.

60. About the transformation of perception in modernity see Jonathan Crary, *Techniques of the Observer: On Vision and Modernity in the Nineteenth Century* (Cambridge: MIT Press, 1990).

61. Walter Benjamin, "The Work of Art in the Age of Mechanical Reproduction" (1936), in *Illuminations*, ed. Hannah Arendt, trans. Harry Zohn (New York: Schocken Books, 1969), 238.

62. Le Corbusier and Ozenfant acted as La Roche's bidders for paintings, confiscated from Kahnweiler during World War I, by Picasso, Braque, Léger, and Gris at four art auctions held in June and November 1921, July 1922, and May 1923. Russell Walden, "New Light on Le Corbusier's Early Years in Paris: The La Roche–Jeanneret Houses," in Russell Walden, ed., *The Open Hand: Essays on Le Corbusier* (Cambridge: MIT Press, 1977), 135.

63. Correspondance Le Corbusier-La Roche, Fondation Le Corbusier P5(1), quoted in Christopher Green, "The Architect as Artist," in *Le Corbusier Architect of the Century* (London: Arts Council of Great Britain, 1987), 121.

64. Willi Baumeister, letter to Oskar Schlemmer, 1924, trans. in Gladys C. Fabre, "The Modern Spirit and the Problem of Abstraction for Léger, His Friends and His Students at the Académie Moderne," in *Léger and the Modern Spirit 1918–1931* (Paris: Musée d'Art Moderne, 1982), 416.

65. Green, "The Architect as Artist," 121.

66. Letter from Le Corbusier to Madame Savoye, 28 June 1931 (Fondation Le Corbusier, Dossier Savoye).

67. Letter from Le Corbusier to Ozenfant, 16 April 1925 (Fondation Le Corbusier, Dossier La Roche), quoted in Tim Benton, *The Villas of Le Corbusier: 1920–1930* (New Haven: Yale University Press, 1987), 67.

68. "Do you recall the origin of my undertaking? 'La Roche, when you have a fine collection like yours, you should also have a house built worthy of it.' And my response: 'Fine Jeanneret, make this house for me.' Now, what happened? The house, once built, was so beautiful that on seeing it I cried: 'It's almost a pity to put paintings into it!' Nevertheless I did so. How could I have done otherwise? Do I not have certain obligations with regard to my painters, of whom you yourself are one? I commissioned from you a 'frame for my collection'. You provided me with a 'poem of walls'. Which of us two is most two blame?" Letter from La Roche to Le Corbusier, 24 May 1926 (Fondation Le Corbusier), quoted in Benton, *The Villas of Le Corbusier*, 70.

69. "On entre: le *spectacle* architectural s'offre de suite au *regard*; on suit un itinéraire et les *perspectives* se développent avec une grand variété; on joue avec l'afflux de la *lumière* éclairant les murs ou créant des *pénombres*. Les baies ouvrent des perspectives sur l'extérieur où l'on retrouve l'unité architecturale. A l'intérieur, les premiers essais de polychromie, basés sur les réactions spécifiques des couleurs, permettent le 'camouflage *architectural*', c'est-à-dire l'affirmation de certains volumes ou, au contraire, leur effacement. . . . Voici, vivant à nouveau sous nos *yeux modernes*, des événements architecturaux de l'histoire: les pilotis, la fenêtre en longueur, le toit-jardin, la façade de verre." Le Corbusier, *Oeuvre complète*, 8 vols. (Zurich: Girsberger, 1930ff.), 1:60 (emphasis added).

70. "L'architecture arabe nous donne un enseignement précieux. Elle s'apprécie *à la marche*, avec le pied; c'est en marchant, en se déplaçant que l'on voit se développer les ordonnances de l'architecture. C'est un principe contraire à l'architecture baroque qui est conçue sur le papier, autour d'un point fixe théorique. Je préfère l'enseignement de l'architecture arabe. Dans cette maison-ci, il s'agit d'une véritable promenade architecturale, offrant des aspects constamment variés, inattendus, parfois étonnants." Le Corbusier, *Oeuvre complète*, 2:24.

71. Le Corbusier's reference to baroque architecture may be a response to Sigfried Giedion, who positively compared Le Corbusier's house for La Roche to a baroque church: "The way in which the

cool concrete walls, alive in themselves, are divided, cut up and dispersed in order to allow new room compartmentalizations has only been known, in a whole different context, in some Baroque chapels "The New House" (1926), rpt. in Peter Serenyi, ed., *Le Corbusier in Perspective* (Englewood Cliffs, N.J.: Prentice-Hall, 1975), 33.

72. Benjamin, "The Work of Art," 238.

73. Le Corbusier, "Twentieth Century Building and Twentieth Century Living," *The Studio Year Book on Decorative Art* (London, 1930), rpt. in Max Risselada, ed., *Raumplan versus Plan Libre* (Delft: Delft University Press, 1988), 145.

74. It is curious that Le Corbusier's concept of "walls of light" and the idea of space that it implies are closer, in their material reality, to the space of Mies van der Rohe's architecture than to his own. Le Corbusier's horizontal window is still a window, even if it presupposes a "dematerialized" (non-loadbearing) wall. On the other hand, Mies will write (and nothing could be further from his architecture): "I cut openings into walls where I need them for view or illumination." Mies van der Rohe, "Building," *G* 2 (September 1923), 1, trans. in Fritz Neumeyer, *The Artless Word: Mies van der Rohe on the Building Art,* trans. Mark Jarzombek (Cambridge: MIT Press, 1991), 243.

75. Bruno Reichlin, "Le Corbusier vs De Stijl," in Yve-Alain Bois and Bruno Reichlin, eds., *De Stijl et l'architecture en France* (Brussels: Pierre Mardaga, 1985), 98. Reichlin is referring here to Steen Eiler Rasmussen, "Le Corbusier—die kommende Baukunst?," *Wasmuths Monatshefte für Baukunst* 10, no. 9 (1926), 381.

76. *Le Corbusier: 1910–65,* ed. W. Boesiger and H. Girsberger (Zurich: Artemis, 1967), 54.

77. Le Corbusier, "Twentieth Century Building and Twentieth Century Living," 146 (emphasis added).

78. Le Corbusier, *Oeuvre complète,* 1:189.

8. DOROTHÉE IMBERT

UNNATURAL ACTS:
PROPOSITIONS FOR A NEW FRENCH GARDEN, 1920–1930

The gardens created in France by Gabriel Guevrekian, Pierre Legrain, and Paul and André Vera during the first decades of this century ruptured the received idea of landscape design. At the same time, they reflected the stylistic currents that prevailed in the applied arts. Fashioned according to the rules of architecture and geometry rather than the demands of nature, these designs were frequently labeled as "cubist." Despite its apparent distortion of the *jardin régulier*, the "cubist" garden featured in fact the "forms" of cubism—such as jagged lines and angled planes of colors—applied like a veneer to the traditional garden structure. The pictorial nature of these landscapes nevertheless warrants assessment, as it exemplified an almost unconditional, if delayed, application of the fine and decorative arts to exterior spaces, and testified to the "trickle-down" influence of painting upon all fields of design. The connection between landscape and picture is certainly not a twentieth-century invention, but it seems to have reached an extreme in the modern French garden. Historically, gardens simultaneously represented loci and ideas about nature. The new French garden, however, collapsed vision and experience within a self-referential aesthetic structure. Whereas vegetation

in the seventeenth- and eighteenth-century *jardin à la française* embodied reason and nature perfected, plants in the 1920s garden were to perform as quasi-artificial elements. Designers of these gardens did not attempt to represent a slice of the natural world—whether seeking a Cartesian or a Virgilian ideal—but instead displayed a plastic composition of lines and surfaces built with living and inert materials, and framed like a picture.

The revised French garden was, in fact, a graphic landscape often conceived as a continuation of the interior ensemble: a picture to be seen through a window. Appearing alien to any previous or subsequent landscape tradition, its geometries and colors should instead be evaluated within the general framework of the decorative arts of the period. The fact that the greater part of the wares presented at the 1925 Decorative Arts Exposition in Paris were stamped with a cubistic imprint—garden design being no exception—testifies to this elision of high and applied arts. Because the mutual influences among the various fields remained only pattern-deep, the impact of one medium upon another was more apparent, if also more superficial. A *Chicago Tribune* advertisement of 1914 announced new "cubistic fashions" reflecting the "influence of cubist art on the new gowns, wraps, hats, and silks" in view of the "much talked of exposition of futurist and cubist pictures at the Art Institute."[1] As one journalist commented, "when one may meet one's best friend buying a jade leather coat just to match the jade line on her new car [if not the reverse], it is not surprising to find the garden coming into this ordered scheme of fitness."[2]

Given their designers' disregard for the heritages of both the formal *jardin à la française* and the more naturalistic *jardin paysager,* these new angular compositions were predictably associated with the graphic inventions of cubism. Designers appeared

to reject *en bloc* the layering and the chromatic and textural lessons of the landscape style, which had prevailed during the late nineteenth century. Their immediate predecessors, the creators of the impressionistic *jardin paysager*, had in fact privileged the experience of light in the sense of sight. In describing the effect of light upon the *jardin paysager* throughout the hours of the day, landscape architect Ferdinand Duprat recapitulated the compositional rules established in the late eighteenth century by René Louis de Girardin.[3] Girardin formed the ideal landscape with the dominant elements—high mountains, deep valleys, and large forests—brushed by morning light, so that each mass would be read as a distinct plane within the perspective. The glare of noon, on the other hand, set to advantage individual reflectors such as bodies of moving water and *fabriques*, for example towers, pyramids, columns, or ruins, whose purpose was simply to be evocative. With the sunset hour came the effect of a Claude landscape, as sheets of water shone within the transparent shadows and the vaporous light softened the green of meadows. Finally, Girardin left the arrangement of the moonlight tableau to the expertise of women, considering their natural inclination toward "love and pleasure" essential to imagine such scenes.[4] Nineteenth-century treatises precluded all suggestions of geometric figures in the landscape, recommending instead ample curves and inflections in tonality, texture, and size of plantings—all in order to achieve the effects of a "painted picture."[5]

Although the designers of the new French garden also envisioned a pictorial creation, they bypassed the dramatic effects of changing light, plays on the natural process, and the collections of exotic species, instead promoting a landscape with singular impact—a landscape that would be built in its "mature" state. In this garden, composed of low or sheared plants to create planes and surfaces rather than volumes, light

was not modulated; at most it was reflected. The perceptual ambiguity in the space and depth of the *jardin paysager* was transformed into an apparent play of geometries. The new garden featured segmented lines, contemporary building materials, and sheared planes of evergreen vegetation. With a craze for speed combined with reduced means of maintenance and a compressed scale, such gardens came to replace the volumetrically rich *jardin paysager* with what might be described as a two-and-a-half-dimensional still life.

Rather than attempting to analyze the direct translation of painted construction into garden, this essay is concerned with the general characteristics of cubism and its influences upon landscape architecture. Applied to the shaping of landscape, the term *cubist* suggested a fashionable trademark, as evident in contemporary articles such as "Cubistic Landscape Architecture on the Outskirts of Paris."[6] This usage betrayed the critics' lack of understanding of the new landscape vocabulary: to them, anything featuring triangles and inclined beds could be read as cubist. The relation between painting and landscape design can rest on the physical evidence of the composition, or on the more diffuse but perhaps more structural influence of the cubist movement on all areas of contemporary creation and thought. The revised definition of a work of art instigated by cubism permitted the creation of form independently of figuration. Exploiting the tension between figurative and abstract composition, between motif and form, the artisans of the so-called cubist landscape constructed hybrid designs that did not resemble traditional landscapes. The parallels critics and scholars have drawn between pictures by Picasso and gardens by Guevrekian are problematic, because they compare paintings and two-dimensional reproductions of landscapes, not the actual spaces.[7]

Due to the paucity of written evidence, the garden designers' intentions remain largely undocumented; that they appreciated the implications of the cubist movement for their field, however, is almost certain. The interior ensembles by Pierre Legrain showcased collections of cubist paintings and sculptures as well as artifacts from Africa and Oceania. Guevrekian collaborated on projects with Robert and Sonia Delaunay.[8] Paul Vera participated in the meetings of the Puteaux Group of cubist artists and contributed to the interior decoration of the Maison Cubiste, presented by André Mare at the 1912 Salon d'Automne.[9] Even though cubist painting still remained controversial after World War I, by the mid-1920s, in particular at the Decorative Arts Exposition of 1925, the patterns derived from cubism had won the acceptance of the general public as a design style. So influential had cubism become that the traditionally conservative domain of landscape architecture, following the models of architecture, painting, sculpture, and furniture design, also adopted the formal characteristics of the style.[10]

André Vera argued for a garden that would be alluring and comprehended immediately: "it is necessary not only to catch and retain the attention of the passerby, but to present him or her with a global and condensed picture. The composition of a decorative work must therefore be not analytical, as it used to be during the past centuries of leisure, but undeniably synthetic."[11] Vera believed that the new garden, now limited in size, needed to be drawn in the *style régulier*, not only to form an apartment out-of-doors but also to root its design within the Gallic tradition. The sinuous lines, serpentine alleys, and undulating lawns of the previously favored *style paysager* he saw as witnesses to "sybaritism, dilettantism, inertia, and weakness" and, ultimately, to foreign derivations.[12] With his brother Paul, André Vera instead promoted

8.1 André Vera (1881–1971) and Paul Vera (1882–1957) with Jean-Charles Moreux (1889–1956), landscape architects. Garden of Charles and Marie-Laure de Noailles, Paris, c. 1926, view from the ground level. Photograph c. 1926. From André Lurçat, *Terrasses et jardins* (Paris: C. Moreau, c. 1929), plate 46.

gardens that were proportioned and ruled in accordance with the plan and facade of the house. In this light, landscape designs that featured electricity and mirrors were justified as the logical furnishing of outdoor apartments.

Acceptance of such designs was not universal in the 1920s. Several American landscape architects dismissed this new formalism as the limited product of architectural brains. Because vegetation played only a secondary role as chromatic or textural medium in the new French garden, these critics held that such designs reflected the "excessive indulgence on paper of the T-square, triangle and compass" and came closer to a layering of painted surfaces than to real

landscapes.[13] On the other hand, one could see in this manipulation of nature a genuine attempt formally to reinvigorate garden design and to define a modern style. The radical nature of the products was partly due to the training of their designers as architects, *ensembliers*, and artists. Removed from the discipline of landscape architecture, they were able to ignore most of the preconceptions and rules governing garden design.

The garden the Veras designed with Jean-Charles Moreux for the *hôtel* of Charles and Marie-Laure de Noailles in Paris exemplified the absolutely pictorial and sparsely planted landscape. Apparently conceived to be seen from the *hôtel*, the design consisted of a

8.2 André Vera (1881–1971) and Paul Vera (1882–1957) with Jean-Charles Moreux (1889–1956), landscape architects; Man Ray, photographer. Garden of Charles and Marie-Laure de Noailles, Paris, c. 1926, view from above. Photograph c. 1926.

parquetry of boxwood, ground cover, gravel, and flagstones that read as three fashionable carpets— or canvases—unrolled before the building's windows. After its realization, the garden was not published using the plans and sketches by the Veras, but with two photographs, obliquely taken, that distorted the viewer's perception of the overall composition. In the view taken from ground level (fig. 8.1), the wedges of low plants shown in winter garb were differentiated from the gravel only by their darker hue. In the other view (fig. 8.2), recorded by Man Ray's photograph, the garden is seen from above, albeit from nearly the same station point: it is summer and the parterres appear fluffier within their frames of gravel and stone.

André Vera's recommendation to trace boxwood lines with patterns borrowed from women's fashion (in particular, sweaters) was exemplified in an earlier scheme for the parterre geometries. The fairly conservative (if regularity is conservative) final plan featured two quadrilaterals, symmetrical along their center lines, that focused on vertical elements such as a statue and a tree. This parti was virtually impossible to perceive in the shattered patterns apparent in the photographs, whether these were taken from ground level or above. The scheme is, in fact, far simpler than it first appears. The geometry of the hôtel dictated a highly ordered pattern, but the trapezoidal configuration of the lot deformed the purity of the architectural

symmetry. Seen obliquely, the structure of the parterres is subverted by the angled lines of the patterns: concept gives way to percept.

Almost contemporary with this mineral landscape in Paris was another pictorial garden—also commissioned by the Noailles—for their villa in Hyères. There, Gabriel Guevrekian anchored the mass of the building designed by Robert Mallet-Stevens with a garden whose plan formed an elongated isosceles triangle. The scheme for the garden, realized in 1927, derived from Guevrekian's own *Jardin d'eau et de lumière* at the Decorative Arts Exposition in Paris. A nearly literal translation of the model presented at the 1927 Salon d'Automne, the Noailles garden featured a checkerboard of tulips and mosaics and triangular beds of ground covers propped against the converging walls. Using a masonry armature, Guevrekian furthered the fragmentation and tilting of textured and pigmented planes of his earlier work. Molding the earth in scalloped ladders and pyramidal flower beds, he created another "instant garden" constructed for immediate effect. Its instant was short-lived, however, as the Noailles garden lasted barely longer than the *Jardin d'eau et de lumière*: only a few years after Guevrekian's garden in Hyères was completed, the vicomte de Noailles proudly issued a postcard of his makeover design which replaced the artifice of the multicolored tiles and tulips with a quasi-xeriscape wall-to-wall carpet of low-maintenance aloes.

Guevrekian, in a rare commentary, stated that in the Noailles garden he indeed had sought to direct attention to artifice. He felt that almost complete seclusion from the surroundings was desirable, because from everywhere else on the site views opened dramatically to the bay of Hyères.[14] Enclosing the garden with stark white walls that contrasted with the rough tan stucco of the adjoining villa, he severed his garden design not only from nature but also from architecture. Guevrekian had painted his tableau with a chromatic and vegetal palette completely alien to the grayish-green Mediterranean landscape that surrounded it. Furthermore, instead of forming an outdoor extension of the villa, the garden was a picture that needed to be entered only visually in order to be comprehended. Like the Noailles garden in Paris, Guevrekian's design became famous through a handful of photographs that represented it as a graphic composition varying with the angle of view. Articles described the design as providing a "flat garden for one point of view and a sloping garden for the other."[15]

Seen from the lawn terrace above, the triangular garden appeared to replicate the image of its maquette (fig. 8.3). Flattened into a picture crisply framed, the garden presented the sum of its colors, textures, and materials in a decorative "cubist" composition. Depth was contracted; the dynamism of the colored panels that articulated the picture plane was countered by the uniform field of tulips, thereby deceiving the eye in the perception of gradient. Vegetation was fragmented into geometric shapes and reduced to the state of inert material, its irreality further warped by the brilliant reflection and illusory motion of the ceramic tiles. Guevrekian was adamant in ignoring the demands of nature. The planting of pyramidal containers with two shades of one genus of ground cover—as if each was brushed by an independent source of light—which would also have distorted the reading of forms, hardly acknowledged the varying solar exposure required by each of the two hues of foliage. Furthermore, because of the east-west axis of symmetry, the balance of the garden was unsettled by the different growth rates of vegetation set against either the northern or southern wall. The inexorable laws of horticulture subverted the artistic intention.

Photographed from the lower salon, the garden

8.3 Gabriel Guevrekian (1900–1970), landscape architect; Marc Treib, photographer. Garden of Charles and Marie-Laure de Noailles, Hyères (1927, restored later), view from the lawn terrace as restored. Photograph 1991.

dispelled any cubistic ambiguity; instead, it resembled an exercise in classic one-point perspective. Bracketed by a pair of orange trees, the checkerboard pattern of mosaics and tulips converged to enhance the perception of depth, focusing on the elusive vanishing point of a rotating statue by Jacques Lipchitz, *La joie de vivre.* In this view, the frame dissolved at the apex of the triangle where the garden rose toward the sky, and the surrounding landscape appeared to be part of the picture.

Seen in reverse, the garden read as an elongated rectangle terminated by the villa's anthropomorphic facade (fig. 8.4). The perception of the checkerboard and slope diminished. With their outlines effaced, the panes of colors seemed to merge with one another. The enclosing wall could be read only as a line, rather than

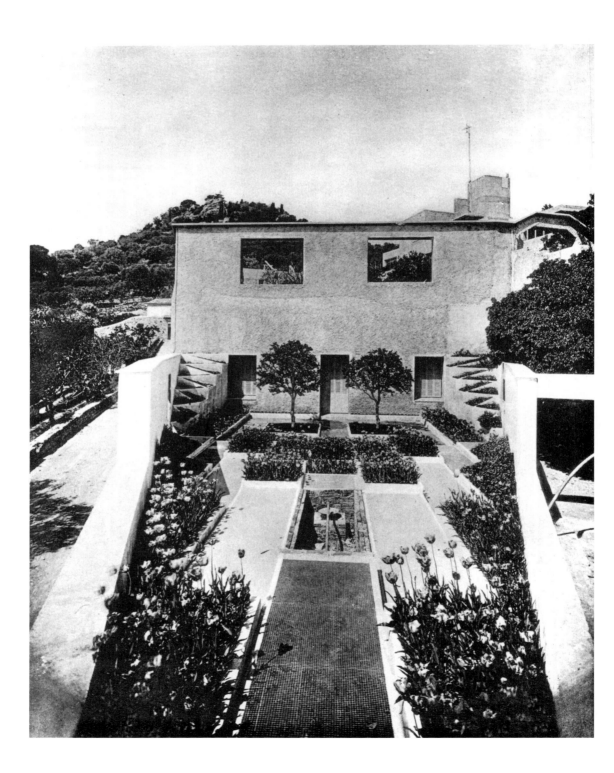

a plane, between the garden of artifice and the hillside vegetation beyond. However stilled, the picture was unsettled by the spatial dynamism of the scalloped geometries expressed in the jagged edge of the ground covers and their continuation into the zigzagging flower beds that mounted the villa facade. Halfway between the cubistic image that one read in the garden seen from above and the forced perspective viewed from the base of the triangle, this photograph also biased the comprehension of the space. Here, the tulips appeared to form an undivided central carpet and the peripheral vegetation to fill continuous containers. That the appreciation of this garden has rested almost entirely on photographs rather than on spatial experience validates Guevrekian's desire to create a landscape tableau, static in time yet dynamic in composition.

Although the garden in Hyères was not as flat as the Veras' Noailles parterre in Paris, it remained nonetheless a two-and-a-half-dimensional picture. A critic of the modernist designer's attempt to create a volumetric landscape—"he gets his height in plant-ing beds for example, not by adroit choice of plant materials, but by tilting the beds at odd angles or by making them pyramidal or otherwise geometrically mounded"—seemed to aim directly at Guevrekian.[16] His Noailles garden was essentially a vertical extru-sion of a planar design, a bas-relief that offered three distinct and explicit pictures.

Guevrekian not only coerced plants to grow within the masonry frame and the axial formalism of his design, but he also avoided the variations of time, the inherent signatures of all landscapes. The brief blooming season of tulips offered a uniform plane of color, a field of flowers that coincided with the winter

and early spring residence by the villa's owners. Tulips, orange trees, and ground covers are architectonic plants; their variation is limited and their growth easily predictable: orange trees being evergreen, tulips attaining a homogeneous height and color, and ground cover behaving like a textured floor covering. In Guevrekian's construction, the applied colors— whether ceramics or flowers—produced a "permanent light" that avoided all the impressionist variations of the palette that defined the *jardin paysager*. Girardin himself had warned that the picture composed to be admired under the noon light should be limited in extent, in order not to tire the eye with a broad reflecting field.[17] The Noailles garden was concise and in all three photographic views it is depicted around noon, as if shadows would detract from the pure symmetry of the garden scheme and the artifice of its components. In developing a plan into a garden figure, and in his use of color sheets, Guevrekian alluded to the polychrome stone reliefs of Henri Laurens in which color became a constructive element that defined the plan and built planes of light and shadow. Thus, instead of a landscape varying with time, Guevrekian proposed an image of stilled life in which time was marked only by the cycles of the rotating statue.

In contrast to the timeless nature and the shallow depth of the Noailles designs, the 1923 garden for the milliner and art patron Jeanne Tachard combined graphics with volumes and contemporaneity with history to form a modeled seasonal landscape. Its author, the interior and product designer Pierre Legrain, drew the site plan as a refined balance of abstract shapes (fig. 8.5). There were no shadows, and planting beds, walks, hedges, and walls were all rendered somewhat indiscriminately. The overall effect

8.4 Gabriel Guevrekian (1900–1970), landscape architect. Garden of Charles and Marie-Laure de Noailles, Hyères, 1927, view from the Lipchitz statue. Photograph 1928. From André Lurçat, *Terrasses et jardins* (Paris: C. Moreau, c. 1929), plate 8.

8.5 Pierre-Emile Legrain (1889–1929). Garden of Jeanne
Tachard, La Celle-St.-Cloud, plan, c. 1924. From J. Marrast,
1925 jardins (Paris: C. Moreau, c. 1926), plate 25.

resulted thus from a graphic arrangement of varying
geometries and tints, rather than from the conventions
of architectural rendering. In this plan (which is the
only extant drawn record of the garden) Legrain
resorted to a vocabulary of triangles, circles, and
squares that appeared a direct translation of his book
cover repertoire.

In reality, or rather in Legrain's description, the
garden was a functional outdoor ensemble that
responded to the interior arrangement of the villa. The
kitchen garden, dining terrace, green corridors, *salle
fraîche*, and sunken lawn-room balanced each other
but remained independent entities. Variations in
foliage and seasonal color modified the garden's

formal evergreen structure, despite Legrain's assertion
that architecture alone, and not gardening virtuosity,
created a contemporary landscape.[18]

The geometry and vocabulary of the Tachard
plan appeared to contemporary critics as a purely
modernist expression, although its design was in actu-
ality a reframing of the previously existing garden at
this site, which was characterized at the time as a
romantic English landscape. To Legrain, the success
of garden design rested on grading. He treated the
lawn as an entity independent of the entrance allée,
and used cut-and-fill techniques to reform a slight
declivity into a sunken garden etched with accents of
grading and planting. Unlike the polychromed reliefs
that Guevrekian extruded from a plan, Legrain's
manipulation relied on the mass and space of the
existing garden, upon which he incised lines and tex-
tures to sculpt the light and articulate the picture
plane. With volumes flattened into facets and outlines
ruptured, the elements of the design merged with the
surrounding space.

In reading these three pictorial gardens—the parterre
for the Hôtel de Noailles in Paris, the bas-relief by
Guevrekian, and Legrain's collage landscape for
Jeanne Tachard—the qualities of thickness, composi-
tion, and enclosure become discernible.

As far as depth (or the lack of it) is concerned,
one should note that the drawings for these projects
were usually restricted to plans. The planar predilec-
tion that had historically dominated the renderings of
the *jardin à la française* was supported by a widely
accepted code for the graphic representation of par-
ticular elements in particular ways. And although
Guevrekian showed the public his Noailles garden in
the form of a model, it seems that André and Paul
Vera's design required no three-dimensional depiction

8.6 Gabriel Guevrekian (1900–1970). *Jardin d'eau et de lumière*, Paris, 1925. Gouache. From
J. Marrast, *1925 jardins* (Paris: C. Moreau, c. 1926), plate 15.

beyond a plan with extrusions of trees and statues.
The garden as built embodied these features directly.
Flatness was characteristic of all these works, in
which the ground plane was treated essentially as a
picture plane.

In composing the 1925 *Jardin d'eau et de
lumière*, Guevrekian had anticipated the photographic
framing of the garden (fig. 8.6). Short-lived and of
limited dimensions, his design was to achieve fame
largely through black-and-white halftone reproduction
in books and articles. Guevrekian manipulated the
ground plane to form a pictorial field, foreseeing
the translation of a three-dimensional space into a
two-dimensional medium. In his garden vignette, the

surfaces of earth were articulated and tilted for better
viewing, like a table top in a still life by Cézanne in
which the fruits appear almost to be pushed off the
picture plane. As a result, the generating motif of the
composition, the triangle, could be visible simultane-
ously in the angled planes of lawn and begonias, the
elevation of the glass fence, and the outlined plan of
the pools of water. Similarly, the garden in Hyères was
slightly inclined like a planted icon propped against an
easel. Its symmetry could be sensed even when not
viewed frontally. On the other hand, the photographs
of the Veras' garden disguise the prevalent symmetry
of the parterres. The two sets of perspectival readings
overlapped: that of the photographs and overall site,

which focused on the corner bench, and that generated by the architecture. With the patterns on the ground shaped somewhat independently from the structuring morphology of the garden, the perception of the plan remained elusive. The hypotenuse of the triangular Parisian site partially effaced the parterre motifs, but it seemed to be a coincidence, as if the picture plane was entirely emancipated from its frame and they just happened to intersect.

The Tachard landscape further unsettled the perception of space in its scenographic arrangements of photographic views. If fixed in space, images of the sunken garden suggest a slight instability in the position of its elements. Legrain's overlay of existing vegetation and geometric figures seduces the spectator with a calculated optical disorder. Perspective is simultaneously reinforced and muted. In one view, the lawn-room appears to rely on an orthogonal order, only slightly biased; in the other, vanishing points contradict one another and what had previously appeared aligned now reads as a swooping arc. The layers of depth are blurred through the mimesis of elements in the foreground and background. The crowns of dwarf trees anchor diagonally opposite corners, their floating spherical shapes countered by the rectangular concrete frame outlining a broad hazel tree. The tiers of lawn in the distance mirror, askew, those fronting the house: stepping toward the corner of the site, the angled grass wedges deny a simple perspectival reading and imply a continuation of the garden beyond its limits into the surrounding landscape. A zigzag band of lawn keeps the viewer at a distance from the edge of the horse chestnut allée, in whose shade the mass of the hedge disappears (fig. 8.7). Although the frame of the garden—as well as that of each individual room—is carefully marked in the plan, the precise limits elude the photographs.

An occult asymmetry pervades the overall design as harmony rests on the balanced relationship of unequal parts. In its conjunction of implied movement with rigorous structure and its multiplication of the center, Legrain's arrangement of shapes, both in plan and in space, recalls certain paintings by Paul Klee. The Tachard garden appears to follow Klee's compositional dictum of "exactitude winged by intuition."[19] The adjustment of nature to a modern design also evokes his recipe for painting:

1) Draw rigorously from nature, possibly with the help of field glasses.
2) Invert the drawing (1), bring out the principal lines according to feelings.
3) Return the sheet to its original position and match 1 = nature with 2 = picture.[20]

In contrast to the strictly "pictorial" tableaux of the Noailles gardens, Legrain's design adjusted to nature. Thus, the singularity of the plan, the overlay of contemporary shapes and materials with a picturesque (and apparently timeless) structure, all contributed to the image of a collage landscape.

The concept of landscape as a pictorial entity is hardly idiosyncratic to the twentieth century. Historically, whether such stage sets were represented in the engraved fêtes of Louis XIV or twilight depictions by Watteau, they centered on the human being. But the compositions of the 1920s and 1930s were consistently photographed as stages on which actors need not appear. A few years after these gardens were built—and for the most part had already disappeared—American critic Geoffrey Baker commented that if the spread of modern architecture was hastened by the perception of the halftone system of reproducing black-and-white photographs, garden design could not equally benefit from such a technique of printing. With images of Christopher Tunnard's

8.7 Pierre-Emile Legrain (1889–1929), landscape architect. Garden of Jeanne Tachard, La Celle-St.-Cloud, 1923, view of side alley. Photograph c. 1924. From J. Marrast, *1925 jardins* (Paris: C. Moreau, c. 1926), plate 27.

landscape designs in mind, he wrote that

one hindrance to the spread of modern garden design . . . is the difficulty of describing a modern garden by photographs, drawings or written specifications. The bird's eye perspective . . . shows all but shows nothing, due to its artificial viewpoint. The photograph taken from eye level usually describes only a single detail, for modern garden design is often too dispersed, and above all too continuous, for photographic description, unless by a movie camera in a series of tracking shots.[21]

But photographic representation did not detract from the appreciation of the new French garden; on the contrary, it broadened its appeal. The illustrations of Guevrekian's *Jardin d'eau et de lumière* reveal a composition that looked best when seen from above (flattened as a tableau) or in the close-up view (abstract and highly textural), both angles avoiding the loss following the translation from a two-dimensional rendering into a landscape. The eye-level colored view of Auguste Léon's autochrome, on the other hand, lacked the simultaneist intensity of Guevrekian's gouache rendering; most of all, it failed to evoke the abstraction of the selective framing of these two other views.

To be seen as pictures more often than to be experienced as spaces, the gardens studied here were in fact not only pictogenic but also extremely photogenic. Photographed as abstractions—without people—these images could freely engage the viewer's attention. The framing of the camera allowed the staging of specific views or a global vision undetracted by the wanderings of the eye between foreground and background, between close-up and wide-angle.[22] Furthermore, such designs were not hindered by the black-and-white medium of photography. Because these gardens were built using a structure of evergreens for year-round effect, the limited number of photographs (for a limited number of views) reinforced their perception as pictures.[23]

Both Noailles designs appeared best when contemplated as self-sustained entities through the frame of architecture. Photographed in isolation, their formalism and contracted space dictated the particular view. Such directional composition implied a conflict with physical movement, functioning like a distorted stage set whose power of illusion was weakened by the contrast of shallow space and the referential scale of the human body. These stilled images reflected not only the control of nature but also the distancing of man from nature. Confirming this severance was landscape architect Fletcher Steele's comment that Legrain's occasional desire to see a plant have its own way was indeed a "fatal weakness."[24]

With plants regarded abstractly as textural and chromatic elements only, the garden severed its ties to the natural landscape. The Noailles gardens, in their ambiguity, could be evaluated as tableaux in which plants played the role of the *papiers collés* in cubist paintings, or as landscapes in which mirrors and electricity unsettled the traditional balance between living and inert materials, between figurative and

abstract compositions. In both Noailles projects, vegetation followed graphic rules rather than those of horticultural specificity. Rather than softening the lines of the design, it reinforced them, thereby rendering structure and composition coincident. However vegetal, the picture inside the frame was only remotely related to the natural world. Instead of imitating or citing nature, these gardens focused on artifice and presented the viewer with a hermetic *tableau-objet*.

Although such architectonic gardens were dismissed by contemporary critics as mere extrusions of plans, the parallel between landscape architecture and sculpture may be warranted.[25] Not only did cubism fracture monolithic sculpture but it also established—through the medium of collage—a dialogue between painting and volume. As Clement Greenberg pointed out, "under the modernist 'reduction'" sculpture is distilled into a visual construct, a pictorial entity devoid of tactility.[26] In these gardens, the volume of the sculptural landscape was flattened into a pictorial bas-relief whose shallow depth was, in turn, belied by the "reality" of *papiers collés*—plants or mirror—thus bringing the tension between tableau and space full circle.

In line with André Vera's assertion that there is no tradition without modernity and no modernity without tradition, and in spite of their radical imagery, the gardens of the interwar years all borrowed from past landscape traditions, whether literally (as in Legrain's appropriation of the existing picturesque setting) or metaphorically (as in Guevrekian's revised paradise garden).[27] Perhaps the Noailles garden in Paris was the most obvious in its citing of historical references. The filigree of boxwood and pebbles framed by gravel literally recalled the *parterre de broderie* of the Grand Siècle so dear to André Vera. But whereas the sequence of parterres, pools, and groves—transitions

between the terrace and the forest—had been grandly orchestrated in the classic *jardin à la française,* all the intermediary shades of formality between architecture and nature disappeared from the Noailles tableau. As a graphic plinth for the *hôtel,* the tableau compressed into a single layer the image of the garden and the minerality of the terrace.

But the ultimate invention of this dry garden was in its use of enclosure. The north side of the perimeter wall was clad with mirrors that created a series of perceptual illusions in reading the space. When seen from the ground level, the mirror of the Noailles garden caught the sunlight and appeared as a modernist *fenêtre en longueur* set in the darkness of the ivy frame. Recalling the visual capture of the landscape through windows in the walls of Le Corbusier's roof gardens, the mirrored lining—when seen from the upper floor—reflected the wedges of gravel and boxwood and implied a continuation of their pattern beyond the garden wall. But the definition of this image and its spatial perception were especially unsettled by the juxtaposition of the "reality" of the mirror with the abstraction of the pictorial landscape. Furthermore, the ephemeral silvering of an outdoor mirror conferred on the composition a surreal touch, as the mineral element, the mirror, was even more fragile than the transitory plants. If the *papier collé* served as a foil revealing the flatness of the cubist pictorial field and simultaneously borrowing depth from the space before it, the mirror in the landscape tableau created a space in negative, a depth *beneath* the flatness. The forced perspective of the garden plan was distorted by the angled photographic view; the reflective window canceled it entirely.

One might seek precedents for these effects in other reflected landscapes. Jean-Charles Moreux, who collaborated with Paul Vera on several garden projects, saw the mirror as a descendent of the illu-

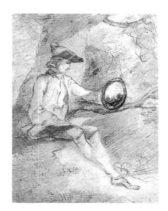

8.8 Thomas Gainsborough (1727–1788). *Study of a Man Sketching Using a Claude Glass,* c. 1750–1755. British Museum, London.

sion-creating tapestries hung in the bosquets of Versailles during the reign of Louis XIV.[28] At the 1668 fêtes, for instance, costly tapestries imitating marble were displayed among the fountains and sculptures of bosks. The textures of these outdoor green rooms answered the materials of spaces inside the château—which were also adorned with fountains and flowers.[29] Whether displacing the envelope of space, duplicating the image of the garden (as in the crystals on the edge of the well in the *Roman de la rose*), or creating perceptual illusions (as in Versailles's Grotto of Thétis or that of Pope's Twickenham), mirrors reappeared throughout the designed landscape.

Perhaps one should also see the so-called Claude mirror as an antecedent to the Noailles reflecting wall: not only did the eighteenth-century device permit one to replicate and reframe the landscape as an image, but it also enhanced the scene's pictorial quality.[30] The artistically inclined English traveler on a walking tour of the Lake District or abroad carried a tinted plano-convex mirror to capture the picturesque beauty of the surroundings (fig. 8.8). The convex surface enhanced the breadth of the perspective, while the overall cast of the mirror softened the intensity of natural colors: dark foils tempered sunny days and silver-backed glass enlightened cloudy

atmospheres. Among its applications, the Claude mirror was intended to frame the scenery during the romantic hour of sunset, when the source of light coincided with the vanishing point. Almost prescient of the impact of photography on our perception of the landscape, William Gilpin recommended the Claude mirror for its ability to duplicate a large scene on a bounded surface, thereby condensing the general and the particular.[31] Whether the framing of the landscape was to aid the creation of sketches or merely to serve the beauties of nature (literally sightseeing), the tourist had to turn his or her back to the view in order to capture it as a reflection. An image of nature resulted, condensed on the glass, although in the process the viewer was distanced from the landscape.

In direct, if inverse, relation to such a pictorial approach, the mirror in the Noailles garden allowed the visitor to project his or her own image into the tableau. In this juxtaposition of deep space and flatness, one is tempted to suggest a correlation with the canvases of Juan Gris that incorporated fragments of mirror such as *Le lavabo* (1912) and *La console de marbre* (1914). As a constantly varying trompe-l'oeil element articulating the play between the depicted flatness and the depth of the "real" element (even though it replicated an image), the mirror could not be imitated. The Noailles garden, like a giant collage, joined the pictorial reality of the parterre with the virtual world of the mirror. In its reflection, the reality of the garden became twice removed as an image of an image. But its reflection also allowed spectators to include their own images within the *tableau-jardin* without disrupting the unstable conjunction of a two-dimensional picture and a three-dimensional human figure. Inherently to be viewed rather than entered, the Noailles garden was a picture in which the image of man was at least optically reunited with the image of nature.

The designers of the new French garden were quick to adopt the vocabulary or "image" of cubist painting without exploiting the factor of time expressed, for example, by vegetation. A garden can offer a sequence of kinetic pictures: analogically, as one traverses the space and sees its components from different angles; and virtually, as the vegetation changes over time, thus modifying the volume, the layering and the depth of field, and the relation of the garden to its surrounding frame. Instead of emphasizing these properties, the "cubist" garden designers reduced the landscape promenade and the seasonal variation of vegetation to a minimum. Compressing space into a bas-relief comprehensible with a cursory glance, they prepared the ground for appreciating gardens through single-instant photographic representations. In the staged photograph, the juxtapositions of forms and the partial occlusion of spaces allowed the garden to retrieve the suggestion of depth it lacked in reality. Thus, images of the Tachard garden suggested a boundless multidirectional space. In photographs of the Noailles parterre, the mirror pierced the limits of the garden and fragmented the composition. Within the frame of the photograph, the directional and selective view distorted the flat picture plane of the garden: assemblages of elements altered perspectival readings; bird's-eye views reduced the volume into surfaces and lines; light and shadows were fixed as part and parcel of the design; and the mirror dissolved boundaries to achieve a landscape of nature sublime. Ultimately, the French garden designers of the early twentieth century chose not to investigate the potential of cubist landscape space, and instead composed slight volumes that looked best when stilled and framed by photographs. Within those photographs—however ironically—depth and dynamism emerged from the emphatic two-dimensionality of cubist painting.

8.

NOTES

1. Advertisement for Mandel Brothers in the *Chicago Tribune*, 1914. See Radu Stern, *Gegen den Strich/À contre-courant* (Bern: Benteli Verlag, 1992), 52.

2. Mrs. Howard Robertson, "Two Views against the Geometric Garden," *The Queen*, 12 December 1928, 5.

3. The ornamental construction was set to advantage by a frontal or three-quarter light, the trees and woods looked best backlit, and the waters captured the soft tones of the evening. Ferdinand Duprat, "Le jardin paysager," in *Jardins d'aujourd'hui* (Paris: Studios "Vie à la campagne," 1932), 44.

4. René Louis de Girardin, "Du choix des paysages suivant les différentes heures du jour," in *De la composition des paysages* (Geneva, 1777; rpt. Paris: Editions du Champ Urbain, 1979), 91–93.

5. Pierre Boitard, "Des jardins paysagers," in *Traité de la composition et de l'ornement des jardins* (Paris: Audot, Libraire Editeur, 1859), 58–60. See also Gabriel Thouin's preface to *Plans raisonnés de toutes les espèces de jardins* (Paris: Imprimerie Lebégue, 1820).

6. "An Example of Garden Design in the Modernist Manner at St. Cloud, France—Cubistic Landscape on the Outskirts of Paris; Mme Tachard, Owner," *House and Garden* (August 1924), 62–63. Cubism was also loosely and widely attributed to architecture, for example the "rue du Cubisme" in Victor Bourgeois's 1922 Cité Moderne at Berchem-Sainte-Agathe, near Brussels, so named for the geometric designs of its stained glass and the cubic volumes of buildings. See *Cités-Jardins 1920–1940* (Brussels: Archives d'Architecture Moderne, 1994), 66–75.

7. Richard Wesley has compared Guevrekian's *Jardin d'eau et de lumière* for the 1925 Decorative Arts Exposition to Picasso's 1912 *Man with a Mandolin*, and the 1927 terraced garden for Jacques Heim to Picasso's 1914 collage *Glass, Pipe and Lemon*. "Gabriel Guevrekian e il giardino cubista," *Rassegna*, October 1981, 17–24.

8. Guevrekian designed a boutique for the simultaneist fabrics of Sonia Delaunay; Robert Delaunay painted the pool motifs of Guevrekian's *Jardin d'eau et de lumière*.

9. Named for the meetings held at the artist studios of Jacques Villon and Raymond Duchamp-Villon in Puteaux, near Paris, in the early 1910s.

10. André Vera, preface to *Le nouveau jardin* (Paris: Emile-Paul, 1912), iii.

11. André Vera, *Le nouveau jardin*, 9–10.

12. André Vera, "Modernité et tradition: Lettre sur les jardins," *Les Arts Français* (Les Jardins) 30 (1919), 90–91.

13. Leon Henry Zach, "Modernistic Work and Its Natural Limitations," *Landscape Architecture Quarterly*, July 1932, 293–294.

14. Guevrekian's description follows Leopold Zahn, "Ein geometrischer Garten an der Riviera," *Gartenschönheit*, June 1929, 223.

15. "Originality in Roof Gardens," *The Ideal Home*, September 1929, 220.

16. Zach, "Modernist Work and Its Natural Limitations," 293.

17. Girardin, "Du choix des paysages," 92.

18. Pierre Legrain, "La villa de Madame Tachard à La Celle-Saint-Cloud," *Vogue,* 1 June 1925, 68.

19. Sibyl Moholy-Nagy, introduction to Paul Klee, *Pedagogical Sketchbook* (New York: Praeger Publishers, 1977), 8.

20. Paul Klee, *Journal* (Paris: Grasset, 1959), 224.

21. Geoffrey Baker, "Equivalent of a Loudly-Colored Folk Art Is Needed," *Landscape Architecture Quarterly*, January 1942, 65–66.

22. See Walter Benjamin's discussion on the emancipation of the work of art from its dependence on ritual through mechanical reproduction, "The Work of Art in the Age of Mechanical Reproduction" (1936), in *Illuminations,* ed. Hannah Arendt, trans. Harry Zohn (New York: Schocken Books, 1976), 224–226.

23. The impact of these images was revealed in the various, and somewhat vapid, English replicas of the Hyères garden, and in the influence exerted by Legrain's zigzag motif on modern landscape architecture in the United States. For the gardens inspired by Guevrekian's design, see Dorothée Imbert, *The Modernist Garden in France* (New Haven: Yale University Press, 1993), 137–139 and note 71; for a discussion of Legrain's impact on the work of American landscape architects see Dorothée Imbert, "Pierre-Emile Legrain: A Model in Modernism," in Marc Treib, ed., *Modern Landscape Architecture: A Critical Review* (Cambridge: MIT Press, 1993), 92–107.

24. Fletcher Steele, "New Styles in Gardening: Will Landscape Architecture Reflect the Modernistic Tendencies Seen in the Other Arts?," *House Beautiful*, March 1929, 354.

25. Robert Wheelwright saw the landscape architect as working the land as a sculptor would a block of stone: "Thoughts on Problems of Form," *Landscape Architecture*, October 1930, 1–10.

26. Clement Greenberg, "The New Sculpture," in *Art and Culture: Critical Essays* (Boston: Beacon Press, 1961), 142–143.

27. Vera, "Modernité et tradition," 96.

28. Moreux clad the facade of the swimming pool and storage facilities with mirrors extending between the wings of the Hôtel de Rothschild. This alliance of neoclassical architectural idioms with the slickness of mirror plates, of solid matter with the dissolution of boundaries, could be perceived as an homage to Ledoux's first project, the Café Militaire (1762) at the Palais Royal. Its walls alternated ornamented panels of wood with planes of mirrors, thus replicating the symmetrical decor *ad infinitum.* The reconstructed Café is today found in the Musée Carnavalet, in Paris. See also Moreux's "Commentaire esthétique et technique" on Ledoux's designs in Marcel Raval, *Claude-Nicolas Ledoux, 1756–1806* (Paris: Arts et Métiers Graphiques, 1945), 48–68. Moreux's design for the garden of Jacques Rouché (in collaboration with Paul Vera) also featured reflective panes that extended the limits of the garden and modulated the spatial definition. See Imbert, *The Modernist Garden in France*, 91–98.

29. See Marie Louise Gothein, *A History of Garden Art*, 2 vols. (1928; rpt. New York: Hacker Art Books, 1979), 2:67–68.

30. Although the reflective device described here is frequently called a "Claude glass," I have chosen the denomination of Claude mirror so as to avoid confusion with the tinted lenses through which one could view the scenery in a chromatic palette matching the mood of the observer. For a description of the various types of such landscape-viewing devices, see Deborah Jean Warner, "The Landscape Mirror and Glass," *Antiques*, January 1974, 158–159. I owe my awareness of the Claude mirror and glass to John Dixon Hunt and his "Picturesque Mirrors and the Ruins of the Past," in *Gardens and the Picturesque: Studies in the History of Landscape Architecture* (Cambridge: MIT Press, 1992), 171–191, 358–362.

31. William Gilpin, *Remarks on Forest Scenery*, 2 vols. (1791), 2:225, cited by Stephen J. Spector, "Wordsworth's Mirror Imagery and the Picturesque Tradition," *ELH* 44 (Spring 1977), 89.

9.1 Pablo Picasso (1881–1973). *Bottle of Vieux Marc, Glass, and Newspaper*, 1913. Charcoal, collage, and pins on paper, 63 x 49 cm. Musée National d'Art Moderne, Centre Georges Pompidou, Paris. Donation de M. Henri Laugier (1963).

9. YVE-ALAIN BOIS

CUBISTIC, CUBIC, AND CUBIST

For Francesco Passanti

Is there a cubist architecture?

Perhaps not. I see nothing cubist, for example, but nothing at all, in Duchamp-Villon's celebrated Maison Cubiste (see fig. 1.1). And though I have only a very limited knowledge of it, I'd say the same of the so-called "cubist" architecture of Prague.

It is all a matter of definition. My definition of cubism is resolutely narrow: it has little to do with the geometrizing style that sent ripples through the entire Western world of art during the teens and developed into art deco a decade later; rather, it is exclusively concerned with the analysis of the conditions of pictorial representation, and their deliberate subversion, carried out by Picasso and Braque. In other words, I cling to the distinction, first established by Daniel-Henry Kahnweiler and then further elaborated by John Golding and Edward Fry, between the work of these two artists from 1907 to 1914 and that of all the other painters and sculptors usually placed under the banner of cubism (especially the much-acclaimed "theoreticians" of the "movement," Gleizes and Metzinger). Though such a distinction can be made on many grounds, the most conspicuous one is that Braque and Picasso's cubism was more or less a

private affair, while that of the other painters filled the Salons and was vastly discussed in the press. The private/public axis, though extrinsic to the works themselves, is remarkably consistent: it was, in great part, in order not to be confused with the others that Braque and Picasso, on the advice of Kahnweiler, made their art relatively unavailable to a broad public in France (which is not to say that their art had no public at all but that it was extremely limited, and voluntarily so).[1] True, a special case could be made for Juan Gris and for Fernand Léger: though they both played an important role on the scene of public cubism, they cannot be fully characterized by this role and do not tally with their colleagues. Indeed Gris in 1913–1914, particularly in his *papiers collés*, maintained an informed dialogue with the recent production of Picasso and Braque;[2] as for Léger, although at first he followed the path of Gleizes, Metzinger, and company (hereafter G. M. & Co.), that of attempting an imitation of Braque and Picasso's analytical cubism without understanding much of it, he quickly developed his own signature style based on the recombination of selected elements borrowed from Braque and Picasso—among others the search for a "unitary mode of notation," to use Pierre Daix's phrase,[3] and the dissociation between linear armature, shading, and color. (Furthermore, Léger's own brand of cubism led him to cross the threshold of abstraction in 1913 and again in 1924, the second time around as an intended "synthesis" between painting and architecture; this, and the fact that, of all the cubists painters, he is the only one, as far as I know, to have devoted any thought to architecture at various points in his life, puts him in a category of his own. But the topic "Léger and architecture," fascinating as it may be and already much explored by Christopher Green,[4] as well as by Robert Herbert in this volume, is far removed from the question that concerns us here: whether or not one can speak of a cubist architecture.)

It is all a question of definition, I said, and cubism, from the moment of its inception, has been, for many, the "movement" that emerged around 1909–1910, coalesced in the two Salons (des Indépendants and d'Automne) of 1911, got consolidated in the same Salons of 1912 as well as in the Section d'Or exhibition of that year, and was definitively launched in Gleizes and Metzinger's book. Picasso and Braque have no part in this (they are merely given lip service): the heroes are the inevitable G. & M. but also artists like La Fresnaye, the Duchamp brothers, and even, though obviously by sheer adjacency, Marie Laurencin.

Take an early dropout like Le Fauconnier. Though his fame was a flash in the pan (by 1912 even G. & M. considered him a has-been and he was not included in the Section d'Or show), his staggering reputation around 1909–1911 offers the most salient example of a dividing line on the public/private axis. Furthermore, when this reputation faltered at home, it found other venues: his texts were widely published in several countries, and by the end of 1912 he had exhibited in Russia, Germany (including a retrospective at the Folkwang Museum in Hagen, an early mecca of modernism), Switzerland, Belgium, and Holland. True, by the time he moved to this last country (in 1914), Le Fauconnier had lost most of his supporters, but the fact remains that at the exhibition where Dutch artists discovered cubism—the first one organized by the Moderne Kunst Kring in the fall of 1911 in Amsterdam—he was much more the star than Braque or Picasso. Even Mondrian was fooled for a brief instant.[5]

Let us now look at Le Fauconnier's most celebrated work, *L'abondance*, bought by the Dutch artist and critic Conrad Kickert shortly after it was exhibited (to much acclaim) at the 1911 Salon des Indépendants and later given to the Gemeentemuseum

in The Hague (see fig. 1.5). It is easy to concur with
Golding: in this work Le Fauconnier "has simply seized
upon the most accessible aspect of Cubism, that is to
say the treatment of forms in terms of simple, angular
facets, as an easy way of dealing with a monumental
subject. There is no atmospheric recession, but the
perspective is completely traditional. The houses and
road have a more or less consistent vanishing point
(the road undoubtedly leads the eye inwards, into
depth) and there is a logical diminution of scale from
one background to the next."[6] In short, it is a nine-
teenth-century *pompier* painting on the surface of
which some misguided Cézannisms have hastily been
sprinkled so as to catch the last train.[7] Of course it
misses that train, not only because by 1911 Braque
and Picasso were miles away from their early investi-
gation of Cézanne, but because Le Fauconnier has no
clue, whatsoever, about the compelling motivation for
Picasso's and Braque's geometrization of the figure
(and of everything else) around 1908–1909.

Now, whoever wants to deem such a work
cubist—as was done, abundantly, by contemporary
critics—has indeed to welcome Duchamp-Villon's
Maison Cubiste as well: just as Le Fauconnier makes a
few cosmetic adjustments on the surface of a nine-
teenth-century Salon painting, Duchamp-Villon pow-
dered a nineteenth-century bourgeois version of a
Louis XVI *hôtel particulier* with specks of angular
faceting.

For my part, since one needs a label, I would call
this type of work not cubist, but *cubistic*.

▨ ▨ ▨

Duchamp-Villon's half-realized project represents the
first attempt at expanding "cubism" to the field of
architecture. The second time around, it seems to me,
the desire for such an expansion came from the archi-
tects. The mediation was provided by the discourse

surrounding cubism (and not only that devoted to
the public cubism, since even Kahnweiler produced a
version of the argument—a Kantian version—with
regard to Braque and Picasso themselves): one of the
most persistent clichés of the period literature on
cubism has indeed to do with the idea that it is about
the timeless "essence" of the object (as opposed to its
contingent "appearance"). Of course this has nothing
to do with Picasso, but it proved extremely popular.
I dare say it does not have much to do with Braque
either, though he is the one who inaugurated this ide-
alist topos, as early as 1908.[8] The invocation of the
geometrical forms of Plato's *Philebus* happened rela-
tively late in the game (the first occurrence, according
to Fry, is to be found in a 1916 article by Ozenfant),[9]
but by 1912 the nonsense about the "essence" and the
"absolute truth" was everywhere (in the writings of
Roger Allard, Olivier-Hourcade, Jacques Rivière, and
Maurice Raynal, among others), varying only in
degrees of crudeness.

If I mention Ozenfant here, it is surely because
the Neoplatonic sound bite was elevated by him and
his acolyte Le Corbusier to the level of a programmat-
ic platform. Purism, however, might only be an epiphe-
nomenon, and the translation one witnesses from the
discourse about painting to that on architecture, in the
immediate aftermath of World War I, might have hap-
pened without it. (One might recall among other
examples J. J. P. Oud's invocation of cubism in many
texts, written from 1916 on, in full ignorance of Le
Corbusier's position—an ignorance that led Oud to
believe, when he read *Towards a New Architecture*,
that he had been plagiarized.)

But if purism was not necessary for the transla-
tion mentioned above to happen, the translation itself
must be read as nothing more than a sign of the
potency of the discourse on public cubism at the time.
Architects fighting against the classical orders and

ornamentation, and for the truth to materials and means of construction, were bound to acclaim pure geometry as their master rhetorical code. They did not need cubism (nor its purist watered-down version) for that: as far as we know, neither Tony Garnier nor Adolf Loos devoted much thought to it. What seems to have attracted the architects is the fact that, thanks to the debate surrounding public cubism in the press, a modernist commentary had been widely publicized (the "law of economy," the picture as an autonomous entity, etc.), a ready-made discourse that they—or, much more often, their champions—could easily appropriate. It did not matter that there were precious few cubes in cubist painting: the architects advocated prisms, did they not? and cubes were prisms, were they not? There were some obvious advantages in teaming up with the "cubists."

Such a nominalist slippage was enough to guarantee the success of a whole literature devoted to the effect of cubist art on twentieth-century architecture. To be labeled cubist, it became enough for architecture to be merely *cubic*.

There are more sophisticated versions of such an amalgam in architectural criticism, where it is not the cube that is invoked but other items selected from the heap of clichés that abound in the literature on cubism. The most pervasive is provided by Sigfried Giedion in *Space, Time and Architecture*, a book once read as a major, if not the major, historical assessment of the modern movement in architecture.

Fully endorsing the idealist reading of cubism mentioned above, Giedion repeats the assumption initiated by Metzinger in 1911 and served up *ad nauseam* in most accounts of analytical cubism, according to which the cubist painters "have allowed themselves to move round the object, in order to give, under the control of intelligence, a concrete representation of it, made up of several successive aspects," and thus have

included time in their pictorial arsenal.[10] Cubism as a cognitive enterprise, cubism as the enactment of a modern concept of space-time: needless to point out the countless texts written along these lines, often featuring the direct invocation of Bergson (if not of Einstein). I would be the last to deny the fascination of G. M. & Co. with the philosophy of Bergson, and I might even be induced into accepting that it had some effect on their art (I might be induced, that is, if I am ever given a satisfactory description of this effect in their actual works). Even so, I would not accept Giedion's careless reinforcement of "space-time" and the multiple viewpoints in cubism in general, for I categorically deny that Braque's and Picasso's cubism had anything to do with it. Mind you, I am not the first to protest: for anyone interested, I suggest reading Leo Steinberg's extraordinary demonstration in "The Algerian Women and Picasso at Large" to the effect that cubism represents perhaps the only moment in Picasso's long career at which his "fantasy of an Argus-voyeur whose eyes see from a hundred points" is temporarily at rest. "Never is a Cubist object apprehendable from several sides at once, never is the reverse aspect of it conceivable, and no object in a work of 'Analytical' Cubism by Picasso or Braque appears as a summation of disparate views," concludes Steinberg.[11]

The space-time cliché is followed in Giedion's book by another one, that of the "transparency" of superimposed and interpenetrating planes that would characterize the syntax of analytical cubism. I am far from certain that the term "transparency" is particularly well chosen for what it seeks to describe (a radical disjunction between drawing and shading and the spatial contradictions that this disjunction produces); but even if one were to admit that transparency plays a major role in cubism, what could the spiky overlapping planes of Picasso's *L'Arlésienne* (Giedion's

example further in the book)[12] or of his *Portrait of Vollard* (to refer to a better-known work) have to do with the stern glass wall of Gropius's Bauhaus?

Colin Rowe and Robert Slutzky, among those who argued for the importance of "transparency" in cubist painting, were quick to denounce Giedion's superficial pairing, and characterized Gropius's glass wall as "an unambiguous surface giving upon an unambiguous space."[13] The "cubism" of the Maison Cubiste was at least grounded on its similarity with something like Le Fauconnier's *L'abondance* (I deny the cubism of both, but fully accept their affinity with each other); there is not the slightest similarity between Picasso's fluctuating planes and Gropius's blunt screen: the only possible link between them is merely an effect of a paucity of language (the fact that the same term, "transparency," is used to denote utterly different visual phenomena).

■ ■ ■

By criticizing Giedion's ill-conceived appeal to Gropius and shifting instead to Le Corbusier's architecture, Rowe and Slutzky give us a hint as to how the question concerning the existence of a cubist (as opposed to cubistic or cubic) architecture can be answered. What they call transparency in Corbu's villa at Garches, and for which they find a precedent in Braque's and Picasso's analytical cubism, has indeed been discovered in cubism, though not where they assume: the "transparency" in question is akin to Picasso's virtual plane in his famous 1912 sculpture *Guitar*, where it is a product, as in Le Corbusier's architecture, of the articulation of empty space as a positive sign. Picasso's *Guitar* signals a revolutionary acceptance of space in the history of Western sculpture and it does so through a structuralist logic that Le Corbusier emulates, consciously or not, in the "transparency" of Garches: it is because signs are not

defined by their substance but by their oppositional relationship to all the other signs in a given system that an absence, a virtuality, can hold a positive value and become a mark among others.[14]

This same logic, as Bruno Reichlin has shown in various articles, governs Le Corbusier's treatment of windows (at Garches and elsewhere) as equal to the walls.[15] Even though such an abstract (at least anti-anatomic) treatment of architectural elements is more directly dependent upon the formal work of De Stijl than upon Corbu's own reading of cubism (it occurs for the first time in the Villas La Roche–Jeanneret, the building in which his debt to De Stijl is the most conspicuous),[16] it would not have been possible—nor would much modern sculpture either—without what I would call Picasso's invention of space as sculptural matter.

But what of cubist painting (that is, of the cubism of Picasso and Braque)? Did it have any effect on architecture? Can we find for it any architectural equivalent? We would be wrong, I believe, to look for this at the merely morphological level (the superficial level at which the analogies defining both cubistic and cubic architecture operate). It would have to be found, instead, at the structural level of cubism's formation as a semiological system. I have written a small history of the semiology of cubism in which the grid plays a major role in the unfolding of Braque and Picasso's analytical cubism, and in which the discovery of the full potentiality of what Saussure called the arbitrariness of the sign marks the birth of synthetic cubism.[17] Contrary to what one might expect, I am not convinced that an analysis of the function of the grid in analytical cubism can yield any interesting insight as far as architecture is concerned (just as architects did not need cubism to think about prismatic shapes, they did not need it to know something about grids). On the contrary, the kind of semiological multivalence

that Picasso explores in his *papiers collés* seems to me very close to the contradictions and "false relations" detected long ago by Steen Eiler Rasmussen (much later by Robert Venturi, then again by Bruno Reichlin) in the work of Le Corbusier. Rasmussen gives as an example the hall of the La Roche house (in the Villas La Roche–Jeanneret), where Corbu extends the upper edge of the large window into that of the library's parapet so that the window's lintel seems to be resting on the latter, and he analyzes this formal inversion of the anatomic (supporting/supported) structure by way of the Rubini cup, a famous case of figure/ground reversibility discussed in most treatises of Gestalt psychology.[18] Had he known Picasso's work better, Rasmussen would doubtless have preferred an allusion to his cubist collages—for while the Rubini cup

displays an either/or relationship, an exclusive alternative, Picasso favors the polysemy of the and/or. Le Corbusier's semiological playfulness brings to my mind a particular *papier collé* of 1913, *Bottle of Vieux Marc, Glass, and Newspaper* (fig. 9.1). In it, not only is a glass defined by a void (its foot is a negative silhouette cut out of a piece of decorative wallpaper figuring the tablecloth on which it supposedly stands), but the content of the glass, running over its brim, is made of the very cut-out piece of paper whose absence defines the foot. This type of manipulation, an endless play on the interchangeability of signs that follows from their arbitrary character, abounds in Picasso's synthetic cubism. When Le Corbusier engages in the same kind of whimsical games, and he does so often, I am glad to bestow on him the title of *cubist* architect.

9.

NOTES

1. Almost from the beginning, at least from 1911 on, the literature on cubism both acknowledged the gap between public and private cubism and attempted to bridge this gap, as is made abundantly clear by Edward Fry's anthology of period texts, *Cubism* (London: Thames and Hudson, 1966). The situation has not changed much today. No one denies the existence of a major cleavage, and everyone agrees that very few works of Braque and Picasso could have been on display, at any given time, on the walls of Kahnweiler's tiny gallery, although some scholars tend to overestimate the number of visitors of these two artists' studios. (Patricia Leighten, for example, puts this private audience at 300, though she does not give any evidence for this. By contrast, Pierre Daix, speaking of the Bateau-Lavoir period in particular, reminds us that even privileged witnesses such as Kahnweiler, Salmon, and Gertrude Stein had very limited knowledge of what was going on in Picasso's studio in 1908–1909. See the discussion following Theodore Reff's paper in Lynn Zelevansky, ed., *Picasso and Braque: A Symposium* [New York: Museum of Modern Art, 1992], 44–56.) On the other hand, "cubism" is continually discussed as a homogeneous entity and Gleizes's and Metzinger's theories are still read as having an explanatory value with regard to Picasso's and Braque's work, as if the cleavage one is ready to acknowledge should be dismissed when one comes to analyze the works. An exception in the current literature is provided by David Cottington's approach: Cottington uses the concept of "subculture" coined by the Birmingham school of sociology in order to define Picasso's and Braque's limited public (Kahnweiler, Stein, and so forth) as a specific social group with specific artistic expectations, and to destroy the "ivory tower" myth that the private/public opposition implies. In doing so, however, Cottington does not eradicate the opposition, and even strengthens it. (See Cottington, "Cubism, Aestheticism, Modernism," in Zelevansky, ed., *Picasso and Braque: A Symposium*, 58–72.)

2. On this particular issue, see Christine Poggi, *In Defiance of Painting* (New Haven: Yale University Press, 1992), especially 105–123. For a serious reassessment of Gris in general, see Christopher Green, *Juan Gris* (New Haven: Yale University Press, 1992).

3. See Pierre Daix and Joan Rosselet, *Picasso: The Cubist Years, 1907–1916* (Boston: New York Graphic Society; London: Thames & Hudson, 1979), 68ff. For a discussion of the notion of a "unitary mode of notation" see my "The Semiology of Cubism," in Zelevansky, ed., *Picasso and Braque: A Symposium*, 180ff. As for the empty-headed imitation of Braque and Picasso by the other "cubist" artists, I'm not in the least proposing anything new here: it appears very early on in the literature (perhaps first in André Salmon's "Anecdotal History of Cubism" of 1912, translated in Edward Fry's *Cubism*, 81–90), and it is agreed upon by many scholars. However, even though the standard textbooks on cubism, such as Golding (*Cubism: A History and an Analysis 1907–1914*, 3d ed. [Cambridge: Belknap Press of Harvard University Press, 1988]) and Fry, provide ample evidence consolidating this line or argument, they paradoxically had the opposite effect and contributed to the common perception of cubism as a homogeneous movement where there would be only differences of degree (in quality) and not of nature between the art of a Picasso and that of a Gleizes. Furthermore, scholars of Gleizes, Metzinger, and other "public" cubist artists have tended to deny the validity of the Salmon line as cliché. I'm merely affirming that, sometimes, clichés are justified.

4. See Christopher Green, *Léger and the Avant-Garde* (New Haven: Yale University Press, 1976).

5. On Le Fauconnier's early fame, see Ann H. Murray, "Henri Le Fauconnier's 'Das Kunstwerk': An Early Statement of Cubist Aesthetic Theory and Its Understanding in Germany," *Arts Magazine* 56, no. 4 (December 1981), 125–131. On Le Fauconnier's Dutch career, see the excellent article by Jan van Adrichem, "The Introduction of Modern Art in Holland, Picasso as *pars pro toto*," *Simiolus* 21, no. 3 (1992), 162–211.

6. Golding, *Cubism*, 158–159.

7. I find van Adrichem much too lenient with Le Fauconnier when he relates *L'abondance* to a School of Botticelli *Allegory of Autumn* in the Musée Condé at Chantilly ("Introduction of Modern Art in Holland," 165). I would instead have looked for a Bouguereau-type version of the same subject.

8. See Georges Braque's statement to Gelett Burgess, first published in 1910 but dating from the autumn or winter of 1908: "I want to expose the Absolute, and not merely the factitious woman." Reprinted in Fry, *Cubism,* 53.

9. Ozenfant's text was published in *L'Elan*, no. 10 (1 December 1916). See Fry, *Cubism*, 153.

10. Jean Metzinger, "Cubism and Tradition" (1911), trans. in Fry, *Cubism*, 66–67. See Sigfried Giedion, *Space, Time and Architecture: The Growth of a New Tradition* (Cambridge: Harvard University Press, 1941), 357.

11. Leo Steinberg, "The Algerian Women and Picasso at Large," in *Other Criteria: Confrontations with Twentieth Century Art* (London: Oxford University Press, 1972), 160.

12. Giedion, *Space, Time and Architecture*, 402.

13. Colin Rowe and Robert Slutzky, "Transparency: Literal and Phenomenal" (1963), rpt. in Colin Rowe, *The Mathematics of the Ideal Villa and Other Essays* (Cambridge: MIT Press, 1976), 167.

14. On this issue, see my "Kahnweiler's Lesson," in *Painting as Model* (Cambridge: MIT Press, 1990), 65–97.

15. See in particular Bruno Reichlin, "Le Corbusier vs De Stijl," in Yve-Alain Bois and Bruno Reichlin, eds., *De Stijl et l'architecture en France* (Brussels: Pierre Mardaga, 1985), 91–108.

16. Reichlin compares the formal treatment of windows in the Villas La Roche–Jeanneret to this passage from Theo van Doesburg's manifesto "Towards Plastic Architecture" (1924): "The new architecture possesses no passive moment. It has abandoned the use of dead spaces (holes in the wall). The openness of the window has an active meaning as against the closure of the wall surface. Nowhere does a hole or a void issue forth, everything is strictly determined by its contrary." Trans. by Joost Baljeu (here slightly modified) in his *Theo van Doesburg* (London: Studio Vista, 1974), 14.

17. On all this, see my "The Semiology of Cubism."

18. Steen Eiler Rasmussen, "Le Corbusier—die kommende Baukunst?," *Wasmuths Monatshefte für Baukunst* 10, no. 9 (1926), 381, cited by Reichlin, "Le Corbusier vs De Stijl," 98–99.

10. BRUNO REICHLIN

JEANNERET–LE CORBUSIER, PAINTER-ARCHITECT

This essay explores connections between Le Corbusier's purist art and his architectural projects of the same period, and notes the parallels between his work in both media on the one hand and cubism on the other.

There is nothing specious about making such connections. Le Corbusier himself, on several occasions, recalled the anticipatory, if not originative, role his pictorial experiments played in his architecture. Note for example his comments in the special issue that *Architecture d'Aujourd'hui* devoted to him in 1948:

> Here I open a side door into where I live. It gives access to a workshop for patient research. Here is the key to my work. Every day of a life devoted to the flourishing of a machinist society is devoted in part to purely impersonal work. Inventing forms, creating relationships, proportioning lines, volumes, colors. . . .
>
> These paintings and drawings date to 1920 when, at the age of thirty-three, I began painting. I have been painting ever since, every day, mastering the secrets of form wherever I can find them, developing

the spirit of invention just as an acrobat daily develops his muscles and self-control. . . .

Can one measure the extent to which this patient and stubborn gardening, ploughing, and weeding of forms and colors, of measured rhythms and dosages, has daily nourished the architectures and urban schemes born at 35, rue de Sèvres? I think that if my architectural work is to be appreciated, its deep value must be sought in such hidden toil.[1]

There is no lack of critical approaches to the identification and characterization of relations between pictorial experiment and architecture. In this regard Colin Rowe and Robert Slutzky's essay on transparency is exemplary, as much for its critical insights (what it reveals of Le Corbusier's purist architecture) as for the tools it affords architectural criticism (the introduction of a distinction between "literal transparency" and "phenomenal transparency").[2] Since this initial approach there have been others, which I will take into account because they have focused on the more "technical" or "linguistic" aspect of the relation between these two modes of expression.

Among the factors basic to the comparison I propose, I include those that seem most obvious as well as those that might seem external or marginal: choice of materials and methods, choice of themes or "objects," rules of composition, and so on. But I focus above all on the concept of space, which plays a central role in the theory and practice of purist painting. Ozenfant and Le Corbusier–Jeanneret[3] themselves used architectural metaphors in discussing their paintings. In their article "Le purisme," for example, they wrote: "Space is needed for architectural composition; space means three dimensions. Therefore we think of the painting not as a surface but *as a space*."[4]

10.1 Charles-Edouard Jeanneret [Le Corbusier] (1887– 1965). *The Red Bowl*, 1919. Oil on canvas, 81 x 65 cm. Fondation Le Corbusier, Paris. FLC no. 135.

FROM THE PAINTER'S POINT OF VIEW

Let us examine one of the earliest purist paintings, *The Red Bowl*, of 1919 (fig. 10.1). Here the formal shapes, dimensions, and scaling of the bowl, cube, pipe, and roll of paper are as clear and intelligible as anything in a Flemish still life. What is problematic is the arrangement of these objects in space, which does not conform to naturalistic canons of perspective. One may in fact perceive this painting as a mere fragment of a larger work in cavalier, or bird's-eye, perspective. But the greater violence done to naturalistic conventions of perspective comes in what one must suppose to be the baseline. The cube, pipe, roll of paper, and their respective cast shadows suggest a surface (a tabletop?) that

one must presume to be horizontal. (The painting's spatial ambiguity severely limits interpretation of such visual cues.) But the roughly rectangular shape of the white surface—a flat surface upon which the roll of paper seems to rest—may be read two ways.

On the one hand, the flat white sheet of paper and reddish-brown background may be read as parallel, rather than perpendicular, to the picture plane; in this case the objects seem to float mysteriously in a rather shallow space squeezed between the front edge of the table and the reddish-brown background. On the other hand, the *sui generis* space of the composition may be read as having two points of projection: an oblique one governing the bowl, cube, pipe, and roll of paper, and a vertical one governing the white sheet of paper and its apparent baseline.

The ambiguity in *The Red Bowl* is ineluctable, but premeditated. In the sketches and drawings Le Corbusier made for the work, the perspective of the sheet or sheets of paper laid flat on the baseline has been "corrected"[5]—a correction Le Corbusier suppressed in the final painting. His pentimento shows in the barely obscured vertical edges of the white rectangular surface.

To antiperspectival "denaturalization" Le Corbusier added another, more insidious effect.[6] The objects represented are governed by a complex system of internal geometrical rules: the parallelism of roll of paper, pipe, and cast shadow of bowl; the coincidence of axis of the table and the vertical edge of the cube; the alignment of the tangent of the bowl and the right vertical edge of the white rectangle; and the coincidence of the axis of the bowl and the right edge of the cube.

There is no better example of the total artfulness of the purist painting. To an illusionistic, "naturalistic" transcription of objects purist painting opposes a compositional strategy that no longer refers to objects but only to their forms, to "pictorial remains" subjected to

a formalization that heeds only the compositional and spatial requirements of the painting. This compositional strategy would later give rise to Ozenfant and Le Corbusier's comment in an article titled "Le purisme" in *L'Esprit Nouveau* (1921):

> The Purist element issued from the purification of standard forms is not a copy, but a creation whose end is to materialize the object in all its generality and its invariability. Purist elements are thus comparable to words of carefully defined meaning; Purist syntax is the application of constructive and modular means; it is the application of the laws which control pictorial space. A painting is a whole (unity); a painting is an artificial formation which, by appropriate means, should lead to the objectivization of an entire "world."[7]

In the *White Bowl* (1919; Kunstmuseum, Saint-Gall), antinaturalistic artifice is even more obvious in the false perspective created by the two forms (one isosceles, one scalene) established along the hypotenuse.

The progressive abandonment of the spatial representation of "perspectival naturalism" (which includes and presupposes a viewer at the apex of the visual cone, and favors a plunging view whose point of projection is infinity, making it comparable to cavalier perspective) is especially evident in a series of drawings for a still life with violin, compote, die, roll, and book that is now in the Fondation Le Corbusier.[8]

In Le Corbusier's studies for *Still Life with Egg* (1919) and *Still Life with Stack of Plates and Book* (1920; fig. 10.2), the axis of projection is changed and lies in a plane orthogonal to the horizontal sides of the painting, so that the viewer is confronted by a curiously frontal axonometric projection in which objects seem

10.2 Charles-Edouard Jeanneret [Le Corbusier] (1887–1965). *Still Life with Stack of Plates and Book*, 1920. Oil on canvas, 81 x 100 cm. Oeffentliche Kunstsammlung Basel, Kunstmuseum. Donation Dr. h.c. Raoul La Roche, 1963.

to float, compressed and driven out toward the viewer.[9] But this is only a way station on the road to a type of representation where what at first appears to be a form of axonometry proves instead to be an illusion that adroitly betrays our habits of perception. Indeed, it is the product of a manipulation that mixes two sorts of projection—one vertical, the other frontal—and forces the viewer to become cross-eyed in order to

decipher the overall effect. Picasso's *Reclining Nude with Figures* had already prodded the public to such an effort—the public being obliged, in Leo Steinberg's phrase, to push hard on their mental levers to keep Picasso's erect *gisante* down.[10]

In Le Corbusier's *Still Life with Red Violin* (1920; fig. 10.3), and in the many preparatory drawings related to it, the two types of projection seem to

share the painting as prescribed in any handbook on descriptive geometry. Vertical projection governs the lower half, and frontal projection governs the upper half. The opposite arrangement characterizes the very fine *Red Still Life* (FLC no. 137) and *Violin and Red Violin Case* (private collection), both of 1920.

But in works foreshadowing developments from this point onward, the two perspectives are inextricably combined—and are occasionally complicated even more by oblique projections that suggest cast shadows, that open incongruous perspectival "windows," and so on.

In an article of 1921 in *Création*, Ozenfant and Jeanneret affirmed: "Perspective means the creation of virtual space. Purism acknowledges, as a compositional means of the first order, the sense of depth that generates the sense of space without which volume is an empty word. Purism uses volume, an eminently practical tool."[11] Purist paintings certainly suggest depth, volume, and space. But they also deprive the eye of that reassurance, that *image policée* of the world that—according to André Lhote, who coined the phrase—was the driving force behind the invention of perspective. To the question "What is basically at issue?" Lhote responded, "Permitting the eye to scan a certain range, receiving all the while a series of impressions that are varied but also linked by some common factor."[12]

In Le Corbusier's *Still Life with Stack of Plates and Book*, as in other works he painted around 1920, everything contributes to a relative homogeneity of space: vigorous modeling of objects placed in the center of the composition (few in number, reduced to their most rudimentary plastic expression); pronounced axonometric effect that results from this procedure; flatness of backgrounds and, consequently, of zones bordering the painting. But for all that, the painting remains equivocal. If the guitar is lying flat, why is its outline the same as that of the guitar case, which a

10.3 Charles-Edouard Jeanneret [Le Corbusier] (1887–1965). *Still Life with Red Violin*, 1920. Oil on canvas, 100 x 81 cm. Fondation Le Corbusier, Paris. FLC no. 137.

viewer may read as vertical? Is it a guitar case at all, or a cast shadow? And by what miracle does the plate atop the stack correspond exactly with the pattern of the guitar's sound hole? Is this correspondence merely, as I think, a visual pun?[13]

In the development of preliminary drawings into finished painting, Jeanneret progressively attenuated the modeling of objects and the articulation of spatial depth. But at the same time he rebalanced the relation between the supposed center of the composition and the periphery of the painting, instituting an even saturation of spaces and events.

In *Vermilion Guitar* (1922; fig. 10.4), the relatively shallow space is enlivened by local relief effects on the flat surround that appears to double the frame

10.4 Charles-Edouard Jeanneret [Le Corbusier] (1887–1965). *Vermilion Guitar*, 1922.
Oil on canvas, 81 x 100 cm. Speiser Collection, Basel.

of the painting. On the left side of the frame the neck of the guitar is tilted up and partly invades the surround—as baroque putti straddle the cornice between illusionistic sky above and real wall below. At the top right the neck of a bottle intrudes; to the right, the flat outline of a glass is defined. And finally, at the bottom, in an incongruous perspectival effect, the flat surround transforms itself into a baseline and thrusts the open book, glass, and die into the foreground. Here composition focused on a dominant center yields to a spatial texture animated by multiple centers of attention.

With the suppression of the unique center, there remains no Archimedean "fixed point" from which to restore order or hierarchy, no unequivocal structure that can steady the perspectival instability. No matter

where the viewer looks, he is confronted by different and contradictory spatial constructs, as in the "impossible spaces" created by M. C. Escher. These constructs are decomposed by projections that combine plan, elevation, profile, section, and cast shadow—projections deeply deceptive in their foreshortening, with colors that advance or recede within the painting;[14] projections that are "married" only by purely formal coincidence (a point to which I will return below). Objects are at one moment here and at another moment there, in front or behind—or, like so many hydra heads, cohabiting a single body.

The kinds of visual phenomena described above were designated "transparencies" by György Kepes in his *Language of Vision* (1944)—a term later taken up

10.5 Charles-Edouard Jeanneret [Le Corbusier] (1887–1965). *Still Life with Numerous Objects,* 1923. Oil on canvas, 114 x 146 cm. Fondation Le Corbusier, Paris. FLC no. 175.

by Colin Rowe and Robert Slutzky. According to Kepes, transparency occurs when two or more overlapping shapes each claim the overlap, without mutual optical obliteration. As Kepes commented, "Transparency means a simultaneous perception of different spatial locations. . . . The position of the transparent shapes has equivocal meaning as one sees each figure now as the closer, now as the further one."[15]

Jeanneret's transition from single focus to polycentric compositions came about in a group of paintings of 1922: *Three Glasses, Pipe, and Bottles on a Light Background* (Kunstmuseum, Basel); *The Orange Wine Bottle* (FLC no. 140); and *Pale Still Life with Lantern* (FLC no. 209). Each of these paintings has a double-focus compositional scheme, with centers

mirroring each other in relation to the axis of the painting, itself marked by a minor compositional element. A fluted, stemmed wineglass is the pivot of each composition. On the left is an oddly hybrid shape that blends guitar case and glass carafe. On the right is a half-full bottle of Bordeaux that screens a milk bottle, which in turn screens another bottle. The interest of this composition resides in the fact that Jeanneret developed it in tandem with the single-focus *Still Life with Siphon* (1921; FLC), as one can see in the side-by-side sketches of the very eloquent Carnet La Roche (FLC). One must conclude that the rather flat, double-focus compositions derive from splitting the composition of *Still Life with Siphon*—one of Le Corbusier's most highly stratified paintings—in two.

10.6 Le Corbusier (1887–1965). Villa Besnus, Vaucresson, plan study of the first floor above ground level, 1922. India ink and red pencil on tracing paper, approx. 11 x 36.6 cm. Fondation Le Corbusier, Paris. FLC no. 9214.

In Le Corbusier's *Still Life with Numerous Objects* (1923; fig. 10.5), the many pictorial metaphors are deployed with no concessions to naturalism, to suggest the transparency of glass. Similarly, the secret lives of dice and small pipes are displayed on the royal-blue silhouette of a glass liter measure—which, in its turn, and rather curiously, gives a gray tint to the red jug that shows through it. But the most interesting device of all is the clear, luminous volume that seems to underlie various objects, and suggests an unexpected depth along the top and left edges of the painting, just at the level where graspable space dissolves into broad flat surfaces. This second frame, which emerged only after long gestation in numerous sketches and drawings,[16] further compresses the objects and has the effect of defining, within the physical limits of the canvas, the objects' real loci of activity.

FROM THE ARCHITECT'S POINT OF VIEW

Up to this point I have tried to characterize Jeanneret's purist paintings by paying special attention to the evolution of various spatial and compositional devices. I will now try to trace the evidence of their effects in his architecture.

Let us consider the Villa Besnus at Vaucresson,[17] among the very first of Le Corbusier's architectural projects (fig. 10.6). The symmetry of the villa's elevations might lead one to expect large interior spaces centered on the great bays, but in fact a *bathroom* occupies the center of the first floor above ground level. Once inside, the visitor is forced to the periphery and must discover the interior progressively, through partial, curtailed views. Transitions are controlled. A wall, a strip window—these recur almost imperceptibly from space to space. Rounded corners and the absence of doors erode the sense of transition. There is no privileged viewpoint, no framing threshold to be grasped at a glance. Neither on the living room level nor on the first floor does the enveloping space offer itself in its

entirety. Here there are no viewpoints like those implicit in traditional interiors—viewpoints to which the traditional iconography of the "interior" refers, based as that iconography is on rules of one-point perspective.

In the little house at Corseau we find the same meandering itinerary along walls and windows,[18] and the same impossibility of distancing ourselves from the immense strip window that disrupts the interior. We are on the living room level, for example, but as Le Corbusier says, "the site [of the building] is there, as though one were in a garden."[19]

Le Corbusier's rapid perspective sketches are an eloquent expression of the ways his interiors are to be grasped. To the perspective *Guckkasten*—to the labored, static vision—Le Corbusier opposes summary photograms that reveal rooms as one moves through them in sequence, even as they show interactions of volumes and evolution of space.

Le Corbusier's representations of this sort culminated in a sketch-filled letter he sent Madame Meyer to illustrate his second proposal for her villa at Neuilly-sur-Seine (1925–1926; FLC drawings 31514, 31525). Here we are at the furthest possible remove from the "architectural still lifes" of a Tessenow, who confected "portraits" of the simple life in his icons of neo-Biedermeier domestic bliss. Instead, Le Corbusier exploits all the cinematic possibilities of the cartoon: perspectives extended to the point of taking in an entire itinerary. They presuppose movable points of view, cavalier perspectives, and rapid zoom shots, from panoramic view to close-up of plan. Explanatory cartoonlike "bubbles" are inserted to avoid breaking the optical continuity that the drawings suggest, and to prevent the reader from mistaking these drawings—these graphic annotations—for illusionistic renderings of the building to be built.

At this point we should return to the connections between Le Corbusier's paintings and his architecture.

From the outset, Le Corbusier's "architectural" objective in his purist paintings was *not* formulated to privilege a single viewpoint from which forms are controlled. In his architecture proper, Le Corbusier presupposed a plurality of views, itineraries, and readings. One may therefore justifiably speak of "antiperspectival" devices in his architecture. Among these devices are the horizontal or strip windows I have already mentioned. In escaping the cone of vision, the strip window denies the view imposed by the traditional window. The strip window cuts *across* the landscape, flattening it by suppressing transitions between near and far. Its excess of light and sight erases the centrality of space and powerfully redirects vision to the exterior.[20]

The perception of an architecture to be viewed in space, and over time, is sanctioned by what Le Corbusier called the "architectural promenade," which alone permits recognition of the unity of a given building. Of the La Roche house (half of the Villas La Roche–Jeanneret), Le Corbusier wrote: "This second house will thus be a little like an architectural promenade. One enters, and the architectural spectacle offers itself to the eye. One follows an itinerary, and the perspectives evolve in great variety. . . . The bays open views on the exterior, where one discovers the architectural unity."[21] We now know that the spatial envelope of this villa is a reflection of the neoplastic decomposition whose various characteristic devices are so many way stations on the "promenade."[22]

We should focus here on the architectural device that arises in the space around the leaning acacia tree, the space that reaches from the nearby garden toward the southeast facade of the villa. In the version of the La Roche house exhibited at the Salon d'Automne in 1923, even more "contaminated" by neoplasticism, this void is experienced as an upside-down cone, and though emphatically cut by a semicircular strip window, it is an important incident on the architectural promenade.

10.7 Le Corbusier (1887–1965). Villa Stein–de Monzie, Garches, first project, 1926. India ink and black pencil on tracing paper mounted on board, approx. 33 x 65 cm. Fondation Le Corbusier, Paris. FLC no. 31480.

In the final version of the villa, the same void becomes, according to De Stijl poetics, an example of the decomposition of the spatial envelope into wall surfaces. The promenade suggests this device twice—once on the first floor, with a frontal view of the tree, then on the library level with a lateral one—as though it were necessary to show it from two completely different but complementary points of view. We are reminded that by looking out of one of the windows of the library floor, we see the exterior of the double window opposite. It is as though this device is trying to show the "constant and invariable characteristics"[23] of the architectural object—in perfect accord with the purist pictorial program.

In the purist painting, simultaneous representation and the arrangement of plans, elevations, sections, and profiles of bottles, glasses, dishes, and guitars suggest a cognitive necessity. "Our concept of the object," stated Ozenfant and Le Corbusier, "comes from total knowledge of it, a knowledge acquired by the experience of our senses, tactile knowledge, knowledge of its materials, its volume, its profile, of all its properties."[24]

Purist doctrine denounced perspective representation because it "only gives an accidental view of objects."[25] In any case, the two views of the acacia, frontal and in profile, together constitute a hidden antiperspectival architectural device.

A striking example of the role Le Corbusier assigned the architectural promenade is provided by the preliminary plans of July 1926 for the Villa Stein–de Monzie. Instead of the "covered garden" that would eventually be built on the south side, Le Corbusier's early proposal, richly illustrated with fine autograph sketches,[26] shows a "garden terrace" of vast dimensions, simply juxtaposed with the house (fig. 10.7). An exterior space is at issue, of course. But the degree of spatial definition, and various windowlike openings, suggest an interior—a reworked "interior" without ceiling or walls—or perhaps an open-air salon. These characteristics give this "garden terrace" a touch of the stage set, of a *jeu d'esprit* freed of all utilitarian constraint.

From the unbounded side of the garden, the

promenade leads to the "salon." From here the visitor simultaneously sees the section viewed from the exterior and the interior—and from the interior the landscape beyond the villa is visible through the two openings in the north wall. Here is a view that has "come unstuck," rather as in an exploded model. An equally synthetic overall view is repeated at the other end of the promenade, when the cavalier perspective offered from the roof plunges down into the "unboxed" space of the "salon." The promenade leads one along the four internal surfaces of the "garden terrace," twice crossing the threshold between interior and exterior. The first traverse comes when the promenade passes from the garden to the steps on the axis of the space. The second traverse comes, straight ahead but higher, when the promenade ascends the staircase in the large opening of the north wall.

Thus, according to the itinerary of the promenade, the visitor experiences, bit by bit or simultaneously, the vertical and horizontal sections of the "garden terrace," the interior and exterior, the volume, and so on—in other words, "the constant and invariable characteristics" of the architectural object.

The space of a painting is virtual,[27] and the exterior point of view unique. The before and after of the various readings invited by a purist painting correspond to an essentially mental time.[28] By contrast, the understanding of architecture requires a multiplicity of views from categorically different viewpoints integrated with each other during the real time of a tour. This temporal dimension led Le Corbusier and Ozenfant on several occasions to suggest an analogy between architectural and musical appreciation.[29] One must let oneself be "caressed by forms," then grasp how they are created and assembled, how they reveal an emergent intention, how they may be classified in the selective repertory of images one has, "measuring and comparing."[30] Such a process of understanding requires a scenario.

It is here that the idea of a promenade arises. What is required is a "tour" that, in the real time and space of observation, selects and structures "physical sensations" so that the viewer's mind—the observer's mental, fixed "place"—yields a synthesis of "elective" images that permits an exhaustive understanding of the object, a re-creation of the "creative moment." In the "theatrical" space of the "garden terrace" the promenade guides the reading of the work.[31]

As the project for the Villa Stein—de Monzie was refined, the promenade dwindled to a fragment and eventually disappeared in the final version.[32] Here, nothing remains but the stairway ramp leading from the park to the covered garden, which is no longer juxtaposed to, but instead interlocked with, the house—and which is, from a spatial point of view, much more articulated than the "garden terrace" it replaced. In the covered garden, various spatial zones and situations coexist, as much because of their dimensions, types, and degrees of spatial differentiation as by reciprocal relations of subordination. One may tally the elements: a two-story covered space that juts into the park; the low space under the terrace, in front of the second-floor rooms; the roofless space of the terrace overlooked by the "roof garden" (fig. 10.8).

In the La Roche house (with the exception of its hall), and in the preliminary designs for the Villa Stein—de Monzie, the promenade draws us, like Ariadne's thread, from event to event. But the various spaces brought into relation with one another retain their relative autonomy and individuality. By contrast, in the final plans for the Villa Stein—de Monzie as built (fig. 10.9), the various spaces of the covered garden are an accomplished realization of the "modern, flexible plan with constant enjambment" that Le Corbusier discussed in an important theoretical text published in March 1926, just before he began his designs for the Villa Stein—de Monzie.[33]

10.8 Le Corbusier (1887–1965). Villa Stein–de Monzie, Garches, south facade and hanging garden, 1927. From Le Corbusier and Pierre Jeanneret, *Oeuvre complète de 1910–1929* (Zurich: H. Girsberger, 1930, rpt. 1977), p. 149.

In speaking of enjambment, Le Corbusier was describing the effects of spatial interference, of overlap or ambiguity, for which Rowe and Slutzky later proposed the term "phenomenal transparency."[34] Le Corbusier's term is more accurate. In poetics, enjambment means the breaking of congruence between syntax and meter, which occurs when the end of a phrase or part of a phrase does not coincide with the end of a line (rhymed or not).[35] Transposed into architecture, enjambment seems to describe perfectly the overflow of one space into another or, again, the breaking of the congruence between functional space and structural space. This constitutes a defiance of the "paralyzed plan" of traditional architecture[36] because "the modern plan of a house, born of reinforced concrete, allows us to escape from the square cellular form of rooms heretofore. . . . One wall of one room is the wall of another room. . . . I am no longer in the 'pink' or the 'blue room'; I am moving on an architectural site that reveals itself beneath my feet."[37] In an architectural situation where spatial enjambment reigns supreme, opening the way to multiple readings of the work, a linear promenade would from now on be a contradiction in terms.

10.9 Le Corbusier (1887–1965). Villa Stein–de Monzie, Garches, axonometric, 1927. Black and blue pencil on gelatin silver print mounted on paper, 115 x 93 cm. Fondation Le Corbusier, Paris. FLC no. 10445.

IN WHICH PURIST PAINTING AND ARCHITECTURE ARE COMPARED

Perhaps the comparison could be extended if the transition from composition by volume and well-defined spaces, unified by a "picturesque, meandering" promenade like that of the double Villas La Roche–Jeanneret,[38] toward the condensation of volumes and spaces like that of the Villa Stein–de Monzie were seen as the architectural equivalent of Le Corbusier's evolution as a painter, in which compositions that highlight several strongly modeled features focused

and immersed in a space still relatively homogeneous (typical of 1920) give way to the compressed, polycentric, ambiguous spaces of *Vermilion Guitar* (1922) and *Still Life with Numerous Objects* (1923).

This hypothesis may be demonstrated by the following arguments. Of the Villa Stein–de Monzie Le Corbusier would say that it was a "difficult" type of composition because of the restraints he imposed on himself, and because it consists essentially in the "compression of organs within a rigid envelope, absolutely pure."[39] The evolution of the villa's plans allows us to appreciate the peculiarities of preliminary

10.10 Le Corbusier (1887–1965). Villa Stein–de Monzie, Garches, first- and second-floor plan study, third project, c. 1927. Black and blue pencil on tracing paper, 57 x 111 cm. Fondation Le Corbusier, Paris. FLC no. 10517.

work that uses the flexibility of the modern plan "born of reinforced concrete." Each space, each function, each fixture struggles with its surroundings for the right to exist (fig. 10.10). On the first floor, the wall that bulges to accommodate the dining room trespasses on the living room level. On the second floor, the stairwell expands in the center to give more convenient access to the bedrooms and bathroom. The rippling periphery of partitions on the second floor suggests difficult connections between rooms, boudoirs, baths, water closets, closets, and so on. There is no center to the condensed plan of the Villa Stein–de Monzie. Instead, there is a multiplicity of events that saturates the frame-volume of the "pure prism" in its entirety. The architectural plan is clearly evocative of the volume that serves as both background and frame for the condensed composition of objects in *Still Life with Numerous Objects*, as described above.

The villa's roof garden offers perhaps the most convincing *architectural* demonstration of the spatial ambiguity of the purist painting at its most accomplished. This roof garden is closed on three sides—by the wing of bedrooms on the north side, and by the wall surfaces on two sides—and looks southward over a balcony that runs the width of the facade. Two large features occupy and structure the space of the roof garden: the elliptical volume of the storage room, to the left for someone reaching the terrace by the stairway; and an L-shaped wall-screen on the right that is seen diagonally (did modern composition require this feature?), has a painting-like opening with window ledge, and is topped by a chimney. It is overall a sort of "aedicule" that refers to habitation, like the rooms that wall the north side. Can a visitor standing behind the window of the roof garden imagine himself in an interior, when this is paradoxically the most "exterior"

space of the roof garden, squeezed against the parapet and open without protection to the limitless view? It would seem that he can. The two low benches behind this colored screen (only interiors are colored in Le Corbusier's architecture), and the corner of the terrace visible through the window, conjure up for the viewer within the aedicule the minimal but sufficient icon of an "interior" with a view on the "exterior" of the roof garden. For guests looking out from bedrooms to horizon, the window in the screen is a "telescope" that frames the landscape and composes a *veduta*. The roof garden is a fiction, an architectural theater in which spaces, places, and objects take on a different meaning and a new shape depending upon whether they are viewed or used.

Certain pictorial devices in Jeanneret's paintings derive, I think, from *architectural* gambits. They are apparent in the paintings of 1926 showing two or three bottles, or in the montages with various objects. Bottles, footed or unfooted glasses set upright or inverted, and other objects are juxtaposed without obvious hierarchy, like the sections and elevations of an architectural plan. Formal invention or manipulation is often based on the objects' functional, technical, or productive characteristics: the neck, shoulder, or bottom of a bottle, the molded profile of the foot of the glass, the shape of the glasses, the refractive effect of glass, and so on. It is as though Jeanneret–Le Corbusier were naturally inclined to mimic in the virtual space of purist composition the functional, technical, geometric, or formal causal relationship proper to the architectural project.

The pictorial device of the "marriage of objects in sharing an outline [mariage d'objets par un même contour commun]" requires our close attention. This device is treated fully by Ozenfant and Jeanneret in the article "Idées personnelles" (1924), under the heading "Composition":

> Purism gives importance to the conservation of the constituent norms of the object. It gives itself no right to reformulate them beyond a certain point. . . . Thus explicable are, for example, those marriages of objects in sharing an outline. The linkage of compositional elements to create a unique object in a painting, often achieved in cubism by alteration of the specificity of an object, is achieved in purism by organic means.[40]

In the paintings of Ozenfant, these "marriages" are immediately apparent, and occasionally decorative and a little mannered. Examples occur in his *Still Life with Glass of Red Wine* and *Cups, Glasses, and Bottles before a Window* (1922), which belonged to Raoul La Roche; in *Jug with Architectural Background* (1926), now in the Kunsthaus at Zurich; in the *Still Life* (1928) exhibited at the Pushkin Museum in Moscow; and so on.

In the paintings of Jeanneret, which are spatially dense, stratified, and ambiguous, these "marriages" are ambiguous but nevertheless omnipresent. In *Pale Still Life with Lantern* (1922), the foot of the inverted glass surreptitiously marries the handle of the teapot; the spout of the teapot delicately covers the molded-glass chalice; the rim of the glass on the left of the painting simulates the sound hole of the guitar. If one looks closely at the preliminary studies for *Still Life: Violin and Bottle* (1926) one discovers a secret union between an open book and a stack of plates and bottles. Behind the numerous objects of *Large Still Life* (1923) lurks a violin case. A specific type of "marriage" is effected when different bottle outlines merge on their vertical axes.

Let us now consider these effects in architecture. If reinforced concrete—the Dom-ino system—liberated the architectural plan from the tyranny of the "square

cellular shape" of traditional construction, the varying spaces of the modern *plan libre* constitute and express the balance achieved by the mutual adaptation of their "constituent norms." In architecture, these norms are function and distribution, and the given geometrical and dimensional, cultural and aesthetic, requirements. The statement that "one wall of one room forms the wall of another room" is not a mere truism. It acquires a formal, if not logical, dimension if we note how, for example, each object in the Villa Stein–de Monzie (washbasin, bath, fixture, etc.) makes its statement among its fellows.

However, the "marriage of objects in sharing an outline"—objects that in their "constitutive" characteristics tend to form a single object—may find expression in Le Corbusier's architecture. In purist paintings, this device is the objective of a dispassionate exercise that manipulates, arranges, and juxtaposes given objects. In architecture, before being a "device," the "marriage" is an inevitable *precondition* of the *plan libre,* an "artifice" that arises not from a poetic but from the economical use of surfaces to be built. As Le Corbusier stated in *Précisions*: "I also show how with curved partitions, easy to build, one obtains two bedrooms with their bath in a space that would normally have allowed only one traditional room."[41]

The comparison of Jeanneret–Le Corbusier's painting and architecture in what is conventionally called his purist period can be extended to include other relationships, ones more superficial than deep, but for all that, more obvious. One of these is his recourse to the *tracés régulateurs* in both his painting and his architecture. Le Corbusier wrote voluminously on this tactic in his architecture, as have critics and historians. For the use of this device in his painting, one may refer to the article "Le purisme" cited above, and to numerous works adjusted by *tracés régulateurs*.

Such compositions are catalogued and commented upon in the doctoral thesis Danièle Pauly devoted to Jeanneret–Le Corbusier's drawings of 1918–1928.[42]

The "project" for the painting was typical of the architect. Innumerable sketches, variants, and corrections on a reduced scale, sometimes with tracings in black and white, in pencil and pen—and in color—precede the mechanical sizing-up of the draft to the actual scale of the painting, just as though it were the plan for a building. There is an exemplary series of astonishing sketches for *Still Life with Siphon* (1921) in the Carnet La Roche.

A passage in *Après le cubisme* speaks of two distinct phases. On the one hand is the search for a balance between the gropings of emotion. On the other hand is materialization "reduced" to a purely "technical" operation—"that is, to a rigorous materialization of the concept, almost a fabrication."[43] Danièle Pauly has once and for all distinguished between Jeanneret and Ozenfant. Though both artists used the same subjects, Ozenfant "drew little and conceived his final works all at once, often as variations on the same theme."[44]

IN WHICH PURIST ARCHITECTURE AND CUBISM ARE COMPARED

Once *Après le cubisme* had been published, Ozenfant and Jeanneret took every opportunity to show how and why purism was a legitimate heir of cubism. Given the call for order in their first manifesto, one can even see in their statements an expression of cubist "fundamentalism."[45] If one accepts as a given the similarities—in the sense of structural correspondences—between Jeanneret–Le Corbusier's painting and his architecture, one must also accept that the spatial and composition-

al forms of his architecture owe much to the adventur-
ous cubist enterprise, and that they are conceivable
only as a result of his apprenticeship in cubism.

Still, one must go back to basics when compar-
ing purist architecture and cubism. Daniel-Henry
Kahnweiler, writing on Picasso's sculptures, asserted
that the plastic and pictorial experiments of
1910–1914 foreshadow "a totally different orienta-
tion for the plastic arts"—a turning point brought on
by a new appreciation of African sculpture. Picasso
and Braque abandoned traditional modeling. Some of
Picasso's paintings suggest, at least to Kahnweiler,
"a kind of scaffolding."[46] And of Picasso's paintings
and sculptures Kahnweiler would write, "Picasso had
split the homogeneous form,"[47] because the resulting
shape is obtained by assembling disparate elements
with no illusionistic reference.

These painters turned away from imitation
because they had discovered that the true
character of painting and sculpture is that
of a script. The products of these arts are
signs, emblems for the external world, not
mirrors reflecting the external world in a
more or less distorting manner. Once this
was recognized, the plastic arts were freed
from the slavery inherent in illusionistic
styles. The [Grebo] masks bore testimony
to the conception, in all its purity, that
art aims at the creation of signs. The human
face "seen," or rather "read," does not coin-
cide at all with the details of the sign, which
details, moreover, would have no signifi-
cance if isolated. . . . Cubist painters at this
time sought to represent things by created
signs that made them appear, in their totali-
ty, in the mind of the spectator, without the

details of the sign being identifiable as such,
though they were "read" by the viewer.

Picasso's reliefs of 1912–1914 emphati-
cally bear witness to this new state of
mind . . . whether one looks, for example,
at the guitar sound hole formed of a sheet
metal cylinder or a plastiline cone [Kahn-
weiler here refers to two small sculptures
of 1914]. This device, which makes concave
read like a convex, is strictly analogous to
the eye tubes of [Grebo] masks. . . . What
gives these reliefs their startling novelty
in European sculpture is the fact that . . .
the shape of these glasses, of these musical
instruments is nowhere continuously
described but acquires continuity only in
the creative imagination of the viewer.[48]

In extending and in criticizing these insights of Kahn-
weiler's, Yve-Alain Bois proposes that artistic language
be understood as a discourse posited on arbitrariness.
In order to keep some referentiality in sculpture,
arbitrariness reaches the level of resemblance: "A
cowry can represent an eye, but a nail can fill the same
function." The choice of materials is arbitrary, and so
too is the syntax "in that it no longer relies on anatom-
ical knowledge"—and the arbitrary sign has a vast
repertory of metaphors at its disposal.[49]

To conclude what can be said here about archi-
tecture, I will limit myself to noting that both cubist
painting and cubist sculpture of the "synthetic"
variety are montages—or, again, as Juan Gris (the
cubist closest to Ozenfant) said, they are a sort of
"flat and colored architecture," in which what counts
above all are the relations established between signs,
the "relative motivation" that governs the painted or
sculpted system.[50]

If any aspect of purism—whether pictorial or architectural—derives from montages of signs and refuses referentialism, it is clearly the "marriage of objects in sharing an outline." The association of objects that have nothing in common but the form that unites them signifies that these same objects—or theme-objects, in purist terminology—integrate themselves into the "whole" aimed at in the purist painting, solely by virtue of purely formal relations that suspend any and all referentiality.

The space in a purist painting is at once indicative of and complicit in this "transubstantiation" of referents into purely pictorial signs. Only in a "virtual space" can theme-objects establish such relationships. These relationships are ambiguous, plural, because the space is not governed by perspectival illusionism but is instead characterized by a stratification of plans in depth.

There are other indicators:

• Once the light source is eliminated—this according to Jacques Rivière, in a precocious and insightful article of 1912 on "present tendencies in painting" and on cubism in particular[51]—what looks like a cast shadow, or has taken the place of one, becomes an object in its turn, to be arranged with other objects in the same formal family: violin, violin case, and so on.

• In purist paintings, especially in the most accomplished among them, the void—the background or interval between objects—tends to assert itself in the same formal role as the other objects, a phenomenon that favors the coherence and density of the composition at the expense of referentiality. It was precisely this aspect of cubist paintings that drew Rivière's fire: "The intervals between forms—all the empty parts of the picture, all the places in it occupied by nothing but air, find themselves filled up by a system of walls and fortifications. These are new, entirely imaginary objects, thrusting in between the first ones as though to wedge them tight." These new objects interpose themselves so effectively that the painter, "if he gives to what separates them the same appearance as he gives to each of them, he ceases to represent their separation and tends, on the contrary, to confuse them, to weld them into an inextricable continuum."[52]

• In the bottom of the dish that "occupies" the guitar's sound hole in *Still Life with Stack of Plates and Book*, discussed above, one can see a scholarly reprise of the example set by Picasso, for whom a cylindrical volume, advancing or receding, could indifferently substitute for a guitar sound hole.[53] This is so true of Jeanneret's still lifes that it becomes practically a demonstration of the arbitrariness of the purist pictorial sign. Despite the evident illusionism of the work, two incompatible effects coexist in the same space: a relief effect, if one "reads" the stack of plates; and a depth effect, if one "reads" the guitar-rose.

We will never be able to demonstrate how much the purism of Ozenfant and Jeanneret owed to Picasso's small sculptures in cardboard, wood, and plastiline. But one cannot deny that bracketing referentiality—and privileging an autonomous system of rational values proper to painting—is common to both cubism and purism. The difference is this. In Picasso's small sculptures, the arbitrarily assembled and heterogeneous bits and pieces generate overall forms with one or more external referents: guitars, heads, and so on. In purist paintings, by contrast, immediately recognizable icons are assembled so that the resulting object—a "whole"—is constituted of pure formal values, without external referents. It is perhaps for the latter reason that one gets a sense of chilly academicism from many purist paintings.

The foregoing considerations shed light on a final aspect of the architectural device that I see as the volumetric-spatial equivalent of the "marriages of objects." In the modern plan "with constant enjambments," one sees in both plan and section that the form, or the spatial modeling, of each room no longer conforms to an iconographic or preestablished norm—nor do the dimensions or proportions, the disposition of doors and windows, or the location of rooms in the distributive scheme, and so on. At the same time, it is important that each room be precisely fitted to the role it plays (to accommodate a round table surrounded by chairs for guests, traffic flow in corridors and on staircases, etc.) or to its fittings (built-in washbasin or closet, bathtub, etc.). The examples just cited relate to the Villa Stein–de Monzie, the best example of its type.

It is important that a given space be blended into adjoining spaces, subjected to the "intimacies" and "indignities" of rooms with which it would have nothing in common in the traditional house.

It is important that the "enjambments" attenuate the boundaries between various rooms, to the point of eliminating them.

The following are, among other things, indices of the profound "resemanticizing" of architectural signs:

• The various spaces, considered one by one, appear interrupted or incomplete, and the elements that constitute them (partitions, pilasters, etc.), taken individually, rarely seem to have any rationale.

• Only the ensemble of spaces, elements, and accidents reveal the rules—the syntax—that structure them. Only on the general level can one read the spatial counterpoint between "Dom-ino" and "Cloison [spatial divider]," a counterpoint that explains the presupposed free relations between structural frame and spatial articulation.

As in Picasso's small sculptures, it is only in an apprehension of the whole that one can understand what the real "subject" of the work is. The "real" architectural subject is the *plan libre*. And all the exuberance of the composition is there to illustrate how rich this new principle of composition is in its possibilities for spatial articulation.

It seems legitimate to conclude that Le Corbusier grammatically declined multiple levels of the motivated and the arbitrary nature of the architectural sign in ways that paralleled those characteristic of synthetic cubism.

10.

NOTES

1. Le Corbusier, "Unité," *Architecture d'Aujourd'hui*, special issue, April 1948, 32–39.

2. Colin Rowe and Robert Slutzky, "Transparency: Literal and Phenomenal," written 1955–1956, published in *Perspecta* 8 (1963), 45–54.

3. By convention "Jeanneret" designates the painter, "Le Corbusier" the architect.

4. Amédée Ozenfant and Charles-Edouard Jeanneret, "Le purisme," *L'Esprit Nouveau* 4 (January 1921), trans. in Robert L. Herbert, ed., *Modern Artists on Art: Ten Unabridged Essays* (Englewood Cliffs, N.J.: Prentice-Hall, 1964), 67.

5. See drawings in the Fondation Le Corbusier, Paris (hereafter FLC), nos. 3601, 2413, 2320, and 3598. I owe much of my knowledge of purist paintings and drawings to the excellent thesis by Danièle Pauly, "Les dessins de Le Corbusier (C.-E. Jeanneret) 1918–1928," 3 vols. (University of Strasbourg, 1984). My thanks to Mlle Pauly for making a copy available to me.

6. For the concept of "denaturalization," see Bruno Reichlin, "Le Corbusier vs De Stijl," in Yve-Alain Bois and Bruno Reichlin, eds., *De Stijl et l'architecture en France* (Brussels: Pierre Mardaga, 1985), 91–108.

7. Ozenfant and Jeanneret, "Le purisme," 73.

8. FLC drawings nos. 1713, 5722, 5721, 5724 (February 1920). Cited in Pauly, "Les dessins de Le Corbusier."

9. FLC drawings nos. 1719, 1599, 1734, 1541, 1536, among others.

10. Leo Steinberg, "The Philosophical Brothel," first published in *Art News*, September and October 1972; revised and trans. as "Le bordel philosophique," in *Les Demoiselles d'Avignon*, exh. cat., 2 vols. (Paris: Réunion des Musées Nationaux, 1988), 2:319–365.

11. Amédée Ozenfant and Charles-Edouard Jeanneret, "Intégrer," *Création* 2 ([November] 1921), n.p. By contrast with classical perspective, which produces a deformed image of the body—so the authors explain—"purist perspective is a creation and arrangement of plans permitting the representation of the essential and invariable characteristics of bodies." In this purist "virtual space," the "theme-objects" are presumed to lie on planes running parallel between them and the picture plane, planes layered at different depths—in such a way as to guarantee an exact (that is, nondeformed) rendering of the objects represented.

12. André Lhote, *Traité de la figure* (Paris: Floury, 1950), 17.

13. See analytical drawing by B. Hoesli in Colin Rowe and Robert Slutzky, *Transparenz*, ed. B. Hoesli (Basel: Birkhäuser, 1968), 48. According to Pierre Guiraud, *Les jeux de mots* (Paris: Presses Universitaires de France, 1976), 10, "The pun, strictly speaking, is a phonetic equivocation of 'joking' and more or less 'abusive' intent." In my text I use the word in an extended and figurative sense. Victor Hugo once gave a superb definition of the pun, cited in *Le Petit Robert*: "Puns are the droppings of the spirit in flight." Ozenfant and Jeanneret

used *calembour* ("pun") in "Le cubisme—deuxième époque" to designate certain excesses: "one goes so far as to indulge oneself in irrelevancies and puns (if some keep their footing on the high-wire, others tumble off)" (*L'Esprit Nouveau* 24 [June 1924], n.p.).

14. Ozenfant and Jeanneret, "Le purisme," 70, where polychromy is at issue: "In the expression of volume, color is a perilous agent; often it destroys or disorganizes volume because the intrinsic properties of color are very different, some being radiant and pushing forward, others receding, still others being massive and staying in the real plane of the canvas, etc."

15. György Kepes, *Language of Vision* (Chicago: Paul Theobald, 1944), 77.

16. Pauly, "Les dessins de Le Corbusier," 2:188–194. Pauly provides a detailed chronological analysis of the development of this important and complex painting. From the iconographical documents she reproduces one can deduce that the volume frame appeared only after a series of minute changes in the final drawing for the work: FLC no. 1192, in color, later signed and dated by Le Corbusier.

17. Ibid., and Françoise Ducros, "La nature morte architecturale: thèmes et références," in André Ducret et al., *Le Corbusier, le peintre derrière l'architecte* (Grenoble: Presses Universitaires, 1988), 72, date the "box house" type, like the Villa Besnus at Vaucresson (1922–1923) or the Ozenfant studio in Paris (1923–1924), to the first period of purist painting, which is in fact characterized by volumetric accentuation of objects.

18. The meandering promenade is neither a modern discovery nor exclusive to Le Corbusier's architecture. Such an itinerary had illustrious predecessors in residential architecture: André Corboz, "Une œuvre méconnue de l'agence Mansart à Genève: L'Hôtel Buisson (1699)," *Genava*, n.s., 32 (1984). The novelty of Le Corbusier's meandering itinerary consisted entirely in its handling of transitions from space to space.

19. Le Corbusier, *Almanach d'architecture moderne* (Paris: G. Crès, 1925), 94. Caption for the photograph of the strip window viewed from the interior of the "little house."

20. In this regard, see Bruno Reichlin, "The Pros and Cons of the Horizontal Window: The Perret–Le Corbusier Controversy," *Daidalos* 13 (September 1984), 65–78.

21. Le Corbusier and Pierre Jeanneret, *Oeuvre complète*, vol. 1 (1929), 11th ed. (Zurich: Artemis, 1984), 60.

22. See my discussion in Reichlin, "Le Corbusier vs De Stijl," 91–108.

23. Ozenfant and Jeanneret, "Le purisme," 66: "the Purist element . . . ought always to embody the characteristic and invariant constants of the object-theme, subject to the modifications demanded by the composition."

24. Ibid., 65.

25. Ibid., 65–66: "Ordinary perspective with its theoretical rigor only gives an accidental view of objects: the one which an eye, having never before seen the object, would see if placed

in the precise visual angle of this perspective, a particular and hence an incomplete angle. A painting is constructed with exact appeals nearly exclusively to sensations of a secondary order and is consequently deprived of what could be universal and durable."

26. See especially the fine page of sketches dated 20 July 1926 and addressed to the clients (FLC 31480). Other drawings belonging to this project are FLC 10409, 10509, 10511–10514, 10586.

27. Ozenfant and Jeanneret, "Intégrer."

28. In theoretical writing on cubism, the theme of duration, the time required to read a work, to read a representation that in fact has the notion of time implicit in it, constantly recurs. It does so often in authors, painters, or critics who quarreled with, or joked about, the inventors of cubism. But the theme of duration was in the air at the time. For example, Jean Metzinger wrote in "Cubisme et la tradition" (*Paris-Journal*, 16 August 1911), "[the cubists] have allowed themselves to move round the object, in order to give, under the control of intelligence, a concrete representation of it, made up of several successive aspects. Formerly a picture took possession of space, now it reigns also in time." Cited with commentary in Edward Fry, *Cubism* (New York: McGraw-Hill, 1966), 66–67. In the text on the *Demoiselles d'Avignon* previously mentioned (n. 10), and in relation to the crouching woman in the lower register, Leo Steinberg makes a passing allusion to temporal duration when he notes that the figure is presented at once frontally and from behind, "as though to be perceived through time."

29. See Ozenfant (writing under the pseudonym Julien Caron, on the Villa Schwob), "Une villa de Le Corbusier 1916," *L'Esprit Nouveau* 6 (March 1921), 683: "Handling volumes that successively present themselves to the viewer moving from room to room is like the musician's ordering successive phrases of a musical composition."

30. Le Corbusier, *Urbanisme* (1925; rpt. Paris: Arthaud, 1980), 58–59: "Behind the eye is that agile, generous, inventive, imaginative, logical, and noble thing—the spirit. What you put before the eye will give it pleasure. Multiply this pleasure. It is the harvest of sowing a man's talents. And what a harvest! A prestigious machine set in motion—knowledge, creativity, symphonies. To be caressed by forms, then to grasp how they reveal an emergent intention, how they may be classed in the collection one makes of elective images. To measure, compare in one's spirit, to see: to know for oneself the creator's joys and sorrows." These breezy lines sketch a program of "interpretative cooperation" in the "writing" and "reading" of an architectural "text" that foreshadows the semiotic theories developed by Umberto Eco in *Lector in Fabula, la cooperazione interpretativa nei testi narrativi* (Milan: Bompiani, 1979) and reprised in *Sei passeggiate nei boschi narrativi*, Norton Lectures, Harvard University, 1992–1993 (Milan: Bompiani, 1994). See my opening remarks in B. Reichlin, "Solution élégante," in Jacques Lucan, ed., *Le Corbusier, une encyclopédie* (Paris: Editions du Centre Pompidou, 1987), 369–377.

31. "Reading the work" is a concept of Le Corbusier's.

32. For a more precise reconstruction of the several versions and variants of the Villa Stein–de Monzie, see Tim Benton's well-documented *The Villas of Le Corbusier, 1920–1930* (New Haven: Yale University Press, 1987), 164–189. One may note other elements of the promenade in FLC 10410, dated 7 October 1926; FLC 10541 from early November; and FLC 10417/10573, dated 7 January 1927.

33. Le Corbusier, "Notes à la suite," *Cahiers d'Art* 2 (February 1926), 46–52. The manuscript at FLC is dated 5 March 1926. See in particular paragraph IV.

34. Rowe and Slutzky, "Transparency."

35. For a definition of the rhetorical device of enjambment, see, among many texts dealing with the subject, J. Dubois et al., *Rhétorique générale* (Paris: Larousse, 1970), 71.

36. The notion of the "paralyzed plan" as opposed to the "free plan" proposed by Le Corbusier is illustrated in a fine color plate in *Précisions sur un état présent de l'architecture et de l'urbanisme* (Paris: G. Crès, 1930), figs. 8–16, and explained in the chapter entitled "Les techniques sont l'assiette même du lyrisme."

37. Le Corbusier, "Notes à la suite," 50.

38. As in the diagram "4 compositions" in Le Corbusier and Jeanneret, *Oeuvre complète*, 1:189.

39. Le Corbusier, *Précisions,* 134.

40. Amédée Ozenfant and Charles-Edouard Jeanneret, "Idées personnelles," *L'Esprit Nouveau* 27 (1924). In his important work on the *Demoiselles d'Avignon*, Leo Steinberg called attention to devices comparable to "marriages of objects" in Picasso's work during his cubist period. Steinberg adduced various examples, then concluded: "The unique descriptive outline that seems to be two contiguous forms is a principle one finds constantly in Picasso as a draughtsman" ("Le bordel philosophique").

41. Le Corbusier, *Précisions*, 132.

42. Pauly, "Les dessins de Le Corbusier," vol. 1, especially "Commentaires de divers dessins," pp. 71–75, col. 2. Among the earliest drawings governed by *tracés régulateurs* are, among others: FLC 2442, dated April 1919 and annotated "Détermination de la surface puriste — Le triangle équilatéral"; FLC 1561, preparatory for *The Port of La Rochelle* (1919–1920); and FLC 3344, preparatory for *Violin and Violin Case* (1920).

43. Amédée Ozenfant and Charles-Edouard Jeanneret, *Après le cubisme* (Paris: Editions des Commentaires, 1918), 56.

44. Pauly, "Les dessins de Le Corbusier," 1:112. On Le Corbusier's working methods, see chapter 4, "Les dessins comme matérialisation du processus créateur."

45. See for example chapter 7, "From Analysis to Synthesis," in Kenneth Silver, *Esprit de Corps: The Art of the Parisian Avant-Garde and the First World War, 1914–1925* (Princeton: Princeton University Press, 1989).

46. Daniel-Henry Kahnweiler, *Les sculptures de Picasso* (Paris: Editions du Chêne, 1948), n.p.

47. Daniel-Henry Kahnweiler, *The Rise of Cubism* (first published in German in 1920), cited in Yve-Alain Bois, "Kahnweiler's Lesson," *Representations* 18 (Spring 1987), 46; rev. in Yve-Alain Bois, *Painting as Model* (Cambridge: MIT Press, 1990), 74.

48. Kahnweiler, *Les sculptures de Picasso*, n.p.

49. Bois, "Kahnweiler's Lesson," in *Painting as Model*, 83–85. The last part of my essay owes much to Bois's richly suggestive article. He establishes a parallel between Saussurian "semiology" and the development of modernist pictorial language. I hope that in applying the theoretical points Bois makes to architecture, I have not strayed from or forced them.

50. Juan Gris, "On the Possibilities of Painting," speech to the Groupe d'Études Philosophiques et Scientifiques (founded by Dr. Allendy), Sorbonne, 15 May 1924, published in its entirety in *Transatlantic Review* (Paris) 1, no. 6 (June 1924), 482–488. I cite from Daniel-Henry Kahnweiler, *Juan Gris: His Life and Art*, trans. Douglas Cooper (1946; enlarged ed. London, 1990), 197. Gris wrote: "Only the purely architectural element in painting has remained constant. I would even say that the only true pictorial technique is a sort of flat, coloured architecture. . . . True architecture cannot be broken up into different pieces, each of which is autonomous and exists alone. A fragment of architecture will be no more than an odd, mutilated object which ceases to exist when it is removed from the one place where it belongs." To illustrate this idea, Gris offered the image of an engine "which is subtly conceived as a delicate arrangement of somewhat impersonal parts, [and] comes nearer to being architecture."

51. Jacques Rivière, "Sur les tendances actuelles de la peinture," *Revue d'Europe et d'Amérique* (Paris), 1 March 1912, 384–406, cited in Fry, *Cubism*, 76. Rivière wrote: "It [lighting] is the sign of a particular instant. . . . If, therefore, the plastic image is to reveal the essence and permanence of beings, it must be free of lighting effects. . . . He [the cubist] has renounced lighting—that is to say, the direction of light—but not light itself." Further on, Rivière defined purist cast shadow *before the fact*: "[the cubist] will use the small portion of shading allotted to each [surface] by placing it against the nearest edge of some other lit surface, in order to mark the respective inclination and divergence of the parts of the object."

On the subject of light—natural light, or at least a single source of light—Ozenfant and Jeanneret wrote: "The particular incidence of light on a subject constitutes 'the effect.' Light acts as a natural deformation. It would be better to banish it and prefer a light more respectful of the integrity of forms" (*Après le cubisme*, 58).

52. Jacques Rivière, "Sur les tendances actuelles de la peinture," 79. Leo Steinberg, in "The Philosophical Brothel," raised this question when he wrote of the watercolor sketch for the *Demoiselles d'Avignon* (1907): "But the notable thing about this final preparatory work is the positive value given to the spacings on the right. The surrounding voids fill out and harden, and the thickening of these intervals transforms the two figures on the right into negative shapes held on an obscure background."

53. See the small sculptures from 1913–1914 reproduced in Kahnweiler, *Les sculptures de Picasso*, figs. 9–11.

11. DETLEF MERTINS

ANYTHING BUT LITERAL:

SIGFRIED GIEDION AND THE RECEPTION OF CUBISM

IN GERMANY

For the past thirty years, the significance of cubism for modern architecture and, more specifically, the cubist idea of transparency have been understood primarily through the lens of Colin Rowe and Robert Slutzky's essay "Transparency: Literal and Phenomenal," first published in 1963.[1] Calling for greater rigor in both the language and formal analytics of contemporary architecture, Rowe and Slutzky set out to distinguish between what they called two "species" of modernism by clarifying the formal properties of cubist "transparency." Taking issue with Sigfried Giedion's comparison in *Space, Time and Architecture* of Walter Gropius's Workshop Building for the Bauhaus at Dessau (1925–1926) and Pablo Picasso's painting *L'Arlésienne* of 1912, they sought to supersede the "evasive" and "approximate" nature of words such as simultaneity, interpenetration, superimposition, ambivalence, and space-time with a formalist notion of phenomenal or seeming transparency. Reworking definitions of transparency taken from György Kepes in *Language of Vision* (1944) and László Moholy-Nagy in *Vision in Motion* (1947),[2] they suggested that there was a kind of transparency

that was not literal or material but ambiguous—
generated by the simultaneous perception of different
spatial locations and by superimposed forms that
appear to interpenetrate without optically destroying
each other. They suggested that this was comparable
to the "manifold word agglutinations" of James Joyce's
puns. The categories of literal and phenomenal trans-
parency were introduced to register this distinction.
"Transparency," they wrote, "may be an inherent
quality of substance—as in a wire mesh or glass
curtain wall, or it may be an inherent quality of
organization."[3]

Taking this opposition as an "efficient critical
instrument," Rowe and Slutzky proceeded to demon-
strate the existence of phenomenal transparency in a
selection of cubist and postcubist paintings, notably
Fernand Léger's *Three Faces* of 1926, and to observe
its absence in a formal model that amalgamated
constructivism, expressionism, futurism, and De Stijl,
represented for them by Moholy-Nagy's *La Sarraz* of
1930. Having taken the notion of phenomenal
transparency in part from Moholy's writings, Rowe
and Slutzky turned it against him, caustically observ-
ing that "he himself had been unable or unwilling
to achieve [it] . . . in spite of the literal transparency
of his paint."[4] Similarly, they disparaged Giedion's
interpretation of cubism in Gropius's Bauhaus as
based on the supposed transparency of glass; instead
they presented Le Corbusier's Villa Stein–de Monzie
at Garches (1926–1927) and League of Nations proj-
ect (1927) as demonstrative of an architecture able
to sustain comparison with the striated spatiality of
Léger's paradigmatic painting. Culling together formal
characteristics from numerous other examples, their
elaboration of the opposed categories tended to invert
their initial distinction between clarity and ambiguity,
commending the specificity of spatial locations in Le
Corbusier over the absence of points of reference in

Gropius, the assertive corners of the villa at Garches
over the dematerialization of the Bauhaus, taut
architectonics over walls flowing and blending into one
another. By dividing the avant-garde of the early
twentieth century into two camps, and arguing that a
superior line of development was latent in one—in
the early transposition of architectonic composition
from painting (Cézanne, cubism, and purism) into
the buildings of Le Corbusier—Rowe and Slutzky
effectively undermined the influence of Gropius,
Giedion, and Moholy-Nagy for architects entering
the field in America after 1963.

Subsequent considerations of the relationship
between cubism and architecture have tended to orbit
around this seminal text, leaving largely unquestioned
its theoretical categories and binary logic, as well as
its authority as a history of cubism in modern archi-
tecture and even its interpretations of Le Corbusier's
purism and Gropius's Bauhaus. One notable exception
was in 1976 when Manfredo Tafuri and Francesco Dal
Co accorded cubism a strategic role in the history of
modern architecture without referring to Rowe and
Slutzky or their terminology.[5] They presented the ear-
liest cubist paintings by Pablo Picasso, Georges
Braque, and Juan Gris as a historical as well as formal
origin for a diverse array of European avant-gardes
trying to "shake off the anxiety provoked by the loss
of a center . . . [in] the chaos of metropolitan form-
lessness," trying to affirm "the possibility of a recon-
quest of the real world." More than just a point of
departure, the revolutionary turn of cubism was, for
them, an origin that already contained its end—the
structural characteristics, problematics, and flaws of
the entire avant-garde project, which they saw played
out during the 1920s, especially at the Bauhaus. Tafuri
and Dal Co presented the Bauhaus as the "decanta-
tion chamber" and "refinery" of the avant-gardes,
striving to achieve a new synthesis that would

draw the various postcubist movements[6] together into a consolidated foundation for reconstructing the world—resolving the antipathy between life and art, art and technology, destruction and construction— moving from painting into architecture.

Tafuri and Dal Co outlined a history of artists and architects concerned with the programmatic implications of cubism for modern architecture, one that other recent surveys of the period have tended to overlook but that Giedion and others had already attempted to represent in the 1930s and 1940s.[7] Tafuri and Dal Co's account also implied that the idea of cubism as inaugurating a line of development not only in art but into architecture had been introduced not retrospectively by historians but *programmatically* by avant-garde artists, architects, and critics—including, of course, critic-historians such as Adolf Behne and Walter Curt Behrendt, as well as Giedion and artists such as Theo van Doesburg, Kasimir Malevich, and El Lissitzky whose conceptions of postcubist art were informed by their readings in art history and subsequently aimed at the realization of a new formal paradigm, fully environmental in scope. Giedion's representation of cubism's trajectory into modern architecture, while inadequate to the complexity of this history, is surprisingly consistent with that of Tafuri and Dal Co, although he did, as they noted, draw different conclusions.

In this essay I explore how the idea of cubism (which was itself multiple and contested) was received in architectural discourse in Germany and actively mobilized as both a point of departure and a goal for a number of influential figures seeking to overcome what they perceived to be the loss, not so much of center as of unity and synthesis. In the history thus constructed, relationships among the avant-garde have assumed a greater complexity than categories such as expressionism, constructivism, and functionalism have

allowed, entailing often perplexing interweavings of history and theory in art and architecture, of practices and programs, complicities, complaints, and misunderstandings. Rivalries between individuals have come to the fore at the same time that the notion of cubism has emerged as a common term among formally and theoretically divergent positions—a term associated with the widespread belief that the path toward a new architecture began in cubist painting and would end in a new age that would be the very antithesis of the preceding one: antirepresentational, postperspectival, abstract, and antihumanist. In the context of this commonality, differences and changes in position revolved largely around the problematic relationships between subject and object, identity and alterity, form and formlessness, construction and destruction. The constitutive instability of these binary oppositions, closely allied with the ongoing destabilizations of modernization, precluded resolution in formal representations and fueled the restless uncertainty and experimentalism of the avant-garde in the early years of the Weimar period.

Within this territory, I present three independent yet overlapping stories, focusing in turn on the critic Adolf Behne, on Walter Gropius and the early Bauhaus, and on Sigfried Giedion. Provoked by the architecture of Czech cubism in 1914, Behne began to formulate a programmatic conception of cubism as a revolutionary anticlassical and anti-European world view. In 1919, he published a strident manifesto for cubist architecture based on the idea that purified artistic means (construction rather than imitation) would facilitate open and unpredetermined creative production, which he conceived as a kind of passage from the immaterial realm of the suprahuman into the material sphere of humanity through the activity of construction. For this he combined preoccupations of expressionism and so-called German cubism with aspects of Paul

Scheerbart's utopian fantasy of glass architecture, a combination that crystallized in a notion of utopian (cubist) images. While Behne's association with Bruno Taut is well known, the implications of his vision for Walter Gropius and the early Bauhaus have been less studied. Their importance, however, is underscored by the fact that Behne began to criticize expressionism as early as 1918 and progressively distanced himself from Taut after joining Gropius in the leadership of the Workers' Council for Art in 1919. The complexity of this episode is compounded by the influence of De Stijl—itself divided after 1921 when Theo van Doesburg and J. J. P. Oud split over the correct interpretation of cubism for architecture—and then constructivism, especially that of László Moholy-Nagy whose artistic research into transparency, central to his teaching at the Bauhaus, was inspired by Behne's call in 1919 for a Scheerbartian cubism. Although he did not refer to Behne, Giedion's notion of construction as an automatic writing of the subconscious implicitly took up Behne's earlier interpretation of cubism, but was distinguished from it by incorporating a phenomenology of perception that he attempted to articulate with the idea of space-time which he took from both scientific and artistic theory. His later reading of the Bauhaus as the first realization of cubist space-time in architecture was offered, then, in the context of a broad spectrum of postcubist research into the implications of modern painting for architecture (De Stijl, constructivism, and purism) and in the context of claims made in the late 1920s that the Bauhaus building at Dessau marked the beginning of a widely disseminated glass architecture, anticipated initially in utopian dreams of a crystalline cubism that would break with the legacy of Renaissance perspective and anthropomorphism.

ADOLF BEHNE'S OPENNESS: CONSTRUCTION AND IMMANENCE

Beginning in 1914, still within the early discourse of expressionism, the critic Adolf Behne began to appreciate cubism for purifying the means of artistic expression into an elemental, primitive, and architectonic language capable of expanding the world of human experience beyond what he took to be the limitations of humanist anthropomorphism. Prompted less by French cubism, or even its German variations by Franz Marc, Lyonel Feininger, or Paul Klee, than by the arrival of Czech cubism in Herwarth Walden's Sturm gallery and magazine in Berlin during 1913–1914,[8] Behne's gradual embrace of cubism was informed not only by the literature on French cubist painting (especially Albert Gleizes and Jean Metzinger's essay of 1912)[9] but also by articles from the young Czech architect Vlastislav Hofman and the artist Josef Čapek, editor of the periodical of the Group of Plastic Artists.

Reiterating the idea of modern art as an art of form, color, and space akin to music, Hofman's "Der Geist der Umwandlung in der bildenden Kunst," published in December 1913,[10] emphasized the impulse to organize and overcome a reality perceived to be formless and indifferent by pursuing the idealization of form as the thing-in-itself and the rational logic of artistic fabrication—turning from the exterior to the interior of reality, to its very skeleton. Likening the cubists' dismantling of space to the outstretching of wings preparing "for the most daring flight," Hofman concluded that the modern world demanded something more elementary and fundamental than comfort and illusion: it demanded its own construction. This idea of modern art as an art of construction was taken up by Bruno Taut in his essay "Eine Notwendigkeit" of February 1914 in which he warned (perhaps with

Czech cubism in mind) against architecture taking over the external forms of painting. Rather he suggested that "architecture was by its very nature cubist," was already free of perspective and need not limit its constructiveness to cubism's angular forms.[11] His own recent projects—the skeletal Monument of Iron in Leipzig of 1913 and the elemental facade of his Hardenbergstrasse apartment block in Berlin of 1911–1912—were subsequently reviewed by Behne precisely in terms of such *sachlich* autonomous forms.[12]

Josef Čapek's essay of May 1914, "Moderne Architektur,"[13] contributed the idea that the transposition of cubism from art into architecture was occurring in phases analogous to those of cubism in art. Disparaging architecture's lifeless performance relative to the discoveries of cubist painting—which he called a new spatial-sculptural presentation of things aimed at the sublime—he considered it necessary to take cubism beyond the application of jagged and crooked motifs on traditional architectural elements and transform the discipline of architecture from the ground up. Čapek suggested that the first stage in developing the architectural equivalent of cubist painting, like the first stage of French cubism, had already been superseded by the "latest architecture" just as the later experiments of Picasso had led to a stronger synthetic stage of cubism. He characterized this stage as transforming the linear spatial net or geometric skeleton of the earlier efforts into a pure architectonic language, a medium itself full of meaning. The "mysterious autonomy" and "incalculable instinctive logic" of this new architecture was distinguished by what he saw as its intelligent translation of inner movement and plasticity into the outer physiognomy of the building, like the functional and formal definitiveness of a machine. While he did not give examples, the structural conception of cubism in the work of the young Hofman, exploring skeletal expression and

cellular aggregation, does appear radically different, for instance, from Josef Gočar's 1911 Tychonova Street houses in Prague. Čapek's emphasis on the contributions yet to be made by the younger generation, along with the numerous affinities in their theoretical dispositions, must surely have stimulated the young architects and critics of the Sturm circle.

In December 1914, Behne began to draw a distinction between expressionism and cubism that is conceptually similar to Čapek's distinction between early and later cubisms. In opening remarks for an exhibition of "Deutsche Expressionisten" at Walden's gallery, and in an almost concurrent article on "Expressionistische Architektur," Behne began by replaying the familiar opposition of expressionism to impressionism, considered in the broadest sense as world views that subsumed art, literature, and architecture.[14] Where impressionism had been satisfied with the surface impression of appearance, Behne suggested that the meaning of expressionism lay in its desire to express or materialize "the spiritual quintessence of experience." Citing the German Gothic as precedent, Behne took expressionist art to signal the return of true artistic work, understood as allowing spiritual things to "arise" and "grow organically" through artistic fantasy and creativity rather than being "constructed like machines." For the artists featured,[15] and for the architects Adolf Loos and Bruno Taut, whose expressionism he contrasted to the impressionism of Richard Riemerschmidt and Ludwig Hoffmann, "the means for the achievement of this goal was cubism." While Behne considered cubism as potentially a cold and intellectual method, it was not "a dumb kind of stylization." Rather "cubism means that for the modern artist elements suggest themselves for the construction of form that make possible the crystallization of expression due to a distant similarity of geometries." Artists were cubists because "there are certain

things that can only be spoken in this language." The fact that Behne felt no need to describe this new language indicates the extent to which, by then, the very notion of cubism as the new, pure, elemental, geometric, and autonomous language of pictorial construction—in Franz Marc's words, of "mystic inner construction"—had become a staple of German artistic discourse.[16]

Behne's distinction between natural arising and mechanical reiteration was drawn from the biologist Jacob von Uexküll, whose book *Bausteine zu einer biologische Weltanschauung*[17] he discussed in detail in an article of September 1915, "Biologie und Kubismus." It was in this essay that his emphasis, and the formal attributes previously associated with expressionism, shifted to cubism. Behne recounted Uexküll's contention that all living beings exist in two worlds: the perceptible world (*Merkwelt*) of knowable, physical, chemical nature which is experienced by beings and is the world of human technical capability, and a larger world of mysterious and fundamentally unknowable life (*Wirkungswelt*). For Uexküll, every living thing exists in both, forming its own world picture (*Weltbild*) from a specific standpoint within an immense ambiguity and flux. Not all world pictures, Behne continued, operate in the same way in relation to the larger domain of life and life-forces. Some—he cited naturalism and impressionism in the arts—were considered to take a fixed standpoint outside the body and outside events, the standpoint of perspective. Behne took architecture guided by perspective to be more limiting than the building art of "truly creative" historical periods, unconstrained by such a representational grid. The cubist world-feeling, he explained, knows nothing of the fixed point of orientation and detests atmospheric evaporation. While he took the standpoint of cubism to be ambiguous, he considered its discoveries to be profound. While its elements were

thought to be fundamental, pure, and clear, its totality was in flux and unfixed. Where Uexküll, in Behne's view, mistakenly supported the "half-new, decorative art" of the *Brücke* (Ernst Heckel, Ernst Ludwig Kirchner, Max Pechstein), Behne argued that the true new art was to be found in the cubist works of Robert Delaunay, Franz Marc, Carl Mense, Fernand Léger, Marc Chagall, Oskar Kokoschka, and Jacoba van Heemskerck.

> Cubism does not want a banal description of the psychological meaning of bodies and events from a specific external standpoint, rather it wants life itself! The cubist artist is in the middle of things, they surround him, their abundance brings him happiness, their never-resting, ever-moving, puzzling, autonomous life is like an intoxication. No positivistic result, no explanation, no moral and no application or lesson—rather glorification, admiration, adoration.[18]

Behne argued that while representations of the larger effective world (*Merkwelt*) are not possible as such—all efforts simply reproduce the conditions of human bodies, senses, and cognitive faculties—it is nevertheless possible, through art, to give form to this feeling for life. He considered it the task of art, more specifically the task of cubism, to expand the perceptible world by making the feeling for life visible.[19]

Although prior to the war Behne had joined the circle around Walden, publishing articles and even his first book with him,[20] in 1918 he was writing against the "bourgeois" art dealer, despite Walden's central role in promoting the new "revolutionary" artists of Europe. In the wake of expressionism's first financial success during the wartime art boom of 1917 and the growing politicization of the Berlin avant-garde

following the October Revolution in Russia, Behne attacked what he called the coopted pseudo-revolutionary art associated with Walden's Sturm as "an art of luxury and pleasure [that] wants isolation, the unconnectedness of art, assails the joining of art and life . . . and yet does everything humanly possible to meld this art intimately with the better middle class."[21] Instead, Behne proposed a cubist art distinguished by its "constructive" relationship to the world. "The cubist," he wrote, "strives for more than pure painting and pure sculpture. Beyond all concern for method and system, he participates in building the world."[22] For this reason Behne saw architecture, drawing all the other arts under its wing, as both necessary and exemplary for the full realization of cubism as a world-making art (*Weltkunst*). Walden's reply, when it finally came in 1919, resisted the assimilation of fine art to architecture and ridiculed Behne's interpretation of cubism as an activity of building (*bauen*).[23]

That cubism could be considered a pure, biological and intuitive constructive activity became central to Behne's 1919 *Die Wiederkehr der Kunst*, in which he turned the metaphor of cubism as language (already conceived as a natural language of pure means) into the idea of a direct and unmediated construction, "an unfabricated fabrication" free of a priori conventions and dogmas. Through true building (*bauen*) Behne believed that creative fantasy could materialize the feeling of life, which was the hallmark of true art—not as "a language of forms" or "a specific body of learning" but something more "fundamental," the "true reality" and "Absolute!"[24] His examples now broadened to include "the free, new, and self-evident constructions of India"[25] and the naive art of children, primitives, and the metropolitan masses. He contrasted the self-effacing transcendentalism of the East against the anthropomorphic

projection of European classicism, technology, and perspective, and distinguished periods of true European art (Gothic and romantic) from periods in which art was eclipsed by classicism and naturalism. In short, he argued that the cubist revolution was displacing Western humanism for a greater openness to the nonhuman, prehuman, and even inhuman.[26] Behne held that humanity could not be the measure of all things, because it was not a closed unity but a world system, both infinite in itself and set within an always greater and more comprehensive world-being.[27] His program for social reform flowed from cubism's artistic mandate—to "free itself from the Greek man-measure" in order to "change the European,"[28] not through evolution but by clearing a space (elemental and impoverished) in which true art could arise by itself, mediated only by the purest of means. By invoking the potentiality of cubism as a revolutionary turn in the history of art and as the quality of latency, immanence, or arising carried by cubist images,[29] Behne attempted to distinguish his vision of the future within the avant-garde's rhetoric of "new beginnings"—among expressionists and Dadaists alike—which assumed increasing urgency at the close of the war, not only in the arts but in all spheres of German life.[30]

The hallmark of Behne's cubism was its "architectonic" character, which he described as a hidden striving for unity, bound to the body of the star earth, and beyond ego, place, and time.[31] He offered no description of cubism's formal properties, for this would have wrongly privileged external appearances. Instead, what he called cubism may be understood as the striving of humanity to expand its own limited domain in order to materialize something of the formless unity of the cosmos. Yet Behne's revised list of cubists in 1919 gives some indication of the kind of work he had in mind—emphasizing Carl Mense,

Fritz Stuckenberg, Arnold Topp, and "especially" Lyonel Feininger: "I find that architectonic, which I previously identified as a secret urge to a final unity, in the pictures of these cubists, among which the sculptures of Alexander Archipenko should be included. Today painting really gives us great hope that the goal of unity will be achieved in the art that should actually lead: architecture. A call then goes out to all young architects to make their contribution so that architecture can emerge from its present impasse."[32] With this call in mind, Behne promoted the role of architecture in the reform programs of the Workers' Council for Art and introduced the "German cubist" Feininger to Gropius, who responded to his transparent crystallizations of landscapes and cities by appointing him the first new "master of form" in painting at the Bauhaus.[33]

But no sooner had Behne put forward the idea that cubism began in painting than he countered it with the proposition that it had actually begun in literature with Paul Scheerbart's 1889 novel *Paradies*, which he called "the first, purest, and clearest, the more universal and so far unbroken articulation of our will." Concerned that cubism in painting could easily be misunderstood as just another way to make pictures interesting, Behne suggested that painting was simply where the "inner transformation of art," already evident less visibly in other places, was first recognized by the public.[34] In assimilating Scheerbart to his conception of cubism, Behne's argument became utopian in a double sense. It assumed epochal dimensions by linking the inauguration of a new era in art—"cubism is what we make it . . . it lies in the future"[35]—first to Uexküll's theory of passage or materialization from the effective to the perceptible world, and then to Scheerbart's 1914 utopian vision of *Glass Architecture*, capable of overcoming materiality, producing nonhuman effects, and transforming the Europeans into a new kind of people

through a "spiritual revolution."[36] Under the sign of a Scheerbartian cubism capable of fulfilling the potentiality of industrial technology as well as of cubist art (a combination that Giedion would later reiterate), Behne saw true art returning "like the sun coming out from behind the clouds" of humanist classicism.[37]

Higher truths, Behne continued, cannot be grasped through reason but only through fantasy.[38] With this in mind, he called the utopian fantasy drawings by Bruno Taut for his Alpine architecture a "spiritual reality, not an ideal project."[39] Yet in focusing on Scheerbart's architectural fantasies, even more than on Taut's, Behne underscored his interpretation of the cubist image as the purest possible expression of utopia, seemingly even less encumbered in the abstract realm of words than in painting or architecture. It was to satisfy the urgent desire at the close of the war for utopian images manifesting spiritual reality that the radical left Workers' Council for Art (led by Gropius and Behne) organized the "Exhibition of Unknown Architects" in April 1919, deliberately featuring works by nonarchitects—artists and others uncontaminated by architectural learning or training.[40] Among the various participants, Gropius singled out the works by the young Russian Jefim Golyscheff—composer and musical child genius, maker of instruments and children's toys, who had then arrived in the world of the Berlin avant-garde and collaborated with the Dadaists on their first exhibition, held (like the "Exhibition of Unknown Architects") at I. B. Neumann's Graphisches Kabinett. Gropius called Golyscheff's drawings "extreme examples of what we want: utopia." In an article on his work, Behne stressed the importance of contributions by the untrained, by children, primitive "barbarians," and proletarians.[41] Despairing of how learning inhibits "holy merriment," he described Golyscheff's ability to lose himself as prerequisite for a new beginning,

the "zero point" from which "the play impulse of the child to begin again goes forth." Criticized by the older generation of expressionists, Behne defended Golyscheff's "renewal of art" and warned that expressionism risked falling asleep. He insisted that many generations would still need to destroy and build again, just as the expressionists had done. In this spirit, he also criticized the Dadaists as just another "ism" and cited Golyscheff's flyer "A-ismus" to explain that Golyscheff had broken his affiliation with Dada, wanting simply to become an atom, to give himself over just like a child, to create with primitive pleasure. The bright pieces of his collages struck Behne as having nothing in them of the expressionist hankering for soulfulness; rather they "bring—as small as they are!—greetings from the greater world!" With Golyscheff, Behne's cubist return of art assumed the character of a continuous cultural revolution—"never a fixed state" but always new. The idea of cubism as an origin had become unhitched from the quest for a new style; instead it now inaugurated an era characterized by ceaseless inaugurations, destroying and building again and again in the unending pleasure, even intoxication, of (godlike) creation.[42]

BAUHAUS *GESTALTUNG*: PAINTERLY AND FUNCTIONAL

Fortified by the hopeful images of otherworldly and unprecedented utopias, Gropius moved quickly from image to embodiment; before the end of the year he had taken charge of the Bauhaus, formulated its new educational program, hired his first teachers, and reopened his practice with Adolf Meyer. While in April he had admired images of utopia, by December he was reluctant to join Taut's Crystal Chain, and did not contribute to their correspondence or their "Neues Bauen" exhibition of May 1920. Behne likewise

declined to participate in the chain, and while he continued to support them he also continued to distance himself from expressionism in his writings.[43] During the winter of 1921–1922, he publicly turned against "the wave of utopianism and romanticism."[44] By October 1922 he had even turned against Bruno Taut, whose work he had championed since 1914 but whose program of painting building facades in Magdeburg he now criticized, calling instead for the use of color as an integral property of materials.[45] But like Gropius's more celebrated turn from expressionism to De Stijl and constructivist functionalism, Behne's critique of visionary utopianism should not be construed as a sudden change of heart about expressionism, for this had begun much earlier and was, in fact, consistent throughout his writings from 1918 onward. Despite his affiliation with and support of Taut in those years, Behne's programmatic conception of cubism distinguishes his own position even then. Privately, Behne had already distanced himself from aspects of *Wiederkehr* in October 1920 when, in a letter to his new friend, the Dutch architect J. J. P. Oud, he wrote: "To start, let me say . . . that I began writing the book more than two years ago. It emerged in the deepest depression of war duty in a military hospital and in the hope that there would be a saving revolution. Today, I would change many things."[46] Having turned his eye to Russia after 1917 and then to Holland, where the revolutionary aspirations for the new art and architecture were being advanced while Germany was still at war, Behne had little patience for the arbitrariness, obscureness, and marginality of expressionism in Germany. "From the periphery, on whose rim paper pagodas for no one had been mounted, one turned to the center."[47]

In Holland Behne discovered not only De Stijl but within it another perspective on the relationship of cubism to architecture. In essays beginning in

1916, Oud and Theo van Doesburg—the driving force behind De Stijl and pan-avant-gardist par excellence—had speculated on the implications for architecture of ideas initiated in cubist painting, which the De Stijl group sought to extend. Over the following five years they pursued this goal in theoretical writings and in experimental collaborations on architectural projects that used color, contrast, and pattern in ways informed by van Doesburg's analytical sketches, paintings, and stained glass. The most celebrated of these projects was De Vonk (1917–1918), a seaside hostel for young women, which featured vibrant and oscillating tile floors and wall mosaics designed by van Doesburg (fig. 11.2). In the early issues of the journal *De Stijl*, Oud presented theoretical projects clearly influenced by the cubic massing and geometric plans of Frank Lloyd Wright, which he associated with this cubist-inspired research in architecture. Despite their long-standing association, van Doesburg parted company with Oud in the fall of 1921 when the architect criticized the color scheme he had proposed for a large housing project in Rotterdam.[48] Van Doesburg had intended to dissolve the mass of Oud's brick building by applying vertical strips of bright colors in a rhythmic pattern, just as he had dissolved the naturalistic contours of human figures and animals into compositions of elemental geometry and color, in keeping with his conception of cubism as the expression of space through the mathematical purification of form.[49] In an exchange of articles that followed their split, each still reaffirmed the ideal of cubism in architecture, which had been a strategic point of departure for their research into elementarism,[50] but with the painter asserting that color was the primary medium even for architecture while the architect insisted on a builderly and social understanding of the medium—rationalist, constructivist, and functionalist rather than abstract; cognizant of

social needs, materials, and modes of production as well as color.[51] For Oud, to achieve pure and elemental architectonic means did not require the elimination of closure or the dissolution of materiality "once and for all." Nor did he consider cubism itself to be the coming style, but merely a transition that once completed would give way to the "new style."

Underpinning the dispute between van Doesburg and Oud was the question of the correct transposition of cubist formlessness to produce an architecture of open forms comparable to the painterly dissolution of objects in cubism.[52] The introduction of ideas concerning open forms, formlessness, and painterliness was informed by van Doesburg's reading of Heinrich Wölfflin's *Kunstgeschichtliche Grundbegriffe* (1915), and the debate between van Doesburg and Oud was marked by the binary categories of Wölfflin's theory of stylistic change. For Wölfflin, the history of art oscillated between opposed psychologies of form and modalities of vision—linear and painterly, closed and open compositions, planar and recessional perceptual effects, tectonic and atectonic form, solid figure and its appearance, enduring form and movement, the thing-in-itself and the thing in its relations, death and life. Van Doesburg fully embraced the idea of movement as the subject of painting not in the futurists' sense of depicting a moving subject, but in the cubists' sense of the model-in-movement and especially the idea that the primary elements of painting themselves could set the whole canvas in motion.[53] Oud, on the other hand, affirmed the ideal of a nonacademic classicism in which form was the purest possible expression of the inner life of the object or building. He interpreted the idea of formlessness in architecture within the framework of H. P. Berlage's rationalism as simply opposed to formalism and the use of predetermined forms. For Oud—whose affinity with Behne becomes clear on this point—architecture was

formless when each new building and each new form emerged into being without preconception, as a unique and pure presence. He called this organic-mechanic cubism an "unhistorical classicism," taking purity to be its hallmark.

Beginning in 1919, Behne and Feininger served as the principal intermediaries between the Dutch and the Bauhaus. Behne's widely distributed "Call" on behalf of the Workers' Council for Art was published in *De Stijl* in September 1919, while one of Feininger's paintings was included in the November issue, together with an appreciation by van Doesburg.[54] Holland became Behne's first foreign destination after the war, in the summer of 1920, and following his trip he praised the new Dutch architecture in numerous articles, started a lasting friendship with Oud, and arranged the first meeting between van Doesburg and Gropius in December 1920, the day after the completion ceremony of Gropius and Adolf Meyer's wooden "block" house for the industrialist Alfred Sommerfeld.[55] Van Doesburg almost immediately moved to Weimar where he stayed for about two years, hopeful of a teaching appointment that never materialized. He nevertheless attempted to influence the school and Gropius, criticizing its embrace of handicraft rather than machine production and its promotion of free individual expression over the collective refashioning of reality. Regardless of the appropriateness of these critiques, he was, consequently, quick to claim credit for Gropius's celebrated turn from the so-called expressionism of the Sommerfeld House to the theater at Jena.[56]

Although van Doesburg's characterization of the Sommerfeld House as expressionist continues to be reiterated even today, it was overly dependent on his prior critique of expressionist art and simply turned the terms of that critique on Gropius's architecture. Yet a consideration of the house in relation to expres-

sionist art remains inadequate to its rich, ambiguous, and strange mixture of forms—recalling works by Frank Lloyd Wright, primitive vernaculars both European and non-European, the English arts and crafts movement, and formal motives from Czech cubism (notably the prismatic windows and entry and the scalloped roof, proposed but not executed), as well as the crystalline geometries of architectonic fantasies by many of the artists singled out by Behne as exemplary Scheerbartian cubists. Considered in terms of such an expanded field of affinities, the house may be understood as a synthetic quest for primary architectonic ur-forms, informed by Behne's case for a primitive architectonic cubism with which the critic had already identified Gropius, as well as Henry van de Velde and Bruno Taut. Prompted by the furniture in Gropius's Berlin apartment in 1919—pieces by van de Velde and a "zigzag" sofa—Golyscheff had certainly encouraged Gropius "to be cubist rather than cubic . . . to unfold all sides."[57]

Similarly, van Doesburg's claim to have influenced the design of the Jena theater, while undoubtedly of consequence,[58] has tended to obscure Gropius and Meyer's long-standing use of generative geometries, which they learned from Peter Behrens and, in the case of Meyer, also from the Dutch architect J. L. M. Lauweriks, who had joined Behrens's School of Decorative Arts in Düsseldorf at the recommendation of Oud's mentor, H. P. Berlage.[59] As a student there Meyer had learned Lauweriks's method of designing based on a geometrical grid, evolved through subdivision and multiplication of a square with an inscribed circle. Lauweriks hoped that the grid would provide an underlying architectonic system capable of drawing every aspect of design, from the site plan to the furniture, into a single unified structure—an idea that Behne identified as crucial to the architectonics of cubism. One of Meyer's student designs was even

singled out by Berlage in a published lecture concerning the use of geometry as the basis for a new architecture, finally free of the need to imitate historical styles.[60] Not only did Meyer continue to use geometric design principles in the work of the Gropius office—in the relentlessly cubic Jena theater as in the open geometries of the prismatic Kallenbach House project of 1922—but he also taught geometric composition in his architecture course at the Bauhaus. Moreover, this interest in geometric design processes intersected not only with the common German interpretation of cubism as a geometric art, but also with Gropius and Meyer's appreciation for the architecture of Wright, which they studied carefully for their own work both before and after the war.[61] Oud too considered Wright important, not only for his theoretical projects but as an influence across European modernism which he associated, at first, with cubism. By the mid-1920s, however, Oud expressed concern over the prevalence of a Wrightian formalism, and instead promoted European cubism, which he now insisted had developed independently of Wright's influence—"a first run at a new synthesis of form, a new unhistorical classicism" that still held the greatest promise for the future of architecture.[62]

Oud's significance for Gropius and his partner Meyer may be seen in their response to his lecture of February 1921, "On the Future Art of Building and Its Architectonic Possibilities." Meyer in particular was so struck by it that he initiated a correspondence with Oud and arranged for its translation and publication in Bruno Taut's periodical *Frühlicht*.[63] In the lecture, Oud developed his program for a new architecture based on a materialist conception of the discipline and its social purposes but striving to overcome them for spiritual effects, the terms of which already articulated the criteria for his subsequent critique of van Doesburg's color scheme. While van Doesburg was

eventually rebuffed by Gropius, Oud was asked to lecture during the Bauhaus week. Moreover, when Behne and Moholy-Nagy organized the small competition for the design of the Kallenbach House, they invited Oud to participate along with Gropius and Meyer and Hilberseimer. Although Oud's design remained unexecuted, it influenced subsequent projects by Gropius and Meyer, leading them in the direction of a functional and constructive (in his terms, "classical") openness rather than the geometric openness that they attempted with the rotated and broken cubes of their project for the Kallenbachs, its site plan a unified structure of inner and outer space rendered as a field of oscillating primary colors.[64] Their approach to the color scheme for the Jena theater—its porches blue, its foyer light yellow, cloakrooms violet, staircases terra-cotta, and auditorium salmon pink, gray, and deep blue[65]—was also closer to Oud's use of color as a means of articulating spatial and architectural elements than it was to van Doesburg's dissolving of substance. And finally, anticipating the critique of formalism leveled against both van Doesburg and the early Bauhaus, Gropius—following suggestions in Oud's 1921 lecture—shifted his program on the occasion of the Bauhaus exhibition to the quest for a new "synthesis of art and technology" for which the Bauhaus became internationally celebrated. Van Doesburg, on the other hand, renewed his quest for the architecture of De Stijl by collaborating with the young architect Cornelis van Eesteren, whom he had met when van Eesteren was a student in Weimar. Using color once more to contrast, dissolve, and mitigate the closed form of three projects for Léonce Rosenberg's De Stijl show in Paris in 1923, van Doesburg finally achieved the breakthrough he aspired to. By coloring the surfaces of van Eesteren's axonometric drawings, he discovered that the closed mass of the building could be elementarized into homogeneous amaterial planes and

opened up, thereby transforming cubic blocks into formless, open crystalline configurations of interpenetrating planes, which van Doesburg thought of in terms of space-time (fig. 11.3). This process of abstraction was pushed even further in van Doesburg's counterreliefs of transparent as well as colored planes, which Giedion later called "a vision of space."[66] In 1925, van Doesburg's theory of planes, colors, lines, volumes, space, and time as the elementary means of architectural expression or *Gestaltung* (form creation) was published in the Bauhaus book series directed by Moholy-Nagy. Here, van Doesburg emphasized the important proposition—first propagated by the formalist theorist Conrad Fiedler in the late nineteenth century[67]—that an observer's experience of an artwork constituted a reenactment of form creation in the consciousness of the observer.[68]

Ironically, just as Behne turned from the most radically utopian aspects of his program, his image of an architectonic and crystalline cubism inspired yet another line of experimentation by Moholy-Nagy, hired by Gropius in 1923 to replace Johannes Itten in the strategic preliminary course at the Bauhaus. Having arrived in Berlin in early 1920, Moholy took up the idea of glass architecture to refer to his work during 1921–1922, prompted less by Bruno Taut than by the interpretations of Scheerbart by Behne and the Dadaists, who also claimed Scheerbart as their spiritual father.[69] He applied the title to works based on color and overlapping geometric form charged with depth and drawn mechanically to eliminate the hand of the artist—elemental compositions influenced also by Kasimir Malevich's suprematist paintings. Unlike the Dadaists, however, Moholy pursued the cause of liberation through the creative rather than destructive capacity of the artist. He believed in the need for a new order based on rationality, the wonder of technology, and the discovery of natural laws of construction and vision. The disembodied utopia of glass architecture, unrealized and unrealizable as yet, continued to inform his work as he explored qualities of transparency and interpenetration, not only in paintings, lithographs, and woodcuts but also in mechanical means of reproduction—photographs, photomontages, photograms, and films—and in designs for stage sets and exhibitions through which he approached architecture more directly. Like Malevich, El Lissitzky, and László Péri, Moholy understood the project of modern art as beginning in painting, more specifically cubism, but aiming for a new architecture—a trajectory registered clearly in his book of 1929, *Von Material zu Architektur*, in which he summarized his teaching at the Bauhaus.[70]

Transparency (*Durchsichtigkeit*) and interpenetration (*Durchdringung*, connoting also fusion and consciousness) became the strategic properties of Moholy's postcubist conception of architecture encapsulated in the idea of space as *Raumgestaltung* (space creation), which he developed together with his close friend Sigfried Giedion and made the central topic of his 1929 book. Traveling through France in the summer of 1925, Moholy and Giedion—together with the photographer Lucia Moholy and the art historian Carola Giedion-Welcker—discovered the pleasures of the new spatial culture in the open structure of the Eiffel Tower in Paris. Two years later, Giedion pointed to the Pont Transbordeur in Marseilles as another early precursor of the avant-garde of the 1920s and was the first to publish (Moholy-inspired) photographs of it.[71] The final section of Moholy's book, in which he compiles a panoramic portrait of *Raumgestaltung* as evidenced in contemporary industrial structures, urban landscapes, and set designs as well as Le Corbusier's Villas La Roche–Jeanneret (1923) and Gropius's Bauhaus building (1925–1926), complemented Giedion's history of modern construction in

his 1928 *Bauen in Frankreich*. With abstracted close-up photographs by Gotthardt Itting and Lux Feininger (son of Lyonel), Moholy presented the Bauhaus building as an exemplar of how "inside and outside interpenetrate one another" in the reflections and transparencies of its glass walls—the tenuous surface into which the boundary between inside and out had dissolved. These would become precisely the terms for Giedion's interpretation of the Bauhaus as cubist.

The final images of *Von Material zu Architektur* are especially revealing of Moholy's new vision of architecture as the nonsubstantial or virtual generation of spatial and volumetric configurations: Itting's almost unrecognizable close-up of the Bauhaus at the virtual intersection of the glazed bridge with the glazed entrance, seen from above as if hovering in space; a view from below looking up at workers scrambling across the steel skeleton of a new planetarium, suspended in the transparent net like "a formation of airplanes in the ether"; and lastly, another barely legible image, an abstracting negative double exposure by Jan Kamann of the van Nelle factory in Rotterdam by Brinkman and van der Vlugt, titled simply "Architecture." The caption reads: "From two superimposed photographs (negatives) emerges the illusion of spatial interpenetration, which only the next generation will be able to experience as reality—as glass architecture."[72]

Moholy was not alone, however, during the late 1920s, in still thinking of glass architecture, and especially Gropius's Bauhaus, in terms of Scheerbart's and Behne's utopias. In an article of 1926 on the properties, potentials, and technical development of glass construction, illustrated with Itting's photograph of the Bauhaus, Gropius himself linked the newly completed Bauhaus to Scheerbart's vision when he wrote that "glass architecture, which was just a poetic utopia not long ago, now becomes reality

without constraint."[73] Also in 1926, Arthur Korn introduced his picture book, *Glas im Bau und als Gebrauchsgegenstand*, by suggesting that "a new glass age has begun, which is equal in beauty to the old of Gothic windows . . . [that] afforded glimpses of paradise in luminous colors."[74] It was the special characteristic of glass, he went on, that it is "noticeable yet not quite visible. It is the great membrane, full of mystery, delicate yet tough. It can enclose and open up spaces in more than one direction. Its peculiar advantage is in the diversity of the impressions it creates." He too turned to Gropius's Bauhaus—particularly to a photograph by Lucia Moholy—to illustrate his contention that "the visible depth behind the thin skin of glass is the exciting factor." It was this same photograph, accompanied with similar observations about the enticements of glass, that Giedion later made famous in comparing it to Picasso's cubist *L'Arlésienne*.

SIGFRIED GIEDION'S TRANSPARENCY: ART AND ARCHITECTURE

Considered within the long developmental history of *Space, Time and Architecture*, Giedion's comparison between Picasso's 1912 painting and Gropius and Meyer's 1926 building offered evidence of the historical progression from painting into architecture at the same time that it exemplified the new formal paradigm for what Giedion called the "contemporary image" in art and "open construction" in architecture. In describing the value for architecture of cubist research into the representation of space, Giedion made the teleological character of this development explicit and even illustrated it graphically in a two-page spread (fig. 11.1). Beginning with a cubist collage by Georges Braque of 1913, Giedion's arrow of

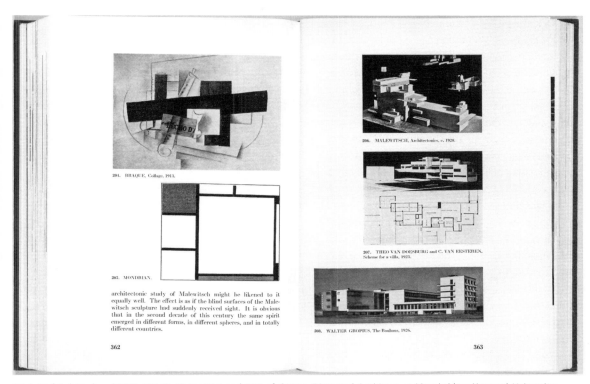

11.1 Sigfried Giedion (1888–1968). Pages 362 and 363 of *Space, Time and Architecture* (Cambridge: Harvard University Press, 1941), showing Giedion's argument for a line of development from cubist art to neoplastic painting, suprematist Architectons, the architectural collaborations of van Doesburg and van Eesteren in 1923, and Gropius and Meyer's Bauhaus at Dessau of 1925–1926. The idea of this historical progression underpinned Giedion's comparison between Picasso's *L'Arlésienne* and Lucia Moholy's photograph of the Workshop Building at the Bauhaus (see fig. 7.2), which Colin Rowe and Robert Slutzky portrayed in 1963 as a principal example of what they called "literal" transparency.

history proceeded to an undated neoplastic painting by Piet Mondrian, followed by one of Kasimir Malevich's suprematist Architectons, and the unbuilt house for Léonce Rosenberg by van Doesburg and Cornelis van Eesteren ("the effect is as if the blind surfaces of the Malevich sculpture had suddenly received sight").[75] The trajectory here culminated in the fully realized architecture of the Bauhaus at Dessau, "the only large building of its date that was so complete a crystalliza-

tion of the new space conception."[76] While Giedion's linear sequence imposed an order and hierarchy on projects that were in fact parallel experiments—suprematism, De Stijl, purism, and the Bauhaus—he did so by drawing on their parallel self-conceptions as moving from painting toward architecture. For Giedion, following Malevich, van Doesburg, and Le Corbusier, this necessarily entailed rationalization in order to correct the "aberrations" of cubism.[77]

In addition, Giedion used the history internal to modern art as parallel to the history of architecture over a much longer time. Picasso had already been invoked when Giedion juxtaposed his sculpted *Head* of 1910 with the baroque cupola of Francesco Borromini's mid-seventeenth-century Sant'Ivo in Rome, claiming that each bore evidence of a new feeling for interconnecting interior and exterior space, a feeling struggling for its own expression still constrained within old conceptions of bodies and buildings as closed forms. From this beginning, Giedion traced the various paths through which the modern space conception—which he called "space-time" citing the poet Guillaume Apollinaire and the non-Euclidean mathematician Hermann Minkowski[78]—emerged into consciousness from within the perspectival conception of space inaugurated in the Renaissance. Although he emphasized the "optical revolution" of cubism over futurism's inconclusive research into space-time, Giedion regretted that futurism had been cut short by the loss of its key figures during the war. He acknowledged the importance of this work for reconsidering the status of the object in terms of time and a new plasticity—as perpetually in a state of motion.

Giedion treated space-time, like perspective before it, as a structuring condition or informing principle that defined the consciousness of the era and regulated not only art but also architecture, gardens, and cities—the entire spatial world of humanity.[79] In contrast to the limited representational and experiential possibilities of perspective, Giedion presented space-time as an expanded optical and spatial realm, one of excited emotions, greater freedom, and enhanced participation by the observer. Unlike perspective, however, space-time could not be represented in a diagram of lines or forms, since it was in fact contingent on the active subject moving in space and time, contingent on a phenomenology of perception

as well as production, signified by the notions of *Gestaltung* and *Raumgestaltung*. In *Bauen in Frankreich*, Giedion had already used the idea of *Gestaltung* to refer to the productivity of the subconscious manifesting the impulses of life in constructions that used the new synthetic materials of iron, glass, and concrete.[80] In keeping with the notion of *Gestaltung* and with theories of *Raumgestaltung* (from the historian August Schmarsow to Moholy-Nagy),[81] Giedion considered the viewer to actively reexperience the formation of buildings and spaces, albeit in cognition rather than in strictly material terms. The expansion of experience made possible by the fluidity and openness of this condition was seen as exemplary of modernity. As he made clear in his descriptions of the Bauhaus and the Villa Savoye, buildings in space-time can only be comprehended by an observer moving all around them, inside and out, up and down. Their identities as objects remained necessarily incomplete, indeterminate, and contingent on the plastic process of space creation grasped through the apperception of partial perspectives integrated over time. In Giedion's conception of space-time, static forms and elements became support for the endless and endlessly varied activity of creating space in the fourth dimension.

Just as he traced the history of spatial and temporal research in the visual arts, so in the realm of building science Giedion tracked the gradual emergence, self-determination, and refinement of technical forms such as the steel frame, the reinforced concrete slab, and the suspended plane of the curtain wall. But what gave cubism its special significance for Giedion was that with it the plane came into consciousness as a constituent element of pictorial construction, while the parallel development of the slab in engineering took place unconsciously. It was consequently the role of architects (as artist-constructors) to make these

into self-reflexive means of expression.

Giedion's selection of Picasso's *L'Arlésienne* was significant historically as well as formally, and was informed (as his caption reveals) by Alfred H. Barr, Jr.'s, retrospective of Picasso's work in 1939.[82] There Barr had identified the painting not only as demonstrative of cubist transparency, simultaneity, and intersecting planes, but as Picasso's first double-faced portrait, showing face and profile at the same time, interwoven transparently on the two-dimensional surface. The device of the double-faced portrait was frequently used in Picasso's subsequent works, and was also taken up in photography by Lissitzky and Moholy-Nagy and in graphic design by György Kepes.[83] It is with this visual trope in mind that Giedion's cubist interpretation of Lucia Moholy's unusual photograph of the Bauhaus should be read. In his words:

> Two major endeavors of modern architecture are fulfilled here, not as unconscious outgrowths of advances in engineering but as the conscious realization of an artist's intent; there is the hovering, vertical grouping of planes which satisfies our feeling for a relational space, and there is the extensive transparency that permits interior and exterior to be seen simultaneously, en face and en profil, like Picasso's "L'Arlésienne" of 1911–12: variety of levels of reference, or of points of reference, and simultaneity—the conception of space-time, in short.[84]

Like Picasso's double-faced portrait paintings, what animates Lucia Moholy's photograph of the Bauhaus is not the crystalline clarity of the curtain walls but the transparency of the relational space within which the image of the building remains incomplete and indeterminate. Paradoxically, the multiplication

of vantage points in the portraits displaced the wholeness of physiognomic figuration, and while promising greater comprehensiveness opened the domains of identity beyond the physical toward the nonsubstantiality of the mental image, which no amount of multiplication could ever depict with the same objectivity that classical perspective was presumed to have achieved. These images, then, are more about the relativity of modern analytics—of the technologically mediated opticality of X rays, multiple exposures, and dissection (Giedion, like Apollinaire, used the metaphor of surgery to describe cubism, and by extension engineering)[85]—unable to close the question of knowledge even as the light of reason exposed more than had ever been visible before. In *L'Arlésienne*, this openness of consciousness to its own limits is registered especially in the delicate dissolving of legible features into the illegibility of the formless yet luminous prismatic field from which they could also—turning cubism's "destruction" into "construction"—be understood to have magically arisen, like a photographic image developing in a chemical bath. Such limits are similarly evident in the suggestive yet partial view of the Bauhaus complex, in the dynamic composition of the image focused on the deep space under the bridge into which the car takes the eye, in the reciprocal reflection of the bridge in the glazing of the stair, and in the incomplete glimpse of the interior behind the curtain wall—its inner mysteries shrouded in darkness and obscured by radiators, reflections, and the interplay of two planes of gridded glass meeting at the corner.

In the end, the transparency that the cubist portrait reveals is paradoxically not of an interior at all but of a luminous yet opaque and misty field, which Giedion called a "relational space"—an enlarged sphere of perception, neither inside nor outside, within which the image of the figure is tentatively assembled

in an open crystalline structure of relationships, as if frozen at a specific moment in the process of its materialization. "It suggests," he offered, "a movement in space that has been seized and held."[86] Similarly, the open space that is simultaneously between and inside the two wings of the building, that flows freely beyond the frame of the camera and extends into the interior by means of the inward and outward reflection of glass, is at the heart of Giedion's understanding of the Bauhaus. While the camera was able to capture this "transparent" moment in time and space—this particular intermingling of closed and open, linear architectonics and painterly disintegrations—the subsequent reception of Giedion's book makes clear that the image was unable to transmit graphically to Giedion's readers the unrepresentable experience of space-time that he had hoped it would.

Giedion's 1941 history of postcubist architecture was, however, more than a history; it was also a self-fulfilling prophecy by an active protagonist. In the fall of 1923, in his very first critical writing on contemporary architecture—a review of the Bauhaus exhibition and Bauhaus week—Giedion had already sketched the crucial outlines of this development, not retrospectively but as the program and potential of modern architecture.[87] The fact that he cited large portions of this text in his 1954 book on Gropius is a measure of the extent to which Giedion remained committed to his initial vision of what modern architecture might become—a vision that he consistently referred to in relation to cubism.[88] In his 1923 article, he explained that just as all the arts, including architecture and the decorative arts, had for the past decade taken off from painting, so the products of the Bauhaus were to be seen as resting on that foundation as well as on formal ideals associated with machines. But he insisted that this had nothing to do with "a convenient

transposition by dexterous opportunists" and could not be the work of a single artist. Instead, he acknowledged the Bauhaus for having drawn together the "most diligent" masters of abstract painting for the task of developing the architectural equivalent to the achievements in art: Paul Klee, Wassily Kandinsky, Lyonel Feininger, and Johannes Itten. The new understanding of the handling of materials as the basis for a new architecture (as it had been the basis for the new painting) was to come "directly out of the principles of their art," showing that "cubism is not only a destroyer of form, as people like to say. Rather a new task is assigned to it in the history of art." Moreover, that task was to continue the shift begun in the seventeenth century when landscape was accepted into painting as a legitimate subject, signaling a shift away from the human-centeredness of the Renaissance and toward the nonhuman,

> the increasingly deep, absolute, and precise assumption by all organisms of their own meaning—especially during the empathetic romantic period. The tree, the meadow, and the land become as legible as a human face! Cubism attempts the next step. It attempts to open for us the empire of the inorganic and formless. Its pictures often resemble cellular tissue seen through a microscope. The efforts of the Bauhaus are concerned to eavesdrop on materials and to open up the hidden life of the amorphous. Dead things receive faces and liveliness. The absolute rhythm of things is awoken![89]

Giedion's comments about the Bauhaus—struggling against anthropocentrism while unable to free themselves from empathy—came to focus on Kurt Schmidt's *Mechanical Ballet*, performed in Gropius

and Meyer's recently completed theater in Jena. What Giedion admired about the stage set was its attempt at an entirely abstract and hence self-alienating configuration in which people disappeared behind blue, red, and yellow planes coming together as "a cubist picture," set in motion to music.[90] "Can one sense here," Giedion asked, echoing Behne's posthumanist conception of cubism, "that things that have nothing to do with humans, animals, or trees are opening a new sphere of experience . . . always driven back through crystalline fantasy to warmer lands."[91]

Giedion disregarded the consistently cubic motifs and polychromatic interiors of the theater itself, which Gropius had hoped would be recognized as the architectural fulfillment of Bauhaus ideals, and which van Doesburg had adopted for his conception of architecture. Instead, reiterating a commonplace in architectural discourse, Giedion observed that architecture continued to lag behind the other arts. For Giedion (the engineer turned art historian) it would be in great constructions that the new architecture would take form, allowing new materials—iron, concrete, and glass—to speak for themselves in the search for a new feeling for statics. He then pointed to a project exhibited by an unidentified French architect for a concrete house, which reminded him of a crane: buildings with air wafting through them, hovering freely, supported by a single concrete column. "The means for *Gestaltung*," Giedion observed, "come once again from cubist fantasy (and give rise to it). Construction is born from the crystal, out of the body, from a sum of crystals, not by the carving out of space as in the baroque."[92] With these thoughts Giedion aligned his conception of modern architecture with Oud's programmatic lecture of 1921 and prepared the way for his later "discovering" in *Bauen in Frankreich* that the potentiality of industrial structures had been realized in the architecture of Gropius's Bauhaus and

Le Corbusier's housing projects, among others. The link between cubism and industrial engineering, so pivotal to his history in *Space, Time and Architecture*, was already conceptually in place as early as 1923, prior to the demonstration of their union in any examples. By 1928, however, Giedion could cite such a union for the first time in the domestic architecture of Le Corbusier, which he compared with the hovering transparency of his "cubist" paintings.[93]

Writing *Space, Time and Architecture* in the late 1930s, Giedion did not consider either Picasso's *L'Arlésienne* or Gropius's Bauhaus to represent the pinnacle of artistic expression in their respective fields (see fig. 7.2); instead he saw them as having achieved a new clarity of means, which was subsequently available for more potent symbolic expressions. He cited Picasso's *Guernica* of 1937 as the greatest contemporary work of art, and distinguished it from the painter's earlier work as the "first real historical painting" of the modern period. Using all the principles and means of cubism, the painter deployed them here to "transmute physical suffering and destruction into powerful symbols"[94]—symbols that for Giedion played the important role of mediating between the inner emotional need for harmony and the turbulent conditions of the external modern world.[95] Where space-time was characterized by the interpenetration of inner and outer space, poetic symbols were understood to mediate between the inner and outer realms of humanity. In architecture, Giedion turned to Le Corbusier, first with his housing estate at Pessac (1924–1926), then the Villa Savoye (1928–1930) and the League of Nations project (1927), concluding with a drawing for a steel exhibition structure for Liège of 1937 juxtaposed with a final example from Picasso, an almost unrecognizable detail from one of a series of paintings, each titled *Woman in an Armchair*, of around 1938.[96] For Giedion, it was only

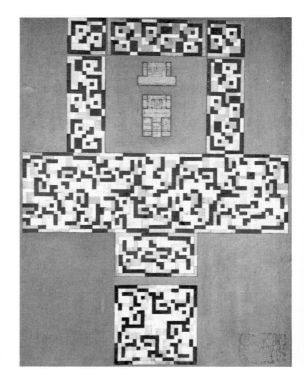

11.2 Theo van Doesburg (1883–1931). Color design for tiled
floor, De Vonk, hostel, Noordwijkerhout, 1918. Gouache and
collage on gray-painted cardboard, 98 x 73.5 cm. Rijksdienst
Beeldende Kunst, The Hague; Van Doesburg–Archive,
Donation Van Moorsel.

11.3 Theo van Doesburg (1883–1931) and Cornelis van
Eesteren (1897–1988). Maison Particulière, axonometric
projection, 1923. Ink, gouache, and collage, 55.7 x 55.7 cm.
Netherlands Architecture Institute, Rotterdam, Collection
Van Eesteren; Fluck en Van Lohuizen Foundation, The Hague,
Archive/Collection Van Eesteren III.181.

11.4 Charles-Edouard Jeanneret [Le Corbusier]
(1887–1965). *Still Life for Pavillon de l'Esprit Nouveau*,
1924. Oil on canvas, 81 x 100 cm. Fondation Le Corbusier,
Paris. FLC no. 141.

11.5 Le Corbusier (1887–1965). Quartiers modernes Frugès,
Bordeaux-Pessac, 1924–1927. From Sigfried Giedion,
*Building in France, Building in Iron, Building in
Ferroconcrete* (Santa Monica: Getty Center for the History
of Art and the Humanities, 1995), p. 171.

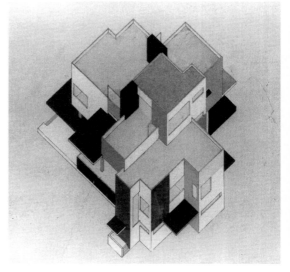

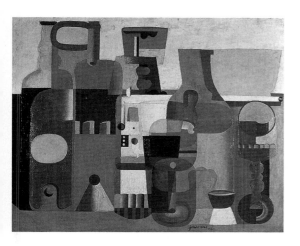

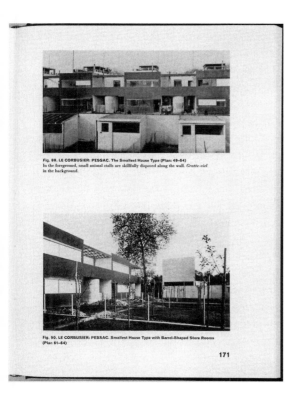

Fig. 99. LE CORBUSIER: PESSAC. The Smallest House Type (Plan: 49–54)
In the foreground, small animal stalls are skillfully disposed along the wall. *Gratte-ciel* in the background.

Fig. 99. LE CORBUSIER: PESSAC. Smallest House Type with Barrel-Shaped Store Rooms (Plan 61–64)

171

with Le Corbusier that works of poetic and symbolic value were first attained, works capable of mediating the division between inner feeling and outer reason that he considered endemic to the transition toward a fully modern age. Recalling once more Borromini's struggles for the interpenetration of inner and outer space, and the first attainment of this feeling of space at the Eiffel Tower (which he characterized as a body without flesh), Giedion focused his enthusiasm for Le Corbusier on the value of his skeletal Dom-ino system of concrete construction for achieving the new conception of space-time in the generalizable form of dwellings. As exemplified by the Villa Savoye, "the body of the house has been hollowed out in every direction: from above and below, within and without. A cross-section at any point shows inner and outer space penetrating each other inextricably . . . as *construction spirituelle.*"[97]

Without recounting Giedion's interpretation of Le Corbusier in detail, what is important here is that Giedion once again pointed to the role of painting in the development of space-time in architecture, reiterating his comparison in *Bauen in Frankreich* between Le Corbusier's *Still Life* of 1924 (signed Jeanneret and displayed in the Pavillon de l'Esprit Nouveau the following year) and the housing estate at Pessac, and extending this interpretation to the Villa Savoye. Where the early purist paintings by Jeanneret and Amédée Ozenfant (implicitly the point of reference for Rowe and Slutzky's characterization of purism in terms of clear spatial locations) compressed and layered their purified objects into a two-dimensional spatiality, their subsequent paintings slid out from under the rigor of architectonic objectivism into the fluid, perhaps even oceanic space of humor that Robert Slutzky later described so eloquently.[98] These paintings, for which Jeanneret and Ozenfant coined the idea of the *mariage des contours*, internalized the

opposition of linear and painterly qualities in a play of perception, illusion, and cognition engendered by the simultaneous assertion and denial of volumes. It was this quality that Giedion acknowledged when he wrote that Jeanneret's "preference for floating, transparent objects whose mass and outlines flow into each other in a *mariage des contours* . . . leads us from Le Corbusier's pictures to his architecture."[99] While Rowe and Slutzky took the language of ambiguity and contradiction from György Kepes's *Language of Vision* (where the marriage of contours was interpreted in terms that echo Giedion's), they used this oscillation and instability nevertheless to support an interpretation of the Villa Stein–de Monzie as an integral and self-referential object. Conjuring a virtual plane of reference immediately behind the garden facade, they likened it to a painting capable of representing the three-dimensional order of the building in two dimensions. In contrast, Giedion followed Le Corbusier's own transposition of his paintings' effects into architecture through color and the alignment of contours (fig. 11.4). As Giedion's combination of planar and oblique views suggests (fig. 11.5), he recognized that Le Corbusier's architecture aimed to dissolve mass into surface for the perception of observers moving in space, appreciating through parallax the phenomenon of "corners merging into one another," of clear independent volumes collapsing into two-dimensionality only to spring back into depth a few steps later.

While Le Corbusier's fascination with perception in motion is well known,[100] what remains less so is the explicitness with which he linked his notion of the architectural promenade to this perceptual play of volumes and colors. In the commentary that accompanies the Villas La Roche–Jeanneret in the *Oeuvre complète*, he described the experience of the promenade not only as a spectacle of perspectives developing with great variety, but also as an essay in polychromy that engenders a *camouflage architectural* in which volumes are both "affirmed and effaced."[101] This double and contradictory moment—assertion and denial, positive and negative, form and formless—was also the key property of the marriage of contours, exploiting the properties of transparent objects (such as bottles) to be both themselves and not themselves at the same time, autonomous and self-estranging, closed and open to the beyond. Through the techniques of camouflage, the painter-architect attempted to generate the effects of his paintings in architecture.[102]

In the sphere of painting, Jeanneret created an oscillating movement in the eye on an axis with the retina, conforming to a conception of vision as fundamentally two-dimensional and of spatial depth as an effect generated by layered planes. Such a theory had been popularized through Adolf von Hildebrand's treatise of 1893, *The Problem of Form in the Fine Arts*, which privileged the representation of space in classical and neoclassical sculptural reliefs. Later Gestalt psychology also contributed to the diffusion of this theory, which emphasized the totality of the image and relationships of parts to wholes in what amounted to a scientific recasting of classical aesthetics.[103] By basing his theory of vision on the late nineteenth-century optics of psychophysiologists such as Hermann von Helmholtz, Salmon Sticher, and Wilhelm Wundt,[104] Hildebrand aimed for the truest representation of objects in space. While the early purist paintings carried similar aspirations, the later ones dissolved the object into a relational network, a kind of liquid space in which objects and spatial relationships become mutually mediating in perception over time, no longer locked into a binary movement between figure and ground, foreground and background, but now free to move in a less determined way—more lateral, dynamic, and open-ended.

Le Corbusier first ventured to transpose this play into architecture by painting the concrete walls of the housing at Pessac in colors that dissolve their mass into surfaces—the same colors as those of his *Still Life* of 1924—in order to merge the buildings with the landscape. Here and in the later villas, he demonstrated that the medium of architecture differs from painting in that movement takes place in psychophysiological space rather than the purely optical space of the eye. This distinction between two-dimensional and three- or four-dimensional theories of space had already been made in 1919 by Fritz Hoeber in his critique of Hildebrand's aesthetics of space, in which he invoked Schmarsow's theory of the cognition of objects by an observer in motion in order to emphasize that the plastic arts were not configurations merely for the eye but rather for the "entire organism," the "experiencing soul."[105] For Le Corbusier, the experimental projects of van Doesburg and van Eesteren for the De Stijl exhibition of 1923 (fig. 11.3) may well have provided a new way of thinking about the relationship between the spatial effects of two-dimensional painting and the four-dimensional space creation of architecture.[106]

If the transparency of constructions in space-time was, for Giedion, a constituent fact of modern architecture, and clearly he found it in Le Corbusier's work as well as in Gropius's, it was not simply a transparency of substance as Rowe and Slutzky later presumed. Rather it was a transparency of consciousness engendered by works of art and architecture that for him mediated between inner and outer worlds—their status as objects recalibrated to the new technologies of vision as well as industrial production. For Giedion's expanded montage optics, objects were no longer closed (visually and cognitively) but rather had become open assemblages whose identity remained contingent on the relationships between elements as

perceived by observers moving in relation to them over time. The notion of transparency marked the fluid openness with which the new kind of architectural object accorded with the constituent facts of the modern era in which "no generation is privileged to grasp a work of art from all sides."[107] That the means of architectonic expression had themselves been rendered transparent (in the sense of a natural language) through rationalization and purification was a prerequisite for their role as artistic symbols capable of mediating the tragic split between inner feeling and outer rationality,[108] which Giedion considered necessary for living through the problematic experiences of modernization. "An official art," he explained,

> has turned its back upon the contemporary world and given up the attempt to interpret it emotionally. The feelings which that world elicits have remained formless, have never met with those objects which are at once their symbols and their satisfaction. Such symbols, however, are vital necessities. Feelings build up within us and form systems; they cannot be discharged through instantaneous animal outcries or grimaces. We need to discover harmonies between our inner states and our surroundings. And no level of development can be maintained if it remains detached from our emotional life. The whole machinery runs down.[109]

Taking into account the history of cubism's reception in German architectural culture, deeply enmeshed in German intellectual traditions and aesthetic theories, Rowe and Slutzky's distinction between literal and phenomenal transparency appears inadequate and forced. Not only was Giedion's understanding of cubism historically valid (at least in part)

and conceptually provocative, but it too aimed to account for the purist architecture of Le Corbusier and to grapple with the problematic ambiguities and indeterminacies of perception and cognition on the basis of modern psychology. What was, rather, at stake in Rowe and Slutzky's critique was the profound difference between the aesthetic theories that under-pinned their respective (two- and four-dimensional) interpretations of cubism and its potential for archi-tecture. While enjoying the play of Gestalt ambiguities characteristic of purist paintings—figure and ground, foreground and background, object and matrix, space and surface—Rowe and Slutzky's game of assertion and denial accepted the experience of doubt, ambiguity, and contradiction only by internalizing, aestheticizing, and neutralizing its potential to desta-bilize cognitive certainty. Based still on an objectivist aesthetics of subjective reception (Hildebrand), itself based on an outdated objectivist optics (Helmholtz), their appreciation of purist still lifes and Le Corbusier's villa at Garches limited the game to the frame of the two-dimensional plane, charged with

the obligation of representing the spatial structure of the building for an observer aligned perspectively on axis. Just as Hildebrand privileged relief sculpture for fear that introducing the subject's gaze into the constitution of the art object would dissolve its autonomy into the uncontrollable space occupied by the observer,[110] so Rowe and Slutzky pulled back from the implications for architecture of the potentially uncontrollable ambiguities and contradictions of the *mariage des contours*—of the object dissolved into a liquid matrix of unstable yet constitutive relationships—and reasserted the pictorial facade as the guarantor of self-reflexive transparency. While Giedion was likewise motivated by desires for unity, control, and consciousness, he nevertheless attempted to think their possibility through an analysis of the structural conditions of modernity and a recognition that synthetic cubism, collage, and montage marked a turn from the determinate representations of a self-positing consciousness toward indeterminate constructions—historical and concrete, yet virtual and ineffable—hovering contingently above the ground.

11. NOTES

1. Colin Rowe and Robert Slutzky, "Transparency: Literal and Phenomenal," *Perspecta* 8 (1963), 45–54. The essay was first written in 1955–1956, and a second part was published in *Perspecta* 13/14 (1971), 287–301.

2. György Kepes, *Language of Vision* (Chicago: Paul Theobald, 1944); László Moholy-Nagy, *Vision in Motion* (New York: Wittenborn, 1947).

3. Rowe and Slutzky, "Transparency," 45–46.

4. Ibid., 48.

5. Manfredo Tafuri and Francesco Dal Co, *Modern Architecture*, trans. Robert Erich Wolf (New York: Harry N. Abrams, 1979); see "Architecture and the Avant-Garde from Cubism to the Bauhaus: 1906–1923," 120–132. Other exceptions include Rosemarie Haag Bletter's critique of Rowe and Slutzky's analysis as "too erratic to make workable categories" and their "unortho-dox" interpretation of cubism and constructivism as only sensible in formal and not historical terms. See Rosemarie Haag Bletter, "Opaque Transparency," *Oppositions* 13 (Summer 1978), 121–126. As well, the scholars of the Institut für Geschichte und Theorie der Architektur at the Eidgenössische Technische Hochschule in Zurich have, over the past decade, repeatedly presented and interpreted Giedion's theory of cubism's relation to modern architecture. See Sokratis Georgiadis, *Sigfried Giedion: An Intellectual Biography*, trans. Colin Hall (Edinburgh: Edinburgh University Press, 1993); Dorothee Huber, ed., *Sigfried Giedion. Wege in die Öffentlichkeit* (Zurich: Ammann Verlag, 1987); and the exhibition catalogue *Sigfried Giedion 1888–1968. Der Entwurf einer modernen Tradition* (Zurich: Ammann Verlag, 1989). Most recently, Terence Riley has criticized Rowe and Slutzky's conception of transparency while reworking their binary cate-gories to distinguish contemporary projects that employ translucent and reflective surfaces from the transparency ideals of earlier modernist ones. See Terence Riley, "Light Construction," in *Light Construction*, exh. cat. (New York: Museum of Modern Art, 1995), 9–32.

6. The term postcubist has often been used in relation to purism, a usage that is here expanded to include all the artistic projects and discourses that defined themselves in relation to cubism, as either extensions or corrections, including De Stijl, suprematism, the constructivism of El Lissitzky, and Czech cubism.

7. See for instance Alfred H. Barr, Jr., *Cubism and Abstract Art* (New York: Museum of Modern Art, 1936); Walter Curt Behrendt, *Modern Building: Its Nature, Problems, and Forms* (New York: Harcourt, Brace and Company, 1937); and Henry-Russell Hitchcock, *Painting toward Architecture* (New York: Duell, Sloan and Pearce, 1948). Barr's well-known diagram of "The Development of Abstract Art" charted the lines of influence among the avant-gardes to 1936, and in so doing transformed what had been the programmatic aspirations of postcubist artists and architects into a statement of historical occurrence.

8. Herwarth Walden, whose gallery, bookstore, and magazine *Der Sturm* had been the locus of the avant-garde in Berlin since its founding in 1910, first recognized the Group of Plastic Artists as early as January 1913 in promoting their magazine, *Umělecký měsíčník* (Arts Monthly). By October he had constructed a veritable axis between Prague and Berlin marked by a group show

at his gallery, their participation in his First German Autumn Salon, publication of works by Emil Filla, Karel Čapek, Vincenc Beneš, and Vlastislav Hofman (the only architect of the group to be featured and its youngest member), and inclusion at the German Werkbund Exhibition in Cologne in July 1914. See Vladimir Slapeta, "Cubism in Architecture," in Alexander von Vegesack, ed., *Czech Cubism: Architecture, Furniture, and Decorative Arts, 1910–1925* (New York: Princeton Architectural Press, 1992), 34–52; and Georg Brühl, *Herwarth Walden und 'Der Sturm'* (Cologne: DuMont, 1983).

9. Albert Gleizes and Jean Metzinger, *Du "cubisme"* (1912), trans. in Robert L. Herbert, ed., *Modern Artists on Art: Ten Unabridged Essays*, trans. T. Fisher Unwin and Robert L. Herbert (Englewood Cliffs, N.J.: Prentice-Hall, 1964), 1–18.

10. Vlastislav Hofman, "Der Geist der Umwandlung in der bildenden Kunst," *Der Sturm* 5, no. 190–191 (December 1913), 146–147.

11. Bruno Taut, "Eine Notwendigkeit," *Der Sturm* 4, no. 196–197 (February 1914), 174–175.

12. Adolf Behne, "Bruno Taut," *Der Sturm* 4, no. 198–199 (February 1914), 182–183.

13. Josef Čapek, "Moderne Architektur," *Der Sturm* 5, no. 3 (May 1914), 18–19.

14. Adolf Behne, "Deutsche Expressionisten," *Der Sturm* 5, no. 17–18 (December 1914), 114–115; Adolf Behne, "Expressionistische Architektur," *Der Sturm* 5, no. 19–20 (January 1915), 135.

15. Heinrich Campendonk, Franz Marc, Oskar Kokoschka, Jacoba van Heemskerck, and Carl Mense.

16. Franz Marc, "Spiritual Treasures" (1912), in Wassily Kandinsky and Franz Marc, eds., *The Blaue Reiter Almanac*, trans. Klaus Lankheit (New York: Da Capo, 1974), 55.

17. Jacob von Uexküll, *Bausteine zu einer biologischen Weltanschauung* (Munich: F. Bruckmann, 1913). Behne also cited this book in his 1919 book *Die Wiederkehr der Kunst* (Leipzig: Kurt Wolff, 1919), 109.

18. Adolf Behne, "Biologie und Kubismus," *Der Sturm* 6, no. 11–12 (September 1915), 71.

19. Implicitly using the notion of artistic *Gestaltung* (form willing or form creation) presented by Conrad Fiedler in the 1880s and popularized by Hermann Konnerth in his book *Die Kunsttheorie Conrad Fiedlers. Eine Darlegung der Gesetzlichkeit der bildenden Kunst* (Munich and Leipzig: R. Piper, 1909), Behne considered every work of art a new origin (instinctive expression) and was disdainful of "cubistic" art that imitated the work of others. Even later he continued to value the work of a "true" artist over any dogma or canon, often admiring the most disparate-seeming work for its artistic value.

20. Adolf Behne, *Zur neuen Kunst* (Berlin: Sturm, 1914). Behne's book ends by citing Friedrich Nietzsche concerning the value of projecting hopeful images of the future.

21. Adolf Behne, "Kunstwende?," *Sozialistische Monatshefte* 23–24 (October 1918), 946–952.

22. Behne, "Biologie und Kubismus," 71.

23. See Herwarth Walden, "Künstler Volk und Kunst," *Der Sturm* 10, no. 1 (1919–1920), 10–11; "Nachrevolutionäre," *Der Sturm* 10, no. 3 (1919–1920), 36–39; "Die seidene Schnur," *Der Sturm* 10, no. 3 (1919–1920), 39–45; "Die Kunst in der Freiheit," *Der Sturm* 10, no. 4 (1919–1920), 50–51; "Die Freiheit in der Fachkritik, *Der Sturm* 10, no. 4 (1919–1920), 51–52.

24. Behne, *Wiederkehr*, 7.

25. Ibid., 14.

26. Ibid., 35, 37.

27. Ibid., 63.

28. Ibid., 38.

29. By calling on artists and architects to bring a new cubist world into being, Behne seized on the sense of immanence that cubism had acquired from its initial reception in Germany following the first exhibition of works by Picasso, Braque, and Derain in September 1910 at the second exhibition of the New Artists' Association in Munich. In his much-read *Concerning the Spiritual in Art* of the following year, Wassily Kandinsky assigned cubism a founding role not only for modern art but also for the larger "spiritual revolution" of which he considered it a part. For an introduction to the reception of French cubism in Germany see Peter Selz, *German Expressionist Painting* (Berkeley: University of California Press, 1957), 191–194.

30. For further information on the discourse of new beginnings and its relationship to movements for social reform see Timothy O. Benson, "Fantasy and Functionality: The Fate of Utopia," in Timothy O. Benson, *Expressionist Utopias: Paradise, Metropolis, Architectural Fantasy* (Los Angeles: Los Angeles County Museum of Art, 1994), 12–55.

31. Behne, *Wiederkehr*, 22, 20, 19.

32. Ibid., 24. Kandinsky was no longer included among Behne's list of artists, for he thought that his work remained in the realm of the human.

33. Marcel Franciscono has reported on Gropius's relative ignorance of modern art prior to the war; see Marcel Franciscono, *Walter Gropius and the Creation of the Bauhaus in Weimar: The Ideals and Artistic Theories of Its Founding Years* (Urbana: University of Illinois Press, 1971), 85. It was in Behne's house that Gropius asked Feininger to join him in his new pedagogical venture; see Hans Hess, ed., *Lyonel Feininger* (New York: Abrams, 1961), 87.

34. Behne, *Wiederkehr*, 38, 39.

35. Ibid., 38.

36. Ibid., 66–67.

37. Ibid., 37.

38. Ibid., 64. Behne argued that human beings have capability beyond their desires and knowledge beyond their experience; see p. 109.

39. Ibid., 59.

40. The "Exhibition of Unknown Architects" was organized by Gropius with Max Taut and Rudolf Salvisberg for the Workers' Council for Art at I. B. Neumann's Berlin gallery, Graphisches Kabinett, in April 1919. Sidestepping existing conceptions of architecture, the show featured the architectonic fantasies of artists next to those of selected architects—utopian fantasies by Hermann Finsterlin, Jefim Golyscheff, Wenzil Hablik, O. Herzog, Moritz Melzer, Gerhard Marcks, Arnold Topp, César Klein, Oskar Treichel, Fidus, and Johannes Molzahn.

41. Adolf Behne, "Werkstattbesuche: Jefim Golyscheff," *Der Cicerone* 11, no. 22 (1919), 722–726.

42. In *Wiederkehr*, Behne had described the role of art as a godlike creation in an extended philosophical digression that opposed nature to spirit (*Geist*) but argued for an art in which spirit would become nature once again; see pp. 25–36.

43. See Adolf Behne, *Ruf zum Bauen* (Berlin: Wasmuth, 1920), which served as the catalogue for the show "Neues Bauen" by the Workers' Council for Art. Translated in Charlotte and Tim Benton, eds., *Images* (Milton Keynes: Open University, 1975).

44. See Adolf Behne, "Architekten," *Frühlicht* 1 (1921–1922), 55–58; Adolf Behne, "Neue Kräfte in unser Architektur," *Feuer* 3 (1921–1922), 268–276, rpt. in Haila Ochs, ed., *Adolf Behne, Architekturkritik in der Zeit und über die Zeit hinaus. Texte 1913–1946* (Basel: Birkhäuser, 1994), 61–67.

45. Adolf Behne, "Das bunte Magdeburg und die 'Miama,'" *Seidels Reklame*, October 1922, 201–206, rpt. in Ochs, ed., *Adolf Behne*, 82–92.

46. Letter from Adolf Behne to J. J. P. Oud, 3 October 1920 (Oud Archive, Netherlands Architecture Institute, Rotterdam), cited by Ochs in the foreword to *Adolf Behne*, 11–12.

47. Adolf Behne, "Neue Kräfte in unser Architektur," *Feuer* 3 (1921–1922), 271, rpt. in Ochs, eds., *Adolf Behne*, 63.

48. See Nancy J. Troy, *The De Stijl Environment* (Cambridge: MIT Press, 1983); Alan Doig, *Theo van Doesburg: Painting into Architecture, Theory into Practice* (Cambridge: Cambridge University Press, 1986); Hans Esser, "J. J. P. Oud," in Carel Blotkamp et al., *De Stijl: The Formative Years,* trans. Charlotte I. Loeb and Arthur L. Loeb (Cambridge: MIT Press, 1986), 124–151; and Evert van Straaten, *Theo van Doesburg, Painter and Architect* (The Hague: SDU Publishers, 1988).

49. See Doig, *Theo van Doesburg*, 83–85.

50. See Doig, *Theo van Doesburg*, 33–42, 81, 83–85, 104–105. From his very first considerations of cubism, Oud considered it "architectonic"; see J. J. P. Oud, "Over cubisme, futurisme, moderne bouwkunst, enz.," *Bouwkundig Weekblad* 38, no. 20 (16 September 1916), 156–157.

In this article Oud cited Theo van Doesburg, "De nieuwe beweging in de schilderkunst," *De Beweging* 12, no. 5–9 (May-September 1916).

51. Jan Gratama, "Een oordeel over de hedendaagsche bouwkunst in Nederland," *De Bouwwereld* 21, no. 28 (12 July 1922), 217–219; J. J. P. Oud, "Bouwkunst en kubisme," *De Bouwereld* 21, no. 32 (9 August 1922), 245; Theo van Doesburg, "Het kubisme voor het laatst," *De Bouwwereld* 21, no. 35 (30 August 1922), 270. This exchange is reviewed by Doig, *Theo van Doesburg*, 104–105.

52. See Doig, *Theo van Doesburg*, 20–22.

53. See ibid., 21–24.

54. *De Stijl* 9 (1919), 104–105. While unattributed in *De Stijl*, this text was attributed to Behne under the title "Aufruf" in *Der Cicerone* 11 (1919), 264.

55. Theo van Doesburg met with Gropius together with his partner Adolf Meyer, Fred Forbat, and several Bauhaus students in the house of Bruno Taut.

56. See Theo van Doesburg, "Bilanz des Staatlichen Bauhauses Weimar," *Mécano*, 1923, back page.

57. Cited by Eberhard Steneberg, *Arbeitsrat für Kunst Berlin 1918–1921* (Düsseldorf: Edition Marzona, 1987), 70.

58. For assessments of van Doesburg's influence see Doig, *Theo van Doesburg*, 140–141, and Troy, *The De Stijl Environment,* 115–116, 179–184.

59. See Stanford Anderson, "Peter Behrens and the Architecture of Germany 1900–1917" (Ph.D. diss., Columbia University, 1968), 136–187; and *Masssystem und Raumkunst: das Werk des Architekten, Pädagogen und Raumgestalters J. L. M. Lauweriks*, exh. cat. (Krefeld: Kaiser Wilhelm Museum, 1987).

60. H. P. Berlage, *Grundlagen und Entwicklung der Architektur. Vier Vorträge gehalten im Kunstgewerbemuseum zu Zürich* (Rotterdam: W. L. and J. Brusse, 1908); Adolf Meyer's student project is illustrated and discussed on pp. 56–58. For an account of Meyer's education and his teaching at the Bauhaus, see Annemarie Jaeggi, *Adolf Meyer: Der zweite Mann. Ein Architekt im Schatten von Walter Gropius* (Berlin: Argon, 1994), 20–44, 115–133.

61. Winfried Nerdinger has recounted that the Wasmuth folio on Wright was the "office bible" and was even consulted by Meyer and Gropius in the design of the Sommerfeld House; see Winfried Nerdinger, *Walter Gropius* (Berlin: Bauhaus Archive, 1985), 54.

62. Oud's interpretation of cubism in architecture remained in currency as late as 1937; see Behrendt, *Modern Building*, 147–150, 152–166.

63. J. J. P. Oud, "Über die zukünftige Baukunst und ihre architektonischen Möglichkeiten (Ein Programm)," *Holländische Architektur* (1926; rpt. Mainz and Berlin: Florian Kupferberg, 1976), 63–76. For an assessment of the relative influence of Oud and van Doesburg for Gropius and Meyer, see Jaeggi, *Adolf Meyer*, 152–169.

64. See Jaeggi, *Adolf Meyer,* 147–152; Esser, "J. J. P. Oud," 146–149; and Annemarie Jaeggi, "Dal blocco chiuso alla compenetrazione dei volumi," in *Rassegna* 15, *Walter Gropius 1907/ 1934,* 37–46. In this last article, Jaeggi describes the Gropius/Meyer project for the Kallenbach House as their first open composition, in the geometrical rather than functional sense.

65. See Nerdinger, *Walter Gropius,* 54 n.3.

66. This analysis is presented in Yve-Alain Bois, "The De Stijl Idea," in *Painting as Model* (Cambridge: MIT Press, 1990), 101–122.

67. See Conrad Fiedler, *On Judging Works of Visual Art* (1876), trans. Henry Schaefer-Simmern and Fulmer Mood (Berkeley: University of California Press, 1949). Fiedler's artistic theories were taken up by Heinrich Wölfflin; see note 19.

68. Theo van Doesburg, *Grundbegriffe der neuen gestaltenden Kunst* (Frankfurt am Main: Oehms, 1925).

69. See Detlef Mertins, "Playing at Modernity," in *Toys and the Modern Tradition* (Montreal: Canadian Centre for Architecture, 1993), 7–16; and Hanne Bergius, *Das Lachen Dadas. Die Berliner Dadaisten und ihre Aktionen* (Giessen: Anabas, 1993).

70. László Moholy-Nagy, *Von Material zu Architektur* (Munich: Albert Langer, 1928); trans. Daphne M. Hoffman and enlarged as *The New Vision* (New York: George Wittenborn, 1947).

71. Giedion's photographs were first published in Sigfried Giedion, "Zur Situation der französischen Architektur II," *Der Cicerone* 19, no. 6 (1927), 177.

72. Moholy-Nagy, *Von Material zu Architektur,* 236.

73. Walter Gropius, "glasbau," *Die Bauzeitung* 23, no. 20 (1926), 159–162, rpt. in Hartmut Probst and Christian Schädlich, eds., *Walter Gropius,* vol. 3, *Ausgewählte Schriften* (Berlin: Ernst & Sohn, 1988), 103–106.

74. Arthur Korn, *Glass in Modern Architecture,* trans. Design Yearbook Limited (London: Barrie & Rockliff, 1967), n.p. [7]. This book was reviewed by Ludwig Hilberseimer, together with Konrad Werner Schulze's *Glas in der Architektur der Gegenwart,* in Ludwig Hilberseimer, "Glas Architektur," *Die Form,* 1929, 521–522; in this article Hilberseimer explicitly linked the emergent glass environment of the late 1920s to Scheerbart's visionary utopia of 1914.

75. Sigfried Giedion, *Space, Time and Architecture: The Growth of a New Tradition* (Cambridge: Harvard University Press, 1941), 362.

76. Ibid., 14, 404.

77. Ibid., 360.

78. For a detailed consideration of Giedion's conception of space-time in relation to scientific theories, see Sokratis Georgiadis, *Sigfried Giedion,* 97–152; and Sokratis Georgiadis, "Von der Malerei zur Architektur," in *Sigfried Giedion: Der Entwurf einer modernen Tradition,* exh. cat. (Zurich: Ammann, 1989), 105–117.

79. Giedion's idea of "space conceptions" plays a similar descriptive and analytical role to Erwin Panofsky's more directly neo-Kantian idea of "symbolic forms," taken up from Ernst Cassirer. Both Giedion and Panofsky were indebted to Heinrich Wölfflin's categories of epochal visualities and Alois Riegl's notion of a collective *Kunstwollen* that manifests itself in the formal and material structures of works.

80. Giedion refers to construction as the subconscious of the nineteenth century in *Bauen in Frankreich* (Leipzig: Klinkhardt & Biermann, 1928), 2, and in *Space, Time and Architecture*, where he also refers to the unconscious and automatic writing of the modern age, pp. 162, 207, 583, 584, 586.

81. August Schmarsow, "The Essence of Architectural Creation" (1893), in Harry Francis Mallgrave and Eleftherios Ikonomou, ed. and trans., *Empathy, Form, and Space: Problems in German Aesthetics 1873–1893* (Santa Monica: Getty Center for the History of Art and the Humanities, 1994), 281–297. While Schmarsow used the idea of *Raumgestaltung* as a space creation that occurs in three dimensions over time, it was also employed by Hildebrand in relation to his two-dimensional theory of space creation.

82. Alfred H. Barr, Jr., ed., *Picasso: Forty Years of His Art* (New York: Museum of Modern Art, 1939), 77.

83. Kepes, *Language of Vision*, was a textbook for modern graphic design based on Gestalt psychology and included numerous examples of double-faced portraits, including his own work and in the art of children.

84. Giedion, *Space, Time and Architecture*, 402.

85. Guillaume Apollinaire, *The Cubist Painters: Aesthetic Mediations 1913*, trans. Lionel Abel (New York: George Wittenborn, 1962), 13, 23. Giedion, *Space, Time and Architecture*, 358: "The cubists dissect the object, try to lay hold of its inner composition. They seek to extend the scale of optical vision as contemporary science extends the law of matter. Therefore contemporary spatial approach has to get away from the single point of reference. During the first period (shortly before 1910) this dissection of objects was accomplished, as Alfred Barr expresses it, by breaking up 'the surfaces of the natural forms into angular facets.' . . . These angles and lines began to grow, to be extended, and suddenly out of them developed one of the constituent facts of space-time representation—the plane." By later comparing the engineering works of Robert Maillart with Picasso's cubism, Giedion implicitly extended the analytic of cubism to engineering, and reciprocally allowed the constructiveness of engineering to pass to cubism.

86. Giedion, *Space, Time and Architecture*, 404.

87. Sigfried Giedion, "Bauhaus und Bauhauswoche zu Weimar," *Werk* (Zurich), September 1923, rpt. in *Hommage à Giedion. Profile seiner Persönlichkeit* (Basel: Birkhäuser, 1971), 14–19.

88. Sigfried Giedion, *Walter Gropius: Work and Teamwork* (London: Architectural Press, 1954), 31–35.

89. Giedion, "Bauhaus," 16.

90. The idea that abstraction entailed self-alienation had been advanced in 1908 by Wilhelm Worringer in his well-known *Abstraction and Empathy: A Contribution to the Psychology of Style*, trans. Michael Bullock (New York: International Universities Press, 1953).

91. Giedion, "Bauhaus," 17.

92. Ibid.

93. For a more extensive treatment of this comparison see also Detlef Mertins, "Open Contours and Other Autonomies," in Rodolfo Machado and Rodolphe el-Khoury, eds., *Monolithic Architecture* (New York: Prestel, 1995), 36–61.

94. Giedion, *Space, Time and Architecture*, 370.

95. For Giedion's theory of the role of artistic symbols, see *Space, Time and Architecture*, introduction, 2–28, and "Do We Need Artists?," 350–354.

96. Le Corbusier's appreciation of Picasso's art and stature never diminished. The year before Giedion's lectures at Harvard University, which became *Space, Time and Architecture*, Walter Curt Behrendt had called Le Corbusier "the Picasso of modern architecture" who "uses modern construction mainly for its emotional power of expression." See Behrendt, *Modern Building*, 161

97. Giedion, *Space, Time and Architecture*, 416.

98. Robert Slutzky, "Aqueous Humor," *Oppositions* 19/20 (Winter/Spring 1980), 29–51; see also Robert Slutzky, "Après le Purisme," *Assemblage* 4 (October 1987), 95–101, in which he turns to the *mariage des contours* directly as the basis of what he called a new poetic imagination, which he tracks to Le Corbusier's Ronchamp and La Tourette, "two structures that encapsulate the subliminal and the sublime." Slutzky writes, "With Le Corbusier, the constraints of Purist aesthetics, of compositional literalness, will be radically loosened, giving way to more ambiguous space and content and allowing the artist's psychic energies to overflow into his work."

99. Giedion, *Space, Time and Architecture*, 408.

100. See for instance Le Corbusier's statement that it is "by walking, through movement, that one sees an architectural order develop." Le Corbusier and Pierre Jeanneret, *Oeuvre complète, 1929–1934*, ed. W. Boesiger and O. Stonorov (Zurich: Editions d'Architecture, 1964), 24.

101. Le Corbusier and Pierre Jeanneret, *Oeuvre complète, 1910–1929*, ed. W. Boesiger and O. Stonorov (Zurich: Editions d'Architecture, 1964), 60. For discussions of cubism in relation to camouflage see Albert Roskam, "Dazzle Painting: Art as Camouflage—Camouflage as Art," *Daidalos* 51 (15 March 1994), 110–115; Roy R. Behrens, *Art and Camouflage: Concealment and Deception in Nature, Art and War* (Cedar Falls: University of Northern Iowa, 1981); and Bruno Reichlin, "Le Corbusier vs De Stijl," in Yve-Alain Bois and Bruno Reichlin, eds., *De Stijl et l'architecture en France* (Liège: Pierre Mardaga, 1985), 91–108. Reichlin discusses the relationship between van Doesburg's polychromatic conception of architecture and Le Corbusier's idea of "architectural camouflage" in terms of compositions that are simultaneously

constructive and destructive; see especially 103–105. My interpretation of Le Corbusier's transposition from painting to architecture is also indebted to Yve-Alain Bois's analysis of movement and parallax in the architectural promenade of Le Corbusier at the Villa Savoye; see Yve-Alain Bois, "A Picturesque Stroll around Clara-Clara," *October* 29 (1984), 32–62.

102. Jeanneret and Ozenfant had previously disparaged the phenomenon of camouflage in the dazzle-painting of warships using "cubist" patterns. See Amédée Ozenfant and Charles-Edouard Jeanneret, *Après le cubisme* (Paris: Editions des Commentaires, 1918), 30.

103. Adolf Hildebrand, "The Problem of Form in the Fine Arts," trans. in Mallgrave and Ikonomou, eds., *Empathy, Form, and Space*, 227–279. The relationship of Gestalt theory to Hildebrand's treatise, on the one hand, and to modern art, on the other (especially spatial representation in two-dimensional media, including the *mariage des contours*), is evident in Kepes's *Language of Vision*, for which Giedion wrote one of the introductory essays.

104. See Mallgrave and Ikonomou, eds., *Empathy, Form, and Space*, 36; and Margaret Iversen, *Alois Riegl: Art History and Theory* (Cambridge: MIT Press, 1993), 73 n.3.

105. Fritz Hoeber, "Die Irrtümer der Hildebrandschen Raumästhetik," *Der Sturm* 9, no. 12 (March 1919), 157–158. Erwin Panofsky also noted this distinction in *Perspective as Symbolic Form*, trans. Christopher S. Wood (New York: Zone Books, 1991), 30.

106. Bruno Reichlin has described Le Corbusier's affinity for van Doesburg's work during the final stage of his Villas La Roche–Jeanneret. See Bruno Reichlin, "Le Corbusier vs De Stijl," in Bois and Reichlin, eds., *De Stijl et l'architecture en France*, 91–108.

107. Giedion, *Space, Time and Architecture*, 5.

108. Ibid., 13.

109. Ibid., 351

110. Yve-Alain Bois has discussed Hildebrand's fear of space—of art leaping from the two-dimensional surface of representation into the three-dimensional world (a fear that he argues Clement Greenberg shared but that Henry-Daniel Kahnweiler and Carl Einstein considered a key limitation of western art); see Yve-Alain Bois, "Kahnweiler's Lesson," in *Painting as Model*, 65–97.

CONTRIBUTORS

EVE BLAU
Department of Architecture, Graduate School of
Design, Harvard University

JAY BOCHNER
Études anglaises, Université de Montréal

YVE-ALAIN BOIS
Department of Fine Arts, Harvard University

BEATRIZ COLOMINA
School of Architecture, Princeton University

DAVID COTTINGTON
Falmouth School of Art and Design

ROBERT L. HERBERT
Department of Art, Mount Holyoke College

DOROTHÉE IMBERT
Department of Landscape, Graduate School of Design,
Harvard University

DETLEF MERTINS
School of Architecture and Landscape Architecture,
University of Toronto

KEVIN D. MURPHY
School of Architecture, University of Virginia

IRENA ŽANTOVSKÁ MURRAY
Blackader-Lauterman Library of Architecture and
Art, McGill University

PAUL OVERY
School of History and Theory of Visual Culture,
Middlesex University

BRUNO REICHLIN
École d'architecture, Université de Genève

NANCY J. TROY
Department of Art History,
University of Southern California

PHOTOGRAPHIC CREDITS

INDEX

COPYRIGHT
INFORMATION